Dedalus Eu[...]
General Edi[...]

The Man in Flames

ok

Serge Filippini

The Man in Flames

translated by Liz Nash

Dedalus

Funded by
THE
ARTS
COUNCIL
OF ENGLAND

DARK BLUE

Dedalus would like to thank the Arts Council of England and the Burgess Programme of the French Ministry of Foreign Affairs for their assistance in producing this translation.

Published in the UK by Dedalus Ltd, Langford Lodge, St Judith's Lane, Sawtry, Cambs, PE17 5XE

ISBN 1 873982 24 0

Dedalus is distributed in the United States by Subterranean Company, P.O. Box 160, 265 South Fifth Street, Monroe, Oregon 97456

Dedalus is distributed in Australia & New Zealand by Peribo Pty Ltd, 58 Beaumont Road, Mount Kuring-gai, N.S.W. 2080

Dedalus is distributed in Canada by Marginal Distribution, Unit 102, 277 George Street North, Peterborough, Ontario, KJ9 3G9

First published by Dedalus in 1999
L'homme encendie copyright © editions Phebus 1990
Translation copyright © Liz Nash 1999

The right of Serge Filippini to be identified as the author and Liz Nash to be identified as the translator of this work has been asserted by them in accordance with the Copyright, Designs and Patents Act, 1988.

Typeset by RefineCatch Limited, Bungay, Suffolk
Printed in Finland by Wsoy

A C.I.P. listing for this book is available on request.

institut français

French Literature from Dedalus

French Language Literature in translation is an important part of Dedalus's list, with French being the language *par excellence* of literary fantasy.

Séraphita – Balzac £6.99
The Quest of the Absolute – Balzac £6.99
The Experience of the Night – Marcel Béalu £8.99
Episodes of Vathek – Beckford £6.99
The Devil in Love – Jacques Cazotte £5.99
Les Diaboliques – Barbey D'Aurevilly £7.99
The Man in Flames (L'homme encendie) – Serge Filippini £10.99
Spirite (and Coffee Pot) – Théophile Gautier £6.99
Angels of Perversity – Remy de Gourmont £6.99
The Book of Nights – Sylvie Germain £8.99
Night of Amber – Sylvie Germain £8.99
Days of Anger – Sylvie Germain £8.99
The Medusa Child – Sylvie Germain £8.99
The Weeping Woman – Sylvie Germain £6.99
Infinite Possibilities – Sylvie Germain £8.99
Là-Bas – J. K. Huysmans £7.99
En Route – J. K. Huysmans £7.99
The Cathedral – J. K. Huysmans £7.99
The Oblate of St Benedict – J. K. Huysmans £7.99
The Mystery of the Yellow Room – Gaston Leroux £7.99
The Perfume of the Lady in Black – Gaston Leroux £8.99
Monsieur de Phocas – Jean Lorrain £8.99
The Woman and the Puppet (La femme et le pantin) – Pierre Louÿs £6.99

Portrait of an Englishman in his Chateau – Pieyre de Mandiargues £7.99
Abbé Jules – Octave Mirbeau £8.99
Le Calvaire – Octave Mirbeau £7.99
The Diary of a Chambermaid – Octave Mirbeau £7.99
Torture Garden – Octave Mirbeau £7.99
Smarra & Trilby – Charles Nodier £6.99
Tales from the Saragossa Manuscript – Jan Potocki £5.99
Monsieur Venus – Rachilde £6.99
The Marquise de Sade – Rachilde £8.99
Enigma – Rezvani £8.99
The Wandering Jew – Eugene Sue £10.99
Micromegas – Voltaire £4.95

Forthcoming titles include:

Sebastien Roch – Octave Mirbeau £9.99
L'Eclat du sel – Sylvie Germain £8.99

Anthologies featuring French Literature in translation:

The Dedalus Book of French Horror: the 19c – ed T. Hale £9.99
The Dedalus Book of Decadence – ed Brian Stableford £7.99
The Second Dedalus Book of Decadence – ed Brian Stableford £8.99
The Dedalus Book of Surrealism – ed Michael Richardson £9.99
Myth of the World: Surrealism 2 – ed Michael Richardson £9.99
The Dedalus Book of Medieval Literature – ed Brian Murdoch £9.99
The Dedalus Book of Sexual Ambiguity – ed Emma Wilson £8.99
The Decadent Cookbook – Medlar Lucan & Durian Gray £8.99
The Decadent Gardener – Medlar Lucan & Durian Gray £9.99

Thursday, 10th February, 1600

I write this date with an atrocious pen, without the aid of glasses, and knowing that I have seven days to live, if rotting in a stinking dungeon counts as living. Living, dying. In here, extreme opposites tend to merge into one. But the devil, who never wastes his time, has seen to it that in my last bedroom there should be a table, a stool, and a cold light coming down from a small window high up in the wall; and I am a stubborn old beast, determined not to lose my reason, even if it means groaning to the bitter end under the burden that my life, all in all, has been. That is why I demanded paper and ink. Orazio obeyed me without hesitation:

'Write as much as you like, Brunus. It'll all be destroyed.'

Thank you, gaoler. And don't worry: I won't give you any trouble at all. I know perfectly well that these notes haven't the slightest chance of ever becoming my last book. All I am aiming to do is to spend seven whole days reading my own life story. After which they will burn me, and these sheets of paper. The world will give a sigh, an imperceptible shudder, and Giordano Bruno, writer, teacher of natural philosophy, former adviser to the King of France, hero of mnemonics, literature, science and the magic arts will be just a memory – a bad one where some people are concerned. Burn the heretic! Farewell to the taste of things, the flesh of boys, the cut and thrust of debate. As I stand on the threshold of an old age that can never be, time will carry away my body and my thoughts. May everything that was me disappear! All that will be left behind in revenge will be my abominable death, like a foot-print in the snow; someone, people will say, has passed by here.

It was yesterday, at noon. Flaminio Adriano, a lawyer of the Universal and Holy Inquisition, was preparing to read out the sentence. The guards called for silence from the crowd, who were stamping their feet in the freezing cold inside the

7

Madruzzi palace and spilling out through the open doors into the Piazza Navona. Good-for-nothing riff-raff! A rabble of scheming rogues, invited along to hear their masters pronounce the death sentence! Brother Cyprian and I had, as it were, been turfed out of our Holy Office cell and dragged for one last time before the assembly of nine cardinals and all their various advisers. A bishop was being paid to take charge of the double degradation, and Rieti, the governor of Rome, was ready to take delivery of the two stubborn recalcitrants. The Holy Church never gets its own hands dirty. It passes sentence, the secular authorities carry it out. The holy men will torture you by strappado, they will fill you to bursting with water, but when the prisoner collapses on to his pallet bed, longing for nothing but oblivion, the body they invite him to repossess is not supposed to show any signs of mutilation, lest God be in any way offended by it.

Adriano cleared his throat. For the last time I observed my judges – not one of whom returned my gaze – as they sat dressed in purple behind the long table: Deza, the fabulously wealthy, depraved Spaniard; Bellarmin, who was studying his razor-blade hands; Santaseverina, the most malevolent of them all, with his cannonball head . . . Madruzzi for his part was rolling his eyes in torment, and looked as if he had been forced to sit straight down on to a red-hot seat of torture. My goodness, how he hated this jabbering rabble that was crushing into his house! He signalled bad-temperedly to a guard, who came over to me. They had already made me kneel; now I was compelled by this thug to bow my head as well.

The last murmurs died down. I heard the lawyer read out the names of those present, then the list of my crimes. In addition to the eight supposed errors and heresies drawn up in Christian language by Bellarmin, which were at least relevant to my doctrine, there were more than twenty nonsensical grounds stemming from evidence produced by the in-house informers, sycophantic apes and gallows-birds employed by the Curia. Before I could even stand up, the guards rushed over to force me back down on the ground. Drowning out Adriano's voice, I was already calling out:

'Miserable cowardly dogs! You are condemning me, yet you are trembling more than I who am being sentenced!'

I was struck violently on the face. All around me the rank and file were muttering, yelling abuse, shaking their fists, a heaving mass from which insults and threats in Roman patois emerged like the sound of stupid crows cawing.

'Put him to death! Burn him!' Yes, you'll have your burning, your entertainment, your mystery play, your moral purge! Just be patient, I'm already down on my knees!

'Murderers!' I breathed. 'Illiterates!'

I received another blow on the head. Madruzzi was on his feet, looking distraught. He barked, demanded silence, reinforcements. Reinforcements, by heaven! Men! This furious rabble was going to smash everything up and swarm all over the place! In the end weapons were raised. There's nothing like a flurry of halberds to calm them down. And indeed they did go quiet. Almost immediately. A beast that bites needs to be put on a short chain. The crowd shook itself, astonished by its own boldness, its hunger not satisfied. The fire at the centre of the storm had gone out. At last the cardinals could sit down again.

The storm! Hasn't that always been my element? I think back to Naples, to the monastery; even there you had to know how to to make yourself heard. The men who ruled the roost there were complete asses. I was young and everywhere I looked I saw nothing but corruption, vulgarity, ignorance and cruelty, those four noisome sisters that were firmly established at every level of the hierarchy. Anyone who wanted to exist there had to start by shouting his mouth off. God knows that saying my piece is something I have never hesitated to do since then and throughout my life, thus making a virtue of necessity . . . It is a merciless vengeance of fate that at the end of it all I should have had to listen to my sentence with my tongue imprisoned in a wooden bit, down on my knees and bending over between two guards. Adriano was getting through his script as fast as he could:

'. . . therefore we command that you be degraded and driven from our Holy Church, having shown yourself

9

unworthy of its mercy; and that you be delivered to the secular Court, in the person of the Governor of Rome here present, so that he may punish you while mitigating, as far as is possible and at our benevolent request, the rigours of the law. In addition, we condemn and censure all your books as containing errors and heresies, and order that they be burned in St Peter's Square, at the foot of the steps, and as such mentioned in the index of prohibited works – Amen.'

The bit was preventing me from swallowing my saliva and no doubt the bishop drafted in for this task, a poor beggar with fear in his eyes, will remember for a long time having degraded not the hero of an undreamt-of truth, but a sort of frenzied maniac, red with anger and dribbling spittle. After I had sent the sacerdotal instruments flying by punching them with my fist, for which I received another good hiding, he demanded that the guards hold my hands, and while he was churning out his set phrases at top speed, hurt me by clumsily cutting the nails of my thumb and index finger, with a timid, disgusted look, as if they were evil claws. The ritual was over. I was not present at the degradation of Brother Cyprian, because Rieti ordered his men to throw me back into the dungeon without delay. One of Madruzzi's lackeys showed them the way out by a back door, which made it possible to avoid the crowd. And so in our little group – a handful of grumbling thugs dragging a half smothered wretch – we walked through a magnificent courtyard, down five or six alleyways lashed by a freezing *tramontana*, and then out on to a wider avenue where, with its back to the Tiber, stood Tor di Nona, my new and final prison.

The guard I was handed over to, Orazio, is a giant with one missing eye. Even as he was chaining up my legs, he confided in me that he too had grown up in Naples, near the aptly named Piazza Perduta where his mother was a whore.

'City of bandits and sodomites,' he grunted. 'The priests and students were the worst of the lot. Spent all their time fighting and planning their dirty tricks.'

Then, when he finally got round to taking the bit out of my mouth:

'Poor old boy, look at the mess they've made of you.'

He allowed me to spit a trickle of blood into a bowl, handed me a pitcher of wine, and went on:

'The executions here are on Thursdays, but I haven't heard anything about it being tomorrow. Never mind, the black brothers may still come.'

The brothers of San Giovanni Decollato are actually lay-men who occupy their spare time ministering, so they say, to victims of torture. Lord, how I hate those people with their partiality for night-time processions, prayers for the dying, severed heads and bodies delivered to the flames . . .

My reply was a raucous groan:

'The sooner the better.'

'That's what I think too. Don't much feel like having people coming in and out of your cell for a week. Opening up for them the whole time and then bringing them all the way here. You can't just walk into Tor di Nona. Something tells me that you must be a difficult sort of customer, judging by that thing they stuck in your mouth . . .'

'When will I know, about . . . the execution?'

'Scared, eh?'

He was growling at me and shaking a sooty finger that was as thick as a stick.

'You're all the same, you really are. All the time you're pestering the lion you keep thinking you're smarter than he is, but as soon as he's got you in his paws, you start trembling like little lambs! To hell with you: you should have thought about it sooner! If you ask me you clerics are just a load of bragging big mouths with nothing between the ears.'

I bent over the bowl again. He got down on his knees to check my chains.

'Be that as it may, Brunus, if that really is your name, don't you take it into your head to give me any trouble. Orazio isn't a bad fellow, as you will see, and the most precious thing a condemned man has is his gaoler, as long as he's an honest one.'

11

With these words he offered me another slug of wine, and as he did so looked at me with his one-eyed, wounded gaze, in which there was indeed perhaps a gleaming flash of goodness. I repeated my question.

'Allow a good two hours after nightfall. If nothing has happened by then, it'll be next Thursday for sure.'

His huge silhouette withdrew behind the door. With great difficulty, given how heavy these chains are, I managed to get my legs up on to the bare plank that was my bed. On this day of suffering, it was not long before darkness fell. All I could do now was lie there trembling, with all my senses fully alert, in the midst of that fearsome black night.

Unlike the Holy Office gaol, where I have lived for the last seven years and which rings constantly with the sound of the brothers arguing and laughing, the senatorial prison seems to be haunted by a terrible silence, undisturbed by a single groan, like a world where even tears no longer flow. No call, no message filters in through its icy walls. There is the grating sound of a door being bolted. A guard prowls along the corridor, dragging his feet. Somewhere a portcullis is raised then lowered again. How many doomed men before me have shivered in this rat-infested condemned cell, this hypogeum, where a last remnant of life is suddenly filled with a chaos of images and reminiscences? I think of Socrates lying down on the stone, shivering as the cold creeps into his legs and belly. Friends weep at his bedside; he lifts the veil that covers his face only to utter simple words that will live for ever. And where are my friends? Hennequin, Besler, Sidney . . . Proud, graceful Sidney died at thirty-two after serving in Flanders, gleaming like a god in the midst of battle. A gifted cavalryman, a wonderful poet, the young prodigy one day laid down his life and his dreams for the sake of beauty, in an insolent refusal to grow old which wrung tears of admiration and sorrow from me. Besler died in Frankfurt, carried off by fever as he was wearing himself out taking down my dictation, Jean Hennequin in Paris, trying to protect me during one of my countless escapes . . . And you, Cecil, death has spared you, hasn't it? What passionate encounter is going on in your house on

Malamocco today? What statesman or powerful lord is drinking the intoxicating draught of your lips, damn him, at the very hour when I am dying of loneliness, abandoned and cursed? Ah! I can hear him snoring, the blackguard, gorged on your costly pleasures, as naked as the day he was born, vanquished and sleeping next to your indifferent hip! Guided by some dream, his hand gropes around under the perfumed sheet for the memory of a soft shoulder. But your gaze has already wandered off, mesmerised by the flames that are lighting up the shadows around a marble fireplace. Would that you might be with me in your thoughts, if only for a split second, for the walls of this dungeon I have been thrown into exude the smell of the tomb. Your Philip, you see, has slapped death in the face yet again, and this time will certainly be the last; and it will not be my friends, oh no, but my enemies who will weep at my bedside and afflict me to the bitter end with their sinister chants.

Although I am tormented by the fear of seeing Orazio open the door to a procession of black brothers, in the end the spiral of interwoven images breaks through the gossamer veil that separates wakefulness from sleep. Suddenly I am walking, in a strange house, on a tiled floor with a geometrical pattern. Painted on to the wall itself is a picture of an over-confident child moving away from the shore on a frail barque, on to the ocean which will soon engulf him. Where am I? London? Prague? I go up a majestic staircase overlooked by Hermes and enter a bedroom. From the bed where he is lying, an aging Cecil watches as I approach; he is sad, motionless, and no quiver of pleasure lights up his face. Cecil! By one of those tricks of which dreams hold the secret, the distance between us is now growing bigger and bigger, and my shackled legs are getting heavier with every step. Suddenly I am frozen by the terrible certainty that as I walk I am advancing towards death. Should I shout out? A wooden wedge has been stuck into my mouth, so no sound can come out from my chest. Now the claws of a wild animal are closing on my shoulder . . . It is this imaginary pain that delivers me from my nightmare and is replaced by a dazzling light: a lantern is dancing in front of my

eyes. I can make out a cavernous face bending over me: that of a cyclops called Orazio who is bringing me a bowl of soup.

'They won't come now,' he sighs.

His tasteless broth does me good. He's the bastard son of a whore, this Neapolitan, in the literal sense, but perhaps he'll be a precious friend. When the dawn light shines in through the little top window, I shall ask him for something to write with.

The shoddy pen squeaks between my fingers. Am I unhappy? No: I know the exact date of my death. And as one who two years ago was twice subjected to four hangings by the rope, I know that there is nothing worse in this world than physical pain, when it is administered by men. They hurled me into the void, they dislocated my shoulders, but I had not yet given up the will to live and I had an inner strength that battled to prevent my arms being pulled off, as sometimes happens. Soon the flames will lick at my feet, roast the hairs on my legs and stomach, and then start to eat into my flesh, and I shall accept this torment. I shall even go along with nature in its efforts to detach my soul from me. Does that mean that I am indifferent to the suffering that afflicts me, and have no tears to shed for my own death? No, that's not true either. I declare that the sentence pronounced against me is the expression of my own will; it condemns you, my judges, for all eternity, whereas it exalts my work to new heights. You will burn my body. You will defile my memory. You will ban my forty books. But divine posterity will recognise the reformer of the heavens and of knowledge, while you will rot for ever in the limbo of ignorance. Every treatise I wrote, every speech or lecture I delivered, every decision I made was a challenge to the fear that you inspire in the world. It remains for me to send out one last sign to the universe, and that sign will be my death agony, in that it will crown, clarify, and unite all the trials of my life. According to your plan I should have recanted, renounced my doctrine and agreed to die of natural causes, repentant, exiled in some monastery, forgotten. But what I want is for science to remember Giordano the Nolan! And I want people to say, when they speak of him in times to

come, not 'He was born in this or that place', but 'Thus did this man die', for in this death lie the meaning and origin of my life.

Should a philosopher tell the story of his own existence? Yes, for it is also that of his opinions, how he has cherished them, embraced them, nurtured them, delivered them to the fury of men, how through the medium of his physical being they have crossed swords with the world. I leave behind me forty treatises and dialogues in which the fires of consciousness glisten like so many unreachable stars; but what of the poet's cry of sorrow? His sighs and joys? What would Plato's doctrine be without the affections, battles, judgement, condemnation and death of Socrates? As the sun goes down, the servant of the Eleven crushes an ounce of poison into a cup; and the humble act of the executioner is the final word of divine knowledge. I too have transformed moving matter into thought, love, pride, courage. Today my ideas, feelings and virtues are corrupting me and destroying my body. Isn't this destruction of my being relevant to my work? Here now is what my life was, as I tell it to myself. Here is my last act, my last labour, my last suffering. Here are my last pages.

I was born in Nola then, in the Kingdom of Naples, on the thirtieth of January in the year of forty-eight. The name by which I was baptised, Philip, may suggest some legendary horseman, a ghostly figure sprung from wild paternal fancies, but it was much more probably taken from the Spanish tyrant who was on the throne at that time. I first saw the light in a comfortless hovel which had been given to my mother as a dowry and which clung on to the side of a slope known as il Colle di Cicala, Cicada Hill. It is a very steep hill, with an extremely precarious path climbing up it, in between a scree-scattered ravine that makes you feel giddy and a forest of oak, elm and dogwood. Our house was right next to the ruins of an ancestral castle from which, when the mist is not too thick, you can see the top of Vesuvius opening up to the sky like a mouth whose lips are mutilated by fire.

Fraulissa Savolino, my mother, spent her life moaning and

groaning, sitting next to a window and staring spitefully into the distance at the San Paolo district where those who had brought her into the world still lived. Her father, she brooded, had given her to a gentleman who was poorer than a tramp. As if a mere child could have been the cause of such hardship, I was subjected until my seventh year to the full brunt of her bitterness and torment. Bitter, timid and tormented myself, I was viciously beaten and shut away in tiny, dark cubby-holes until I nearly lost my reason. This woman who, I believe, hated God and religion, albeit without any passion, did not even deign to equip me with the rudiments of piety which would have enabled me to pray to heaven for deliverance from her.

Owing to lack of fortune my father, Gioan Bruno, was compelled to sell his talents as a cavalryman to the viceroy for a fee of sixty ducats a year. Painted on a dusty wooden escutcheon above the fireplace, his coat of arms showed a lion towering over a mountain which was none other il Colle di Cicala. Was that the dream he was chasing after in all four corners of the Kingdom, always fighting wars that he never talked about? I do not know, and perhaps he didn't either. His visits to Fraulissa were rare and brief, and I only knew him, as it were, through his interminable absences. Every time he returned his eyes were full of sadness as he gazed at his cramped, miserable domain, which his wife had deserted as soon as he arrived to run off and take refuge with the Savolini. While Gioan sighed discontentedly over his lot, his famished horse neighed desperately, tied up in the garden to the trunk of the old fig tree tree that grew up out of the wall. My father had no peace until he could get out of that house and run off as fast as possible in pursuit of his mysterious destiny. Soon I would see him riding off again along the stony path, stiff and enigmatic in his helmet and armour, his lance up on his shoulder. After I had gone down with him to the bottom of the hill, as far as the pine tree that had been blasted by lightning, our dog would come back and prowl around my legs; and I would wonder what on earth the world might look like when you got beyond the path.

Fraulissa seemed to have no other aim in life than to torment my soul. And so, in preference to such a mother I turned to the neighbouring forest, that body inhabited by countless beings, both visible and invisible, which I would go into and explore for whole days at a time, sometimes until after dark, and at the risk of my life, I would think, foreseeing the rain of blows that awaited me on my return. Yes, that was where the underbelly of the universe, my only real home, was to be found. On my knees, I would sniff the excrement left by animals, I would examine its size, shape, texture, grain and position, before depositing my own in places more precise than the points of the compass; and as the days went by I kept an eye on both sorts and observed the slow, inexorable stages of their decomposition. My goodness, how I loved the humble obliteration of matter! Under a tangle of brambles and roots, I had dug out a shelter with my hands where I could disappear myself. There, amid the odours of the soil, I would forget everything, even the existence of daylight, as I searched frenetically in that simulation of death for the white lightning flashes of pleasure. Was it not as if I were seeking, in a mysterious congress with the earth, to mingle my salty secretions with its own?

It was in this vast wood streaked by oblique, quivering rays of light that the first fruits of my intelligence burst forth. I had no books, no teachers, and no friends; and yet in my imagination I was already forming a conception – oh! a very crude one – of the lines along which the living world might be divided up into a hierarchy: mineral, vegetable, animal. I would examine the shape of stones on which the erosive effects of time are imperceptible, free a chestnut from its husk so that I could stroke its fresh, new skin, listen to the beat of my heart as I watched a snake put a fieldmouse to death. All of a sudden I would be filled with an intuitive sense that my presence was essential in this forest, this world within a world, this body within a body; and out of that feeling there arose a new type of pleasure. Does not each thing have within it another? I would murmur to myself, burning with excitement. A gust of wind would rush in among the branches.

Stretched out on the ground, I abandoned myself to intoxication, gazing deep into the abyss, beyond a canopy of great black trees that were slipping by beneath the clouds. Many natural and supernatural beings peopled these thickets. Did we all belong to the same species, or was I the only one to experience such strange feelings?

Gioan must have glimpsed my true inclinations, and seen them as a timid flame shining in the nebulous dream that was all he had by way of an existence. He gave orders to my mother that I was to be educated, and she sent me to have lessons with old Joseph Provenzale, a Jew who, despite being renowned for his violent changes of mood, and the legendary temper tantrums in which his pupils took delight, had nevertheless enabled generations of rowdy little Nolans to fumble their way through the rudiments of Latin. His inexpensive school consisted of a single room with benches and two windows on whose sills were stacked, in a higgledy-piggledy mess, the first books I ever got to read. I had grown up wild and free in the company of ants and snakes, yet under his iron rule I learned without difficulty to read and write the language of Cicero and Valerius Maximus. Soon I could recite by heart extracts from Caesar's *Commentaries*, conjugate active and passive verbs, and decline nouns with unfailing accuracy. Needless to say my astonishing memory aroused the jealousy of my classmates; it also commanded the admiration of the schoolmaster. Moreover, although until then I had had no experience of religion, I seemed to display a marked flair for metaphysics, if metaphysics means the art of asking questions. There were many people in that town who prided themselves on their knowledge not only of grammar, but of philosophy, and Provenzale was one of them. One day I came out with this piece of treachery:

'Master Joseph, is it true that God has a body?'

The crazy old man looked at me suspiciously.

'The name of God,' he said, sidestepping the issue, 'is the one we least understand . . .'

'Yes, but . . .'

'And the one we know best . . .'

'Excuse me: the priests don't talk about His name, but about His body. I'm sure about that. I've heard them preaching in Santa Chiara . . .'

Provenzale could not contain his irritation:

'Ah! That's the priests' god!'

He was fully-primed and ready to fly off the handle. Feigning honey-tongued innocence, I asked, all astonishment:

'So is there more than one god then, Master Joseph?'

The pupils squeezed on to the benches could no longer contain their sly sniggers, mingled with the usual muttered insults concerning the Jew. Leaping aside to dodge the volley of clouts he was about to give me, I dashed out into the street and started to run in between the patches of light, intoxicated by a strange feeling of triumph.

A strange and derisory feeling of triumph, I should say, and one which has never left me. The snotty-nosed little kid, revelling in the power of language from the moment he discovered it, did not yet know that that scene would be repeated countless times, so often in fact that it would become one of the essential motifs of his life. How many times, dear Lord, and with what jubilation, have I been obliged to flee from the consequences of my words? It is they which today are rebounding on me and, as I myself foresaw, *biting me to death with their cruel teeth*. Will that appease the great cohort of angry, red-faced opponents whom I have roughed up, humiliated and infuriated? In a sense, Joseph Provenzale was the first of them, and my heart has always retained a touch of affection for him, for it was thanks to his insistence that the decision was made to send me off to college in Naples. There, he argued, my mind, memory and judgement would find better opportunities to develop than in his own school in Nola.

Poor Provenzale! The College did indeed presume to call itself an *Academia*, but what was it other than a haven for priggish pedants whose only talent lay in turning Latin into Greek and Greek into Latin? The cold rhetoric that was served up there had the stale smell of an old soup into which so-called professors of literature dipped their fingertips to fish

19

out ancient quotations in order to relish, so they said, their poetic, comic or tragic flavour. They were the comic ones! Ridiculous! And as vicious as mules to boot. I held them in such contempt that I took the earliest possible opportunity to seek out a master who was worthy of me. My father, who was with his company at the time, waging a war between the Vermini and the Moroni, granted me a meagre portion of his pay, so that I could have individual lessons. My footsteps, or the destiny that was guiding them, led me to the illustrious Teofilo da Vairano, the only real philosophy master I was ever lucky enough to have. When I met him, he was already at the peak of his fame, and had given up honouring the dreadful college with his presence.

Under his direction I studied Augustine, whom he loved to read aloud, standing behind his desk. The sage's intonations fitted perfectly with every last detail of the text's form, of Augustine's memories, and of God's intent perhaps, as it was revealed in those memories. Squatting uncomfortably on a broken-down stool, I would run my finger from one line to the next as I went through the pages of my copy. The voice and the written word became as one, and Augustine's Latin spoke to my heart. If the word has an essential existence beyond grammar, I thought, then it is poetry, a divine murmur, a breath of air rippling the water's surface at the world's beginning, an act of creation; and, as in the past in the moving forest, I felt that my soul would soon touch the substance of being.

'Your turn to read now,' I heard.

I looked up. Vairano never smiled. Grains of light played on his venerable face. I would have done anything that man asked of me, even given up my life. Having closed the volume then opened it at random, I happened upon a passage where Augustine, speaking about his father, recalls the day when, at the baths, he noticed in his son the first signs of virility, the *quivering garment of adolescence*. Once again, the power of words! And so I read, diligently; and under the eye of my master my own garment quivered in its turn. My heart was gripped by a new feeling which threatened to render me

speechless. By magic, the text had transported me to the baths at Hippone; I was no longer a pupil bent over my book, but young Augustine in person, sitting naked on the warm stone; and there against my dripping stomach, in full view of the impassive onlookers, stood my nascent puberty. I stopped reading. The divine madness that was stirring my senses troubled Vairano, who looked away. Cutting short the lesson, he dismissed me.

No doubt about it: I found myself, like Augustine as he emerged from childhood, in search of a love object, and the sage had become that object. Through his readings he had begun by creating a new world for me whose real richness lay, beyond the infinite variety of things, in the secret and necessary unity that governs all order, beauty, and justice. But from that day on, he appeared in person in most of my dreams, amid the impassioned ceremonials that my imagination constructed every night. Like the strangers at the baths in Hippone, he would envelop my naked body with his gaze, and I never sought pleasure any more without conjuring him up in my mind, my hand clutching my *telum*.

The master did not take up my offer of love. Quite the contrary, he redoubled his severity and took pains to rid our relationship of any signs of tenderness and affection that had managed to creep into it, so that he could direct our discussions toward the only goal that he saw as useful: my instruction in philosophy and religion. In my secret heart I was furious; were the two things as incompatible as all that? Was it not possible to seek to awaken someone's mind and love him at the same time? He seemed to have decided that it was not, and as the days went by I watched in vain for any sign to suggest that his attitude had changed. In a short letter that he wrote me much later from Palermo – not long, in fact, before he died – he admitted that he had made use of the pain I was suffering at that time as a fermenting agent for my mind, which he could see was being greatly nourished by the feverish efforts I was making to seduce him. He had, he wrote, thought it more necessary to repress his own desire than to fulfil it.

The book he had introduced me to by this means, those *Confessions* in which Augustine's passions burn with such a bright flame, was not only to intoxicate me at night with disturbing images, it also contained the very principles that were most likely to stimulate the mind of the *smooth little talker* I had become. No indeed, God did not possess a body! He contained heaven and earth, and at the same time filled them with His being. He was the outside and the inside of the world, its beginning and its end, its invisible soul, its driving force, its thought and substance, the immaterial One with neither physical size nor weight. I have written and taught that God is present in nature like a voice in a room; no-one can observe or touch Him, but everyone can hear Him, for it is to us that the One speaks. Today, I in my turn confess: this philosophy of mine originated in those days when we read aloud, Teofilo da Vairano holding out like a sea wall against the forces of love, and I struggling to conquer him.

One day the sage announced to me without ceremony that he was preparing to leave Naples. Prince Colonna, with whom he lived as a permanent guest, had just been elected Viceroy of Sicily, and he had chosen to follow him.

'Is this my last lesson?' I faltered out.

'You don't need my lessons any more,' he assured me.

But it's you that I need! cried a voice from the depths of my shaken heart; did he hear it as clearly as I did? As if to cut short this silent protest, he added:

'Next year you will enter the Dominican order. Fra Ambrogio Pasqua is an enlightened man. I had no difficulty in persuading him.'

What difficulty could this prior have raised? I knew Latin and Greek better than than the so-called professors at the college! I had a phenomenal memory and perfect diction. Was it my family's poverty that could have offended the priests?

'Not so much your poverty itself as its consequences,' answered Vairano who, as was his habit, was reading my thoughts. 'Rumour has it that you earn your living playing postboy for the whores of Santa Maria del Carmino . . .

'Everyone needs money to live,' I protested.

'The novices Fra Ambrogio receives into his monastery are supposed to be motivated, let us say, by a certain amount of faith. And that's not generally regarded as something that goes hand in hand with prostitution . . .'

My feelings were torn between distress and anger.

'I have no ambition to go into the church,' I retorted insolently. 'I want to be a sage, like you, Fra Teofilo!'

'Well, is the monastery such a bad way of achieving that?' he answered, feigning surprise.

And, for the first time, he did not suppress the smile that was creeping over his lips.

The Dominicans had four monasteries in Naples, including the illustrious San Domenico Maggiore within whose walls the good doctor from Aquino had once drawn breath, meditated, and taught theology for a salary of one ounce of gold a month. It was there that he wrote the third part of his universally renowned *Summa*, and they still kept a fragment of his skeleton in a reliquary. Since then the monastery had become the seat of the University. After two earthquakes, the second of which had destroyed half the city, and the fire of 1506, the church had been restored, as had the three huge lecture rooms on the ground floor. One of these, the very one where the Sage had taught, was reserved for the arts, philosophy and theology.

I entered the cloister as I was nearing my sixteenth birthday, when Fra Ambrogio Pasqua da Napoli was prior of the place, and a certain Brother Reginaldo was master of the novices, or *pueri*, as we were called. In the presence of three fathers, I solemnly swore that I had entered the monastery of my own free will, and not under threat of violence or (a ludicrous conjecture, since neither of them cared less about me any more) pressure from my parents. Then I made the vows which subjected me to the rules of the establishment, and pledged absolute obedience to God, the Virgin and Saint Dominic. I was baptised with the name Giordano, and donned the brown monk's habit.

Brother Reginaldo's job was to tame our feverish souls and

bodies and train them in clerical discipline and the renunciations that it involves. That didn't stop him later on from being thrown out of the order and ordered to repay dozens of stolen ducats. Every Dominican, young or old, knew his duties: to take part in the offices, sacraments and processions, to practise humility and prayer, read the authorised books, avoid arguments and slanders, respect the will of his superiors, observe silence and spend long hours with his head bowed in the solitude of his room. But the authorities had their work cut out dealing with breaches of the rules, and it was by no means uncommon for one monk to be packed off to the galleys, while another was dying in a brawl with the Neapolitan pimps. Those of my friends who had not given up their vows immediately after taking them seemed irresistibly attracted by the sins of the age, and it was not difficult to persuade the dirty-eyed she-devils of Santa Maria del Carmino, who sold themselves to the novices for a pittance. Every night, several rutting *pueri* climbed out of the dormitory window, slid down the wall, and took off to the alleyways around the harbour. I knew the contempt that the whores reserved for this callow clientèle of guilty youths betraying their vows, for I had in the past been paid by them to go round enticing customers. Sometimes, by way of a favour, they had even let me use them myself, free of charge! But the slimy cesspit between their legs made me sick; to me it was just a limp rag, so very much inferior in quality to the firm, unyielding annulus that the young male offered up to friendship. Sagging breasts, slothful embraces, desperate gazes with no lustre but the spineless gleam of vice, underbellies devoid of ornament, slit open by a stroke of Nature's blade. No! Nothing that women possessed moved me, and nor did women themselves, least of all the so-called Virgin, the one who grieves at the back of chapels over the memory of having given birth to a god – doubtless she reminded me too much of my own mother and her never-ending lamentations. While the novices were toiling over the whores, I was opening my arms to my friend of the time, one by the name of Felix, who would later be thrown in prison for striking a reader of canonical law with

24

a sword, and who died in Paris, strangled in a dungeon. He respected and venerated his images of the Virgin with exasperating fervour, and in a fit of jealousy I tore them up. Felix reported me to Reginaldo. This man exercised a reign of terror over the novices. The very next day I was dragged before the monastery fathers, who gave me a talking-to. No idol, I argued, merits devotion.

'Are you saying that the images of the Virgin and the saints of the order are idols?' choked Fra Ambrogio.

'I kneel only before my invisible God,' I replied.

I had concocted the phrase during the night, and I thought so highly of it that my heart swelled with pride as I uttered it. But kneeling I most certainly was, for the time being, at the feet of three monks whose prosaic faces expressed no divine indulgence whatever. I was severely punished, and observed for the first time that the esteem in which the monastery authorities held me could very easily turn to mistrust: in that world fashioned by fear where no-one thought twice about abusing his little scrap of power, nothing was more likely to arouse the worst suspicions than a flash of intelligence and freedom suddenly shooting forth from the mind of a student.

How far I was from my good master, my guide, my dear Teofilo! But I remained faithful to him and did not allow either the terrible monotony of my studies, or the ignorance and spite of those who were in charge of them, to erase the near-carnal memory of the readings we had once shared: often, by the light of an oil-lamp, I would secretly and with trembling lips delve back into Augustine's confidences. And then I would be seized by a strange sensation, an intimate shiver – the same one that many years before, in the shelter of the dark forest, had been felt by the child who had now died in me for ever.

The order of Saint Dominic was created to carry out the salvation of souls through preaching. At San Domenico Maggiore their stale ecclesiastical rhetoric was based on a daily commentary of Aristotle or Quintilian, the most indigestible of authors, whom we were forced to dress up with the appropriate pronunciation and a series of quasi-liturgical

postures. In addition to these exercises as far removed from real philosophy as Mercury is from Saturn, there were verbal sparring matches, set up by the masters as a means of checking their students' academic progress. Naturally I excelled in these, for I was a good combatant, an irrepressible, impulsive warrior. True, I learned nothing new from those interminable hours spent arguing over a point of grammar, but I used them to cultivate the art of oratory for which I was to become famous in Paris and London. I perfected the scholarly register of argument which enables one to let fly at an opponent, in exactly the right tone of voice, the dart that will reduce him to silence, and if necessary cover him with ridicule.

As for the real nourishment that I needed at that age, I found it not by fleeing the monastery as my friends did, but by going to the richly-stocked library which was its soul and centre. The librarian was a half-crazed brother called Marcellus, a sort of brutish lout with an infernal past who had to be bribed in order to gain access to the works which neither Fra Ambrogio nor the novice master would ever have authorised for study. This fellow, it was murmured, had committed murder in his time. I can still see his tormented face, his bald pate, and his deceitful, evasive eyes. Although he kept silent as to the nature of his travels, his madness and the crimes he had been sentenced for, it was not hard to guess his secret. Once I had seen through it, I resolved to try and soften him up, and with that end in view, went to see him in his room after compline. By his own account, he had spent his whole life with books, whether authorised or not, and the domain over which he now reigned harboured a vast wealth of enigmas in print. Was it just the desire for knowledge that made me do what I did? No, clearly I was also longing to overcome the fear that this man inspired in me.

No sooner had I tapped softly on Marcellus' door than he opened it and let me in. The monster's den was not at all what I would have expected; the walls were plastered with gilded, illuminated vignettes of the good saints of the order, all of whom were in an ecstasy of love and peace. The brother sat me down beside him and, without at any point allowing our

eyes to meet, told the story of Acteon, the legendary hunter who was turned into a stag and devoured by his dogs, after catching a glimpse of beauty. Perhaps the tale reminded him in some way of his own destiny. I could not tell whether the librarian was talking to me, some supernatural interlocutor, or just himself.

'Hunting and knowledge are the daughters of desire,' he muttered. 'And desire leads to death.'

As he said that he slipped a nervous hand under my shirt and started squeezing my ribs. This man was as ugly and false-hearted as the devil, and his breath stank like poison, but I refused to run away from him. And so, what I myself had secretly desired happened: soon I was suffocating in his murderous arms, crushed by his body with its animal smell. To find out what the blackguard was capable of and how far he would go, I made a show of pushing him off. In return he gave me a hail of blows on the head; and in no time at all I was obliged to give in. As his thumbs were parting my buttocks, he started muttering the story of the hunter who was devoured by his dogs again. I could hear him breathing in my ear:

'Acteon was too good a hunter. You'll end up like him . . .'

And you, you old lunatic, you'll burn in hell! I thought, half stunned by the beating he'd given me. Tears of pain were burning in my eyes. Like a man in the throes of death, my hideous lover uttered desperate groans as he sought to rid himself of his seed, then I took pleasure in my turn; but as I did so, for all it haunted me I could not recapture the memory, as fragile and fluid as a reflection on murky water, of Teofilo Vairano, the good master I had lost. As the mad librarian kicked me out, he threatened me with a horn-handled knife which he kept hidden under his mattress:

'Talk and I'll kill you.'

I did not talk. Who knows whether a spark of reason and liberty did not live on somewhere deep inside that chaotic mind? Henceforth the brother and I seemed to be united by a silent pact, a curious bond of friendship woven by some demon under the stuff of outward appearances: as from that night, I was allowed to read whatever I wanted.

Despite the white marks left on their pages by the censor's paste, the books that Marcellus got for me contained dazzling little fragments of the universe, living sparks of the mind. Yes, there existed, within the reach of my senses, a *real* language which filled heaven and earth. I could no longer be unaware that the world, weary of being held captive by Aristotle's worn-out syllogisms, longed only to see itself reflected in a rich profusion of words. And as for me, how much longer was I going to put up with reclusion, this illusory life of wisdom? For the time being I was exercising my freedom tucked away in the library, in the nocturnal company of banned books, but every step I took towards the truth with a thousand faces was eating away at my patience and arousing in me the desire to journey all through my age and dominate it. Marcellus would be snoring a few feet away from me: his room adjoined the collections of books. Overwhelmed with fatigue, I in my turn would nod off over the lectern, and every time the dream I had was the same: I was finally awarded a doctorate. A man who looked like me, but whose features, of course, were also reminiscent of Vairano's, had opened up a school surrounded by a garden in Paris, Rotterdam or Rome: a shining, Epicurean academy, where philosophy merged with life itself, and which took in one generation after another of *pueri* with necks like angels. Since I had entered San Domenico Maggiore, the circle of my existence had been shrinking all the time, but at the centre of that circle, like the macrocosm within the microcosm, the horizon of another possible existence was coming into view.

For the infinitely small joins up with the infinitely large, just as the purest movement fades away in the illusion of immobility. I had toyed with these paradoxes when I found them in a book more than a hundred years old published by a certain Cardinal Cusa, with a title which seemed to have been coined with the deliberate intention of arousing my curiosity one day: *Of Learned Ignorance*. With his passion for mathematics, the cardinal applied his idea of a 'concordance of contraries' to every sphere, and my memory had retained most of the examples he gave to back up his discovery.

Imagine a polygon inside a circle, he taught; if we divide its sides up to infinity, we will see the straight lines become the same as the curve. If we spin a top, it will speed up before our eyes until it appears to be completely immobile. Did not the whole of nature obey such laws? In particular, did not the supposed immobility of the earth, which the Aristotelians made so much noise about, conceal some invisible movement which they would never have been capable of imagining? Did not the absolutely finite nature of living matter coincide with the absolute infinity of God? These revelations made my heart beat as furiously as if I were madly in love. Who was I? Philip, rebaptised Giordano! Where was I? On an earth hurled at high speed into the black sky of a limitless, perhaps increate universe! And You, almighty God, who were You, if not that Universe, a breath with neither beginning nor end, an immeasurable river rolling and shaping the atoms of its being, the form of the Whole, the soul of the world and the world itself? The wise exist for the mad and the mad for the wise, I was to write one day. A new wisdom was well and truly taking shape within me as my reading progressed; and I only possessed the key to that wisdom thanks to a madman!

The fathers were not content with using their censorship to stifle the ancient doctrines, for fear that they might, so they said, nurture the seeds of heresy; the monastery's index of prohibited books also struck at modern thinkers, and I took great delight, as if they had sprung from my own pen, in the gibes which an indefatigable traveller called Erasmus directed at all those prigs, pedants and preachers who devote themselves to mimicking virtue like monkeys and stuffing their listeners' heads full of extravagant nonsense. I was also studying the writings of the Catalan Ramon Lull, whose famous mnemonic wheels were providing me with the principles by which I could organise my already excellent memory. Finally, I discovered the astronomical treatise of Canon Copernicus who described a cosmos that was literally *immensum* – not measurable; and above all, who turned the low, petty one that the Aristotelians believed in head over heels.

Even their sky is wrong! I would exclaim to myself,

banging my fist on the table. The flame of my candle would flicker. In the bedroom next to the library, Marcellus would stop snoring and give a nasty grunt. The first light of dawn had just shone in through the high window. I blew out the candle. What an extraordinary revelation it had been! In the canon's limpid, ethereal world, the sun was at the centre! Playing with the compasses, I had drawn and redrawn all night long the concentric orbs in his map of the sky through which, driven by their own will alone, not only Mercury, Venus, Mars, Jupiter and Saturn moved around harmoniously, but also the Earth, a star among stars, restored to its true nobility. Even so, there was still a circle for which the compasses had to be opened wider, symbolising a sphere supporting fixed planets, the supposed outer limit of the world . . . Why on earth had Copernicus stopped when he was doing so well? I wondered, furious. Why keep this family of immobile stars in a universe where everything is in motion? Why must there be a limit? Were we going to destroy one prison only to shut ourselves straight into another? Frenziedly, I kept sticking the point of the compasses into the four corners of the sky, creating new suns, and around those suns, new immaterial orbits all tangled up with one another. Along them rolled a hundred unknown planets criss-crossed by rivers, bristling with mountains, covered with oceans, enveloped in clouds, all daughters of eternal time, benevolent, well-rounded sisters baptised by me with divine, secret names . . .

By the time the librarian threw me out of his domain, morning prayer was long since over.

It was in the autumn of sixty-eight that I made my first visit to Rome, at the age of twenty. What was I then? Just an obscure student stuffed full of book-learning, a mere monk, always ready for a battle of words to be sure, but rather solitary and with a thin, sallow face that betrayed how exhausted I was by sleepless nights. And yet here I was with an invitation from Pius V in person to come and describe to him, so I was told, some mnemonic techniques! The art of memory is of course a speciality of the Dominicans, but I still do not know how,

whether through a report from my masters or some other intermediary, the pontiff had heard about my personal talents in that sphere. Having never at that time set foot outside the Kingdom, I greeted this special permission to get away from the cloister like a pat on the head from the gods.

At the very moment when I was preparing to get into the carriage, a strong blast of north wind cleansed the sky of the last of a heavy curtain of steel-grey clouds, and at the same time a triumphant sun lit up both the *cortile* of the monastery and the cracked, colourful painting of the Virgin on the church's façade. Gathered in clusters under the arches, the monks were muttering, nudging one another and giving me sidelong looks. Fra Ambrogio blessed me. Just for a moment, I was mesmerised by the gentle swaying of his hand; it made me think of the infinite movement of the universe and the merging of its countless random phenomena. The veil of the world was tearing apart and my whole being, flesh and mind, longed only to rush in through that opening. My fever was tinged with delicious fear and I felt a quiver of pleasure, of the sort you get when you dream that you are flying above the earth with your member swollen with life and fit to burst, and a great, crazy laugh running through your head.

Two days later I was kissing the foot of Pope Ghislieri. What a pitiful sight he was, this puny old man, wrinkled, bearded, probably ill, and forsaken by the Lord in the depths of a freezing cold palace! This, I reflected, was a place where fear lurked everywhere. The pontiff was flanked by a papal body-guard with a murderous face, and at his right hand by Cardinal Rebiba, a loathsome man if ever there was one. Once I had gone through the protocol I knelt down again, still humbly showing him my tonsure, which had been trimmed that very morning by a travelling barber.

'His Holiness is ready to listen,' ordered Rebiba.

And so, puffing out my chest, I gave him, all in one breath and in Hebrew, the psalm which I had learnt off by heart for the occasion. Sitting as still as a statue in a niche, the Holy Father showed no sign of impatience. When I had finished, a nasty smile crept over the cardinal's lips, and he observed:

'What a frightful accent the boy has.'

Pius V seemed not to have heard this remark.

'Be thankful to Our Lord,' he sighed, 'for giving you such a memory, my son.'

You could hardly see his lips moving behind his long, flowing beard. Rumour had it that he still wore his old Dominican habit under his papal vestments. This fellow was once a herd-boy, I thought, and now he's the Pope, a sad old man at the height of his power . . .

'Your Holiness is infinitely good,' I murmured, bowing to the ground. 'But there is also an ancient art of memory. I have studied it . . .'

'You have?'

'In a work by Ramon Lull.'

'*Ars raymundi*,' groaned the Holy Father, his eyes gleaming with contempt. 'Why should those arbitrary groupings of letters and symbols be of any interest to a priest? Isn't there anything else to read in your monastery?'

'They are not arbitrary groupings, if Your Holiness will forgive me for being so bold, but a means to knowledge . . .'

Pius V had raised a weary hand and looked away; he didn't give a fig for my mnemonic techniques. What did seem to interest him, on the other hand, was the current state of affairs at the monasteries in Naples. Very faintly, he continued:

'And what other extraordinary works has your prior given you permission to consult?'

Fra Ambrogio didn't give permission for anything at all! The sinful monk in charge of the library, however . . .

'Recently a treatise by Copernicus on the celestial orbs . . .'

'By whom?'

'Nicholas Copernicus, Your Holiness, a German . . .'

The wrinkles on the pontiff's forehead deepened somewhat.

'Do you know about this?' he asked Rebiba in a soft voice.

'I've heard the name,' said the other man hesitantly, rubbing his chin. 'Wait . . . yes: a work of fantasy to do with the sun and mathematics, I believe . . .'

I tried to explain:

'One can indeed read the work as . . . a sort of game, but it contains – in my opinion at least – a hidden truth . . .'

Pius V interrupted me with a wave of his hand:

'There are many books in libraries. Perhaps more than is necessary. Some appear very appealing at first sight. The important thing is not to let oneself be blinded by a deceiving light. What is that you are holding in your hand?'

'If Your Holiness will excuse my vanity: it is in fact another book. Written by me. For Your Holiness.'

'And what is it about?'

'An ark. *Noah's Ark.* That's its title. It's about a . . . an allegory, let's say. Knowledge is portrayed in it as . . . as an ass standing up at the stern of the boat . . .'

'An ass, now,' said the Holy Father, getting irritated.

The world gave way beneath my knees; I had suddenly remembered a Lutheran engraving that had been passed around on the sly at the monastery, showing the Pope dressed up as an ass, playing the bagpipes on his throne! Irreverence breeds rebellion, and rebellion breeds heresy. Had the forbidden image just come into the old man's suspicious mind at the same time as it came into mine? To cut things short I rattled the rest of my speech off parrot-fashion:

'Sometimes ignorance conceals great wisdom and great knowledge, Your Holiness, as was taught by the divine Socrates, himself a most wise and learned man, although in a sense really quite ignorant. Conversely, there are times when the doctor's gown masks a deep stupidity: in exceptional cases, I mean . . .'

This over-bombastic rhetoric was more than Pius V's sensitive soul could take. Rebiba lost his patience:

'The monk's habit is supposed to imply some wisdom too! His Holiness is grieved by the news coming from the provinces. We hear of nothing there but priests armed to the teeth, thefts, infamies and crimes of every description – not to mention the women! And now, to cap it all, we have clerics showing insolence towards their masters . . .'

'There is nothing insolent in what I have said, Your Eminence. I have written a fable, a tale, a . . . a fantasy . . .'

'Get rid of him! Get rid of him!' puffed the pontiff, waving a transparent hand.

The bodyguard, who had been restraining himself from yawning all through the interview, stared at me with a look of profound contempt. Rebiba leant over towards his sovereign, who started whispering into his ear, about something completely different, no doubt. Clearly the audience was at an end. It only remained for me to take my *Noah's Ark* away with me as I shuffled, on my knees and backwards, across the twenty paces that separated me from the door.

Ghislieri had once held the office of Grand Inquisitor (which I may add had had to be withdrawn from him, so frightened were the cardinals by his zeal!) and the construction work he had ordered for the new premises of the Holy Office was well under way, since the workmen perched on the scaffolding were already completing the first level. The herd of visiting monks dressed in white which I had been told to join quickly discovered the building site, which was on the way out of the palace. Soon, we were informed, heretics would be held and interrogated there.

'A lovely new prison!' called out one of the masons, showing his bad teeth. 'For ruffians like you!'

Was that kindly prophecy from a man of the people aimed at me? Ever superstitious, the clerics began to fiddle with their rosaries. I did not yet know what was really meant by heresy: the type of all-purpose accusation that those in power use constantly, a reliable piece of machinery for getting rid of anyone who upsets them . . . That mason didn't know how right he was. Did he have any idea that I would spend the last seven years of my life within the walls that he was building? At the time his prophecy was quickly forgotten, not least because I was itching to find a way of sneaking away from my half-witted so-called colleagues. Ah! To go off at last in search of what interested me most intensely: books.

The bookshop I had been recommended to go to was hidden away at the back of an alleyway cluttered with handcarts, just off the Piazza del Duca. But in Rome as in Naples, there

were any number of pickpockets running the streets, and the owner, one named Jacobi, hesitated to open his shop up to a young lad, even one with a tonsure and dressed as a monk. A very well-dressed individual of about thirty-five came to my rescue. The fellow declared that his name was Jean-Antoine de Baïf, and that he was a man of letters from Venice, but living in Paris, a city in France, as he thought it necessary to explain.

'I know where Paris is,' I replied. 'And I am Giordano Bruno of Nola, a writer. I am looking for works on the new sciences.'

As for Jacobi, although a rich man he was soberly dressed. His features and manners couldn't have been more agreeable, and at the touch of his hand, books became as fragile as flowers. He showed us an opuscule printed sixty years earlier in Strasbourg, whose frontispiece was decorated with a ship being carried away by a breath of inspiration from the mind.

'*Discourse on the dignity of man,*' he said.

And, stroking the pages of the volume all the while with a voluptuous magnifying glass, he added:

'The author was called Giovanni Pico della Mirandola. His life was truly one of torment, believe me. Fine opinions don't always find favour with the world.'

'Better to stick to poetry,' asserted Jean-Antoine categorically. 'Make fun of the powerful with rhymes and you'll make them smile. Invent a science that disturbs them and they'll throw you in the dungeons . . .'

'Poets sometimes go to prison too,' observed the bookseller with a slight smile.

I for my part was thunderstruck: there was a portrait of this Pico at the back of one the chapels at San Domenico Maggiore! And yet not one person there could claim to know anything about his philosophy! Grabbing the book in a thoroughly uncivil manner, I asked:

'What did he teach?'

'His doctrine was that man has the ability to arrive at divine truths.'

'By what means?'

By *sumpathia* (the sage had borrowed the expression from

the Greeks) with what naturally binds the elements of the universe together, that force known as love, a magic spell that weds amber with straw, the elm with the vine, two people who are attracted to one another, and of course heaven and earth: in short, the Harmony that inspires all harmonies, which the human soul could and must learn to fathom.

It was as if this dear man Pico was speaking to me directly through the bookseller's voice, but far from astonishing me, his views were simply an echo of my own religion. Yes, it would soon reach maturity; for the time being it was still striving towards its final form. Over the years a patient alchemy had been at work, moulding together the intuitions of childhood, Vairano's lessons and my secret reading; now the process was nearing completion. I listened, nodding, to Jacobi's explanations, but already my ideas were racing ahead of Mirandola's. There is a day, I speculated, when God speaks His Name, and in such an act the universe is created and recreated at every moment. It was that enchantment without beginning or end that the cabbalistic sages of old sought to contemplate by endlessly unravelling the meaning of the Four Letters of the Name; for my part, I shall turn my attention to the soul of the world, the *anima mundi*, as it is mirrored in man. The spirits of Moses and Hermes Trismegistus have managed to slip past the guardians of ignorance, and the breath of their inspiration has come through to me – oh the magic of language, of suggestion, and of signs that surmount, like a melody coming over a high wall, the ramparts behind which reason is held prisoner . . .

'The Ancients, who were more learned than our academicians, knew about these mysteries,' continues Jacobi. 'Whereas we have forgotten them. Pico considered it his duty to invite the Church to rediscover them, for they alone will save our ailing religions, which are doing nothing today but drive men apart . . .'

'What you are saying largely coincides with my own meditations,' I said.

'I'm sure it does,' he agreed.

And then, seized with fervour, he declared:

'The modern philosopher will not be a grammarian, no, but a magus who has the power to communicate with God . . .'

'Inspiration, the intuition of the Truth . . .'

'Ecstasy!' cried the shopkeeper.

He was quivering with emotion, and seemed to be having strange visions.

'Ecstasy,' he repeated. 'But take care: if it is too powerful, it is likely to detach the soul from the body, which means death. *Mors osculi*, as Pico called that experience . . .'

'Death by the kiss . . .'

'It goes right back to the Egyptians.'

'I say, old chap,' interrupted Baïf suspiciously. 'What you're on about there is magic!'

The bookseller gave a start and appeared to recover his wits:

'There's magic and magic, my dear fellow. 'Pico's is scholarly, learned and entirely beneficial. It's all about natural philosophy. Nothing to do with sorcerers' evil spells . . .'

But the poet persisted:

'To go back to what we were talking about just now, are you sure that the little book you are going to charge this boy a fortune for isn't in the index and liable to get him thrown in gaol?'

Offended, Jacobi seized the volume and without further ceremony whisked it off to the back room.

'Wait!'

But the bookseller reappeared empty-handed.

'The work contains a printed letter,' he said, 'which was once dictated by Alexander VI to absolve the author of all suspicion . . .'

'The current pontiff,' Baïf cut in, 'isn't much like Alexander, from what I can gather. Popes come and popes go . . .'

'. . . of all suspicion of heresy, as I was saying. As for selling it, I very much doubt in fact whether the priest has the money to pay for it. Don't let me detain you, gentlemen.'

He was already opening the door, but I had one more thing to say:

37

'I've written a book too! Look. I presented it to Pius V himself, this very morning.'

I held my manuscript out to him. Jean-Antoine burst into a great, merry laugh.

'He presented his book to the Pope! Can you believe it!'

'It's the truth!'

'And why didn't the Pope keep this masterpiece then? Because he can't read, perhaps?'

'He didn't like what it was about!'

'In that case you don't stand a chance, my friend. The excellent bookseller you see before you sells only writings that bear the pontifical seal of approval.'

And he laughed again, bringing out an embroidered handkerchief with which he wiped the corners of his eyes. The bookseller, bristling, was turning the pages of my *Noah's Ark* one by one.

'Take it, Jacobi,' Baïf joyously persisted. 'Take that book. I guarantee you'll sell it. Don't you sense that this little priest has something of the prodigy about him?'

'No,' said the other man, digging his heels in. 'His pensum isn't even printed. What am I supposed to do with it?'

'You'll sell it for twice as much as you pay for it, of course! Take it, bookseller! You buy his Elzevir, and I . . . Here's what I'll do, I'll buy the Pico from you! I'm serious. How much is it, by the way?'

What a marvellous fellow Jean-Antoine was. A little later he was to set up a true academy of music and poetry in Paris. But his own little poems were too full of nymphs dancing around in a circle among the flowers for me to be moved by them, and I never took the trouble to read any of his collections right through to the end. As I write these lines, I am being punished for my discourtesy by a touch of remorse, and quite right too: isn't every writer, and most of all the amiable Venetian, entitled to expect of his reader that ounce of patience and friendship without which there would be no art or philosophy in this world, or even the slightest degree of understanding between men? Baïf, whom I ran into again later in France and who contributed so much to my success,

has been dead for eleven years now, and I am no longer in a position to make amends. No doubt I sensed that his poetry would be slight, too frivolous for my taste, and already in contrast with my grandiose future plans – which were for nothing less than a reform of the heavens!

Be that as it may, on the day in question he paid out two fat crowns, and handed Pico's treatise straight over to me, declaring:

'It's a gift, my friend! Now, get the money you're owed and let's go, if you don't mind.'

In exchange for *Noah's Ark*, I received from bookseller Jacobi one miserable *carlino* which didn't shine much brighter in my hand than the ones we had in Naples.

Despite the relentless campaign of harrassment by which Pius V was attempting to push the prostitutes of Rome back towards Trastevere, we passed large numbers of them, dodging out of sight of the watch, starving, huddled in the shadows of the alleyways leading from the Via Giulia to the Tiber. What a lugubrious time that was, at the end of the Sixties in Rome! Whores and courtesans were the pontiff's nightmare, and he made life as hard for them as he could. But, as Baïf said, every ruler has his quirks, and we all suffer the consequences of them at some time or another. According to him it wouldn't be long before the city saw its sirens back on form and hanging out of windows as usual.

'It's a Roman speciality, my dear fellow, and so very necessary. And there's nothing the Pope can do about it.'

As we stood next to a bridge, he pointed with a graceful wave of his cane to the other bank. We had a choice, he said; on one side there were tarts who were cheap and often pretty unappetising, to say nothing of the danger of being relieved of your money on the way. On the other side, there was luxury, refined and free of charge, providing one had access to the best circles – which he did.

'The only privilege of poets,' he said.

And he quickly added:

'As for the danger of being stabbed in the street, well, you'll

find that everywhere. But I'm just thinking, are you allowed to enjoy yourself a little, or are you supposed to be back in some monastery or other before dark?'

I remember having to hold back an ill-tempered gesture:

'I don't care about that.'

'Follow me then! Personally, I prefer luxury that's free of charge.'

And, turning his back on the river, he took off resolutely down an alleyway leading to Capodiferro. I didn't budge an inch.

'Well? Why are you standing there like a doorpost? Are you coming or not?'

'I don't go with women,' I answered. 'They repel me.'

Jean-Antoine walked back to me.

'You're making a big mistake,' he whispered. 'Knowledge is the key to success, but love is the key to pleasure, and perhaps to happiness. And it was to give humanity love that Nature divided it into two genders . . .'

'Excuse me: you are mixing love up with procreation. The other species were divided in the same way. Does that mean that they know what we call love? The difference you are talking about is useful for reproduction, that's all. What pleasure do you find in servicing a woman? All that disgusting flesh . . .'

The poet brushed my lips lightly with his fingertips:

'Not another word on the subject, my friend. I understand. Where I'm taking you, there are dishes for every appetite.'

Artichokes macerated in oil, sea bream stuffed with almonds, dragées, figs, orange soup and plump grapes picked that very day by wretched monks on Mount Celius: that was the meagre supper that Cardinal Vita was getting ready to give in his palace guarded by henchmen from the Piazza Capodiferro. The prelate, who always wore a bonnet to keep his head warm and went round draped in an ash-grey chasuble, was generally regarded as being of unsound mind. His guests, who were twelve in number, included a Dutch painter with a distinctly aquiline nose, a cynical-looking would-be poet, and several

gentlemen, to say nothing of a gaggle of women with lips outlined in black powder . . . The master of the house wandered from one to the other making raucous chuckling sounds, like a wild animal – but Baïf had not deceived me: already my attention was being caught by a person with eyes darker than night, who seemed to be playing the role of favourite at the Monsignore's side . . .

'What is he called?' I enquired of my companion, nervously pinching his arm.

'Cecil.'

Cecil? Two syllables that I had never heard before. The cardinal's lover had been born in England, continued Jean-Antoine in an undertone, the son of a knight and a French courtesan who had had her hour of glory at the court of Henry II. As I listened, I was watching the man we were talking about moving around the room. Was it to please his master that he had chosen to conceal his obvious beauty under dark, mysterious clothing: a sombre doublet with black embroidery, and silk hose that glinted like the night? Baïf seemed to know all about him:

'His whole family lives in *Britannia*: his father is Governor of Ireland, he has a half-brother of fourteen, and an uncle who is said to be in Queen Elizabeth's good graces . . .'

'Nice pair of thighs,' I said ostentatiously.

'Not so loud!'

And suddenly he put on his bright, cheerful smile; Vita, in his sepulchral robe, was coming over to us, apparently gliding over the brown tiled floor. He was so startled that his face took on a dumb expression which betrayed fear. Pinching his nose, he turned to his favourite with a look of desperation: who on earth was this monk in sandals and a grimy, rank-smelling habit?

'Giordanus Brunus Nolanus,' Jean-Antoine hastened to declare. 'A scholar, or future scholar. He met Ghislieri this very day . . .'

With a muffled grunt, the cardinal shrugged his shoulders and moved away. Cecil looked me up and down impassively.

'Welcome,' was all he said.

He and Vita remained silent for most of the dinner; it appeared that they were happy enough to listen to their guests bemoaning the misdeeds of the pontiff, a bigot who hated the arts and showered favours on ill-bred yokels while abandoning the streets to thieves. This man's ambition, maintained the painter, dipping his fingers in a silver ewer, was nothing less than to turn the city into a monastery.

'Is it true what they say, that he burns anyone who puts up the slightest show of disobedience?' I asked.

'Without distinction of birth,' confirmed one of the women.

'Didn't you know,' interrupted the dog-faced writer, 'that a poet has recently been sent to the stake for a something that was just a lampoon . . .'

'. . . which it must be admitted he did stick up on the new latrines at the Vatican,' added the woman, rolling her eyes greedily.

Jean-Antoine smiled with the most complete detachment:

'And what did it say, this . . .'

'The whole of Rome knows it by heart!'

'Well, go on then?'

The would-be poet, his face contorted in an expression of spiteful joy, leant over towards him and recited:

> *Pope Pius the Fifth, in a moment of pity*
> *For all those he'd shat on in Rome's fair city*
> *Called in his builders and said he saw fit*
> *That they put up this nice little place for a shit.*

'Very funny,' admitted Baïf, biting into an almond.

And then, pulling a face as if the almond was bad, he said:

'Even so, to go to the stake for something so trivial . . .'

'I should think,' interrupted one of the hussies, shaking her golden hair, 'they'll have to bury this Pope on the quiet, for fear of his coffin being stoned . . .'

Was a callow Dominican, barely arrived in town from his distant province, obliged to let the conversation flow by without taking part in it? Not at all, but I was completely

enthralled by the gentle, silent favourite. I was speculating as to what sort of thoughts might be going through the head of such a strange, serious being, and at the same time envying his beauty, his grace, his manners and even his way of pricking the food with a fork so that he could carry it to his mouth with the greatest of ease, whereas I on the other hand was struggling – oh what torment – to learn how to use the instrument!

'Just eat with your fingers,' hissed a vapid courtesan who was sitting beside me with her breasts nearly bursting out of her dress.

My cheeks burned crimson and I suddenly felt slightly sick. Turning away to avoid the rotten breath that was coming up from this woman's insides, I involuntarily gave Cecil an imploring look, hoping to find help in his eyes. He didn't avert his gaze, but his face refused to betray any feeling. Speaking to Vita, he said quietly:

'According to Baïf, you have a scholar at your table, Your Eminence. Perhaps you should ask him some questions . . .'

The effect of this was to bring all conversation to a standstill. I saw Jean-Antoine smiling like an idiot, the Dutch painter darting a look at me with his eagle's eyes, and the spiteful poet opting for a mocking expression. The women were squirming on their chairs as if worms were nibbling at their arseholes. Like a man wrested by silence from his labyrinthine meditations, the cardinal gave a start and responded merely by spitting a fishbone on to his plate.

'You wouldn't happen to be a soothsayer, would you?' asked my fat neighbour in a drawling voice. 'They say that there's a magus in France who can give definite predictions of the future . . .'

'His name is Michel de Notre-Dame,' added Jean-Antoine amiably.

Then the Dutchman said:

'You are a theologian: what end do you see to the religious wars that are tearing the heretic countries apart?'

I looked questioningly at Baïf: was this kind of discussion acceptable at a monsignore's table? The poet blinked encouragingly.

'I have never set foot in the heretic countries!' I exclaimed, forgetting to keep my croaking Naples accent under control. 'Perhaps I will go there one day, if it is God's will. As for the wars you are talking about, I have read *De Pace fidei* by Cardinal Cusa who lived in the reign of Pope Aeneas Sylvius. That scholar cherished the hope that he would see the birth of a single religion based not on a complex dogma, but on the elementary principles on which the lives of nations are founded . . .'

'Why is the monk shouting so loudly?' complained a woman, covering her ears.

'Was this cardinal burned by Aeneas?' someone enquired.

'Most certainly not! Let's stop tarring the men of the past with the brush of our own sorry age!'

Had my declaration aroused a flicker of interest? It certainly seemed as if most of the guests were waiting for me to continue. As for Cecil, he was staring at me attentively, with his hand resting on his chin. And so I went on, talking in an uninterrupted flow about the corruption of the Neapolitan brothers, the ignorant asses who were hogging all the professorships, and the treacherous preachers who were forcing the idiots of the common herd to worship images, idols, bones shut up in a box! The orator in me was ablaze with passion. So the people around this table had been grumbling about Rome and the pontiff? Now it was my turn to air my grievances! How much longer was that old goat Aristotle going to get way with quelling the forces of reason with his obscure concepts? How much longer must wisdom remain confined within the prison walls of theology? All at one go I vomited up everything that was weighing on my stomach, in a torrent of argument accompanied by an extravaganza of details and examples that were amusing, racy, comic, hilarious, grotesque, monstrous, vile: in short, Neapolitan! My audience was entranced. Helped on by the wine, I launched into a description of my own work, not forgetting to add a finishing touch by boasting about the banned books I'd read. I then moved swiftly on to Ramon Lull (yes madam, it is possible to predict the future, thanks to Lull's wheels! And his numbers as well!),

Denys the Areopagite, Ficino, Plotinus, Erasmus, Copernicus and even good old Pico della Mirandola, whose doctrine I was quite confident I could expound, despite the fact that I had never heard of it until that very afternoon in Jacobi's bookshop. At one moment I paused and took a long swig of wine, and as I put the glass down I noticed that my hand was trembling. Keep going, keep going, was the message I thought I saw in Cecil's black eyes. But didn't his molten gaze betray some storm or other that was raging inside him? No matter! I was sure of my talent. Like one unveiling a mystery, I started to talk about *Death by the Kiss*, an old image, as I solemnly explained, ancient even, probably Egyptian, which . . .

'That's enough!' thundered the cardinal, banging his fist on his plate.

All his life this man's mind and body had been tormented by madness. I never knew what had unleashed such an outburst: was it my words or the terrible images that were battling for control over his soul?

Cecil's only response was to say, in an icy voice, 'It's of no importance.' Then, turning angrily to me:

'Death by the kiss, you were saying?'

Goodness knows he was the one who managed somewhat later on to give the expression a quite different meaning. The darkness was about to give way to the first light of dawn. The guests, having retired in cheerful pairs to the palace bedrooms, were struggling with their own nightmares. After wandering from one room to another, crying out with rage as he chased the demons that were clawing at his robe, Vita had finally taken refuge in a secret hiding-place which no-one at all was allowed to enter, and Cecil had been able to close behind us the door of an alcove with walls hung in red, adjoined by a boudoir in which a bulbous lute lay next to a backgammon board, a writing case, some maps and books . . .

'Why are you so anxious to change the world?' he shouted at me, furious. 'Isn't it better to enjoy it?'

'How can you enjoy being in a ship that's leaking all over, or a house that's in danger of falling down? No, it has to be changed . . .'

'Keep your voice down! You're in Rome now, not in your monastery! The ship you're talking about has always been the same as it is now . . .'

'Not at all: the Ancients knew the Truth . . .'

'The real truth is that there's no such thing as the Truth.'

Our voices ran on amid the silence. His was crystal-clear, mine as rough as a torrent. As a set of circumstances willed by the gods played itself out, one and the same spell was urging us towards one another – or, should I say, was urging our bodies towards one another, for every one of the words we were exchanging seemed destined only to tear asunder, break up, separate that which Nature was at this point endeavouring to unite.

'Nature!' raged Cecil. 'Take care that it doesn't side with men one day and decide to take revenge on you!'

And then, from behind a screen decorated in a pattern of inscrutable mythical beasts with hairy, intertwined tails, he appeared, unreal, as naked as marble, and unlike me, completely devoid of *pilus*! Oh, the wonder of it! Before long that flawless body would belong to me! The devil take the world, the stars, nature, men and animals, the gods on Olympia and the Almighty in his stupid, Three-in-One being . . . I undid the cord that served as my belt, and as I took off my habit, attained a feeling of completeness that I had never known before. Was not my only god, my god of that moment standing no distance from me, trembling, spotless and incorruptible? Naked in my turn, I came up behind his back, breathed in his odour, touched his slender thigh. Then I probed that wonderfully tender backside in search of the brown planet that would presently become a golden ring and scabbard for my sword. At last I could accept myself for what I was: yes, I was small, swarthy, stocky, uncouth, stubborn . . . My goodness, we were so different in so many ways! But more different than straw and amber? Than the elm and the vine? In a sequence of universal motion, a *sumpathia* was at work, our *sumpathia* . . . Cecil turned abruptly to face me and started, like an insolent urchin, playing with his white spur with the

tips of his fingers. With one quick movement, as one catches a bird, I took it from him.

'It is completely virgin,' he affirmed arrogantly. 'It has never penetrated anywhere, and it never will . . .'

I knelt as if to pray, and my feverish mouth immediately applied itself to the task of rendering such a statement null and void. With both hands Cecil hit me and pushed me away. A struggle ensued, the outcome of which was inevitable. Thrown against each other, we rolled on the cold tiled floor. Our breaths mingled – oh Lord! how I desired that slave, vanquished and trembling with rage, that dry-lipped prisoner, trying to get his breath back in the unyielding stranglehold of my arms. In a faint-sounding voice, he shot his last arrow:

'Forget your dreams and your imaginary heaven, Philip. It's better to be feared as a prince than loved as a poet . . .'

Tears stung the back of my eyes: that was just the point, the one thing I longed for was to be *loved*! Ah, Cecil! Cecil and his accursed prophecies! Was it to stop having to hear them that I crushed his lips? Their precious taste was to stay with me for ever. They in their turn devoured me, to the point of oblivion, of that other death by the kiss: a lightning flash of eternity in which everything is obliterated.

I had to wait nearly eleven years before I saw him again. By a simple calculation, three thousand nine hundred and fifty days, not one of which went through my veins without being coloured by the memory of those few brief hours that vanished into the dawn in Rome in the year of sixty-eight. I can remember very precisely a garden planted with orange trees, and with three lion's heads sculpted into the marble above a fountain decorated with large letter 'S' s. Like a mnemonic picture from which one can reconstruct the exact evolution of life, its image has remained imprinted in me: solemn and dressed once more in his dark clothes, Cecil goes off to find his demented cardinal, while I prepare to escape through a hidden door. No sooner have we met than our paths are already committing the crime, the injustice of parting. And

yet, however brief it may be – and it almost always is! – the happiness that Love brings fills life, as God fills the world, with an invisible, necessary vibration. Thus I was going to have to live, as Petrarch put it, *col ferro avelenato dentro al fianco*: with a sword planted in me that was soaked in the poison of love, a sweet martyrdom, an indispensable pain, a torment which never leaves the soul in peace. The illustrious Tuscan's name has just cropped up as if from nowhere, and I know why; as I crossed the boudoir on my way out of the alcove, I appropriated, with Cecil's consent, a book of his poems: and when, in the coach that was taking me back to Naples that same day, a priest took it into his head to confiscate the precious work from me, I flew into a rage and got so carried away that I even threatened to kill him.

Yes, in those three days in Rome I had become a different person, and I took no pleasure in returning to Naples, with its monastery walls, uninspiring studies and grim teachers, in whose ugly faces, as in a faithful mirror, those of their pupils were reflected. News of the incident in the carriage got round the college, and needless to say this gave rise to a mistrust tinged with jealousy which fuelled the mutterings that surrounded me. Urged on by his sycophants, Fra Ambrogio recalled that day long ago when I had torn up Felix's pious images, and accused me of arrogance. I answered him by quoting Plato:

'If they can hold him in their hands and kill him, will they not kill him?'

'What do you mean?' mumbled the prior, searching through his own stock of quotations.

Like the prisoner who had seen the light, I explained loftily, I was back in the cave, among ignoramuses whose fear of the truth left them no other choice but to hate me.

Filled with dismay, Fra Ambrogio made a few vague threats and dismissed me.

I also had an altercation with the librarian which very nearly led to disaster. What started it was my sudden refusal to go on satisfying his murky appetites.

'Why?' he growled, panic-stricken.

It was the one and only time that he dared to look me straight in the face. Cecil's naked body trembled before my eyes.

'Don't feel like it any more,' was all I said in reply.

'In that case, no more books,' he answered, lifting up his straw mattress.

Without leaving him time to grab hold of the horn-handled knife, I seized him by the throat and tightened my grip as hard as I could. Did this murderer think he could use his power over me? I was young, agile, strong, pugnacious! I was a demi-god! I hurled the brute on to the ground, seized him by the hair and rammed his face twice down on to the stone floor of the bedroom. In the heat of violence, a malicious instinct no doubt took control of my actions, because I found myself, in a gesture that was as futile as it was spiteful, angrily tearing down the holy images on the walls of his room. While I was fighting to get my breath back, I hid the weapon in my pocket.

'I intend,' I said, 'to go on reading whatever I please; and you're going to go on helping me . . .'

'No!'

In view of the fellow's attitude I was forced to lie:

'When I was in Rome I saw Ghislieri and his right-hand man Rebiba. They know who you are and my wish is their command. One letter from me and you'll be sent back to the galleys. Do you by any chance feel like setting off on your travels again, Marcellus?'

Pius V died four years later (the Romans did not stone his coffin), at the time when I was being ordained a priest. Marcellus died shortly afterwards in mysterious convulsions, as did Fra Ambrogio. The former master of the novices was rotting in prison, and many of my old companions had left the order. Some had become highwaymen, others were fomenting unrest against the Spanish and the Inquisition.

Urged on by the Vatican and wishing to appear as zealous as possible, the new prior had barely moved into his predecessor's office when he took it into his head to clean up the

library by getting rid of all the heretical books that it was alleged to be harbouring. But he soon discovered that all written matter is by its very nature liable to fall under such suspicion, and we saw him marking time in the face of the titanic nature of the task that lay before him. Thrown off balance, this dispenser of divine justice fell back on a shabby expedient, which consisted of publicly burning about thirty books that were chosen almost at random. The ceremony took place at the foot of the steps of San Domenico Maggiore, in the presence of the archbishop and a crowd of beggars who had been rounded up from the *bassi* and cudgelled into coming along. At that time I was free to come and go as I chose, but as luck would have it I witnessed the scene from my bedroom window. Among the books thrown to the flames, I thought I spotted Erasmus' work on the joys of folly which I had recently found so diverting, a work by Plato edited in Florence by Marsilio Ficino, and even a copy of Aristotle's *De Anima!*

'If he's not careful, this ass of a prior will end up burning his missal.'

'What's going on?' inquired the novice who was with me at the time.

'Auto da fe.'

'I beg your pardon?'

' "Act of faith". In Portuguese.'

The response to this frenzy of purity punctuated by numerous deaths, natural or otherwise, was a confusion of souls that bordered on folly (hardly, in this case, of the joyful kind!), and an unquenchable thirst for disorder that seemed likely to invade every mind. People in Naples lost count of the scandals provoked by monks, all of whom seemed to want to bear witness to the moral decay which the austere, inflexible Ghislieri had merely exacerbated. As for his successor, he issued more and more edicts. It was forbidden to walk alone in the streets, to carry a weapon, to hear a woman's confession before the age of thirty-five! But it was all in vain because evil, without the slightest doubt, was wrecking the foundations of the edifice; and if the Roman Church was seeing its authority

over the clergy evaporating like mist in the sun, it was because it was itself corrupt, cruel and obsessed with going back and back, like an old maid harping on her virtue, over a dogma which was now doomed to sterility. If a monk was dishonest, he took refuge in crime; if sincere, he aspired to a reformed spirituality, reread the ancient authors, and studied the various competing doctrines. And yet, he too would be treated like a villain: let him but think freely and they would call him a heretic. *Heresy*: that was all they ever talked about now! You had to hear them utter the word as if it contained the venom of all the devil's works, past and to come; as if they were afraid of harbouring in their own bosom the germ of some cunning evil spell to which it held the key, and which was liable at any moment to have them ruined, thrown into prison, interrogated under torture. And yet, for the Ancients, did the Greek word *haìresis* mean anything other than 'preference', 'inclination', 'choice', all such entirely human, natural concepts?

'Go ahead and choose for yourselves who you intend to love and follow!' I burst out one day to my pupils. 'Let your masters nibble away at their Aristotle like an old cheese rind, while you read Erasmus, Pico della Mirandola . . .'

'But they're heretics, Brother Giordano!' chorused those hypocritical little namby-pambies.

'These heretics, as you call them, sometimes express themselves more skilfully than your accredited grammarians!'

Having recently become a doctor of theology, and thus acquired a brand new authority which had gone to my head, I at last held a teaching post. My ambition was to pioneer a doctrine that was free of all pedantry, a way of thinking woven from the golden thread of life, in which the most secret portion of the soul was revealed. My lessons were peppered with wonderful metaphors: the earth was a great and generous fellow running the length and breadth of the firmament, the mind was a voice that sang into the ears of the world, being was a sparkling infinity of random occurrences. In addition to Augustine and Nicholas of Cusa, I encouraged the *pueri* to read the poets, and discover the Philosophies and Dialogues of Love, for in these works too, I asserted, one could see

the glittering splendour of divine wisdom shining through; and with the help of those words I was able to invoke your presence, faraway Cecil! Thus I intoxicated myself with your memory and your philosophic beauty!

Naturally my lessons were inspired most of all by fierce opposition to official scholasticism. In my opinion it was nothing more than a watermelon skin, a fruit emptied of its pulp, a collection of outdated notions that people kept repeating over and over again in Latin, without grasping their original meaning any more, and with the sole aim of establishing a position of bogus superiority. The old language of the School, from which all knowledge was absent, was threatening to dessicate our brains, I said, and now it was time to drink at the fountain of true wisdom!

But the atmosphere in Naples was growing more and more oppressive, in those times of uncertainty when the face of the world was changing. And how much wisdom has there ever been in people's minds when a storm is brewing? I knew it by intuition: Brother Giordano was merely hastening the moment when he would have to flee the monastery, the city of discord which had created him in its own image, and even the Kingdom. Besides, was not that my secret and most cherished desire? I was a doctor, after all! Wherever I went, I could open a school which would bring me in a hundred and fifty ducats a year! Would I have to spend my whole life cooped up in this quivering heap of entrails lying at the foot of Vesuvius? There was Rome! And in Rome there was Cecil . . .

I was indeed soon to leave Naples, and never again to return. Fate helped me on my way by sending Father Montalcino, a vain, obese pedant from Lombardy, to preach his Aristotle at the monastery. A debate was organised. The confrontation took place in the theology room, which was packed for the occasion.

'Heretics are ignoramuses,' began the Lombard, 'because they do not conform to the norms of scholasticism . . .'

A fine argument, to be sure! I shouted him down without ceremony:

'If you don't mind, father, you're getting it all muddled up!

Everyone has his own way of expressing himself. Intelligence is not the same thing as slavish adherence to a grammatical rule. There are some philosophers who know how to make themselves understood, even if they don't suck on Aristotle's teats!'

Always fond of these verbal sparring matches which sometimes ended in a fistfight, the monks squeezed on to the benches were laughing fit to burst. A clamour arose from the gathering. I knew of no medecine more restorative than a good audience. My natural pugnacity found in it a subtle echo which I was usually able to turn to my own advantage with no little panache. Montalcino's moon face lit up in a friendly, tranquil smile; he too was a seasoned debater.

'Which ones are they?' he asked. 'Give us an example . . .'

'Forgive me, but your strategy is rather like you: it is somewhat gross. If I cite the name of an author, you will immediately conclude that I am inclined to favour his arguments, and you will suspect me of heresy in my turn.'

'Name one anyway, Brother Giordano. We'll see what happens.'

'Let's take Arius, a heretic according to your criterion . . .'

'He denies the divinity of Christ!'

'That's your interpretation! In my opinion, all he says is that Father and Son are made of different substances. Which in my opinion is not a bad argument . . .'

'In stating that, he is outside the law of God and the Church. And I observe that you do indeed take up his defence with great passion . . .'

My voice was like the crack of a whip:

'So now we have it! He is outside *your* law. God's laws are the laws of nature. Besides, I haven't expressed a view on the content of his arguments. I am merely giving you an example, since you demand one. Whether he is right or wrong, Arius expresses himself with clarity, unlike certain . . .'

The preacher was of course accompanied by his henchmen, a delightful bunch of individuals who would have broken your arm for no other reason than to teach you to think in a Christian way; and Montalcino was the guest of the prior.

Someone was kind enough to warn me of what lay in store: one more night in Naples and – as far back as then! – I would be arrested for heresy. The trial went ahead all right, but it took place in my absence. That same evening, near Cuma, on a ribbon of white sand from which a handful of ragged urchins were throwing their nets into the sea, I boarded a felucca which was headed for Rome.

The *Urbs*, the sailor had warned me, was not much safer now than in Ghislieri's time. Weakness of character, old age and precarious health were preventing Gregory XIII from governing; and it was impossible to imagine a worse captain than his son Giacomo, who nevertheless had been appointed Governor of the Sant' Angelo fortress and Gonfalonier of the Church. Lords and cardinals, who were given a free hand, had retained the custom of surrounding themselves with thugs armed to the teeth, and in the streets and on the banks of the Tiber as well there were continual brawls between rival gangs. They didn't just put their enemy to the sword, sometimes they just threw themselves on him, several at a time, battered him to death and then hurled him into the river. Another scourge was fuelling the rumours: the plague. The carter transporting salt, with whom I travelled from Ostia on the last leg of my journey, told me that it was already rife in Venice, Milan and Padua, and that as a result there were more rigorous checks on new arrivals at the customs. They were also likely, he said, eyeing my canvas bag, to confiscate my books. We hid them under the seat of the cart along with my habit, and thanks to a tabard he lent me, I was able to pass myself off as his assistant.

On the Piazza Capodiferro, a gang of thugs clustered on a marble bench prevented me from entering the Vita palace. Eyeing me suspiciously, they told me that the cardinal had recently died. As for Cecil's name, the only reaction it got was vulgar jokes and sly sniggers. The local residents were equally unhelpful; in response to my questions they feigned imbecilic dumbness. Greatly vexed, I was about to give up when I noticed a man carrying books, whose distinguished features

were familiar to me: Jacobi. And indeed, his shop was just round the corner. He told me that it had been pillaged by a horde of monks.

'They're burning heretical works,' he said in a low voice. 'And the heretics themselves. After my shop was sacked, a cardinal from the Holy Office called me in for questioning . . .'

'Were you tortured?'

'No. It was just a warning. They suggested that I consult the index in future. As a result I'm not selling anything any more.'

Glancing disdainfully at the books he was holding in his hand (a little *Rettorica* and a collection of canticles in praise of the Virgin), he added:

'No-one's interested in authorised books.'

'What about Baïf?'

'Never saw him again. Went back to France, apparently. The air in Rome isn't healthy, believe me. Not to mention the plague that's coming . . . Please excuse me, but I have business to attend to; they're waiting for me at the *banchi* . . .'

I held him back by the arm.

'Did you know Cardinal Vita?'

'One of my customers. A very strange character. Died three months ago . . .'

'And Cecil? Where is Cecil?'

'The favourite? He was a great book-lover too. He was spying for Venice, did you know that? His younger brother came from London to study in Italy, and they both ran off together without a word of warning. They say that it was his departure that killed the cardinal, but stories go round so fast in Rome . . .'

'Where did they go?'

'I don't know. He loved books, as I was saying. Which reminds me: he came to my bookshop a few days before . . .'

'Yes?'

'No. Nothing. Excuse me, I'm in a terrible rush. And these people who are coming towards you don't appeal to me in the slightest.'

'Wait!'

But already the bookseller was dashing off in the direction of the Piazza del Duca. And indeed, a soldier of the watch, accompanied by a hooded priest, had drawn level with me and stopped.

'Who are you looking for?' asked the guard.

'And what are you carrying in that canvas bag?'

'I don't have to answer you.'

'You'll answer the officer, believe me.'

And they led me away, to chuckles of pleasure from the local riff-raff. As for the officer, I did not have the privilege of meeting him, because quite soon afterwards we turned off to the left. I realised that I was being dragged off to the Tiber, for no other purpose than to relieve me of my money and perhaps do away with me. Once again I could see what a good school the streets of Naples had been: the mêlée was of short duration. The soldier, a greenhorn with slow reflexes, lost his helmet, slipped on the sloping bank, and fell heavily into the water, wounding himself with his sword. As for the priest, who was an agile, vigorous Calabrian of my height, I decided to make a run for it and shake him off. Further upstream I spotted a group of fishermen who might help me, next to a boat that was tied up to a rope stretching from one bank of the river to the other. But my canvas bag was slowing me down, and the scoundrel, once he had caught me up, hung on to my shoulders, dragging me down with his full bodyweight. I had pulled out of my belt the knife that I had stolen one day (one day? It seemed like a century ago!) from the librarian at San Domenico Maggiore. We rolled on the bank, which was covered in filthy seaweed and the corpses of dead fish torn to pieces by rats. When I staggered back on to my feet, the priest was dead, with the blade thrust two inches deep into his heart.

'So now here you are, defrocked, in the proper sense of the word.'

Standing by a window hung with a brocade curtain with a design of putti and vine branches, Brother da Lucca, the prior of Santa Maria Sopra Minerva, was smiling as he looked me up and down from head to toe. This refined, high-ranking

Christian had the reputation of one who would never shrink from any paradox. A man who seemed amused by everything in this world, he devoted a certain amount of his time to fighting against heresy – in particular of the Lutheran variety – and to promoting Aristotle. And yet, without the slightest hesitation, he had offered me hospitality in his monastery! I had been there for five days, staying in a comfortable room where the walls were lined with the best books, and the fire was tended by an old monk who was extremely amiable, albeit deaf and dumb. But there was no question that it would soon be time to leave: in place of my excessively compromising garb, the prior had just brought me a pair of hose, an old serge tunic and some new shoes. Through a gap in the curtain he began staring absent-mindedly again at the Pantheon's arse, as he called it.

'What news?' I asked, playing at tearing strips off my habit before throwing them into the flames with the aid of a poker.

'From Naples, it's bad: your trial is over.'

And after a silence:

'You've been excommunicated.'

I closed my eyes, because at that moment I felt as if my soul was about to burst. They had made me a doctor, an orator, a teacher, a theologian, a master of debate, and now they were hounding me out as if I were a piece of scum, a villain! My mind was suddenly witness to an upsurge of images more brutal than a nightmare: standing on the steps of San Domenico Maggiore, the archbishop was blessing a book-burning, and the librarian, his eyes shiftier than ever, appeared from nowhere armed with his horn-handled knife. Somewhere, the dying Fra Ambrogio was muttering his maledictions; somewhere else, Reginaldo was tormenting the *pueri*; depraved clerics were prowling beneath the arches of the cloister; grammarians were vaunting their wares by sucking on the bones of their emaciated Latin: a grotesque, hellish society which for good measure included the young Brother Giordano, a beardless adolescent whom I could see prostrating himself, with his face on the ground, during a ceremony long ago. My admission to the Dominican order! Vairano had

decided that I should face that ordeal. No doubt even then it harboured – but did he know that, by heaven? Did he know that? – the invisible seeds of my present humiliation . . .

'Just as I expected!' I exclaimed. 'That Montalcino is a crazy fool! If I hadn't taken to my heels he would have had me thrown in prison . . .'

I opened my eyes again and turned towards da Lucca who was nodding amiably, and smiling again.

'Forgive me . . . And from Rome?'

'Bad news from there too.'

They were searching everywhere, he said (was he ever going to wipe that damned smile off his lips?), for the monk with the canvas bag who had attacked a guard on the bank of the Tiber and killed the priest who was with him. Witnesses had seen me talking to a bookseller from the Piazza del Duca, and it wouldn't be long before the man revealed my name. The Inquisitor, for his part, was sure to make the connection between the murderer and the Neapolitan heretic who had just been excommunicated . . . *The Neapolitan heretic!* Despair was already closing its wings over my heart, and despite the flames crackling in the hearth, I trembled under my secular garments.

'And there was I, wanting to open a school here . . .'

'You'd do better to flee as quickly as possible.'

'Of course, but where?'

'The north.'

After I had thrown the poker into the fire, thus stirring it into a wild blaze, I exclaimed:

'You of all people are advising me to go to the heretic countries, Brother da Lucca?'

'Why not? Perhaps you'll have more luck under other governments.'

'But people say such terrible things about them!'

I imagine a statement like that suggested that I was not so much afraid as fascinated. The prior was not deceived.

'God loves those who travel,' was all he had to add.

I was to do a very, very great deal of travelling. And the list of

cities I was destined to pass through, until my arrest in Venice eight years ago, would in its own right constitute one of those poetic, invigorating catalogues which have always delighted me: Florence, Genoa, Turin, Chambéry, Geneva, Lyons, Valencia, Montpellier, Toulouse – to mention only the early ones . . . But soon darkness will blot out the light from the little window up there, and by now I can barely make out the lines on the paper. Oh Cecil! Oh my past life! This evening, death by the kiss has the heavy, bitter taste of English tea. And yet it exists, if it once did exist, and so does the world itself that rustles in this confounded cell like wind in the autumn leaves! Today for the first time I have written without the intention of constructing anything. Doomed to oblivion, the words that my wretched pen has written are like stones picked up along a path, each one carrying a hidden load of events, circumstances, coincidences and faces. And by heaven, how I love those circumstances! How dear those faces are to me this evening! Is it the proximity of death that is sharpening up my recollections like this? At the end of my life, that life is coming forth and making itself heard in a quarrelsome clamour which I cannot hold back. And I know that if sleep comes, it will be of no comfort to me; for even in sleep, the universe goes on hatching its endless mysteries.

Friday, 11th February, 1600

I have always had troubled nights, haunted by those dreams that the *spiritus phantasticus* fosters to deepen the enigmas of life, and which I had to make titanic efforts to decipher when I woke up in the morning. There is not much difference between nocturnal life and its bright, transparent sister, apart from the fact that they happen at different times. Both offer the mind epiphanies in the form of shadows and images which, like the words of a foreign language, can only be made meaningful by the use of reason, but which also require a knowledge of the alphabet used by God. And that was precisely what my ambition was: to penetrate the mystery of that alphabet through and through. If I never achieved my aim – but who will ever achieve it? – at least I came close to it, as close as any human being can. In doing so I was following the example of men like Agrippa of Nettesheim, Pico della Mirandola, Marsilio Ficino, Denys, Plotinus, Socrates, Zarathustra, Mercury Trismegistus, and so many other initiates, including, no doubt, Jesus, who was not a god, no, but a magus like the others. The Catholics are very good at misleading the common herd, and they only appropriated the memory of the unfortunate Nazarene so that they could turn him into an idol. But a man might have any number of motives for proclaiming himself the son of God! Didn't Jesus express himself through parables? Why insult him by taking his declarations literally? Like the rest of us, he knew the power of words which, when restored to their pure meaning, suddenly enter into harmony with divine thought and the spiritual nature of the world, and all at once give you an idea of the Truth: a magic, poetic bedazzlement that grips your very soul . . . No, really, this sage was skilful enough at perceiving the *sumpathia* between people to merit the title of philosopher. Jesus Christ? When all's said and done he was a colleague, with a feeling for the importance of proper nouns and furthermore with a

marked and shall we say somewhat childish penchant for conjuring, which is a rather vulgar form of magic: hence his so-called miracles . . . His reward for his talent was to die hanging on a cross, like a brigand, betrayed by Judas who gave him a kiss to point him out to a Roman officer. *Mors osculi*, so to speak, but resulting from one of those fatal errors of judgment that cost you nothing less than your life. An informer hides himself under the disciple's cloak, and suddenly you're a gallows bird, being dragged before justice and condemned to death! And what a hell of a death it is! The worst one, always, and the longest. My false disciple was someone I knew in Venice, and I already have him to thank for eight years in prison. And now here is my Pilate, it seems, in the person of Clement VIII. He and I do not see each other face to face, but it would appear that he is suddenly observing me with a highly politic benevolence, since he doesn't think twice about sending messengers to see me.

Last night, while I was howling in the darkness like a maniac being beaten by a shrew (my mother, I suppose, dragged by yesterday's jottings from her eternal sleep), I was brutally awoken by Orazio's lamp lighting up my dungeon. He was carrying a little flat-bottomed wicker basket containing a bowl of hot soup, a crust of bread, an apple and a pitcher of wine. He put it all down, along with his lantern, on top of the pieces of paper strewn over the table. With him was a Turkish boy of twelve or thirteen, dressed in a black cape. Moving shadows cut across the child's face, which was petrified with fear. The Hercules ordered me to eat first and listen afterwards. They both watched as I pulled on my chains, sat down, drank the soup straight from the bowl, and sank my teeth, which are still good, into the hard bread. I went without dessert.

The boy was an emissary of Pope Clement, Orazio informed me. He had come from the Castel Sant' Angelo with two guards, and had a message to give me. Shading my eyes with my hand and blinking, I answered with a question:

'And where is this message?'

'There must be no trace of it: they've made him learn it by heart.'

With those words he went out and locked the door.

'I am listening,' I said to the trembling emissary.

Did this angel know that in a short while he would die? There he was, delivering in Latin the personal exhortation of Pope Aldobrandini, a little masterpiece of diplomacy from which nothing was missing but the smell of ink and paper, and the arabesques of handwriting. In it I was told that I was destined for public obloquy and doomed to hell, but the threats were tinged with a flattering hint of admiration for a man who once taught at the Sorbonne, was an agent and friend of the King of France, a guest of Prince Rudolph . . . In the name of a wisdom which I am supposed to have derived from those noble connections, and in exchange for my life being spared, the Florentine implored me to renounce my deadly ambition and agree to save myself by a humble, sincere confession, made with the utmost discretion to the Cardinal Inquisitors alone. I would, he assured me, be granted secret conveyance, at the expense of the Vatican, to the refuge of my choice, somewhere outside Italy, in one of the heretic countries that I am so fond of, for example. Nonetheless, to respect the terms of my sentence my books would be burned, as would an effigy of me . . .

You're nothing but a miserable, low-life crook, Aldobrandini, and the wretched motive behind your scheme is crystal-clear. No sooner will your roughneck soldiers have dragged me out of this gaol and got me away from Rome than they will slit my throat in the corner of some wood, as if I were a common thief. Do you think I don't realise that? Here is what I think, in case you should ever read these pages: the year that's just beginning is a jubilee year, and to start it by sending someone to the stake isn't really very good politics. You fear for your peace and quiet, of course, and you are ready to commit any infamy rather than allow your prisoner the advantage of an heroic death. I can imagine you in the shelter of your fortress, secretly cherishing the hope of some ideal reconciliation between the people and its masters . . . And now – damn and blast! – here it is being compromised before it has even got off the ground, by an infidel who has suddenly

turned as stubborn as a she-ass! I remember the rumours that were still getting through to me a few days ago: everywhere it is whispered that the Romans are exasperated by the number of executions there have been over the last few months, and that the memory of that young parricide – what was her name again? Oh yes, Beatrice Cenci – who was tortured and then beheaded in September after a grotesque trial, still haunts everyone like a spectre of fear. Malicious tongues have even murmured that after the execution you bequeathed all the *Cenci's* property to your nephews! Is that true? Of course it is! And it's a routine, customary procedure! But it seems that people have had enough of certain customs: the executioner's axe glinting on the scaffolds of Campo dei Fiori and Campo del Ponte, and your family filling its coffers with stolen crowns. Not to mention the unfortunate troublemakers who are sent off to the communal graves at the Torto wall, supposedly for heresy! No doubt your advisers have made sure to put you on your guard also against the insurgents who are making life difficult for the Inquisition in the south: there are hundreds of them now, just waiting for one false move from the authorities, and highly likely to become even more enraged when they hear of the martyrdom of one of their own, isn't that so? Oh my enemy! My tyrant! Just to appease the plebs, you want to burn an effigy now, and make a blaze of some of my writings! And the sage whom your lackeys have imprisoned, questioned, judged and condemned is all of a sudden supposed to grovel to your whim, and accept the humiliation of a clandestine death!

'Recite the letter to me again, boy.'

Although exhausted, drained, more dead than alive, and light-headed with the sudden anger that was boiling up inside me like water under the lid of a cooking-pot, I wanted to feast my heart on Clement's cowardly prevarications, but the messenger burst into sobs. Vivid as a lightning flash, a demon drew a picture in my mind of the blade that in a little while from now would slit the child's innocent throat, cutting short the thread of his life; and suddenly the letter, learnt by heart and soon to dissolve into nothingness, was no longer of the

slightest importance. I got up with difficulty on to my legs which were weakened and wounded by the chains, and stretched out an emaciated hand towards this comrade. What an absurd, futile gesture it was: here was the human, philosophical condition, reduced to a fetid dungeon where the two of us, he young and I growing old, were at the mercy of fate, a few steps from eternity and the final abyss. Already the lock was grating. Already the Neapolitan brute was showing his Cyclops face in the flickering light. Seeing him take hold of the emissary with the beseeching eyes to drag him outside, I could not hold back a groan.

'What does a Turk's life matter to you?' said the guard, before he disappeared.

It does matter to me, I murmured, sobbing in my turn in the dark, like one who stands on the bank, awaiting his turn to ford the stream. Orazio and no other would embody Charon, the immortal ferryman, and Tor di Nona would be my last dwelling-place: the first pit of hell.

The angel of the night with the melodious voice is dead by now, and only the shadow of his tormented soul brushes against the surface of the world, between these trembling lines. As for me, this morning I am a poor lunatic, still writing down words one after the other, and still finding cause to sound off about the barbarity of his fellow men, even after passing through half a century of acts of cruelty.

I note that most of these acts were called religious, such as the appalling slaughter in Paris at the time of my ordination, reports of which didn't fail to reach San Domenico Maggiore. I remember the *Te Deums* that the whole monastery sang when the masters learned that the Medici woman and her son Henry – my future protector, by heaven! – had ordered the massacre of the heretics. Apparently the carnage, having begun at the first light of dawn on a Sunday, St Bartholomew's Day, went on for several days; no fewer than four thousand people were done away with, all Calvinists or so called for the sake of convenience. They were hunted down and had their throats cut in the street, or were beaten to death, hanged,

or drowned in the Seine. Meanwhile their houses were pillaged, which brought in two millions in gold for the Catholics.

Five years later, I was wandering through the north of Italy, and every day was bringing me closer to the centres of heresy which, it was said, smouldered beyond the high mountains. At that time I was going from inn to monastery, begging hospitality, and earning my daily bread by taking any opportunity that came my way to teach Aristotle to beginners, the art of memory to some fabulously wealthy knight or other, or astronomy to a handful of students gathered on the benches of a cathedral church. To be sure, Pastor Calvin had been called to his Maker thirteen years earlier, but the accounts of travellers were still full of gossip, some favourable, some not, about the heresy in nearby Geneva. In Chivasso, a banker from Lyons who had just crossed the Alps and was heading for Venice told me that the Calvinist people lived as freely as the Hebrews after the Almighty had delivered them from servitude. And the order that reigned there? A model of sincere reformation, he assured me. In his opinion the faith of those people was a mirror of true religion, and he judged their city to be more beautiful than Paris and London put together, having seen it with his own eyes lying peacefully by a lake, surrounded by snow-capped mountains from which colonies of angels watched over it. On the other hand, the belligerent keeper of an inn where I stayed in Turin painted a hellish picture of it as a hotbed of excommunicates and renegade monks, all of them scandal-merchants who were weary of serving the Lord and went around filling fonts with unspeakable waste matter, smashing up the sacraments and consorting with the thieves, gangsters and drunkards who abounded there.

Shall I admit it? It was not so much the banker's description as the innkeeper's that whetted my appetite and aroused my curiosity! For a payment of one silver *teston*, a guide led me up the shingly path over Mont-Cenis; from up there, it was not long before I could see a vast, verdant plain adorned with lakes which shimmered under a bright autumn sun. The air here

was no longer Italian, nor was the language. I dismissed the guide and went down alone towards Lanslebourg, from where I intended to go on to Chambéry.

This town had a Dominican monastery. Having hastily donned a scapular that I had bought in Milan in anticipation of this sort of occasion, I managed to get myself admitted there for a few days, and thanks to the hospitality of the venerable prior, ended up staying the whole winter. Imagine my surprise when I found that Felix was there, the Virgin-worshipper who had been my protégé during our noviciate! The poor boy's features were hardened by long years of prison, and he now took shelter behind a suspicious attitude and went under the assumed name of Brother Saturnine. He had three fingers missing from his right hand; they had been crushed by blows from a stone and then torn off by fellow prisoners, he admitted to me.

'Officially it was an accident. Make sure you don't give me away. And you, Philip? Problems?'

'I was excommunicated,' I confided in my turn.

He examined my new garment distrustfully.

'I would like to go to Geneva,' I added.

'You're crazy!'

We were just leaving the church. He dipped his mutilated hand into a font shaped like a conch-shell. Without saying a word, we walked past a circle of monks who were chattering away nineteen to the dozen. It was only after a long silence that my friend from the past began to speak again . . . Like the innkeeper in Turin, he told me some fine tales about the reformed city – calumnies learned off parrot-fashion, I thought. The vicissitudes of an unjust fate seemed to have anchored his soul in the Catholic faith, a religion to which he would cling furiously until his dying breath.

'That Calvin must be roasting in hell,' he said with a sudden malicious delight.

From what he said the man had been nothing but a crook, a tyrant with a talent for pocketing the money collected for the poor and handing it out to his friends while pretending that it was all a matter of predestination. Was the truth ever that

simple? And what pleasure could one take from the damnation of a mortal soul? Sounding sententious and a little ridiculous, Felix-Saturnine grumbled on:

'It's a perverse doctrine that says that salvation depends on God's will alone.'

And, pointing nervously towards the north:

'Up there they all live like the worst of infidels, convinced that their destiny is played out in advance by the workings of grace . . .'

'They say that one can live freely there. For my part, all I want is to work in peace, to write . . .'

'Write!' cried Felix, flaring up as if the very idea was quite intolerable. 'Haven't you heard of a man called Gentile who was publicly humiliated and ordered to throw his own books on the fire? And that Spanish doctor, Servet, who denied the Holy Trinity . . .'

'I'm perfectly happy to deny it myself!'

'Shut up, in the name of Christ! Don't you know that the gentle, merciful Calvin had him thrown alive into the flames?'

Poor Felix! In his opinion Servet had well and truly deserved his punishment, but the fact that the man had been put to death on the orders of an infidel made him roar with indignation! What a pitiful thing it is to see how sour bigotry wins over hearts to whom life has been unkind! Reaching out to touch the back of his neck with a caressing hand, I attempted a joke:

'Do you still have a liking for pictures of the Holy Virgin, Felix?'

'Don't say that name!' he whispered, stepping away. 'I'm called Saturnine here!'

We had come to the bottom of the garden and now the coward was quaking for fear of being caught with me in a compromising position. I seized him roughly by the shoulders and shoved his back against a plum tree. His panic-stricken mouth tried to escape from mine. Furious, I punished him with a hard slap on the face.

'You little pest! You didn't by any chance take up chastity in prison, did you?'

'Yes!' he said arrogantly.

Not in the least bit mollified, he was still trying to free himself. A bellicose strand of hair trembled on his forehead. The fit of cruelty that was raging inside me at that point drove me to have a little fun from his futile exertions. Smiling, and without loosening my grip, I kissed him hard on the neck.

'Tell me,' I murmured very close to his ear, 'why did they crush your fingers?'

What treachery there was in that question! But hadn't the idiot tried my patience beyond the limit? Suddenly he was nothing but a toy in my hands. As I had foreseen he soon stopped struggling, and I knew that there were tears pouring down his poor, humiliated dog's face. Then he spoke, in a few sentences interspersed with sobs. I had guessed correctly, and I had no difficulty in imagining the revolting dungeon, the pique of the bandits to whom he had refused to give himself, the ignoble vengeance they had cooked up, the finger-bones suddenly pinned down on a stone, the other stone crashing down on to them to shatter them into fragments, once, twice, twenty times, a hundred times, perhaps! The punishment dreamt up by these villains was aimed at the hand that was guilty of the solitary pleasures which their victim, as they could not but know, did not have the courage to resist. And without any doubt at all it was accompanied by the usual repertoire of mocking insults. Oh Lord! I was visited briefly by the memory of a Felix intact and already doomed to misfortune, the Felix of the time when we were *pueri*; it was a point of pride then for the innocent lad to maintain that he could choose his lovers for himself. We knew that in reality he was suffering the martyrdom of not loving women or, who knows, of not being one himself. His soul, I thought, had remained the soul of a girl, incomplete, puny, insignificant and spineless . . . Yes, a toy that had fallen into my power.

'Will you help me get to Geneva?' I said, affectionately grabbing hold of his poor, forever misshapen hand.

He did indeed help me, despite his pitiful convictions. His role consisted not only of teaching me the rudiments of French

that he possessed, but also of putting me in contact with a certain lawyer in Chambéry by the name of Lagrange, a Calvinist who was very well in with the Gentlemen of Geneva. He had a comfortable house, a wife and three or four children. He received us in his study, which was cluttered with registers. There was a quiet humming noise from the stove, at the foot of which a black cat lay sleeping. The Protestant exchanged a glance with Felix and looked at me with inquisitorial eyes. For a split second I wondered what the connection could be between two people with such conflicting opinions, came to the inevitable conclusion that the link between them must be secret, and guessed that Lagrange had once freed the hapless monk from his vile prison. After dozens of questions about my present and past situation (Felix-Saturnine kept urging me to tell him the real truth, omitting nothing), the fellow must have deemed me ready to embrace his religion, for he ordered me, with an air of satisfaction, to take the best pen I had and write a letter in French to the Council of the reformed city.

'Don't forget to lard it with Latin quotations,' he added, 'and to mention that you are married.'

'But I'm not!'

'You will pretend you are,' he replied without the slightest alteration in his tone of voice.

I was speechless with amazement. He continued:

'We have in Chambéry a lady called Morgana, who comes from Naples like you, and like you wants to get to Geneva. If she tries to go there alone, she will immediately be taken for a whore, do you see, and she will be subjected to the difficulties imposed by an irksome state of celibacy. On the other hand, there's nothing the Genevese like more than a woman who's a good wife. Man follows Christ, said Calvin, and woman follows man. *Christum homo sequitur . . .*'

'I'd rather your client followed someone else, Monsieur Lagrange. I haven't the slightest intention of saddling myself . . .'

'I can well imagine you haven't,' he cut in, dismissing my objection with a wave of his hand. 'But don't worry: you won't be saddled for long, and nor will she. This is just a

stratagem, a formality that will help you get through customs more easily. Once you're there you'll get a divorce, or rather pretend to get a divorce . . .'

'I beg your pardon?'

'Ah! I see you don't know the word, or that use of it. It comes from Latin, of course. *Divortium itinerum*: a fork in the road. It is in Livy, I believe; and Cicero: *divortium facere*. In short: the law in Geneva permits it, as you will see.'

As if the matter were settled, he had stood up to see us out. His hand was already hovering close to the doorhandle.

'I can't agree to a stunt like that!' I protested, glaring furiously at Felix.

He merely gave a timid smile. What trap had the treacherous rogue dragged me into? Even as he was pushing us out, Lagrange suavely said how amazed he was that I should show any hesitation at all over a lie of so little importance, when I was concealing the fact that I was an excommunicate, or heaven knows what else that was even more serious, he insinuated, under a scapular that I had borrowed, or perhaps even stolen . . . My heart stopped beating: why in the name of heaven had I opened up to this crook? Would the prior of the monastery soon be hearing about my misadventures? At that point we were on our way back downstairs, on one of those *virolet* staircases where you nearly break your neck on every step.

'Whatever you do, don't feel anxious about the small favour I'm asking of you,' Lagrange went on, holding tightly on to the rope that ran along the wall. 'Everything will be fine; and in exchange I shall provide you with an excellent testimonial.'

We were just arriving on the ground floor:

'Those people on the Council are very vigilant, you know,' he asserted. 'And above all, don't forget the letter. I shall pass it on myself. Saturnine will help you with the vocabulary . . . Heavens above, it's been snowing again!'

The snow was so thick in those parts that it completely covered up all the roads, and this was another reason for

putting off my departure until the beginning of spring. The monastery would be a safe haven for the winter, which promised to be exceptionally harsh. As for the old prior, he had travelled in days gone by to Italy and Naples. In the course of three or four conversations during which we talked mainly about his memories, he and I became friends, and I soon received permission to work in peace in the library. This, admittedly, was too closely supervised for my taste, but didn't my canvas bag contain most of the books I needed? Their margins were black with a dense weave of notes and comments which already formed the outlines of my future works. I was in particular contemplating writing a treatise on memory which, like the temple at Khios, would show a forbidding face to those who wished to enter it, and a laughing one to those who managed to get out. Was it not in the very nature of any enigma to present itself initially in the harshest possible light, so that it can take on a milder aspect once it is solved? That was how my philosophy would be: obscure and indigestible for ignoramuses and pedants of every sort, clear and rewarding for adventurous minds. I had in mind a dialogue conducted by a character of my own invention, who would act as a mouthpiece for myself; in it the quality of divinity would be represented by the alphabet, that extraordinary interplay of a score or so of signs that can be joined in a hundred thousand ways, a web of infinite possibilities which is a storehouse for all the thoughts in the world.

Bent over the desk and wrapped up in a thick cloak, I was drawing up lists of names that are brought together on the Lullian wheels according to their relation to light and darkness: dark, nocturnal ones like the witch, the toad and the basilisk, and diurnal ones such as the lynx, the swan, the eagle and the phoenix. This strange inventory intrigued Saturnine who would come in, silent as a shadow, and bring me a bowl of hot milk and some oatmeal bread. That was my lunch, after which I would bury myself in my notes again, spurred on by the hope that presently a pale, friendly ray of sun would shine in through the casement and warm up my fingers.

When the fine weather returned, those thoughts occupied

my mind like a living presence, just waiting for the moment to go down on paper and be transformed into the written word. Something else that I was also prepared for now was the teaching that would enable me to earn my living as a teacher in Geneva. Thanks to Saturnine's lessons and the very Petrarchan ten-line verses of a certain Scève whose book I had bought (I can even remember the frontispiece: four cherubs blowing from the clouds on to a rock towering up in the middle of the sea), my knowledge of French had greatly improved. I questioned the monk:

'Will I really have to take along this . . . what's her name again? Morgana? Have you talked to Lagrange about it?'

'He's adamant, won't budge an inch,' answered Saturnine, trying to pretend he was sorry about it.

I had never yet laid eyes on the Neapolitan woman, but every day my imagination presented me with a portrait of an abominable strumpet lurking in the shadows of my life. I dismissed these images from my mind, then abandoned my work for a while and wrote the letter demanded by the lawyer:

TO THE MAGNIFICENT
AND HONOURED LORDS,
SYNDICS AND COUNCILLORS OF GENEVA
FROM GIORDANO BRUNO OF NOLA,
ALL HAIL

'Can he or can he not live happily of whom it is said: "*Abiit in regionem longinquam?*" Such is the unhappy condition, Magnificent Lords, into which I have been thrown by a grievous fate and the cruelty of those who, having suckled me on Aristotle's teats and offered me room & board, kicked me out of their house & condemned me to exile. To be sure I had sampled other dishes than the ones boiled up in their kitchens, & glanced through a few works which according to these fine men's criteria were wicked, but where is the offence in that? Did not their own master, the great Thomas Aquinas, advise: "*Cave hominem unius libris?*" No, by no means did I want to be the man of only one book. So why must I come up every-

where against the determination to embrace one dogma to the absolute exclusion of others, that determination being synonymous with forced conversion, torture & death? For my part, I have studied all the doctrines & concluded that every one has a grain of truth in it. Rather than espouse one, I often used to say, it is better to study them all – & lo and behold, on the perilous road, from beyond the divine Alps the celestial message reached me, the news of your Jerusalem! I have no ambition but to live in peace, oh Magnificent Lords, such as I am, such as I have been made, an academician of no academy, & for that reason resolve today to beseech with this clumsy letter that it please you to grant me a lodging in your beautiful city. It is washed, from what I am told, by a peaceful & philosophical lake, & by the Rhône, a river of supple soul according to the etymology of its name. You will say to me: what do we want with a peripatetic? Is it not curriers that we need, clockmakers & spectacles-makers? I shall answer that *Natura & Caelum* have made me expert in instructing *pueri & studentes* in all the truths, visible and hidden, that this world contains, & that in these incommodious times when no-one knows any more *ubi est aux Solis*, it is no bad thing to entrust their instruction to one who knows not only his Latin grammar, but also the true & just & pleasing philosophy.

'You might fear, oh Magnificent ones, that I come to bring discord to your city & shatter the harmony that reigns among you; you would be wrong. I am it is true from a region where the volcano thunders, but I have learned not to feed on quarrels, loving only books – those that I read, those that I make – & the sweet peace of study, armed with no point but the nib of my pen. Do not fear either that, barded with the reputation attributed to men from the other side of the Alps, I come to lust after your women: I already have one – oh not a divinely beautiful one like the sweet-breathed Delia of Mauricius Scaevius whose verses I am savouring at the moment, on the contrary the ugliest & stupidest of them all; but she is my wife, by heaven, of Neapolitan stock, & I swear that she has me under her thumb! *Omnis regula exceptionem patitur*, do you see my Lords.

'I make so bold as to call on the recommendation of a man of means, Monsieur Lagrange of Chambéry, a lawyer by profession & whom I charge with this letter; as one in the darkness, I await the day, Admirable Lords, & your decision on my request, so that I may be able to say once more, but with confidence in my fate, whatever it may be: *Surgam et ibo*.

'Valete.'

Was Morgana really the ugliest creature of all her sex? To be honest I no longer know, if I ever did know. But whatever her true nature, after all my wild imaginings she was bound to appear as she did: with the body of a carthorse, breasts like a couple of wineskins, a flat head and hollow cheeks! As for her voice, I swear by Almighty God that it was ear-splitting, the worst sound I had ever heard, compared to which the quacking of the ducks squelching about in the muddy ditches at the gates of Geneva seemed like sweet, delicate murmurings! I repeat, an evil genius was guiding my destiny. No sooner had it united me with this woman than I started imagining the hussy swooping down on me, like a fever, or an attack of coughing, scrofula, dysentery, gall-stones, haemorrhoids, or those other sores, ulcerations, varices, infirmities and stinging, purulent afflictions, whether temporary or everlasting, which all belong to the feminine gender. Thus I viewed her from the outset as a sort of illness, an infection which was going to contaminate my existence and whose corrupt bosom would surely nurture my future torments.

According to the frame of mind I was suddenly in, Morgana was bound to have a soul that was even more ferocious than Fraulissa's. Her father, she told me, had given her in marriage to a Naples shipowner who ended up ruined and ill before he reached old age. I immediately concluded from that that the poor man had succumbed, after an excruciating death agony, to some electuary purchased from a witch in the *bassi*.

'That's not true!' she protested.

'You hated him, I can tell . . .'

'I didn't poison him!'

But I stuck to my guns. Continuing my inquisition, I found

out, or thought I did, that several of the men on to whom she had saddled herself had died a violent death, for instance the last one, a patron of letters, poor devil, whose breeches she had got her hooks into, it seemed, and who was killed in an inn in Susa in the course of a religious dispute. Needless to say, wherever she had been the confounded woman had dropped infants, all of her own sex, the fruits of her murky womb, abandoned brats, wailing at church doors or abandoned to the mercy of unknown and cruel foster-mothers. As I listened to this tale of misfortune, a dark sense of foreboding weighed upon my soul, but it was too late: the deal was well and truly done, and Monsieur Lagrange, the evening before, had pocketed his two lovely handfuls of crowns. And now, if you please, the shrew was making so bold as to gaze lovingly at my canvas bag full of books. Didn't she claim to love the arts, music, poetry and philosophy? Hadn't I just heard her talking, in her terrible southern gabble, about the warm feeling of hope that was already swelling her heart at seeing me pushing a barrow loaded with *our* belongings? We had barely crossed the drawbridge at the Porte de Rive when she declared herself to be my wife forthwith, and to be quite determined to remain so. As for the famous *divortium* so much vaunted by the lawyer, according to her it was out of the question.

'All women need a man,' she decreed.

'But . . .'

'And all men need a woman!'

'Not all, in the name of Christ! Not all! Do you hear?'

We had known each other for barely a day, but if it hadn't been for the disgust I felt at the idea of touching her body I would gladly have strangled her!

'I'll find a way of forcing you to keep your word,' I said, gripping the handles of my barrow.

And so I entered Geneva, pushing before me the burden of inevitable fate, accompanied by my malefic shadow, and convinced that the worst of dangers hung over me. We were walking through a market, and it wasn't long before a flock of bleating goats prevented me from moving ahead. Looking up, I saw the stocks and the blood-soaked face of the roaring

brute who was in them. A shiver went through my body: were the authorities here really milder and more liberal than elsewhere, or had I been blinded by the deceptive glare of a liberty that didn't really exist?

At that time the city was a refuge for colonies of foreigners, a large number of whom were Italian: merchants from Piedmont, Lombardy and Venice, but also men of letters, artists and scholars exiled from Rome or the Kingdom of Naples who had managed to escape the Inquisition. On the recommendation of Lagrange we had to present ourselves to a certain Signor Marchese, a Neapolitan who was held in a respect that far exceeded the limits of common sense. This powerful man, whose family had in times gone by been despoiled by the Catholics, ruled over the Italian community and considered it his duty, he said suavely, to extend a helping hand to every refugee. The truth revealed a very different picture: under the guise of charity, the false-hearted rogue was enriching himself by slapping on to every newcomer a sort of advance tax on his future earnings!

His house was located in the district known as du Molard, very close to the black waters of the lake. He received us in a room heated by a stove, around a long oak table. His accent still had a hint of Naples sing-song about it, but its tones were unpleasant. A shadow dressed in grey, his wife or daughter, had brought in a jug of milk and two bowls.

'So,' he began, 'you wish to join the Reformed Church?'

'Oh yes,' said Morgana, her flat face and milk-wet lips lighting up in a candid smile.

I silenced her with a thump, then declared in the friendliest of tones:

'Churches mean nothing to me, signor. And I have already been excommunicated once. I don't plan to do anything but work . . .'

'You have nothing to fear from religion here, quite the contrary; the Genevese doctrine aims to convince, not to coerce by violence. The weapon we use is divine mercy, not excommunication . . .'

'Forgive me for interrupting you, Signor Marchese, but all

religions are valid, from the point of view of their principles. It's the people who serve them that frighten me . . .'

Did he consider that remark insolent? Turning with a pained look towards Morgana, he asked:

'Surely you don't want to live without God?'

'No, by the Holy Virgin!' the idiot exclaimed.

'I live with God in my own way!' I then proclaimed, raising my voice. 'But most important, I write. I have a hundred plans for books in mind. Treatises, dialogues in the Genevese style . . .'

Morgana was wriggling about on her stool, chortling with vanity.

'You will need a library,' said Marchese, 'a printing works, colleagues who share your faith . . .'

'I fear that my faith is of a type that is too singular to be shared,' I replied.

After that outburst I could see that his opinion of me was formed once and for all: this Nolan was a conceited fellow who would soon need to be taken down a peg or two. Before he had finished weighing up an appropriate comment, I began to speak again, looking him straight in the eye:

'If it is necessary to embrace Calvinism to have access to a library, well then I am willing to give it a try. Put my name down on your lists . . .'

'Yes, yes, put our names down!' said Morgana approvingly . . .

To which I added:

'But let me tell you that I am only accepting this condition in order to be agreeable to you.'

Marchese replied with an unpleasant smile. Moving on with an air of cunning to the matter of financial help, he offered me a job as a proofreader in a printing works run by a Florentine called Giovanni Bergeon. I acquiesced in silence and took a small gulp of milk. Finally, moving his last pawns with care, he explained that I would be viewed as a student here. I would have to attend the university regularly, go to lectures, read Aristotle . . . I set my bowl sharply back down on the table.

'Aristotle? But I know him off by heart! You forget that I am a doctor of theology!'

'I'm afraid you can take it or leave it!'

At which point the outlook for my stay in this city of Calvinists was beginning to look decidedly bleak. So this was the fine generosity of the pious believer! First he haggled over giving his help, then he withdrew it, because all that counted was making a profit for his church, or for himself.

'Very well,' I agreed. 'It's humiliating for me, but as before I accept, out of regard for this city which is so good as to take me in. I would merely ask you to note, Marchese, that my attitude is entirely civil . . .'

'I advise you to keep it that way, Brunet. There is no citizen more jealous of his peace and quiet than the Genevese.'

On this kindly note of warning, he called in the grey-clad shadow, a poor, austerely thin creature of ascetic thinness who came down the creaking stairs and suddenly appeared with a pile of clothes in her arms. A roll was opened in a cashbook, into which Marchese gravely entered the total amount of our debt, and so it was that, dressed in new clothes (for me, a cloak, hat, shoes with double-thick soles, and even a sword, great heavens! For *my wife*, petticoats, a dress and a ridiculous ribboned bonnet) we left that house in which everything conspired against knowledge and life.

We had lodgings with a woman from Rome by name of Silvestri, a grasping shrew who owned an inn in the seediest part of town. Our accommodation there amounted to no more than a garret which by some miracle was equipped with a stove, and which we had to share with another couple, the Borzelli, who needless to say were from Naples. Anyone would have thought that Geneva was actually governed by Italians! He was a giant who was originally from Cuma and earned his living as an arquebusier of the watch; she sold poultry on the du Molard market. The only partition dividing the room consisted of our underwear and the tattered sheets supplied by the landlady, hanging from a cord.

Sleeping with a woman! What crime had I committed to

deserve such a penance? And to have to do it in such a stink-
ing, hellish dormitory! No sooner had the curfew sounded,
with much ringing of bells and rolling of drums as was the
custom in those parts, than all four of us found ourselves
imprisoned in motionless time, in the most odious mixture of
nocturnal company. Like a machine designed to produce
snores, belches, farts, stomach rumbles, groans and cries of
pain, Borzello filled the night – our night! our communal
night! – with his colic pains and despair. Dante's starless hell
was as nothing compared to the nightmare that that man put
us through; and when by some fluke the blackguard managed
to break free from his dreams and drive the spirits out of his
vast carcass, it was to obey the command of the worst instinct
of the species. How many times did I have to suffer from
hearing him service his chicken-seller! Lying right on the
very edge of the bed, mad with rage, with a pile of blankets
over my head, I had to abandon my meditations and despite
my best efforts imagine the monumental coupling that such a
liaison involved. Needless to say his wife gave herself to it
heart and soul, moaning as if the earth had opened up beneath
her. As for Morgana, what hope was there that in these condi-
tions she had gone to sleep? Good heavens no! In fact I
already knew the next torment that was lying in wait for me:
contaminated by the ardour of our neighbours, she would
come over to me a little while later, giving studied moans,
eager to get in under my nightgown and try her hand at
humiliating me with her horrible fondlings, her disgusting
caresses, artifices and strategies. No doubt these were the
normal ploys used by her sex to bewitch the male and arouse
his appetite; the only effect they had on me was to cause
vomiting, headaches, choking fits, fermentation of the blood
and irritations of every sort, never at any time the slightest
desire to embrace her unwholesome body, let alone enter it
through that defect in nature, that gaping tract, that viewless
window, that gash in mid-flesh, that malodorous sepulchre,
that sluice bored between the thighs . . . Cautious at first, then
shameless, and finally sour and furious – admittedly this was
not entirely unconnected with the strenuous resistance that I

put up! – my persecutor soon found her impure soul, her bestial, prostitute soul, descending into madness. How could I defend myself, dear Lord, except by beating her black and blue? And so I thrashed her – oh how unfair that it should be necessary! – until I was nearly out of my mind, or to be more precise until Borzello had thrown himself on to our bed, groped around in the dark to separate us, and then flung me on to the ground, swearing that one day he would break every bone in my body.

'You married her in the eyes of God!' he cried, giving me a good trouncing. 'You are supposed to honour her, not beat her!'

'This whore is not my wife!'

'That's a lie!' yelled Morgana between sobs. 'We are registered as a married couple at the City Hall!'

Had I wanted to *honour* her, as he put it, there would have been no hope of my doing so. As Michel de Montaigne, a French gentleman who is a friend of mine, wrote somewhere: of all our members, the male organ is the most free and the least co-operative, delighting in being obedient to no will but its own. How very true, as I was rapidly discovering: mine, by now more puny and wrinkled than an old man's, seemed to have lost all its vigour, so greatly was my freedom being restricted by the unspeakable lot that fate had willed upon me. Since my arrival in Geneva, a thousand scourges had been heaped upon my body – poor appetite, deadly pallor of the skin, sudden dizzy spells, gumboils, fevers – but the most unbearable of all was without question the debility that had struck at my desire. To be sure there were times when, while engraving woodcuts and correcting proofs at Bergeon's, I eyed up the apprentices who were carrying around the print-cases and bales of paper; but not one of them succeeded in arousing me. Nor did the students sitting on the benches at the university, whom I considered spineless, coarse and devoid of beauty. My senses were only prepared to be awakened by the workings of memory, for example when I was relaxing in the steamroom at Longemalle. That was where, in my mind's eye, I would once again see

80

Cecil's slender shoulder, his lips as cool as soft rain, and the purple ring deep in his loins. True, they were just images from the distant, too distant past; but at least they were quite willing to transmit themselves to my flesh. Then I would feel a brief bubbling sensation, a vague recollection of happiness: a paltry pleasure which left me quite naked and trembling with cold, more solitary than a broken-hearted wretch deserted by love.

As for working on my writings, I was turning out to be incapable of it, as if the power to create and discover had abandoned me along with the power to love, while the combination of the proofreading job and going to the university was overwhelming me with fatigue and swallowing up all my time. I spent my rare moments of freedom wandering about, exhausted, under the domes and among the market stalls, thinking bitterly of my books, notes, drawings and commentaries, abandoned for ever at the bottom of a bag in the Silvestri woman's garret.

A man called Jean Pruss, whose laboratory adjoined Saint Peter's Church, agreed to let me visit him. This alchemist had been a disciple of the wandering doctor known as Paracelsus, who viewed man as a complete firmament in himself. Just like the world, this master had once taught him, the human body is full of stars. There Jupiter is called the liver, Venus is the loins, Mercury is the lungs and the moon is the brain. What we call wisdom is the search for a balance between these two heavens.

'He who achieves this balance knows the universe,' repeated Pruss, 'and his powers are infinite.'

Did he possess these infinite powers? One day I saw him with my own eyes cure a German nobleman who had lost his nose, by grafting the appendix of one of his servants on to his face. The operation was a complete success, and the whole of Geneva was talking about the German with the miraculously repaired face. But as misfortune would have it, the servant happened to die of some fever or other. No sooner was he buried than the nobleman's graft decomposed, gave off a

putrid smell and fell off: it was linked in its essence to the man to whom it had once belonged, and therefore had a duty to join him in the hereafter.

'Like the universe,' sighed the magus, 'the body of man is one, and so is man himself.'

To help him commune with occult forces, there was in his den, hanging on the wall next to the athanor, a richly-coloured picture depicting the wholeness of nature and the mirror of the arts. In it human ingenuity was represented by a monkey sitting on a sphere. With one hand the animal was holding a golden chain, and this chain attached him to a woman, a goddess no doubt, whose hair parted to reveal her breasts and belly, and the dusky crotch concealing her supposed attractions. A second cord linked the divinity to a blazing cloud containing the Four Letters of the Hebraic Name, the *Tetragrammaton*. Is not the soul of every one of us a world at the centre of the world, attached to all things, desires and thoughts? As if the sight of these painted forms had burst through the barriers that were keeping my soul prisoner, I opened my heart to the alchemist about my melancholy, talked about the desolation, shame and impotence to which my life had fallen prey in Geneva, and, stifling a sob, uttered the name of Cecil . . . Was the magus listening, or was he thinking about something else? From a drawer where he kept them hidden, he brought out some new engravings which he calmly unrolled on his table.

'If there is a *sumpathia* between you,' he said in a soothing voice, 'then although you are wandering in different places, you are forces which long to unite and which, have no fear, will manage to do so sooner or later . . .'

'Is it not possible to help nature on by some artificial means?' I persisted. 'The smoke from your athanor would go up to the sky of its own accord, wouldn't it? And yet you have built a chimney for it . . . Good Lord! What are these drawings about?'

What my eyes were seeing would have terrified the most insensitive of mortals: a man of mature years sitting on a stone was lifting up the skin of his belly, as if were just a garment, so

82

that he could display his entrails! So was that long tube with a thousand coils and twists really . . .

'The intestine, yes. The digested food pulp travels along it to the anus, like merchandise along our winding roads. And here is the liver, his majesty the liver . . .'

As a philosopher I had already thought about how my own skull was invisible, like a sardonic allegory of death, but to look inside a body like this and see what it was composed of made me feel so dizzy that I had to sit down in my turn: I had just, for one fleeting moment, imagined myself in the place of that person chosen by fate to offer for ever to the eyes of the living the spectacle of his innards, and perhaps of his mysterious soul; and my legs had very nearly failed me. Without the slightest concern for the agitated state I was getting into, Pruss went on showing me his pictures: one impassive *écorché* with all the muscles of his arms, shoulders, abdomen and thighs exposed; a fellow who had a pensive expression but was also completely without skin, so that he looked like an open cabinet with his spleen, kidneys and bladder sitting in it; the cranium of someone who had had a trepanation; the womb of a pregnant woman, split open like a watermelon, with a foetus curled up inside. It was when I was suddenly presented with an all too life-like picture of a beating heart, hanging on its tangled bush of nerves and vessels, that I began to sense that my faltering reason was about to topple over into nothingness. I did in fact faint a minute later, at the sight of a male organ cut up into slices, still joined to its egg-shaped testicles, which were bare and stripped of their scrotum.

The smarting of vinegar at the back of my nostrils slowly brought me back to consciousness. A sage was leaning over me, smiling amid a halo of golden light. To whom did this quivering beard belong? To Teofilo Vairano? It was today, but when was that? At what transient point was I on the wheel of time — and where, dear Lord? Was this the steamroom at Longemalle, the baths at Hippone or my old master's reading-room? San Domenico Maggiore? An alcove in Rome with crimson wall-hangings? The alchemist spoke, and once again

I could make out the athanor and the monkey sitting on the sphere . . .

'Tell me, Pruss, have you performed . . .'

'Dissections? Of course.'

'The plates you showed me . . .'

'Yes?'

'. . . are they of life or death?'

'You have a fever, Giordan,' I heard him murmur.

And the heavy curtain of illness came back down over my eyes. Life is in death, and death in life; that would have been the sage's answer, no doubt, but it it did not reach me because I fainted a second time. With the help of the disciple who lived under his roof, Jean Pruss carried me to a bed.

Then, like the cemetery for plague victims in Nola, my mind was completely haunted by chimeras, and I was forced to wander for days on end in one of those darkened regions of the soul where reason lets go of its power. The black rocks that towered up there seemed to curse an ashen sky that was closed in as if under a dome and had all my demons swirling around in it. The cruellest of these were embodied in a pair of abominable twin sisters: Fraulissa and Morgana. These hysterical tormentors had a favourite form of torture, which consisted of exploring a strange palace furnished with my liver, lungs and kidneys, and their searches unleashed unbearable attacks of nausea in me; if indeed this was still me. As for Morgana's strident voice, it inhabited every single one of these dreams, like a rasping forewarning of death. How many times did I find myself leaping out of my bed, yelling with fright, with my hands over my ears so as not to hear her any more!

Pruss cured me by letting my blood several times, while his obedient pupil fed me with scholarly medicines. When the illness had passed, he let two Sundays go by before giving me permission to leave his house, and I spent some quiet times there, reading and writing next to the athanor with my feet on a foot-warmer, or meditating by the hearth to the crisp, dry sound of wood crackling on the fire. To put this enforced period of rest to good use, I devoured the books of his master Paracelsus, a writer who commanded respect for the fact that

he had been so much hated in his lifetime. As far as I could see, men had such a natural penchant for spitefulness that by the usual interplay of opposites, anyone they hated immediately became a favourite of mine. And moreover, how could one not admire this colleague as a tireless pilgrim in pursuit of knowledge? His study of the forces at work in the body fascinated me. I learned that he had shown as much skill in the art of metaphysics as in that of medicine. According to one of his doctrines, the illness that I was suffering from came from a venomous power which had subverted my being; I had never been in any doubt of that, and could even identify with precision the demon concerned.

My host's astonishing engravings were within arm's reach; all I had to do was unroll them. Once I had recovered my health and my judgement, I examined them all again, with a more philosophical eye this time. The skin is not a barrier closed off to reason any more than Aristotle's sphere of fixed stars is, I concluded, if in passing through it we gain access to a portion of divine truth.

Post tenebras lux, proclaimed an ornamental scroll above the college gates. A fine maxim to be sure, but behind those walls philosophy was held in such low esteem that its chair was held by the most appalling scoundrel imaginable! It was perfectly clear that Master Antoine de la Faye had pulled strings to be appointed to this post, as a means of filling in time until those Gentlemen and Magnificent Noblemen had found him some other gainful employment where no-one would have to suffer from his cruel absence of talent. It was plain to see that this wretched enemy of thought, who was a quack by profession, endured his ignorance as others endure an infirmity: by cultivating a hatred of destiny. He was a puny individual in both body and mind, miserly by reputation and fiercer than a battered dog. On top of that he had never opened a book by Aristotle. It was pitiful to see him coming upon the difficult passages in *On the Heavens* at the same time as the students to whom he was meant to be explaining them. All he could do by way of comment was to repeat with an air of deep

conviction the sentence which he had just had great trouble working out a moment before. True, he was good at putting up a show of self-assurance, but he often stumbled over a word he didn't know.

'The world,' he declared, 'is contained in a solid sphere whose convex part constitutes the limit of the universe.'

'Concave.'

The pedagogue's wrathful gaze searched among the forty students crammed on to simple wooden benches in front of him. Where had the interruption come from? Without raising my voice, I explained:

'Not convex, sir, concave. The convex part is not limited in any way. And that, moreover, is what discredits Aristotle's theory, if you will permit me to raise an objection, for if we admit the existence of such a curious sphere, where is the world? In nothing?'

'Objections are not permitted!' cried la Faye.

Had I insulted him? I certainly had not, but no doubt custom demanded that he shout angrily the moment a student expressed an opinion. Confident that the incident was closed, he calmed down, immersed himself in his text again and said:

'Kindly just follow the lesson in your textbook, Brunet . . .'

'I don't have a textbook and you know it. I could recite *De Caelo* to you by heart: I studied it in Naples for years. It's got more mistakes in it than the parish priest in Grandazzo has in his head. And we are not *pueri*; we can't just be told we're not allowed to raise objections . . .'

Although they were not *pueri*, the students were all younger than I was. One of them, who had large reddish ears, suggested in an undertone that I should go back to Naples, Grandazzo, or whatever god-forsaken dump I had come from – and keep goats there, he added. That remark immediately opened hostilities. Rather than argue with him, one of his fellow-students responded by giving him a good, hard clout on my behalf, whereupon all the others, at the prospect of a complete free-for-all with fists flying everywhere, started jigging about and bursting into loud, vengeful sniggers. I had a handful of loyal followers in this class who could be relied upon to give me

86

their outright support. Why was I not sitting where that parasite sat, clinging like a bat on to his office! Shouting to make myself heard above the confusion, I begged:

'At least let me put the case in front of these students against the syllogism on movement, sir! It'll only take a moment . . .'

'No!' yelped la Faye.

'Yes! We want a debate!' demanded my disciples, one of whom, young Jerome Besler, was to become my secretary many years later, and at that moment was thrashing his fists about like the very devil.

'That Italian can bugger off back to where he came from!' growled the student with the big ears.

He was set upon and thumped again. Besler threw himself at him with the intention of strangling him, a bench was overturned, and it looked as if a full-scale brawl was about to break out. I raised my hand to call for silence.

'Listen to me, all of you! Here is the wonderful syllogism that Aristotle concocted to prevent the world from turning . . .'

'Stop immediately!' yelled my opponent.

I kept going:

'Major premise: infinity is immobile . . .'

'The devil take your infinity!'

'Major premise: infinity is immobile,' I repeated. 'Minor premise: there is movement in the world. Do you follow me? Conclusion . . .'

'Conncloosionn!' bleated an imbecile in an attempt to imitate my accent.

'Let him go on, damn it!'

'Conclusion,' I repeated. 'The world is not infinite! Doesn't that seem extraordinary to you? Do you want to know now how I refute this learned proof?'

La Faye interrupted me with a vengeful shake of his forefinger:

'You're not here to give astronomy lessons, Brunet! You're here to take them!'

'I'm not a student, I'm a doctor!' I cried, staring arrogantly at him. 'And unlike you I'm capable of contradicting

Aristotle! Why am I being prevented from opening a school? Why am I being forced to attend your lessons in return for my safety?'

'Ah yes, your safety. You should think a little bit about that!'

Suddenly this exchange was drowned out by some students who started mimicking us by making snarling noises. The whole class was jumpier than a pack of animals listening to rumbling thunder. An idiot on the bench at the back started letting out rhythmical series of farts. The confusion reached its peak. I could feel the desire to laugh getting the better of me. Lifting my leg in a single, comical movement and turning my back on la Faye, I asked the joker:

'So you can control your arse, can you, and do wonders with it like Augustine did?'

A rumbustious, or should I say ferocious hilarity shook the assembled company. Like shooting stars accompanied in their flight by the clamour of mortals, copies of *De Caelo* winged their way through the tainted air. Back down on earth, war was raging. Students were hitting one another with their berets, blood was spurting from split lips – oh how I loved the feeling of plenitude that soothed my soul when the wind blew like this, throwing up a dark sea spray, lashing and bending the rows of black trees and clearing the heavens! Yes, there were times when the world rose up like a furious ocean! Squealing like a stuck pig, the pedant hurled insults at me and threatened to call the watch, but I scarcely heard him, so completely absorbed was I in the strangest sort of happiness imaginable. I let the tumult blossom and flourish; I revelled in it. Then, turning to the students, I raised my hand to call for a little calm. Finally, I declared in a quiet, entirely confident voice:

'Aristotle's major premise is false, gentlemen.'

And what I had wanted came about; the din died down to a murmur and the murmur to silence. I continued:

'False, or at least arbitrary. Why should *infinity*' – I uttered this word with all the necessary gravity – 'be condemned to remain immobile in its perfection? And why should its existence be only potential?'

The class stirred back to life for a moment; my handful of loyal supporters re-assembled round me, and at the same time out went the other students, the ignoramuses and idiots, the intellectually limp: and la Faye himself.

'Do you mean,' asked young Besler, 'that infinity is in actuality the principle that governs everything: nature, matter and the heavens?'

'Those three entities belong to the same world,' I answered. 'They are of the same essence, driven by one and the same force. But let me ask you the questions. What about this: is it true or not that God is perfection and the infinite cause?'

'Of course it's true!'

'So the world is His creation, His effect?'

'Certainly.'

'In that case, why on earth should an infinite, perfect cause produce a finite, imperfect effect?'

Besler stood for a moment open-mouthed with astonishment – and visibly happy. A drop of blood from an injury sustained in the fight a few minutes before was just coagulating under his nostrils.

'So in your opinion,' broke in a second student, screwing up his eyes as if to produce a difficult line of reasoning, 'the universe is infinitely infinite, and thus without any limit at all . . .'

'Exactly,' I said. 'Like reason itself . . .'

'Wait . . . and everything, absolutely everything that is part of it is in motion?'

I nodded my agreement. The student cast an anxious glance around him.

'So, you're saying that the earth we are on at this moment is in motion . . .'

'That goes against the evidence of the senses,' exclaimed a third student. 'Look: everything appears to be immobile! And as for this movement of the earth, who has ever felt it?'

'And yet, it is turning!' Besler declared with spirit.

'Yes,' I confirmed, 'it is turning. Aristotle saw it as sitting motionless in the centre of a firmament limited by a solid sphere, as if it was, oh I don't know, a large, inert billiard ball,

89

do you see, clamped in under a cheese cover. What I say is that it turns around the sun, just like the other planets, in an infinite space filled with innumerable worlds.'

Turning to the student who had contradicted me, I mildly added:

'You refer to the senses. Do you want to condemn yourself to philosophical blindness by trusting their evidence alone?'

'Weren't the senses created to enable us to perceive . . .'

'We do need the senses. But we must accept them as commonplace, deceiving, illusory faculties which never perceive anything but what is present and finite. Conversely the intellect can appreciate and be aware of things that are absent, subtle and invisible, the only things that are truly real and important, such as God, the soul, infinity . . .'

'Freedom,' Besler added to the list, dreaming behind closed eyes.

Just for a moment I thought I was back in Naples, in the monastery garden at the time when I made my debut as a teacher there and secret meetings were held by *pueri* who had already grown weary of the monks' cold teaching. The places were different, as were the light and the perfumes in the air – more to the point, there was no perfume here at all; ah! these walls were greyer and colder than those of a prison – and yet the same ideas were going through our minds and stirring emotions in our souls . . .

The impromptu lesson was interrupted by the reappearance of la Faye. He was accompanied by a magistrate and a guard wearing a helmet and carrying a lance.

'That's him,' he said, pointing at me. 'Busy stuffing the students' heads with false ideas as usual.'

'Are you Jordan Brunet the student?' asked the man of law.

Bowing courteously, I corrected his mistake:

'Giordano Bruno of Nola. I am not a student, but a teacher of natural philosophy and sacred theology . . .'

'Brunet, whatever title you call yourself by, I order you to leave this college . . .'

'What have I done wrong?'

And turning to la Faye, I pretended to be terribly indignant:

'Can it be that, like Socrates, I am being accused of corrupting your fine young men? It's too great an honour, really . . .'

Besler and his corrupted friends let out a few approving laughs.

'Get out,' puffed the master.

The guard came towards me.

'Easy now, gentlemen! I know the way and I have no desire to sleep on the straw in your cells tonight. I shall go, since that's what you think is best. The only battles that interest me are battles of wits. Unfortunately I'm being prevented from debating here, even though I'm being forced to attend this gentleman's lessons . . .'

'Debates are not allowed,' the magistrate coldly interrupted me.

'Whatever you say,' I conceded.

With the guard's lowered weapon pointing at me, I had backed towards the door. Everyone was staring at me – in la Faye's case with a gleam of ferocious hatred in his eyes. I stopped for a moment on the threshold and called out to him:

'Since I am forbidden to debate, I shall print my objections, master, and post them all over the walls of Geneva!'

That said, I turned on my heel and ran off, to the sound of applause from the students. I heard their philosophy master choking with anger:

'Print!' he cried. 'Print and I'll drag you before the Grand Consistory!'

A troupe of actors from Naples had got permission to set up camp inside the ramparts at the foot of the Maîtresse tower, and since their arrival I had frequently fled the Silvestri woman's attic to go and spend the night there with them. These people, forced to live in the mud and shelter from the rain under the boards of their stage, had plenty of talent to compensate for their lack of wealth, and were just as good at swindling as they were at acting – although what is acting but

the shadow of a shadow, a form of dupery raised to the level of aesthetic dignity? The fact is that these travelling players soon became my friends. By the light of oil lamps, we sought comfort together by draining bottles of wine as rough as pumice stone and cursing Geneva and Calvin in song:

> *Mirror of pride, Jerusalem the worldly,*
> *Gilt on old lead, whited sepulchre,*
> *Thou preachest Christ, ungodly art thou yet . . .*

After much drinking, too much no doubt, we would improvise bits of entertainment, drawing on our memories to add new characters to their repertoire of masked and grotesque figures. Here I perfected my natural talent for dashing off a dialogue, as readers who have taken the trouble at some time to open my works will have realised. The leader of the group was called Sanguino. This likeable rogue who was originally from Borgo di Santo Antonio was later to have one of my characters named after him, as was his young wife Carubina, a squinty-eyed creature who was for ever making attempts, as futile as they were charitable, to deploy every facet of her prowess in the nether regions, in the hope of distracting me from my many problems.

'You're wasting your time,' I confessed to her with genuine regret. 'Nature forbids me to love your sex, and that's all there is to it.'

Continuing to maul my wizened member with her fingertips, she said with an air of compassion:

'Poor old stick.'

And then, suddenly more excited than a nun:

'Why don't you take me as if I was a boy?'

As if she was a boy! The sight of the rotten meat stirring between her splayed legs made me feel quite uncomfortable. I pulled her dress down over her thighs and answered with a pained expression:

'It's not that simple, my poor Carubina. Not that simple at all. Forget about that and tell me: where on earth has your Sanguino gone?'

The medicine that Jean Pruss had prescribed for me – mandrake root, dove's brain and cock's testicles, all ground up and mixed together into a liniment – had not cured me of my lack of appetite and, except for dreams of Cecil at the Longemalle steambaths, no mental or manual enticement could do anything to change that. No, what was needed was to strike right at the very source of the *venomous power*. The cause of my torment was called Morgana, and I wanted to exorcise her from my life at the earliest possible opportunity. And indeed, it seemed that fate . . .

'Sanguino?' said the actress, withdrawing her hand nimbly from my unbuttoned hose. 'Here he is now.'

'I'm taking him off somewhere. Wait for us here.'

A moment later, he and I were walking stealthily along the city walls towards the Cornavin Gate, where I knew that Borzello was on guard that evening. Hiding behind a cart fifty paces from the guard-room, we could see the arquebusiers playing dice by the light of a wood fire. From time to time the bastion stood out in silhouette against the restless sky. The last filaments of a cloud rippled over the moon, and luck smiled on me, I believe, by decreeing that the dull-witted Borzello should break off from the group without even taking a weapon, and come in our direction.

'That's our man,' I breathed.

Once he was right next to the cart, he turned his back on us, undid his aglets, and pointed his backside in our direction. Then he crouched down as if to meditate, like a god in a garden. To tiptoe softly up behind him, slip a shoelace round his neck and hold him at arm's length was child's play for Sanguino, who murmured:

'One squeak and I'll pull it tight.' (You would have thought he was whispering sweet nothings into his ear). 'Do you want to die the Spanish death?'

But in fact there was not a single squeak from the throat of the arquebusier, who sat back with a bump on his own excrement.

'What a stink!' groaned the actor.

Having to hold the lace with both hands prevented him

from holding his nose; as for me, I held a handkerchief over my nostrils and called out to Borzello:

'No doubt you've noticed, you treacherous blackguard, that Morgana is pregnant . . .'

'What's that got to do with me?' grunted the henchman.

'Do you seriously think I could be responsible?'

'What do I care, in the name of Christ? You can go to the devil, you and your missus . . .'

'Pull a bit tighter, please, Sanguino.'

The cord slowly cut into the fat on his neck.

'So tell me, who has got my wife pregnant?' I went on in a soft voice.

'How should I know?' groaned the prisoner, struggling in vain to free himself.

'Tighter, my friend.'

His eyes bulging, Borzello looked upward and adopted an ecstatic pose, like a saint contemplating the infinite heavens. Beads of sweat stood out on his brow, and his face turned purple.

'Do you really want to die like this, sprawled like a pig in your own shit?' I said, thumping him with all my might. 'You're the father, aren't you? Admit it!'

I thought I saw a look of assent in his eyes, which were bathed in tears of suffering and mortal agony; I signed to Sanguino to loosen his grip a little. Another thump and the pig appeared to come round.

'What do you want from me?' he asked faintly.

'Marry her. And take her far away from here.'

'I'm already married.'

'Haven't you heard of *divortium*, you stupid ignoramus? From now on Morgana belongs to you, and so does the brat she's carrying. If you don't take her off my hands, I'll order my men to strangle you both.'

'I know the company you keep!' he puffed in a sudden fit of insolence. 'I'll denounce you for sorcery.'

'Silent are the night and the Spanish death,' crooned Sanguino, pulling on his cord once more.

'No!' said Borzello.

★

'Are you sure that this is really all about philosophy?' Giovanni Bergeon asked me, suspiciously examining the sheet of paper I was holding out to him.

'Read for yourself.'

The printer, whose Italian name, *Bercione*, had once evoked the memory of a family well-known for peddling their wares on the markets of Tuscany, was one of those men who are full of life, as round as a barrel and bursting with rosy-cheeked health. When I was not at the college I had to work for hours on end at six sols a day on his wretched almanacs, catechisms and illustrated books designed to denigrate the Pope and propagate Huguenot ideas. What a complete waste of time, ink and poor quality paper! I thought, imagining the learned, polemical works on magic and astronomy that should have been coming out of his four hand presses. The Florentine was not a bad boss, to be sure, but so feeble-minded and lacking in boldness! Born a Protestant in Geneva, he had devoted the years of his youth to travelling in Germany from where, he told me, he had brought back his profession. All in all, the climate here suited him to perfection, as he was fond of repeating; I assume he was talking about the religious climate, which enabled him to grow a little richer every day. His main concern? Not to upset the Gentlemen of the Consistory:

'If a book contains errors, you know, they strip you to your shirt and make you beg for God's mercy at an auto da fe!'

He put on his spectacles and set my manuscript on a lectern. His lips moved as he read through it, following the lines with his index finger and hesitating from time to time over a word . . .

'Concentric spheres, sublunar worlds, first cause . . .' he said, running through the list. 'These terms make no sense to me. There's nothing here to convince me that these aren't magic incantations which will get us both packed off to prison in no time at all . . .'

'Who said anything about magic?'

'Haven't you been seen hanging around with that Jean Pruss fellow? And as for that band of travelling players, who

95

knows whether one of them isn't some Neapolitan sorcerer in disguise . . .'

'There isn't one illicit sentence in this document, don't worry. They are just points of doctrine. I have drawn up a list of the errors made by la Faye in the course of a single lesson on Aristotle, a scholar whom he hasn't even taken the trouble to read . . .'

The printer took off his glasses and rubbed the red patch they had left on his nose with two fingers. Meanwhile his lips went into a heavy pout which betrayed his inner fears. I could read his mind: we've already seen how printing off a few dozen copies of one piece of paper can force you to shut up shop, he was thinking.

'Antoine de la Faye,' he went on, 'is what they call a man of influence. He's protected by several syndics . . .'

'He's an illiterate.'

'Yes, yes . . . You will vouch for the fact that these sentences don't contain any sorcery, won't you . . .'

'Philosophy, Bergeon. Nothing but philosophy.'

'And nothing insulting either? That word there: sublunar; it doesn't conceal some veiled gibe or malicious intent . . .'

I sighed impatiently.

'You've got nothing to fear, I tell you! Here is the title of the tract, listen closely: *Reply to Sieur Antoine de la Faye, Master of the College of Geneva, on twenty errors included in his lesson of 30 July 1579, by Giordano of Nola, doctor of philosophy and sacred theology.* I want this pamphlet to reach the syndics and professors, and I want you to send the apprentices to post it on the walls around the college. I'll pay for the printing myself . . .'

A pensive Bergeon contemplated the page covered with my writing, and beyond this page, the swarm of future troubles that were already darkening the sky.

'And I'll pay in advance,' I added, slipping a purse into his hand, which was the only thing I could do that had any chance of convincing him.

'What is the purpose of such an undertaking?' he asked.

I answered without hesitation:

'To demonstrate that in Geneva the teaching of philosophy is being entrusted to an ignoramus.'

The printer weighed the purse in his hand, put it in his pocket, turned towards one of his presses and with a disapproving look picked up from where I had left off:

'And maybe that there is another, more competent candidate for the chair once occupied by Calvin . . .'

'Quite possibly so.'

This modest, uninspired poster, this catalogue of the stupid blunders committed by a priggish pedant, was the only piece of philosophical writing I was able to produce in Geneva, while the ambitious speculations that had kept me occupied for a whole winter in Chambéry seemed doomed to remain unheeded at the bottom of a bag. The Muses were watching over me, however. Anxious to deliver me from a shameful lethargy, they came and whispered in my ear. And so I did not write for science, but for the theatre; and if I was the first to be surprised by that, it didn't embarrass me in any way, for there is nothing more metaphysical than the mystery, as our ancestors called the art of performance. In the unlikely event that I have a reader, has he never laughed at a comedy entitled *Il Candelaio* (which was to be published three years later in Paris by a printer who was less timid than Bergeon)? He will no doubt be interested to learn that I sketched it out in the course of that sweltering summer, for the benefit of my friend Sanguino.

You have to call a man stupid, don't you, when the object of his desire is a mere image, a pale memory, a vague recollection more remote than transparent vapour? And what can you say about a teacher without a school, a writer without a readership, a sage with no disciples apart from a handful of callow students? That was how things were for me in Geneva, and although the play was based on some of Sanguino's improvisations, it was very much a reflection of the way my life was at that time. To be sure, the reflection was as grotesque and monstrous as it was unintentional, one that could only have been given by the most warped and fortuitous of mirrors,

97

but doesn't the truth sometimes choose to surprise us by appearing in a decidedly unharmonious form? Yes, when you looked closely at the ingredients that went to make up this more or less digestible soup, they were indeed those of my miserable existence. The story? It told of the intertwined misadventures of a love-struck half-wit, a redundant grammarian and a rascal with a passion for magic: three facets, no doubt, of the wretch who was living on at that time under my name. In keeping with the state of mind I was still in, the women in the play demonstrated their essential maleficence, and the characters roamed through my plot among courtesans and madams of unsurpassed deceitfulness. Bonifacio, the half-wit, had just, if I may put it this way, turned his back on the love of boys and fallen in love with a strumpet whose favours he was endeavouring to win by sorcery. And since it is never a good idea to follow the demon on paths other than those that fate has marked out for you, the poor blighter ended up being ridiculed and punished, while some rascally fellows disguised as policemen were giving the grammarian a good spanking. Who knows whether, looking back now on that web of circumstances, I should detect in it some dark forewarning?

In the form in which we presented it to a cold, solemn, well-read audience which had condemned me in advance, the comedy consisted as yet of only three short acts, but it was already couched in a bawdy style and heavily spiced with lively expressions which I had had great fun fishing out of the well of our nostalgic memories. Sanguino had set up his stage in the courtyard of a palace belonging to a certain Rizzo, a Venetian duke who described himself in a fluty voice as a Calvinist with a passion for poetry, entertainments and artful devices. That evening the gentleman had invited along some Genevese writers and poets in the hope of cheering them up, if ever that was possible. Needless to say all he succeeded in doing was offending them.

His first mistake was to turn up late for his own *soirée*. Rumour had it that he was awaiting the arrival of some important ambassador from Venice, and refused to appear before the assembled company in the absence of his most

prestigious guest. But the thirty or so chairs set out in the courtyard by his lackeys were already filled with punctual, serious-minded people, who were probably starving (supper was to be served after the play), and all these lovers of anodine verses and French-style theatre were shooting tormented looks at the garish scenery, a simple backcloth, rippling in the breeze, on which Sanguino had done a painting of the Via Catalana which I must say was not bad at all. The family of the capricious master of the house kept stamping their feet nervously, and rushing as one man over to the gate whenever they heard the sound of a coach coming up from the street, but it was all to no avail; they came back every time looking even more vexed than before.

The second topic of displeasure was the nature of the show, which we now really had to go ahead and give. The invisible Rizzo having sent a messenger to tell us that he had decided to listen through an open window until the ambassador arrived, I climbed nimbly up on to the stage and without further delay addressed the audience:

'My name is Giordano Bruno of Nola. Perhaps it already means something to you, perhaps not. Who am I? Not an actor, gentlemen, but a philosopher, an astronomer and a writer. What do we care? I hear you cry. We're here to enjoy a well-turned plot, not to put up with speeches in Latin! And by heaven, Your Lordships, you are right! But please, be patient. You see, it so happens that I am also the author of the charming piece of mischief that you are about to witness, and it is customary for the man who is to blame for producing a comedy to present it himself to the highly esteemed audience which has given him such a kind and – h'm! h'm! – warm reception, by means of a brief poem, normally followed by a dedicatory epistle, then an argument which in turn gives way to the antiprologue, leading on to the proprologue. This latter, as you will have guessed, ends at the point where the prologue begins, and this dies away only to give birth to a commentary, which in our case is entrusted to a *bidello*, announcing the voice of the singer, the feat of the acrobat, the playing of the musician, the act of the mime artist . . . However . . .'

Thirty motionless individuals were cursing me from the bottom of their hearts. Their thoughts were but cleavers cutting up my tongue, funnels thrust down my throat to drown my loathsome sarcasm, awls piercing my lips and sewing them up, drubbings to make me cry out to God for mercy.

'However I haven't had time for all that. I am in a position to recite the poem to you; as far as the rest is concerned, you'll be able to read it in the book when it's published, if it ever is. The title of the piece? *Il Candelaio*! Its hero? An oaf, Magnificent Lords; a fellow who goes around carrying his miserable dipstick, not knowing any more what orifice he's meant to stick it in . . .'

'Enough! This is intolerable!' cried someone, leaping to his feet.

'. . . Which sums up the human condition, and the comedy in which you are shortly going to delight, thanks to the sublime Nolan. But here . . .'

Unseen by the audience, Sanguino and Carubina were doing their utmost, with silent grimaces and pantomime gestures, to urge me to get started as quickly as possible. He was wearing Bonifacio's costume (a ridiculously short jacket revealing a monumental behind and a codpiece stuffed with rags) while she had more make-up on than a whorehouse madam.

'. . . here is my poem. It has been composed especially for you, poets whom the Muse holds in her power, rhapsodes of such skill and inspiration, paragons of rhyme next to whom I am but a pitiful mountebank imploring your indulgence . . .'

By now the man who had stood up was about to leave; with a great deal of noise he was trying to drag a handful of infuriated spectators along with him. Having whipped out a piece of paper, I declaimed:

> *Ye who suck at the breast of the muses*
> *Ye whose lips are soaked from birth*
> *In their rich and nourishing brew,*
> *Hear me! (If ever faith and charity*
> *Have burned in your Excellencies' hearts.)* . . .

I was interrupted by a chorus of snorts, exclamations and creaking chairs. Raising my hand in the hope of restoring silence, I went on:

> *I weep, I plead, I beg for an epigram,*
> *Sonnet, eulogy, hymn or ode*
> *To attach to my prow . . .*

(I proudly grabbed hold of an imaginary phallus . . .)
> *. . . or to my poop*
(I stuck my backside out to the audience . . .)

> *So that I may return with a happy heart to where I belong.*

Like a little kid I skipped to the back of the stage, then immediately came back, woeful and desperate:

> *I am weary of walking with nothing but hunger to clothe me.*
> *Alas! Who goes more naked than I?*
> *And worse: perhaps, poor beggar that I am,*
> *I shall have to show myself to my Lady*
> *With nothing on my arse or my tail* (same actions as above),
> *As father Adam always did*
> *When he lived in bliss in his palace of old.*
> *But even as I beg for a poor man's breeches . . .*

Before I could launch into the last two lines, the truth of them was already being confirmed by an outburst of insults, death threats and warnings to me to stop. By the time they sprang to my lips, all I could do was shout them out at the top of my voice:

> *. . . I suddenly see coming up from the valley*
> *Some cavalry men in a terrible rage!*

One of these enraged cavalrymen, a poet of the Genevese sort, struck me such a violent blow with his stick that he nearly broke the bones in my foot, and it was with the greatest

difficulty that I hobbled back amid murderous booing to the edge of the stage where Carubina awaited me, squinting horribly, her arms outstretched and her breasts glistening with sweat. Sanguino, who seemed to have abandoned all pretence to bravura, hesitated to go on stage in the middle of such chaos.

'It's your turn!' I ordered him with a resolution that brooked no disobedience.

And I took refuge under the shelter of the boards with their richly-coloured canvas covering, in that place known in the theatre as hell. I was surprised to find Besler the student hiding in there, smiling broadly, his pointed teeth glittering in the darkness.

'What are you doing here?'

'I've been waiting a long time for this moment,' he answered, throwing his arms round my neck.

'Leave me alone, for heaven's sake!'

My foot was hurting me dreadfully. Above us, Sanguino leapt on to the boards and began to play Bonifacio having an argument with an arrogant lackey called Ascanio. In the latter role was a young slut of sixteen whom Carubina had put in a jester's costume.

'*I shall strive to do my job quickly and well,*' she bawled. '*No point in wasting time: "Sat cito, si sat bene."* '

'*God be praised!*' exclaimed Bonifacio, '*I thought I had a servant, and here at my side I have a majordomo, a governor, doctor and counsellor; and they will say that I am just a poor gentleman! I order you, by the blessed cock of . . . of . . .*'

Like a flame blown out by the storm, Sanguino's speech was in danger of dying away.

'Go on, go on, I beg you!'

Didn't that falsetto voice belong to Duke Rizzo? I heard him add:

'Don't be upset by those prudish people leaving, Sanguino. It doesn't matter at all. And now, on with the comedy!'

There followed some brief murmurs and two or three bursts of laughter, and after one last prevarication the actor obeyed, resuming both the role of Bonifacio and his speech,

just at the point where he had been interrupted. Brutally pushing away the callow youth who was busily rubbing my ankle, I drew back a corner of the cloth cover. What I saw was to remain etched in my memory like a scene from a dream: first, the almost empty courtyard, with a few overturned chairs and the last guests rushing towards the gate, like devils driven from the feast. Next, facing the stage, a group of gentlemen, all very elegantly turned out. At the centre of the group, Rizzo shone forth in his startlingly red doublet and puffed-out breeches. And finally, beside him, no less sumptuously attired, but impassive and all in black, stood the famous Venetian ambassador; and that ambassador was none other than Cecil.

Jacobi the bookseller had not deceived me: while he was living in Rome, my beloved was already spying on behalf of the Serenissime, with Cardinal Vita's palace (where he was the accredited favourite) making an ideal observation post. His obscure and unenviable mission at that time, he told me, was to inform the doge's cold emissaries about the most secret rumours of the court. But his luck turned, and soon decreed that he should find himself in Venice, at the time when Henri de Valois was staying there. This prince, having reigned for five months in far-off, frost-encrusted Sarmatian lands, had now returned from Poland and fulfilled his most cherished ambition by inheriting the crown of France. Delirious with pleasure, his only concern before returning to Paris was to revel in the celebrations that were planned in his honour and the liberties he saw fit to grant himself, such as the passion he had for escaping from the palaces where he was staying and walking the streets incognito, or having himself taken from one district to another in a modest gondola, as if he were an ordinary visitor. Anxious to find out all about this new sovereign, the doge had given Cecil the job of noting every detail of Henri's behaviour during the ceremonies, and watching all his movements, including the clandestine ones.

While his entourage thought he was asleep, worn out by sumptuous receptions, excursions on the Bucentaur, jousts

and entertainments, Henri was spending his nights in the company of exquisite young men and courtesans with more or less cultivated minds; and it was on one of these occasions that he had a secret meeting with a gentleman with a view to fomenting an act of vengeance against a Protestant leader. The doge, who greatly relished everything Cecil told him about Henri's visit, most particularly appreciated this last detail. He sent someone to warn the wretched man of the fate that lay in store for him, and seized the opportunity to advise the King of France in the presence of the senate to pacify his kingdom by granting a general pardon to the enemy factions. Henri was surprised, and guessing that the doge was hinting at the assassination he had ordered, pointed out in his own defence that restoring royal authority was no easy matter.

'It seems to us, Sire,' answered the doge, 'that royal authority should seek to impose harmony on the different religious groups. After all, is that not already the case in Poland, from where you have just returned?'

Everyone in Venice was fully aware of the role that the very gallant, very Catholic Henri had played in unleashing the wholesale massacre of the Calvinists in Paris two years earlier. What kind of barbaric principles had he and his fearsome mother given themselves over to? And what future miseries did these events portend? People here believed that for peace to reign in a kingdom, clemency must come from the monarch himself.

After Henri III had left Venice, the doge was clearly happy with the especially warm welcome that the people and the nobility had given the visitor, and he wanted to savour for one last time, in private, the accounts of his favourite spy. The two men exchanged views on various questions, some of which were related to art and the government of peoples. At the end of the interview Cecil opened a box and handed his master a portrait of the King of France, sketched from life.

'I took the liberty of commissioning it for you from my friend Jacopo Robusti. The painter carried it out without the model knowing. Notice how natural it is.'

'Is Robusti really your friend?' asked the doge in amazement.

Then, nodding with an air of satisfaction:

'This man's talent is a gift from the heavens. His sketch is a perfect likeness. But who is to say that I wouldn't have preferred a portrait of the handsome Cecil?'

His interlocutor merely smiled and bowed his head.

'From now on,' the doge went on, 'I shall entrust the task of watching over this Valois to you alone. What would you say to being elected in a little while as an ambassador by the gentlemen of the senate?'

'I am not a native citizen, your Serene Highness. I was born in London of a French mother!'

'What a magnificent page-boy you must have been! But there is no beauty or intelligence more Venetian than yours, believe me. We will find a way of sorting things out.'

After congratulating and rewarding him, the doge ordered his agent to go back to Rome and stay there while he waited for a new mission.

Cecil told me that he had had to mope around in Vita's palace for another year, while the air grew ever more noxious and the cardinal ever more crazy. Finally, under the pretext of travelling with his brother, he had found his way back to the Serenissime, where he had once more been showered with favours by the doge. Soon, appointed as secretary to the ambassador, he had found himself attached to a delegation to the Spanish king (whom he had even had the honour of speaking to in the course of a crossbow hunt), then to another which was sent to the court in Naples.

'What a fine city you come from, full of relics, superstitions and fake miracles,' he taunted me. 'It doesn't surprise me any more that you're as stupid as you are. Have you seen how the priests heat up the phials containing the blood of Gennaro to liquefy it?'

'Of course,' I sighed, irritated. 'That's how they keep up the faith of the common herd . . .'

'Not just the common people. The Venetian gentlemen I was travelling with were all taken in by it. As for you,

you're like the priests: trained to create worlds of make-believe . . .'

It was one of our most dreadful times, that post-coital conversation which threatened at any moment to veer towards the exercise of cruelty. It ended at dawn in Rizzo's garden, a dark green setting in which the first glimmers of dawn were already killing off the coolness around the trees. How could we not think back to the fountain with the three lions and the orange trees in the Vita palace, to another dawn eleven years before, the memory of which kept flickering at the back of our minds? Just as on that past occasion in Rome, everyone in the house, including the master of the place, was asleep, and all of them were in highly agreeable company. But Cecil had to leave that same morning, called away, he said, on an important assignment; and whatever it was, the call of duty that he was determined to obey opened our hearts up to bitterness, making us forgetful of all pity and affection. The two of us walked slowly – in my case, limping like a cripple from being hit with a stick the night before, while he was as supple and light-footed as Mercury – over to three magnificent horses which were stamping on the paved courtyard. His was as black as the devil and wore a dark brown harness.

'What about Rizzo?' I asked in a cold voice.

'What do you care about Rizzo?'

'I do care about him, in the name of Christ!'

Cecil stopped, heaved a long sigh, and said:

'I thought you were free and defrocked, Philip. But you seem even more like a monk than you did in Rome eleven years ago . . . A crippled monk into the bargain . . .'

'It's that woman who's bringing me bad luck . . .'

'Oh, so it's the *malocchio*, is it? A plague on your Neapolitan superstitions! No woman brings bad luck!'

'This one does!'

'Shall I tell you something? You're going to end up like those asses, those imbeciles, those grammarians that you claim to abhor!'

How beautiful he was, my beloved, in his night-black garments! I had stripped him of that uppity attire a little earlier, so

that he could be subjected to the simple, everyday chastisement of love, the lash of my rediscovered strength. Was I now going to have to punish him in front of the two lovely young men who served as his bodyguards? Did he by any chance want a taste of my fist? The idea of a fight, or perhaps a duel, went through his mind as well, for he shot me a sarcastic question:

'So you carry a sword now, do you?'

It was Marchese's sword, a useless weapon with a rusty blade, not even fit to be used as a stick. The one that hung from Cecil's baldric, on the other hand, was decorated with a jewel.

'Don't worry,' I answered, 'I won't cut you in pieces: I haven't learned how to use it. As far as I know I'm a writer, not a roughneck soldier . . .'

The plumed hat he was holding in his hand twirled in time to a resounding peal of laughter.

'A writer!'

And it seemed that the hilarity that had seized hold of his chest and throat would go on for ever. Trembling all over with contained fury, I said in a whisper:

'What's so funny?'

'Have you ever written anything of value?'

'Lots of things!'

'Printed books?'

'Not yet!'

'Look at yourself! You're as thin and pale as a galley slave! You're making a fool of yourself playing the schoolboy, the travelling artiste, the proof-reader!'

'Go to the devil!'

'Do you think you might be a conjurer, Philip? Or a bird-catcher . . .'

So as not to hit him I had to turn my back on him and flee, abandoning him without further goodbyes to the company of his horses and equerries. As fast as my wounded foot would allow, I ran towards the garden.

'Philip!'

'Shout as much as you want,' I panted, hobbling along under the branches, 'I'll never see you again.'

'Philip! Wait!'

The whole world was full of enemies, and the cruellest of them all was my beloved, the soul of my soul, the one person whose return I had been waiting for, whose eyelids I had kissed once more, whose soft neck I had bitten . . . I got as far as a half dried-up pond, then collapsed, mad with pain, face down on the bank. I breathed in the smell of the reeds and stuck my face in the mud so that my tears would mingle with it. Insects, deceived by the glints of light on the water's surface, were suffering the agonies of death. It was not long before the aquatic demons attempted to instil their poison into my cold thoughts. Could it be that that schemer thought he was a god? I could hear them insinuate. He was born of a woman like everyone else, wasn't he? He came into the world in the midst of mire, phlegm, urine and blood, didn't he? No! I replied. Let him go, the insensitive brute, back to his doge, his Spanish king, his painter! No! No!

Like Narcissus leaning over his own image, I contemplated my squalid soul and discovered that the arrow Cecil had thrust into my heart was the arrow of truth. So Geneva refused to recognise my talent? Here was I, dressed like a beggar, poorer and more resigned than Job, still wandering in vain through its stinking streets as if through the maze of a life that was wretched, limited and spiked with suffering.

Cecil! The sun was high in the sky when I came back to prowl around outside the house. A table had been set up at the foot of the steps; Duke Rizzo was drinking a glass of wine and paying court to a half-naked youth who no doubt had only just been dragged out of bed. Ribbons flowed through his tousled hair. I must have looked more frightening than a ghost to Rizzo, suddenly looming up as I did from his garden, dark and spattered with mud. It had formed a crust on my face, which was furrowed with tears.

'What has happened to you?' he cried in his very high-pitched voice.

I went on my way without answering and slowly walked around the house. Perhaps I had been crazy enough to hope for something else; in the courtyard, Cecil's horses had well

and truly disappeared. Carubina was sitting on the stage with her legs wide apart, along with young Besler. They were both laughing, eating cherries which she was pulling out of her cleavage, and playing at spitting the stones out as far as possible, like children. I motioned stupidly towards the tracks left by the animals, and spoke to the actress:

'Where are they?'

'Gone!' she replied, shrugging her shoulders. 'Flown! Here, this is for you!'

And she threw me a book which landed at my feet. It was a beautiful thirty-two-mo, printed in Venice on paper of pretty good quality. How can I describe the turmoil I felt when I read its title, *Noah's Ark*, and the words beneath it, *A fantasy by Bruno Nolano*? I opened the volume with difficulty, because my hands were trembling so much, and saw the first capital letter standing out in a frame decorated with finely chiselled vine branches, then the text itself. Written by me eleven years earlier, presented to the Pope, sold in Rome for the sum of one *carlino* and bought back by Cecil a little later, all of a sudden it was coming back to life in its printed form on these soft, quivering pages. This work of mine, far-distant and almost forgotten, opened with these clumsy sentences:

That the ass should occupy the most foremost position on the Ark, like a sailor standing up at the stern of the ship, will come as no surprise to the All-Wise, for with all our knowledge, we are but asses. Likewise our life is a fable, the world a comedy and the universe a dream.

'I should have known this would happen,' sighed Bergeon.

His normally jovial face betrayed signs of anxiety and hostility. They had come to arrest him as he was opening his workshop, well before daybreak. Since then he had been waiting in this dungeon to be brought before his judges. In the same way, the soldiers had come to the Silvestri woman and asked questions about me. When I got back to my box-room, she pretended she knew nothing about it, brought me up an ewer of warm water, and while I was having a wash and seeing to my foot, went off and reported me to the watch . . .

'I hope to get away with a fine of a few florins,' the printer went on. 'It all depends on la Faye. They say he's kicking up a tremendous fuss and crying out for vengeance. But I have a few connections as well, and my reputation is pretty good. As for you, Brunet . . .'

Bergeon was sentenced within the hour to stay in prison until the next day, and to pay a fine of fifty florins, a considerable sum which he swore on the Bible he was not in a position to pay. Having got hold of some ink and paper, he wrote a long letter of appeal to protest his good faith. The man named Brunet led me into error, he wrote, by stating that what he had written was only concerned with philosophy, and contained no invective against God or Master la Faye. On the afternoon of the following day, which was Friday, the 7th August, they agreed after reading this letter to reduce the sentence and lessen the fine by half. Bergoen was freed, and left our cell, promising to make me pay the fine down to the last farthing. I in my turn was questioned by the Grand Consistory.

Everyone knew perfectly well that la Faye had never heard of metaphysics, and was hogging a public office for no other reason than to assuage his legendary avarice. Nevertheless, the magistrate who was presiding over the proceedings, a Florentine by the name of Varro, paid very close attention to his pitiful wailings. The master complained of having been insulted in the course of a lesson on Aristotle, accused me of spreading false ideas and fomenting a rebellion among the students, and finally considered that he had been libelled by the pamphlet which had gone around the city and been a source of rejoicing to even the most ignorant of students.

'What do you have to say in answer to these accusations?' Varro asked me, staring at me as if he could already see me hanging on the end of a rope.

'They are lies. This is the second time I have been prosecuted for offences that I have not committed. Doctors everywhere are expert at complaining that they have been insulted, even when all one has done is to demonstrate their errors. They start out being guilty because of their ignorance,

and somehow manage to end up victims. It's a well-known trick.'

Was it my native accent that grated on the ears of these fine people? They were all grimacing under their black berets, as if they were undergoing torture. One of them asked me:

'Is it true that you called Sieur la Faye a schoolmaster?'

'I asked him to let us debate freely, and argued that we were not schoolchildren . . .'

'And this document?' continued Varro, lifting a corner of the printed pamphlet with disgust.

'Anyone who can read Aristotle will readily confirm that what it says is correct. All I wanted to do here was open a school. I was forced to enrol myself on a list of Calvinist students and attend the lessons of my opponent. Unfortunately for him I have a degree in philosophy . . .'

'May we know what your faith is, Brunet?' interrupted a third.

'The wars between religious sects do not interest me. I am a servant of nature which is in essence peaceful and good, of the sun which nourishes souls and enlightens the mind, of the infinite universe, as it is reflected in my spirit . . .'

The judges did not conceal the state of annoyance into which they were thrown by these nebulous words. Why the devil did they have to put up with a fellow like this?

'It is said that you practise magic,' insinuated someone.

'I practise natural magic, a magic of the word and of the bonds that unite beings in spirit. No sorcery.'

Varro mopped the sweat from his brow with a handkerchief, and went on in a hostile tone:

'Let us return to the matter in hand. Do you or do you not intend to acknowledge your offences?'

'I shall acknowledge whatever you want when someone proves to me that they are offences . . .'

'It is an offence to publish calumnies against a master of the college, in a city where you have found refuge and protection! If we had not taken you in, you would have roasted at the stake in Rome or Naples!'

That little outburst cost me twenty days of rotting in

prison, sentenced to drink nothing while Geneva was stifling in a scorching heatwave. Such was the justice of Varro, whose chosen torment could be carried out without the help of any machine or torturer. No doubt he considered it vulgar to use a rack the way Catholics did! These Calvinists want me to dry out, I speculated when my suffering was at its height, and they want my soul to shrivel up until it can produce only meagre thoughts, like the hard, mean little droppings that my body is producing at the moment. If I stretched out on the rough bed, I fell prey to delirium. If I stood up I was attacked by unbearable nausea. My actor friends were not allowed to visit me. I was forbidden books, ink or paper. At first I stood up to my accusers and repeated at each hearing, in a voice that became weaker from day to day, that there was no personal abuse in my document, just philosophical propositions which were readily verifiable. Varro would listen without turning a hair, then, with a weary gesture, order that I be taken back to my cell. Once again I had to collect my ever scarcer urine and drink it out of my cupped hands, beg the unyielding guard to spare me a drop of water, and scratch the earth with my nails in the hope of finding a little moisture there. On the twentieth day I decided to save my life.

Varro dabbed at his forehead, sighed, and repeated the same question:

'Do you admit to having made libellous accusations against Sieur la Faye?'

'I admit it,' was my barely audible answer.

The clerk of the court, who had not bothered to transcribe the magistrate's words yet again, threw me a questioning, surprised look. His pen dipped into the ink and scratched his sheet of paper.

'Excellent,' Varro went on. 'I shall therefore impose sentence: Jordan Brunet, for having published a libellous document intended to be detrimental to Sieur Antoine de la Faye, Master of the College, I sentence you to tear up the offending pamphlet with your own hands, publicly and in the presence of the ministers and students; I declare the said pamphlet censored and order you to follow the true doctrine in future.

Decreed in Geneva this twenty-seventh of August fifteen hundred and seventy-nine. The hearing is . . . Yes?'

'May I make a request?'

'What is it?'

'That I be spared public humiliation. I agree in exchange to leave Geneva as soon as I am released from prison, and to be banned for ever from residing here.'

To tear up my printed pamphlet in front of the entire college and endure the whole city hearing me beg God for mercy would have been, in a sense, to cross the threshold of shame. Those heretics were no less the enemies of my cause than the henchmen of the Roman Inquisition. Had he understood that I was a philosopher without an academy, a monk without a church? Was he relieved to see me go? Varro accepted my proposal without hesitation.

Sanguino was taking his troupe to Lyons where Italian actors, he said, were appreciated. He hoped to be allowed to put on my *Candelaio* there. I accepted his offer to board one of his dilapidated carts, and turned my back on the Calvinist city as I had fled the Catholic one: poor, unknown and alone.

My debts to Marchese and Bergeon amounted to about forty florins; Jean Pruss helped me pay them off and wished me a good journey, wherever it might take me. When the time came to leave, Morgana brought me a basket of provisions. She told me that she had tried in vain to help me while I was in prison. She would soon be going back to the Kingdom with Borzello. Later, I was indeed to receive a letter from Naples informing me that they had found refuge there, he having signed up as a captain in the viceroy's army.

Every being has its own place in this world, I pondered as the carriage jolted along and we, who were hungrier than our horses, made our way through lush, green plains, along abundantly flowing rivers, on roads that were travelled by bankers and merchants from Lyons. Why do rivers go to the sea, if not for love of their element? Does not the wanderer himself think of the inn he is always heading for as a kind of homeland? So where was mine? By one of those exceptions to

which nature holds the secret, it quite simply did not exist, and it would take me nothing less than the experience of a lifetime to understand that. Yes, I was, I am, a monstrous form of humanity.

Saturday, 12th February, 1600

Jesuits, Dominicans, brothers of the new Church or Saint Jerome, comforters from San Giovanni Decollato: for two days now the emissaries from the various orders have been coming into my cell one after the other to exhort me to confession, contrition, repentance, renunciation, penitence, all of those Christian virtues on which they base their slavery of the body and mind. A plague on them, obsequious dogs, coming here to get a sniff of death! I am still alive, and I piss on their mercy as I piss in that dark, stinking corner of the wall that I have to chase the rats away from when I want to relieve myself; and I refuse to break off from my writing and my death agony to listen to their miserable paternosters. Just now I actually instructed Orazio to forbid them to enter my cell. Why should I go on putting up with these people? As for Clement, he rushed a second ambassador here yesterday evening, one of his Spanish advisors, a young man who exuded the luxury of the court and in whom I detected a family likeness to Inquisitor Deza, that well-known lover of women and very young girls, and an inveterate Virgin-worshipper . . . Probably his son, or his nephew.

Having put the lantern down on the table, the visitor noticed the one stool in the cell, and sniffed several times with an air of disgust. Yes, my dear chap, this cell is a revolting cesspit, a pigsty, a chamberpot for the excrement of the Holy Apostolic Mother . . . Eventually he sat down and stared silently at the sheets of manuscript spread out under the halo of light.

'I know you will destroy these notes too,' I said.

The ambassadorial assistant's black eyes peered into the corner where I was huddled up.

'And despite that certainty, you go on writing. Despite this . . . this stench as well . . .'

'Only so that I don't lose my reason.'

We observed each other for a while in the semi-darkness. As a matter of fact his face was by no means unattractive, even though his features were distorted by having to look at this squalid place.

'Clement feels no hatred towards the philosopher from Nola. That is the message I bring.'

'His justice has condemned me to death; let it carry on to the bitter end. That is my answer.'

There was a silence, then the stool creaked and he added:

'I am also authorised to discuss things with you . . .'

Discuss! If my memory serves me well – and there is no more accurate memory in the world than mine – I was arrested in Venice on the 22nd May, ninety-two, in other words nearly eight years ago. I was held in the prison at San Domenico di Castello, and I was there waiting for my trial to end when Pope Clement, who feels no hatred towards me, suddenly decided to bring me up before the central tribunal, and got me transferred under close guard to Ancona, then to Rome. Since then I have undergone twenty-five interrogations and hearings, two of them under torture; I have also written three statements in my defence, each of them more than a hundred pages long. Nine judges of the Inquisition have recorded the denunciations, heard the witnesses, studied my heresy, examined my past life, listened to my arguments, consulted my works, and drawn up two sets of accusations; whereupon, after much grave deliberation, they have pronounced a sentence in accordance with the rules of their law, and the pontiff has ratified it, although he feels no hatred. Unless this procedure has been a comedy and a farce, and thus the whole thing is a farce – the Inquisition, the Holy Office, the throne of Saint Peter, the Mass, the angels, the apostles, the sacrifice of bread and wine, the Virgin birth, the four Gospels, the epistles of Paul, the Catholic Church and its three-in-one godhead – what I want now, yes, what I really want is for this business to be carried through to its conclusion: in other words to death, to that dazzling, heroic death which alone will give breath and life to the being that was me, Giordano Bruno of Nola, an immortal fragment of the soul of

the world, and enable him to accomplish his destiny in the light . . .

Pulling myself upright with difficulty on my pallet-bed, I ask the young man if he is one of Cardinal Deza's family, as his features seem to suggest.

Another creak from the stool.

'Pietro Deza is my father,' he says, averting his gaze.

He is ashamed of his name. Imagine owing one's life to Deza, the Spanish prelate, a fabulously wealthy, refined pervert, a fanatical Virgin-worshipper and cardinal of the Inquisition! The son is plotting against the father. Will he pour poison into his ear? Will he dare to stab him to death? I continue:

'He is also a member of the tribunal that sentenced me. Isn't the whole thing laughable? The father sends the heretic to the stake, the son tries to save him . . .'

Irritated, he makes a gesture to ward off a swarm of unpleasant images, and replies:

'This isn't an inquisitor you have before you now, but a papal advisor. Certain people who deal in ideas are a danger to the peace in a Christian state. It's just a matter of finding a . . . a compromise.'

And, lowering his voice:

'Of course, no-one can prevent a man from wanting to die at all costs . . .'

'I ask only to live. But my spirit wants to live as well . . .'

'It will live,' he sighs. 'Far from Rome.'

'No. It will live in Rome. Thanks to Clement's stake. What a pitiful sovereign your employer is. Go and tell his Holiness that I cannot do him the favour he's asking of me . . .'

'The movement that your doctrine is fostering is more political than you seem to think,' he persists with some passion. 'There are revolts in the south . . .'

'The Neapolitans abhor the Inquisition, there's nothing new about that . . .'

'And soon they'll have a martyr to justify their acts of violence! Even though your ideas are inaccessible to the common herd, in other words to most of them . . .'

'I have taught my religion to the students of seventeen

117

European cities and the sovereigns of three powerful states. I have travelled five thousand leagues, written more than forty books, instructed dozens of monks accused of heresy in prison. Who can foretell what use the world will make of my opinions? You, perhaps?'

As before, we observe each other without saying a word. His handsome face is determined. I don't doubt that mine looks like the mask of Satan: the face of a crazy old sorcerer! My face, black with stubble and filth! Can he make it out in the half-light? Can he read anything in it other than fear? No love lights up my eyes, because I desire nothing but death! Cecil, where are you? Listen to me: last night they cut a little Turkish messenger's throat here; they sacrificed an angel. I'm prepared to bet that the elegant Deza (God, how like him you are!) will not meet a similar fate. And now he is standing up; his great shadow spreads over the wall. He bangs on the door to call Orazio. It's as if he wants to run away . . .

'To burn in the flames is a terrible death,' he said angrily. 'This crime must be prevented!'

You're wasting your time! The flames, yes, in five days' time! And until then, five nights without one wink of sleep. Five times the natural revolution of the earth in the skies will bring back the darkness, and it will prevent me from writing. Chained to the board of torture that serves as my bed, I shall force myself to bring back out of my memory the figures of the zodiac that I once described in my *De umbris idearum*. This mental discipline is supposed to raise me above time, to enable me to reach the eternal realm. But before I have visited the second decan of Sagittarius, where an old woman in mourning carries off a child in her arms, the most terrifying thoughts will have breached the defences of my willpower. I am so very tired. My spirit, when it is not buoyed up by writing, no longer has the strength to resist terror. Then the Furies that guard over hell come away from the invisible wall and whirl around the cell, flapping their abominable wings. The daylight coming in through the little window seems like a deliverance. Orazio brings me a bowl of warm soup; I have already taken up my pen again, and resumed my futile chronicle.

*

It was the morning of my thirty-second birthday. Camacho the barber had just finished freshening my face with some fragrant Cordovan toilet water, when Jean came in and announced that Brother da Lucca was here to see me. I saw him smiling under his thick cowl; his prominent nose was red with the cold. On the pedestal table which was already cluttered up with the basin of warm water, soap-dish and razor, he set down a dwarf basket decorated with ribbons, then clumsily opened it with his gloved hands. It contained an assortment of my favourite sponge cakes, bought near the Capitole from the best *pâtisserie* in Toulouse.

'He'll be coming upstairs in a moment. Happy birthday, Philip.'

'Happy birthday, sir,' echoed Camacho, who was wiping his instruments and putting them away one by one in a box.

'Brother da Lucca,' I said brightly, after I had bitten into a cake. 'Go and welcome him, then show him into the study, and by that time I'll be dressed.'

As holder of the chair of philosophy at the University, I had extremely comfortable lodgings, with a huge study into which light poured through two tall windows, one of them overlooking the Jesuit college. Jean went out. Unconcerned by the barber's stares, I let my dressing-gown slip down on to the tiles, opened the cupboard and took out stockings, hose and a white shirt. I sat down next to the roaring fire in the hearth to put on my shoes, and Camacho helped me put on a dark woollen doublet. Then, pocketing the coin I gave him, he said goodbye:

'See you on Thursday, sir.'

No sooner had he shut the door than it opened again. It was Jean, still in his cowl. In the bustling manner to which he was disposed by nature, he went over to the table and pinched a cake from the basket.

'Is he here?' I whispered.

Demanding a kiss in return for his answer, Jean said in a low, ironic tone:

'The papal ambassador awaits you, your Lordship.'

'When are you going to take off that damned cowl? You look even stupider than usual.'

With those words I left him standing there, walked across the gloomy hallway and pushed open the study door.

Prior Sisto da Lucca looked as elegant in dress and bearing as when he was hiding me in his monastery at Santa Maria Sopra Minerva. His face was just the same, close-shaven and lit up by the white of his scapular. His delicate, sensitive hands, which were continually stroking one another, had remained in my memory as the mark of his ingenious mind. He had come from Rome, he told me, and was heading for Spain with a message from Pope Gregory to Philip II. He had travelled under close escort, but not without enjoyment, through the dangerous Huguenot regions of Provence and Languedoc, and was now staying for three days as a guest at the Capitole. Gesturing gracefully towards the window, he added:

'So you've gone back to your first love now, it would seem. Toulouse! The Rome of the Garonne, the rampart of the Catholic faith in the Languedoc! And you were the one who wanted to lead the heretic life . . .'

'Don't mock me, Brother da Lucca. Here I am allowed to work, to live . . .'

'To live rather well, I think. A pleasant apartment, servants . . .'

'The man who let you in is not a servant, but my disciple. His name is Jean Hennequin . . .'

True to form, da Lucca gave a gleaming smile.

'Jean,' he said. 'John, the favourite apostle.'

His gaze travelled around the room once more, and settled on the long desk. On it were two book-stands and a jumble of books, some open, some shut, and pages on which I had been writing down the dialogue that was going on in my mind, just as I had left them when sleep had forced me to break off. Alongside the ink and pens lay a ruler and an open pair of compasses: the art of geometry together with that of literature.

'These notes,' da Lucca went on, 'will soon provide the material for a second book. Or am I mistaken?'

So he knew about the existence of the first one. Still smiling, he continued:

'Bruno Nolano . . . What kind of *fantasy* will it be this time? A dialogue in the Platonic mode? A volley of unseasoned timber to throw at old Aristotle? Let's see . . . a treatise on Copernican cosmology, perhaps . . .'

'It will all depend on who reads it.'

'Good Lord, what a lot of mystery! Am I not your friend?'

'It is true that you helped me once, and that in doing so you went against your opinions, but . . .'

'But?'

'Forgive me, Brother da Lucca: I made my confession to you in a letter, nearly four months ago, and I do not yet know whether or not that was a mistake. Before I can trust you I need to know your answer.'

I thought back to the seedy inn in Lyons where I hastily wrote that letter, at the time when I was leaving Sanguino to walk southwards to Toulouse. A professor from that city whom I had happened to meet had assured me that there were no prigs or pedants at his university, adding that the chair of philosophy would shortly be vacant and open to competition. I was poor and tired, and my behaviour was entirely governed by the hope of a better life. I soon started to entertain two hopes at once: that I could get this position as soon as possible, and that the Church would agree to go back on my unjust excommunication, now that there had been time for my enemies' fury to calm down.

True, I was to keep myself as far removed as possible from the Catholic faith in Toulouse, working in complete freedom according to the dictates of my conscience, and attending mass at Saint-Sernin only in body and out of respect for my peers. The religion that I had come to believe in firmly while under the Calvinist yoke required neither processions nor ceremonies; its only liturgy consisted of meditating in solitude on the images, emblems, figures, words and numerous signs of the spirit that are capable of transporting us until we are filled with a sense of wonder. As for the god I held dear, he was neither hanging on a cross nor sitting thunderously on a

cloud, still less surrounded by cherubs blowing into trumpets; in fact he couldn't be represented by any image, manifesting himself only in the invisible, always welcome guest of nature, present in my spirit and body in his immaterial, exacting form. In him, Love and Knowledge were as one. Such a very heterodox god, and one whose only messenger was, I admit, a distant, much too distant archangel called Cecil. And yet my heart cherished a mysterious desire, which was somehow or other to be loved by those who had made me what I was. Had not the good Pico once convinced Alexander that his opinions were sound? And my master Vairano, had he ever moved away from the church? And Doctor Aquinas? And Augustine? And Nicholas of Cusa who was the ambassador to the Turk? In Geneva I had found to my surprise that I was constructing a dual-purpose version of Christianity: one that was useful both to the common herd, to whom it would dictate the laws of morality, and to superior minds, which it would use its power to protect. Needless to say my imagination lent substance to this dream by painting, in meticulous detail, the picture of a solemn meeting held in a gold-trimmed room with a high, vaulted ceiling in some Roman academy. There the hotheaded Nolan was being received by a cenacle of honourable, learned cardinals with kindly eyes and transparent hands, all of them bent over my books, unable to conceal their enthusiasm and admiration. Before setting off I had written to Sisto da Lucca, asking him to intercede on my behalf with the Holy See.

Had fortune finally resolved to smile on me? I was welcomed in the Languedoc by the best, most generous people imaginable. Unlike the Genevese, they recognised my talent and offered me the chance to teach the sciences to their students. After which, as if it were the most natural thing in the world, and without inquiring about my past life, they elected me to the chair of philosophy, which was indeed vacant. I had still not heard anything from Rome, however. And now here was da Lucca, honouring me with a visit. Perhaps he had some favourable message to give me . . .

'Trust,' he went on pensively. 'By the way, do these

gentlemen of Toulouse know that their University is harbouring a Protestant?'

A question like that could only be taken as a threat. There was a highly dangerous faction here, whose only concern was to pursue and massacre Huguenots . . .

'I am not a Protestant,' I replied calmly.

'You lived as one in Geneva . . . You even married as one . . .'

'I was forced to register on a roll of Calvinist students! As for the marriage, it was a sham! A stratagem to enable that woman to get into the city!'

My defence speech seemed destined to produce no reaction in da Lucca but brief, incredulous shakes of the head. Was there any point in going on?

'I concealed nothing from you in my letter about the conditions in which I lived there. Am I now going to be penalised for my sincerity? As God is my witness, I have never preached the reformed faith, quite the contrary. Why do you think they took me to court and threw me out of their city?'

'Oh certainly, certainly,' said the prior, pretending to agree.

I watched him wander dubiously round my study, and it was clear by now, as he opened the books one after the other, glanced into them briefly, and dropped them again with a limp hand, that he was nothing but a messenger of ill omen. His lips barely moving, he went through the list in an undertone:

'Copernicus, Pico della Mirandola, Ficino, Erasmus . . .'

Losing patience, I exclaimed:

'Give me a straight answer, da Lucca! Did you or did you not defend my cause in Rome?'

'Perhaps,' he said coyly, as if my anger had given him an unexpected moment of entertainment.

This individual had charmed me once, and claimed to be my friend; now suddenly I thought he would be capable of watching his own father being tortured without once letting that smile of his slip. I went on contemptuously:

'And what answer am I to expect?'

Da Lucca heaved a long, pained sigh:

'May I be frank, my dear Nolano?'

'I repeat: give me a straight answer.'

'The order is pondering the matter. It is wondering whether you have not already chosen a highly dangerous path, the one that all those loudmouths, fanatics and inventors of new beliefs have taken, mostly because they're infatuated with their own death . . .'

'Jesus would conform to that sort of definition,' I observed darkly.

'Oh indeed, that's a fine argument. According to which the world ought to be visited by three or four messiahs a century . . .'

'You cannot accuse me of heresy! That takes proof . . .'

Da Lucca spread his beautiful hands, and on his face there was a look of amiable astonishment:

'Who said anything about accusing you? Do you take me for an inquisitor?'

'The people that you call loudmouths and fanatics always end up being thrown to the flames, chopped to pieces with an axe or hanged by the neck. There's no shortage of examples, even here, far from Rome . . .'

'You're right, it does take proof. And the highly amusing little book that was published in your name in Venice doesn't count. Not yet, shall I say . . .'

'Ah, so that's it!'

'Even though you obviously didn't publish it without some mysterious complicity in infidel circles; but that's another story . . .'

'You're being absurd . . .'

'That . . . *fantasy* has gone the rounds in Rome, did you know that? It has been . . . glanced through, let us say, in high places. And I have to tell you that our dear old stick-in-the-muds thought it bore a strong resemblance to the wild imaginings of someone like Valentine, for example, or Sabellius. He was the one who claimed, if you remember, that the Father himself was his own Son, or whatever moth-eaten old paradox it was that the idiot went and dug up! What you have written is of the same ilk, my dear Bruno, which can be put

124

down to your youth, no doubt. That is of no real importance. What is more worrying is that you keep alluding to that madman Arius; he has already cost you a trial in Naples. In short, your petition went down badly, very badly . . . Not to mention that unfortunate accident on the banks of the Tiber. The Calabrian priest you disposed of worked for the gonfalonier's police . . .'

'I was attacked!'

'Of course you were . . .'

'Save yourself the trouble of going on. I understand you only too well . . .'

'Come now, all may not be lost . . .'

'I understand, I tell you!'

I strode over to the door as if to storm out of the room, then stopped, made an abrupt about turn, came back to the desk and sat down. He was standing by the window that overlooked the Jesuits, motionless and still smiling, with his hands slipped under his cowl.

'I am listening,' I said after a silence.

Almost whispering, da Lucca went on:

'A profession of faith should be enough. You write extremely well, everyone knows that. You've had a taste of Calvinism, and now you have returned of your own free will to live on Catholic soil . . .'

'I am living where I'm allowed to live, in the name of Christ! What do I care who governs a city, so long as they don't interfere with my freedom . . .'

'You are here in Toulouse, the cradle of the Dominican religion! Not in Nîmes, or Albi or Montpellier! It's up to you to admit it and shout it out from the rooftops! You're the one who's got to see this plan through to the end now by swearing fidelity to the dogma you were brought up on and to the men who are offering you hospitality. Nothing but a sincere document has any chance of convincing the judges who will have to pronounce judgement on your petition. Your colleagues will bear witness to your good faith . . . Of course, we will not have breathed a word to them about the regrettable Geneva episode . . .'

'And my books?'

'*Noah's Ark* will be quickly forgotten. An inoffensive satire, written by a student of eighteen . . .'

'I was talking about my other books, da Lucca. These ones here . . .'

My hand skimmed over the jumbled pages of my various manuscripts. He appeared to hesitate before answering:

'Yes indeed, perhaps I ought to cast a glance over these notes. What is the title of this one?'

'*De umbris idearum.*'

'The Shadow of Ideas. A nice Platonic expression. And what is it about? May I ask that now?'

'Haven't I already answered that question? It all depends how discerning the person who reads it is. My works are not written for peasants, because peasants do not possess the necessary intelligence.'

My guest tightened his lips and replied:

'Even when the reader is not a peasant, he likes to see respect shown for . . .'

'What reader are you talking about? The one who belongs to the Inquisition, the lawyer who's responsible for banning books?'

'. . . respect shown for a certain orthodoxy. Judging by the authors you refer to . . .'

'I respect the only orthodoxy that has any value in my eyes: my own.'

I had grabbed the compasses and was pointing them furiously in his direction:

'I am a scholar, don't you see? A geometer in the Platonic style! Not a scribe whose job it is to write sermons by copying out sentences dug up from the Bible . . .'

Suddenly the wise, the generous, the impassive da Lucca lost his temper:

'A geometer! I am afraid you may actually be more stubborn than all the Aruises, Sabelliuses and Valentines put together! So why are you playing the prodigal son? Why are you determined at all costs to get back into the Church?'

To get back into the Church! Suddenly the idea seemed

completely absurd. And the laughter that burst forth from my throat blew out like a candle-flame the malicious smile that clung to the prior's lips. It was as if I had spat in his face: that handsome face that a few moments ago had been flawless, and was now more sombre and more grimacing than death itself.

'Anima! Anima!'

That was the cry, chanted by enthusiastic students, that greeted me on my arrival at the school of theology. I had come on foot, with Jean at my side, carrying a writing-case as ever, and had not failed to notice the gangs of armed youths running all over the surrounding districts, trying yet again to pick a fight with the watch. This permanent war between town and gown had an air of tradition about it in Toulouse which I would not have found at all disagreeable had it not been known in the past to end up in a blood-bath. The battle of opposites may well be the essential pattern of life, but the spectacle of young bodies torn to pieces and dragged through the streets, even if it is the sort of thing that brings joy to the common multitude, didn't appeal to me in the slightest.

And so spirits were inflamed with fever that day, and the whole school of theology, as indeed the school of law, was in a seething uproar, the echo of an ancient fury. It didn't take me long to realise that I would not be allowed to give the lesson I was meant to be giving. No master dared show his face in the midst of such turmoil, and the guards themselves who normally roamed about in the district seemed to have withdrawn to some safe shelter. Only an old Spanish door-keeper still had the courage to occupy his post.

'What are you going to do, sir?' he enquired.

'The same thing as you!' I answered, entrusting my cloak and beret to his safekeeping.

They're demanding to be told about the Soul? Oh yes of course, that's a terrific idea . . . Sitting in the front row, with his pen in his hand and his writing-case on his knees, Jean appeared to be hanging on my decision and was smiling the smile of a happy man who is brimful of confidence. I called out in a loud voice:

'Believe me, gentlemen, nothing would please me more than to gratify here and now a desire that is expressed so generously, however . . .'

'Yes, *Anima*!' shouted the students.

'However in accordance with my responsibilities I am required to deliver a lecture on the Sphere, which is a different subject . . .'

'*Anima*, sir!'

Make them wait a bit. Savour the beauty of this youthful defiance. Not too long though, because the clamour was rising to a crescendo. They started banging out a rhythm on the benches with their swords. Happy and proud, I smiled. Then, opening my arms apostolically:

'First, my friends, let us listen to the Ancients. Democritus teaches that the Soul is a sort of fire. Hippias, on the other hand, sees it as similar to water. Critias compares it to the blood. As for Heraclitus, nicknamed the Obscure, although he is perhaps the most lucid of us all, he sees in it the principle of reality, which according to him is perpetual flow, a river eternally the same and yet ever-changing . . .'

By now silence reigned. While the breath of inspiration was pushing these words out to my lips, deep down inside I was thinking about Philothimus, sometimes known as Filotheus or Theophilus: my Trismegistian hero, my emissary, my creature, my voice, my spokesman, my Mercury, my divine double, a form of my mind, another version of myself. His soul was entangled in mine, and soon he would be braving censure and speaking in my name in subtle printed dialogues. And indeed, as Socrates had spoken through Plato, this character would later speak through all my writings, with his wealth of Apollonian wisdom, like a master in whom the Egyptian gods had deposited the treasure of their ancient erudition. I had invented him for my *De umbris idearum*, the manuscript of which was lying on my desk, just round the corner; and this ideal mask, this lie, this companion who was just a literary invention, never failed to come back in his turn and inhabit my consciousness every time I had occasion to speak in public.

'The Pythagoreans,' I went on (or he went on, the blighter!), 'held that the Soul is like the dust that swirls around, hanging in the air, and they added that movement was its principle. On the first point they were getting close to the truth; on the second they were spot on. I shall also mention Empedocles for whom the Soul, the property of which is to know, is composed, listen carefully because this is important, of all the elements of the world: *It is through the earth*, he taught, *that we see the earth, through water that we see water. Through ether we know the divine ether, and through fire, the fire that destroys.* And also: *Through love we know love, and finally, discord through wretched discord.* Let us turn now to Aristotle, who I imagine is familiar to you. A deplorable custom dictates that this man be treated as The Philosopher par excellence, as if, great heavens, what he said was the last word in rational thought! Allow me to digress for a moment and smile as I think of those who have put him up on that pedestal and taken advantage of it to call themselves Peripatetics without having the necessary knowledge, let alone the talent, given that they are nothing but obscure pedants, blind grammarians, over-cautious schoolmasters, impotent pedagogues, incapable of performing the function that is theirs, of knowing how to get inside the *pueri et studentes* − their minds, that is − and give them what they want: the seed of lively thought, of real learning. Believe me, these enemies of knowledge and sound opinion have resolved once and for all to bow to this triple and rigid credo: love Aristotle, love him who loves Aristotle, hate him who hates Aristotle. Isn't there a confusion here between science and devotion, wisdom and fanaticism? Let me tell you furthermore that they fear like the plague those who dare to tickle them in a certain part of their person, the very place in fact where Aristotle is making them itch! And finally, I assure you that they have taken on as a law and a religion the task of defending this god to the death, even though in some cases they have never opened a single one of his books. And had they done so, the wretches, the first word of the first line would have stuck in their throats like a stone dipped in honey, however hard they tried to swallow it!'

I was standing up as I spoke, furiously peering into their eyes, and every face I could see in front of me was completely enthralled. As for Jean Hennequin, he was taking notes like a man possessed . . .

'Can you imagine that this *Philosopher*, since that is what we must call him, got it into his head to deny that movement was an intrinsic feature of the Soul! And that is why we always find him clinging on to the idea of a First Cause, an immobile being which is outside the great body that is the universe, and at some time in the far-distant past gave it a flick with his fingers to set it in motion around the earth . . .'

I paused for a moment to let my audience ponder over this image. Then, abruptly raising my voice as if in anger, I addressed an assembly of invisible opponents, pedants steeped in ignorance, timorous, aged, sickly, idle scribes who emerged on cue from my memory or my imagination:

'Goodness me, esteemed Peripaticians, will you show me what the exact nature of such a being is? Will you tell me what is this place without air, liquid, heat, breathing or movement where He is supposed to live? And what is this extraordinary perversion that dictates that the principle of the world should live outside the world, the creator outside his creation?'

Like a light breeze ruffling calm waters, a frisson of pleasure and support ran through the audience. Lord how I loved these moments, and how I loved being carried away by my art! At those times my voice and mind were as one. Word fitted together with word, concept with concept, the flow of language with that of time. As in the act of love, the One manifested himself in his blinding perfection; and from this long intercourse with pure language, I would emerge a little later, exhausted, happy, trembling and dripping with sweat, like a victorious hero . . .

'Think hard about this, my friends: unlike that of Aristotle, my universe is not shut in by any boundary, or torn apart by any distinction. As for the Soul of this universe, it is not external, but intrinsic to it, like the pilot at the stern of the ship, travelling with it and imposing his direction on it. This

130

Anima mundi, you see, is absolutely present in every part of matter, for increate matter is at all times and in all places living. If, taking another metaphor, we decide to compare the world to a vast, welcoming forest, then the entire Soul would manifest itself in every breath of air moving around under the branches, in the quivering heart of every animal, in its eyes, limbs and internal organs, in what its organs contain and carry through it, even in the excrement left by that animal, and also in the slightest blade of grass that that excrement had fertilised; and in the smallest stone, however tiny, insignificant and for ever invisible it might be. It would be present, yes, present even in the innermost depths of being, not as something physical, but in the way, perhaps, that a voice is present in a room; a little like these words I am speaking at this moment, heard by you all, and which would be heard just as well by a thousand listeners. Remember old Empedocles whom we were talking about a moment ago, and remember the Soul as he saw it, composed of all the elements in the world. Yes, gentlemen, to sum up, the one, single spirit is the totality of what is: the form of all being, the form of all forms and the thought of all thoughts.'

Brother da Lucca's kindness was beginning to produce results. The old German printer to whom I had entrusted the typesetting of *De umbris idearum* (not without promising him three other books in the near future, one of which was my lecture on the *Anima* duly copied down by Jean, and then quickly read through and corrected) greeted us with a guilty look. He had had a visit from a member of the anti-Protestant Union, a Capuchin called Faure, and had been strongly advised against publishing my books.

'Please understand. The Catholics are the only people who give me work here. The reformed people get their stuff printed in Montpellier . . .'

'I am a Dominican,' I answered categorically.

The artisan turned his back on us and made an impatient gesture.

'This Faure has heard a lot of very bad rumours about you . . .'

'What sort of rumours?'

He pulled out of a cupboard and handed to me the coarse canvas bag in which I had brought him a wad of papers two weeks before. I immediately gave it to Jean, who opened it to check the contents.

'What a pity, what a pity,' the fellow went on, somewhat hypocritically in my opinion. 'A nice piece of work, and I was already well on with it. You'll find the proofs we've had time to typeset in the bundle. It'll only cost you one piece of silver . . .'

Making no effort to conceal my ill humour, I paid him.

'Well, what about these rumours then?'

We saw him shake his head. He stared at my disciple, then looked away:

'I'd rather you heard about them from someone else, Brunus. Take back your book and don't curse me. As God who watches over us is my witness, it's nothing to do with me. I may as well tell you that this *De umbris* will never be published in Toulouse.'

From his determination to turn the conversation towards more general topics, I realised that he was not going to reveal anything about the Capuchin. The Germans, he chattered on as he was showing us to the door, had introduced the hand-press and the publishing industry to the Languedoc; he was the last descendant of one of those men who had come in days gone by from the heretic lands, but his life was nearing its end and he was content from now on to obey, since there was no longer, thank heaven, any conviction in his soul . . .

'You're right,' said Jean approvingly, thinking he could soften him up by playing the philosopher. 'God couldn't care less about religions and priests . . .'

But the old man shrugged his shoulders: what did he care about all this talk? Soon he would be dead, and that certainty was all he could think about. Just as we got to the doorway of the workshop, we noticed a procession of penitents in grey hoods, going up the rue de la Pourpointerie singing psalms. At that point the insufferable fellow started up again and

132

began to recall the terrible things it had been his lot to witness: the civil war, the City Hall falling into the hands of the Huguenots, the sacking of churches, Catholics thirsting for vengeance, suspects being hunted down, humiliated, having their heads cut off on the block and put on show at the gates of the Capitole; images that were so alive in his memory that they were still swirling around in his exhausted head . . .

'Let's go,' I ordered.

A plague on the old cynic and the anti-Protestant Union! And as for the Capuchin, I said aloud that I hoped he would rot in hell, this fanatic who didn't even know me, who was bloated with hatred and bigotry, stuffed full of canticles and dripping with holy water, this serf, this henchman of the Inquisition which had used him to carry out its lamentable duty! Who was I going to entrust my manuscripts to, if they wouldn't have anything to do with them here? To the booksellers in the reformed cities? What a fine solution that would be, since it could hardly fail to confirm the people of Toulouse in their confounded suspicions: and then farewell to the chair of philosophy! Damn and blast it, was I going to have to give up publishing? The mere mention of such a possibility filled my belly with anger. Weren't the students full of enthusiasm for my opinions? Wasn't I being talked about in the right circles? And wasn't the reader (the real reader, not the one the sinister Prior da Lucca had referred to!) longing to discover me? What was I to do, Lord? What was I to do?

'Paris,' said Jean, who was puffing and panting behind me.

I stopped walking and the idiot, hurtling along in his cowl at top speed, crashed violently into me. The collision sent the bag containing *De umbris idearum* flying into the gutter. No doubt about it, I was lumbered with the most idiotic disciple on earth! A stupider ass than all the asses in Italy!

'You pack animal!' I cried, exploding with anger. 'You complete she-ass, you're barely fit to be put under the yoke!'

Shameful and panic-stricken, the imbecile decided to get straight down on his hands and knees (thus exhibiting the curves of his plump arse under the black cloth of his tunic) to repair the damage and pick up my work which was lying,

soaked, among human and animal excrement, cabbage leaves and bones abandoned by dogs. Throwing open the flaps of my cloak, I gave him a masterful kick which sent him flying face down on to the muddy ground. This peasant with a brain smaller than a woman's boasted that he belonged to a Parisian family which included a finance controller, a bishop and an alderman lawyer in Parliament! Wasn't it about time he showed himself worthy of his illustrious relatives?

Yes, the Hennequins were indeed an eminent family. Their home (as I was to discover the following year) was a rather attractive mansion on the rue du Cloître, in the Temple district. Jean's father had sent his son to Toulouse so that he could study law away from Protestant temptations. The innocence of a father! No sooner had the student moved to that city than he was rushing to give up law school and attend nothing but theology lectures from then on. My lessons in particular had whetted his appetite and touched his soul. Having heard that I was looking for a secretary, he had submitted his application, out of admiration for me, I observed, and not for financial gain, since I had very little money to offer him. Won over by his enthusiasm, I had taken him on; and since then he had been watching over my health and my happiness like a good companion, sharing my bed, keeping a record of my lectures, and for hours on end diligently copying down what I dictated to him. Loyal and never balking at his task, he was endowed with an excellent memory and an invaluable talent for oratory. As for his knowledge of my works, after a while I considered it so perfect that I authorised him to speak on my behalf. Little by little he had proved himself so useful to the development of my work that I had become inseparable from him. Wherever I went, to the University or the palaces in Saint-Géraud or Pont Vieux where I was often invited by the gentlemen of Toulouse, both lords and members of Parliament, I was never seen without my disciple at my side. And when, at the end of an evening during which the wines of the Languedoc had flowed too freely, I sank, belching, into a divine and metaphysical state of drunkenness, it was he who threw himself headlong into the midst of discord. Crossing

swords with my opponents, he would boldly uphold my opinions, arguing and battling against Aristotle, singing the praises of nature, pleading the cause of the infinite heavens and the innumerable worlds, shattering religious doctrines and demanding philosophical freedom, fiercer than a fighting cock, prouder than a soldier, more handsome and valiant on nights like this than a Greek hero, ready to give his life, transported by love for his master; who meantime was lying on a sofa with his eyes half-closed, his doublet unbuttoned, his parted lips stained blue by the wine, a stranger to all reason, sunk all the while in the contemplation of a universe with neither top nor bottom, as fearsome and turbulent as a raging ocean . . .

Forgive me, little Jean, if my pen awakens your ungainly soul, but it too really must come and hover among these lines. How you must have suffered in my shadow! In everything, including those swords that ran you through at the College in Cambrai, I was your destiny, your sorrow and your misfortune; and in a way I was also the sword that murdered you, since it was in yet another attempt to defend me that you met your death. It was right that the conclusion of our story should be in keeping with the bond that united us: you never wanted anything but my happiness, while I for my part went out of my way to torment you. To what sort of unjust, brutal master had the demon entrusted your life? Yes, truly the cruellest tyrant you could ever find in this world.

Spattered from head to toe with dirty water and mud, Jean got back up.

'Paris!' he repeated, clutching the drenched canvas bag to his chest. 'Let's get it published in Paris.'

This idea of the disciple's was not at all bad; not quite good enough, though, to find favour with the master, who replied:

'And who will oversee the proofs, you stupid idiot? And the printing? You, perhaps?'

'Why not?'

Shrugging my shoulders I turned on my heels and set off again. Jean followed close behind and set about trying to persuade me: I wouldn't need to leave Toulouse at all, he claimed,

emboldened by his own enthusiasm. He would be responsible for taking the precious *De umbris* off to Paris and handing it over to a book-seller, he already knew which one, on the rue Saint-Jean de Beauvais, at the sign of the Olive Tree. Overseeing the artisan's work? He swore to devote more care and zeal to this task than I could supply myself, busy as I was with writing new dialogues and teaching the students. His mission accomplished, he would come back after a few weeks, carrying in his hand the freshly printed book smelling sweetly of ink and paper! He implored:

'It's the best solution, Philip! Please agree, I beg you!'

We had arrived at the doorstep of our house. Two Jesuits, chatting as they passed through the gate of the college, looked at us out of the corner of their eye. Shaking with nerves, my pupil was going through his pockets in search of the key.

'No,' I said calmly. 'What we need to do is to meet the Capuchin as soon as possible . . .'

'He's a fanatic, Philip! And a member of a powerful league! What do you hope to gain from meeting him?'

'Are you finally going to open that door? What are you waiting for?'

The poor boy looked as if he was on the verge of tears. Hadn't I gone a bit too far? As he complied with my instructions, then stood back and looked at the ground, I couldn't help feeling sorry for him. When we reached the top of the stairs I stopped and grabbed hold of his chin. Would little Jean forgive the tyrant for his brutality? I gave him a friendly thump on the shoulder.

'The master begs forgiveness,' I whispered, kissing him.

'It's nothing,' he sniffled.

Brave little soldier. And now here he was, trying to smile. There, there, it's all right now. Raising my voice again, I went on:

'As for this crazy idea of going to Paris to get published, I don't want to hear another word about it. Understood?'

Three days later I was alone in the house tidying up my notes – for a future *Song of Circe*, I do believe, which had no

chance of being printed in Toulouse either – when a letter was delivered in the normal post:

'To Philip Bruno Nolano,

'Philip, this morning I received your letter & your gift of this beautiful, as yet unprinted *De Anima*, which you say is a copy of your lectures at the University, duly recorded by this Jean whom you call your disciple. Do you think I am so naïve that I cannot guess that he most certainly is your disciple, especially in certain areas which do not require ink and paper? Let's see now: could it be that he occasionally turns his back on you in private so that he can receive the essence and substance of your teaching? Does he only kneel before you to drink from the fountain of your words? Don't you sometimes force him to bare his ugly behind so that he can feel the lash of your divine rod? Oh hypocrite! Oh pharisee! You vilify the Catholics and the Protestants, yet your soul is more deceitful than theirs! When I awoke this morning and read that word disciple written in your hand, I very nearly sent someone straight to Toulouse to poison the villain who is hiding beneath that handsome disguise. Don't worry, I have given up the idea, because very soon you will get rid of the irksome fellow yourself.

'You should be proud, because thanks to that subtle "disciple", your letter has acted (as you intended, admit it!) like an arrow planted in my heart: the poisonous arrow of jealousy. If there is jealousy, you will be thinking, then there must be Love. Have you ever doubted it? My affection, it is true, had been put to sleep by a medicine more sleep-inducing than mandrake: absence. And now, by this rival, you have whetted my desire, & absence, in its turn, is spurring on Love. Since this morning your letter has been kept in the lining of my doublet, like an amulet, & no doubt because of some magic it brings with it, today you are my master. For my part, I shall use no metaphor or periphrasis to describe my feelings: I yearn to rob this Jean of the privilege of kneeling at your feet. To be sure I am a far from docile disciple – less docile than him, quite clearly – but oh how much more precious, since I have to be

conquered before I can be possessed. I tremble to enter combat again, Philip: come to me.

'Not in Venice, but in Paris, because listen to this: I have been chosen by the doge to go on an embassy mission to King Henri whom I told you about, & I am setting off any day now for France, where I shall be living for a long time. Join me there. Leave those gentlemen of Toulouse to their holy water, their futile sermons and *Te Deums*, or soon they will be forcing you to write and think in their Catholic language. You're not thinking of becoming the Pope of the Garonne, are you? Haven't you heard that Paris is the most beautiful city in the world apart from Venice? The sovereign who reigns there loves parties, games, the arts, & free spirits. Thanks to the friends I have, you will be able to earn a living at the Sorbonne from your philosophy & you'll be able to print your books, & you won't be forced into the vile self-abnegation that is imposed on you, I'm sure of it, in that Dominican university. My residence will be at the embassy of the Most Serene Republic, where you have only to ask for me, for I shall be waiting for you there &, as they say in Venice, I shall greet you with kisses & sweet words: *Gratatusque darem cum dulcibus oscula verbis*.

'Are you short of money? This letter contains another, addressed to a moneychanger in the Luccan House of Cenami in the rue de la Pourpointerie. He has an order to hand you 20 livres, the sum you are owed for sales of *Noah's Ark*. Use it for the journey. While I'm on that subject, I am told that the roads in the Languedoc are not at all safe because they are infested with Protestant bandits who are no better than their papist cousins. As you still don't know how to use a sword, I think it would be best to follow the Garonne as far as Bordeaux & come on to Paris on better roads.

'*Col ferro avelenato dentro al fianco* . . . Do you remember that line? If Love is in you, Philip, run to join your beloved. As for this copyist, this Jean whom you call your disciple, if you want to find the best way of enslaving him under your bitter yoke, leave him behind in Toulouse, by order of your

'Cecil'

Written on the eleventh of May in Venice, the letter had travelled for nearly three weeks before reaching me. After I had read and reread it aloud a hundred times, I closed my eyes and kissed it at length. Then I slipped it into my old copy of Petrarch. Whatever happens, I thought, it must not fall into the hands of Jean.

But Jean, meanwhile, was groaning under torture. It was not until the next day that I found him, lying half dead at the foot of the steps and using his arms to hide the fact that he now had a face like a monster's.

On his way out of the college of theology, he had found himself being subjected to abuse as a Protestant by men from the Union, armed to the teeth and under the command of the Capuchin Faure in person. With great haughtiness, Faure had made certain none too precise allegations against the student and, despite the latter's resistance, had ordered his thugs to take him to the outskirts of the city, near the gate known as the Porte du Château, where the Inquisition had its seat. There they began by showering him with threats and commending him to hell. Then, taking it in turns to play the torturer, as if it were a game, the fanatics struck him in the face until his eyes disappeared behind the bruises, burned his feet, broke one of his arms and finally threw him into a dungeon for the night, saying that he should thank them for sparing his life. The next day, the poor fellow had to walk completely unaided to my house, more pitiable than a leper, staggering from one street to another on his wounded feet, his eyelids so swollen that he could scarcely see.

His interrogation had taken place in complete disregard of any law, in the absence of any cardinal of the Inquisition or clerk of the court: which was some indication of the powers enjoyed by this anti-Protestant league, whose leaders appeared to be authorised to exercise their justice with impunity. From the questions that Faure had asked it was clear what Prior da Lucca had revealed to him about my past life. The Capuchin knew about my trial in Naples, the excommunication, the investigations that had been launched against me following

the death of a priest on the gravel bank of the Tiber, and just about everything about my life in Geneva, Protestant and marital. As for the doctrines and opinions that I defended in private and in my capacity as professor in Toulouse, his informers had made it their business to report them to him.

Back at home, Jean was laid low by fever and his mind was taken over by a delirium filled with violent images in which he relived his torture over and over again. The doctor who was hastily summoned – doctor? An ignoramus, more like, who had never read a line of Paracelsus! – set the bones in his arm, put them in a splint, and applied ointments of his own invention to his feet. Then he demanded a payment of one *livre* and started chattering away in Latin: it might be necessary to do bleedings; he was afraid he might not be able to get the better of a deeper ill which had, it seemed, affected the patient's soul, etcetera, etcetera . . .

'You take care of the body,' I said. 'I'll look after the soul.'

In somnis veritas: certain phrases that Jean stammered out in the course of his bouts of fever and other nocturnal terrors (all night long he kept begging God to deliver him from life!) inclined me to think that Faure had also taken care to interrogate him as to the nature of the bonds that united him with me. I guessed that the Capuchin was stirring up a denunciation not only for heresy, but for the crime of sodomy as well.

'Is there anything you haven't told me about the interrogation, Jean?'

At first he turned his swollen eyes away, refused to answer and growled darkly in protest at this sort of inquiry.

'Have I become your enemy? Are you ashamed of something?'

Jean sighed. I could see that my questions were achieving nothing except to disturb the fragile equilibrium of his spirits, but was not this melancholy a pretence? Perhaps he was denying me the right to know what he had revealed to his torturers! To get to the truth, I was soon obliged to raise my voice and use threats. As I was lifting my hand to hit him, he gave in, the little coward: yes, chained to the rack and worn

down by the thousand deaths of torture, he had admitted to Faure that he shared my bed!

'Bloody idiot!'

I slapped him hard in the face.

Didn't this Judas realise that an accusation like that was enough to send a man to the galleys? Was this my reward for allowing him to enter my service? Was this his much-vaunted love for me? What had I done wrong to deserve such a companion? Ah! And all he could do was cry like a girl, as usual!

'Get out of this bed!' I roared, giving him a kick.

Jean did as he was told, ashamed, with nothing on but his splint and bulky foot bandages which made him more pitiful to behold than a lame animal. He took refuge on a chair by the fireplace.

'What are you going to do?' he moaned, trembling with fear and sobbing all the while.

'Leave you in Toulouse! And get off to Paris as quickly as possible!'

Heavens, how unfair I was! Poor Hennequin was suffering the effects of a certain letter from Venice. (But this was nothing compared to what was to come: a few days later, as he was busy piling books into a trunk in preparation for my departure, he would happen upon my old copy of Petrarch and open it . . .) A new bout of weeping contorted his face, and at the same time he kept hitting his temple with his good hand. Suddenly he looked up and stared at me.

'Paris?' he sniffled, astonished. 'Why Paris?'

I did not answer. No, I shall not abandon you, mused my soul: even though you deserve it! But how could I have the heart to condemn you to the infernal existence that awaits you here from now on? There would be no more question of studying at the University, of course, for the boyfriend of a heretic, sodomite runaway! Having failed to drag the master before the courts, Faure would be sure to take revenge on the disciple. Ah! The little pederast from the college of theology! That would be a choice morsel to throw to the rabble, wouldn't it, something really meaty to chew on and slaver over! God knows what abominable threats those people from

the Union had left hanging over the poor boy's head; and if Jean were to find himself alone in Toulouse, all they need do was carry them out. No, it's really impossible . . . And yet, it's equally impossible to join Cecil unless I've got rid of him! Thus I ruminated on my problems, not knowing that luck, or the devil, would come to my aid during the journey, and in the most unexpected fashion.

And so it was with some bitterness, and with no sense at all that things might resolve themselves happily, that on the twelfth of June, that is to say a week later, I had to set off with all my effects, books and manuscripts on a barge which was not chartered for me alone. How could I not feel sad at giving up a university chair, and the many advantages and privileges in money and kind that were attached to it, one of which was a convenient apartment where I could live comfortably and work in peace on my writings? But by Heaven, what was the point of writing if I was forbidden to publish? By denouncing me to the leaguers, Prior da Lucca had destroyed my future in this city and had placed me in the gravest danger. My only comfort was the hope that henceforward I could find happiness and fame in Paris; and above all, see my beloved, my god of the moment once more. Oh Lord, the very thought of possessing his body, his soul!

Anxious to follow Cecil's instructions to the letter, I had gone to see Cenami the moneychanger so that I could pocket my dues. So that was something at least: thanks to *Noah's Ark*, I was setting off this time with a full purse. On my orders, the boatman had promised to put up a canopy which would protect me from the sun. This meant that I could make good use of the long journey down the Garonne by getting on with my work and continuing to dictate to my secretary.

He, on learning that he was allowed to accompany me, was happy at first, then, as the date of departure drew nearer, I saw that he was growing more and more gloomy. Something unpleasant was going through his mind, but what was it? He gave me the answer himself when he pretended to be surprised by our destination:

'Bordeaux?' said the treacherous rogue in amazement, as

we were putting the finishing touches to our preparations. 'Do you think that's the best way?'

Sitting in an armchair by the window, with the writing-case on my knee, I was busy covering the margins of a *Virgil* with notes. He, with his good hand, was arranging clothes in an open trunk at my feet.

'The roads in the Languedoc are infested with Huguenots who are armed to the teeth,' I replied without breaking off from my work, in as steady a voice as possible.

Had his adventure with the Union fanatics made him insolent? Yes, judging by the remark he now hurled at me with a defiant stare:

'You're right: they're no better than their papist cousins!'

'Have you by any chance exceeded your prerogatives, Jean, and taken it upon yourself to open my post?'

He turned his back on me and resumed his task.

'I'll kill him,' I heard him mutter.

Kill Cecil! Who did this infatuated little half-wit think he was dealing with? Did he want another taste of my boot? But it was he who suddenly threw himself on top of me. With a furious gesture, he hurled the writing-case to the floor, along with the pens and the *Virgil*, some pages of which got covered in spilt ink.

'Why take me,' he yelled, 'if you intend to get rid of me?'

'Would you rather stay in Toulouse? And fall into the clutches of that Capuchin again? Wasn't the thrashing he gave you enough?'

Trying to control my anger, I gazed at the scene of disaster. The most urgent thing was to get out of Toulouse. Once we were on our way, we would find a solution . . .

'I know what the solution is! He's the one who's dictating how you're behaving now! I'll kill him, your arsehole of an ambassador!'

That was too much! I felt the urge to grab him by the hair and shake him until I could see the tears spouting out of his eyes! And that's what I did. After which, addressing his head, which I was holding out at arm's length as if I intended to cut it off with a sabre blow, I warned him:

'You won't kill anyone, do you hear? Because before we even get to Paris I'll have polished you off with my bare hands, if you don't stop making my blood boil!'

In Bordeaux, over which a thick ocean mist was floating, I spotted a suitable inn, expressed my intention of taking a bath, and once I had settled into a room, sent Jean to enquire after a post-chaise to Angoulême. The disciple had probably had enough of playing the lackey, because he went out conspicuously dragging his feet and pulling the door behind him much harder than he needed to shut it. But I was too exhausted by the journey to worry about him, and all I wanted was to doze off in the bath with a piping hot cloth over my eyes; at which point my mind was visited by, or made up for itself, some disturbing illusions. First I saw a place that looked like a garden. It wasn't clear what part of the world it was in, but my beloved was there, and he had stripped off his black clothing. Would I finally be allowed to enjoy him as I pleased? No. Dreams have the power to rob us of pleasure the moment they have offered it to us, and by now Cecil, or his ghost, had vanished. I threw the greyhounds off in hot pursuit; they caught him. Soon the beasts were fighting over his limbs, and sinking their fangs into his white skin. Their tongues were lapping up the blood that spurted from his wounds. My love was writhing with pain and I was revelling in his suffering, crouched down among the dogs and patting them to egg them on. Could it be that pleasure went hand in glove with martyrdom? At the heart of my sensual delight lay pain, in the form of a horse that was tied up to a tree just nearby, stamping and neighing with despair. Loud bangs rang out in my head. Were my temples going to burst from this sound of a hoof beating rhythmically on wood?

'Who's there?' I cried.

Jean opened the door and came in.

'Mission accomplished!' he declared. 'I've found a carriage.'

'Be quiet! Keep your voice down!'

Then, with the sigh of an exhausted man:

144

'I'm sorry. Come over here for a moment, little Jean.'

When he was close to me, I begged him to spare me a caress. Would he mind sticking his good hand into the water, please?

'I don't feel like it,' he said firmly.

That night I slept alone, and badly. When morning came, we had to set off again. Ah! Those coaches, always overrun by women reeking of Spanish perfume! I could only dictate a few pages to Jean, who was finding it hard to write because the carriage was jolting so much. One of the passengers had heard what I was saying and hadn't missed one word; all of a sudden he inquired:

'Would you be a philosopher by any chance?'

In the name of Christ, could we not be left to travel in peace!

'Let me assure you, sir, that I shall agree to answer you when you have been so good as to tell me who you are, for with things as they are nowadays it's a dangerous business talking to strangers . . .'

'My name is Tarsac,' he introduced himself. 'I sell wine in Bordeaux. And this is my daughter. You most certainly have nothing to fear from us. I was born a Catholic, but if my neighbour chooses to live as a Huguenot, that doesn't stop me greeting him with all the civility in the world, unless he has played some dirty trick on me; and if that is the case, I shall refrain from putting his treachery down to his religion, for among Papists and Protestants alike the decent man rubs shoulders with the crook. Such is my modest philosophy, if you don't mind hearing it . . .'

'My dear sir, you appear to me to have acquired quite enough wisdom by your own means to enable you to get by without my teaching. So, let's leave it at that . . .'

But the fellow insisted. He said that in his youth he had studied a bit of Greek and Latin, and had been fascinated all his life by the things of the mind. What type of metaphysicist was I then? Was I a cynic philosopher?

'It all depends what you mean by that. You no doubt know that there are various sorts of cynic philosopher . . .'

145

'I confess my ignorance . . .'

'You do well to do so. He who believes he knows every-thing generally talks nonsense. Thus the world understands what an imbecile he is.'

'That seems to me like a pretty good line of reasoning!' exclaimed the fellow. 'Although it does sound rather harsh, I must say. But what about my question?'

'Sir, if to be a cynic is to despise mathematics and astron-omy as that old fool Antisthenes did, then no, by heaven, I am certainly no cynic! Didn't Copernicus – perhaps the name of that canon from foreign parts means something to you – didn't he know how to put those disciplines to the service of divine knowledge? Nor am I at one with Antisthenes when he states that there is no point in experiencing pleasure, because for my part I like enjoying myself, and see no harm in it. Finally, if to be a cynic is to consider prudence as the highest of virtues, then I fear that I shall never manage to be one! That is my answer.'

'Now there's a well-turned speech!' exclaimed the bour-geois, giving his neighbour a nudge.

And suddenly, quoting me with enthusiasm:

'*I like enjoying myself, and see no harm in it.* Splendid, by the holy mass! But didn't you give me to understand just now that there were, as you were saying, several types of . . .'

'I was thinking of Diogenes,' I answered gravely. 'He has been portrayed as a licentious, atheist loudmouth. It is true that he was outspoken. But when it came to contriving an excellent paradox, that sage really knew what he was doing! And, like Socrates, he was not afraid to speak his mind to all and sundry, which in my opinion is not a bad philosophy. So now, I've told you all you wanted to know, I hope?'

That's as much as this fellow is going to get, I thought. I was weary of the whole thing, and really didn't feel like continu-ing the lesson. But my interlocutor, visibly delighted to have found a way of livening up his journey, was already rubbing his fleshy hands together. As for the passenger sitting next to him, he was twitching his lips, searching, it seemed, for some well-phrased question:

146

'I would like to question you in my turn,' he broke in. 'If you have a doctrine (one of your own, that is), can you tell me what exactly it is?'

'As God is my witness, I had the very same question right on the tip of my tongue!' added the wine merchant joyfully, not wanting to be outdone.

'Unless I misheard you,' continued the other, pulling up his hat, which was in danger of falling down over his eyes, 'you mentioned the name of a canon a moment ago . . .'

'Gentlemen,' I declared, 'you see before you an exhausted man. My disciple, here present, knows my work as well as if he had written it himself, although he is incapable of such a feat. He will answer all the questions you ask him. As for me, if you don't mind, I shall try in the meantime to have a little nap, since I slept very badly last night owing to all sorts of torments.'

Needless to say the nap was out of the question. But at least, after a thousand apologies and thank yous, I was left in peace. I shut my eyes and listened to Jean explaining astronomy to the passengers. Nicholas Copernicus, he said, had drawn a very different map of the sky from the one we had inherited from Aristotle. The sun, and no longer the earth, was at the centre of it. As for our primaeval mother, she, like the other planets, was endowed with movement, and not stationary as the ancients believed. I could imagine the two listeners making disbelieving faces and shaking their heads . . .

'My master,' Hennequin went on, 'has given this theory the extra dimension it needed by stating that if the universe is thus composed it must be infinite, not closed in . . .'

'Forgive me,' Tarsac interrupted him, 'it's this idea of the earth turning that I can't stomach. To be quite honest, it won't go down and it's making me feel giddy! Don't we like to feel that there's good, firm, steady ground beneath our feet? Why should we have to live every hour of our lives as if we were on the bridge of a pitching ship? No, thank you very much! I prefer the old doctrines!'

The man in the hat agreed:

'And anyway, look up at the sky! What do we see there? By

night, the stars moving around the earth. By day, the sun rising in the east and setting in the west. Think what you like, but for my part, I believe what my eyes tell me!'

Imbeciles, I thought, still pretending to be asleep. Why don't you look out of the window . . .

'Just look out of the window,' I heard Jean say.

'What do you mean?'

'Look out of the window. Don't those trees look as if they're moving, rushing away behind you?'

'To be sure . . .'

'So, your eyes are deceiving you. Imagine this: a man wakes up on board a coach that's less bumpy than ours, let's say. He doesn't know where he is. When he opens his eyes, he sees a landscape that's in motion. What will his first thought be? That the landscape is moving around him?'

There followed a long silence, loaded with enigmas and profound ponderings.

'However much I chew this philosophical argument over and over in every possible way,' sighed the wine merchant, 'I just can't find a weakness in it . . .'

'And yet, damn it, there must be a weakness in it somewhere,' said the other. 'You're right.'

Half-opening my eyes, I witnessed the spectacle of the man in the hat peering keenly at the moving landscape, then shielding his eyes with his hands and suddenly uncovering them in order to carry out the experiment described by Hennequin.

'Oh, never mind!' he grumbled. 'These fantasies are giving me a headache as well!'

With these words, he returned to his seat next to his neighbour, and we heard a shot ringing out from an arquebus. This was followed by neighing sounds, then the passengers were thrown everywhere as the coach started to slow down, jolting harder than ever on the rutted road. What was going on?

'Papist bandits, no doubt,' ventured Jean.

Arrogant little ninny! I rebuked him inwardly. But the blasted fellow had never spoken a truer word. Before you could say 'daylight robbery', we were all neatly stripped of our belongings by Catholic brutes armed with muskets, swords

and cutlasses. They made us get out of the carriage and performed their task with awe-inspiring efficiency. While we were being relieved of our gold and silver jewellery, pocket watches, money and pendants, the bandits who had climbed on to the roof of the coach were opening the passengers' trunks and emptying them of their most precious contents. The leader of the band didn't even dismount from his horse, and was content merely to supervise the operation, motionless and staring at us scornfully from behind his shield. Beside him, perched on a mule, was some buffoon dressed up as a monk, who was revelling in our misfortune and laughing as if it were the happiest day of his life. Then, suddenly filled will malicious wrath and addressing the clouds, he implored:

'Oh God who reigns over earth and heaven, dost Thou not take pity on these poor mortals? Behold them stripped bare, deprived of their miserable riches . . .'

Then with great haughtiness he threw in his dismal conclusion:

'In short, just as Thou didst want them to be.'

And with that he let forth another burst of hysterical laughter.

When the pillage was over and the booty loaded on to two asses – those brigands had given no quarter, as it were, except to my books – the one who was in command pointed with the barrel of his arquebus to the wine-merchant's daughter and two other women. Our pleas and groans were to no avail. I can still see my bourgeois kneeling in the dust, begging them to leave him his daughter, and promising considerable sums of money in return; the only answer he received was a cudgel blow on the head. Tied up together behind a horse, then brutally dragged off, the poor women would not have been saved but for a troop of armed men riding on horseback along the river Dordogne. Realising that human lives were in danger, these men, alerted by our shouts, came to their aid. The thieves, who had reached the edge of a nearby wood, were afraid they might have a fight on their hands, and chose to take flight, abandoning their prisoners there and then. Thus the ladies got off with no more than a terrible fright.

The providential cohort was led by three gentlemen, one of whom was nearing fifty and looked a fine figure of a man. When he heard what my profession was and what part of the world I came from, he declared himself a lover of the Italians and civilly invited me to come and recover from this experience in his home. This, he indicated, was less than three leagues away.

'You're very kind,' I answered testily. 'But am I to go there on foot?'

This answer did nothing to lessen the nobleman's courtesy. On the contrary, he sympathised once again with my misfortune. Having assured me of his friendship, he urged me to dispense with ceremony and climb up behind him on the croup of his horse.

'Your servant has only to wait here,' he said. 'We shall send a carriage to fetch him and your luggage shortly.'

'Jean Hennequin is not a servant, but my disciple. And I shall not mount your horse. Thank you again for your invitation. I think I shall go on by coach to Angoulême.'

But I had no money left! Once in Angoulême, how was I to get to Paris? Would it not be better to take time to think things over in the company of this amiable Gascon? A plague on my insufferable nature!

'Very well then, I accept,' I continued in a milder tone. 'But please just allow me to wait here for the carriage, for in truth, I have never learnt to ride a horse and I am afraid that if I travel that way it will turn my insides upside down . . .'

'So instead of that you're going to roast in the sun!' he cried. 'Oh well, if you insist. Come, *transcurramus solertissimas nugas*! I'll send someone for you.'

'*Let us pass quickly over such trifling nonsense,*' translated Jean with an admiring smile.

Intrigued, he whispered in my ear:

'It looks as if this gentleman knows his Seneca off by heart!'

The gentleman was now paying his regards to his friends and to the passengers, who were all returning to their seats on board the coach. To each of them he slipped a warm, encouraging word, taking particular pains to console Tarsac,

the bourgeois whom the bandits had struck with such cruel spite. Then he ordered some of his servants to stay with me, and advised me to take shelter under a tree while waiting for the carriage. Eventually we saw him ride off at full tilt and gallop across the fields.

What a strange personage! Hennequin had seen the truth of it: under the outward appearance of a country gentleman, we were soon to discover a philospher and a writer. He lived near the Dordogne in a domain flanked by a tower, on the second floor of which was his *librairie*, as he called this odd-looking place, with its walls all covered in inscriptions, apophtegms, and Greek and Latin maxims taken from the Scriptures or from Sextus Empiricus. This was where he worked, meditating on Plutarch, Virgil or Pyrrho, annotating ancient books and drawing out of these annotations a new text: his own. He had withdrawn into this tower at the time of the civil war, and had just brought out a curious volume, published in Bordeaux, which bore a strong resemblance to the fellow himself. I found him tired and very much preoccupied with this barely completed work, a copy of which he had sent to the king. He made me a gift of one too, and inscribed a few pencilled words of welcome in it. Then he left me to look through it for a while in his *librairie*, while he, as he explained, went to give instructions for dinner.

The book that I saw before me presented a patchwork, stitched together in no apparent order or direction, of the observations and reflections of my host, who went by the name of Michel de Montaigne, on a whole variety of subjects such as the soul, the imagination, falsehood and justice, the science of diplomacy, the customs and practices of cannibal countries, events that had taken place both in his native Gascony and in places like Gibraltar or Palestine, the deeds and sayings of illustrious personages, the greatness of Rome, the institution of the *pueri*, coats of arms, names, jobs, pomps and vanities, and a thousand more things besides. There was an entire page, which put me into very good spirits, describing the last jokes told by a number of unknown people as they

151

were being taken to their deaths. Made up of digressions and stuffed full of Latin phrases, bons mots, paradoxes and Italian verses, the different themes mingled together as if the author had let his thoughts flow from his pen in an order chosen by themselves, and had made no attempt at all to mould or connect them to suit his own purposes. I admit that these *Essais* – for that is the title of this delightful book – made a great impression on me. To tell the truth, they gave off a curious aroma of liberty, and their words spoke in a mysterious murmur. It seemed that the countless ups and downs of human societies, swept up by some whirlwind that was capable of uniting the familiar and the remote, the humble present and the glorious past, had suddenly gathered together within these pages, in this tower where they had been written.

'This is an exceedingly fine book.' I said to Seigneur de Montaigne when he reappeared, 'There is one thing that's bothering me, however: what is its subject?'

'Myself,' he replied without hesitation.

I smiled as amiably as I could at this witty joke.

'Do not jest, please. I have just read a large number of passages: you don't describe the events of your life at all, as Augustine did . . .'

'Myself,' he repeated more firmly, in the very tone, as a matter of fact, that I spoke in as a matter of course. 'The volume you are holding in your hands, my dear Bruno, is my entire soul, freshly turned out, if I may say so, and pocket-sized.'

For the Lord's sake, what in heaven's name was he talking about? Didn't a book exist to serve an idea? Didn't it have a purpose, which was to support a doctrine, to prove a theory? I have no talent for concealing my feelings, and my perplexity showed so clearly on my face that the fellow read my thoughts and felt obliged to reassure me with a broad, candid smile. I studied the allegorical picture (of a commonplace divinity overhanging the star-studded sphere of the world) which illustrated his pocket-sized soul. Then the volutes, details and ornamental angels and chimeras of the drawing, the name of the printer (Millanges of Bordeaux), the quality of the type,

the inscription *Avec privilège du Roi*, and finally the year of publication: MDLXXX. From the point of view of its external appearance, the work looked like a hundred others. But what was I to make of its author's strange opinion? Had I properly grasped the meaning of what he had said? Somewhat irritated, and curious to understand, I asked:

'Let's see now: are you working on another one?'

He shrugged his shoulders and smiled again.

'I am tired of my tower,' he said. 'I very much want to have a change of air, to travel, to escape for a while from the vexations of domesticity . . .'

As he was speaking he came over and sat in an armchair close to the one I was sitting in, and immediately the cat who was his companion in this place jumped up on to his knees. His fingers sank into the animal's fur. Without showing the slightest concern for what was worrying me, he let the conversation drift towards other areas of his universe. He would go to Paris first, he went on nonchalantly, because he was eager to hear from the king's own lips what His Majesty thought of his *Essais*. After that his journey would take him to Italy. The waters there were excellent, he believed. Still in a chatty tone, he touched on various questions relating to the conduct of public affairs, and mentioned the heavy responsibilities he had once borne in the Bordeaux parliament. Thanks to certain hints that he dropped, I also learned that he did a little spying for the Medici woman, and that he wouldn't have said no to an ambassadorship in Rome or Venice . . .

'Rome!' he exclaimed, abruptly leaning over towards me. 'One cannot walk there, Cicero used to say, without treading on history! How lucky you are to be Italian!'

Surprised by this sudden outburst, the cat got off his master's knees and took refuge on the book-strewn table. It's said that they love paper, I thought. And Montaigne loves paper too, which is why he writes about things, or rather about himself, in his omphalic tower . . .

'As for starting another book,' my host concluded pensively, 'well, I have no wish to do so for the moment. No

doubt when I return I shall have material with which to expand these *Essais* . . .'

Was that an answer to the question I had asked him a moment ago? I understood that this man did not write books here, but *one* book, and always the same one. More than the refuge into which he had withdrawn, his book was his home, his excretion and his life, a work with no other purpose or justification than itself. Soon, when he returned from his journey, he would open his own copy of the *Essais* and, annotating it in the margin as he had annotated his Plutarch, he would enrich it with new reflections; and so on and so forth from one edition to the next, always adding more stones to the same wall and always observing himself and his own thoughts . . .

'In short, as the bird sings, Montaigne writes.'

'Well, that's not a bad way of putting it. We would be wrong to pride ourselves in any way on our books. They are merely a more or less digestible and useful way of presenting ourselves to our fellow men . . .'

'Oh come now, that's not true! Books teach what the world is to those who do not know, and that is done with the aid of language which harbours . . .'

Montaigne had a crafty smile on his face.

'. . . which harbours the divine truths . . .'

'Don't worry, you will explain to me presently what sort of work you produce. But I still insist that your book tells who you are . . .'

'I repeat: it all depends what it's about!'

He conceded:

'If you wish. I can see that you won't give in. Let me tell you a story, however. A certain gentleman of my acquaintance, when he was asked what he did, was in the habit of giving no answer except to display the seven bedpans into which he had defecated on the seven days of the week: and thus the seven turds, of varying degrees of softness, which he had kept. That was his way of saying: "What do I do? Look!" And he would show you his shit. Amusing, don't you think?'

'Yes, I do.'

'Believe me, Bruno: our scribblings are our excrement.'

Montaigne was similar in a way to the man with the bed-pans; treating himself as usual as his own subject of study, he had acquired the habit of continually concerning himself with the movements and products of his body. For three years, since he had begun to suffer from a hereditary illness passed down to him by his late father, his bladder had been pro-ducing stones which caused him terrible pain as they passed through. Once the stone was out, he would put it neatly away with the others, in a box on the mantelpiece in his library. Thus, just by lifting up a lid from time to time, he could stoically observe the ornaments, the marks, the evidence of his current existence. He hoped that the Italian waters would cure him, he said, or at least alleviate his troubles, for he had no confidence at all in doctors, in fact he execrated them, refus-ing to take their drugs or listen to any of their advice. In my opinion, however, it would have been possible to get the better of these dreadful colics by studying the poisonous, spiritual, astral or more probably natural *ens* which was exer-cising its power over the writer's organs, but he wouldn't hear a word about Paracelsus either, and became angry if I even ventured to utter his name in front of him. He preferred, I believe, to lend an ear to the slightest fart that came out of his arse, and measure the water he drank and the water he pissed every day in calibrated glass beakers, so that he could compare the quantities. In everything, and this was his strength and pride, Montaigne trusted only his own judgement, never that of others.

In the course of dinner on the evening of our arrival, I observed that our host did not set much store by lingering at the table. He scarcely took the time to chew his food, and ate so quickly that he frequently bit his tongue. His wife remained with us for a while, barely touching her meal and saying nothing at all, so melancholy was she at the imminent departure of her husband. When Hennequin, himself more gloomy and disquieting than death, asked her how many chil-dren she had, she answered with an ill-humoured sigh that she

had brought five into the world, all of her own sex, but that only one, little Léonor who was now aged nine, had survived.

'It was the will of God,' she said.

So saying, she thanked us for allowing her to retire and relieved us of her presence.

'I sense that you don't like the company of women much,' remarked Montaigne, devouring a capon leg.

And, pointing a gleaming index finger at a dish of oysters which had just been brought:

'Eat, gentlemen! Those shellfish are all for you. I like them, but I cannot touch them owing to my stony colics . . .'

'No thank you! The very sight of them turns my stomach. As for women, well, I don't know what people see in them. Aren't we all sick and tired of hearing about the love of a mother! Even Augustine made a great song and dance about it. For my part, I never knew any such thing, for mine hated me from the moment she gave birth to me . . . A little more wine, if I may . . .'

'Come now, do help yourself! I'm just the same, mark you. My mother has no great liking for me. But it wasn't the company of a mother I was thinking of. Don't you like oysters either, Jean?'

But Jean wasn't hungry. Montaigne asked the servant to take the oysters away, and advised him without the slightest ceremony to eat them in the kitchen before they went off. Then, plunging his fingers into the dish of poultry, he poked about to choose a third piece. And I was still enjoying my first! How good the cooks were here! This dish had been prepared with excellent oils. As for the nectar we had been served, it was so rich in flavour that I couldn't stop drinking it.

'At the time of my noviciate,' I went on, 'I serviced two or three whores in Naples, and all I got for it was headaches and vomiting. Their soft flesh doesn't suit my appetite. And as well as that, I don't like that gash they have under their stomachs . . .'

Montaigne started tearing the meat to pieces again as if it were a matter of utmost urgency. He said:

'As far as I'm concerned, I am sure that knowing women is

beneficial to me; because of the discharge that the act brings about, no doubt. It's not good to keep too many secretions inside the body, you know. The older I get, the more I force myself to have sensual pleasure, just as in the past I used to steer clear of it.'

Licking his fingers, he abruptly concluded:

'Now, gentlemen, how about a walk . . .'

'A walk?' I cried. 'But there's plenty of time, for heaven's sake! I haven't finished eating!'

Montaigne, immediately followed by that sheep Henne-quin, stood up as if I had not made the slightest protest. He was already standing, hands on hips, at the open door, looking out into the gathering dusk. I took a long slug of wine and called out:

'It's not pleasure I object to, Seigneur Michel, it's women!'

'You allow your imagination too much freedom,' he answered without turning round. 'Nature is more simple and less given to dreaming; in which it is not wrong.'

I saw that I would not get out of his confounded walk, for he was busy choosing three sticks from a sort of rack.

'Now then,' he continued, 'come along. Our thoughts go to sleep when we stay sitting; if the legs don't stir the mind, it stops.'

Wretched man! A moment later, all three of us were stir-ring our legs and our thoughts on the precarious path leading to the plain. The air seemed sultry to me and, like the Naples air, heavily laden with unpleasant smells from the sea. Climb-ing down this slope, I was suddenly oppressed by the feeling of a Dantesque descent towards the depths of hell:

La valle d'abisso dolorosa.

No doubt about it: I was drunk. I kept stumbling on stones and swearing, and I was having the greatest difficulty in fol-lowing the conversation. When we reached the foot of the hill, night had fallen and my head was spinning harder and harder. I would never get back up that hill, I thought. Ah well: better to die here. Wasn't that wide, dark ribbon that we could see over there the Acheron?

'The Dordogne,' said Montaigne, pointing it out with his stick.

In order to reach me, his words were first having to cut a difficult path through the limbo of my consciousness.

'I must say I find your way of scoffing at the papacy rather appealing. But look at the Lutherans: they started out by condemning the evil actions of the Catholics, and now they are running through the vices one by one in their turn. That's what lies in store for reformers of all shapes and sizes, in my opinion. For my part, I take pleasure in upholding the faith I was born into, knowing all the while that goodness has nothing to do with religion. There are some Mohammedans and cannibals whom we ought to call Christian, given how gentle their customs are compared with ours . . .'

I tripped over a large stone.

'You are even more heathen than I am,' I stammered thickly.

'You? You aren't heathen! I have listened to you: you want to destroy Aristotle's heaven so that you can replace it with Copernicus's! In short, repair the roof of the world, and the world itself! So what? Do you think man will become better because you have built him a new house, more extravagant than the one he had before? I sense that you will soon be inventing a new sect, a Brunian one, as if we didn't have enough to put up with already . . .'

'No,' I said as clearly as I could. 'The devil take theology. It's pitch dark . . . Shouldn't we be going back?'

'In any case, take care that the cardinals don't burn you. You have something of the fanatic about you. Doesn't he, Jean? What do you think? You never say anything. Well now, where has he got to?'

'Who?'

'Your Jean!'

He was to spend the whole night wandering along the river, more lonely and wretched than a phantom. After searching for him in vain and calling out in the darkness, Michel and I made up our minds to go home to the domain without him. My host, who slept alone in the room under the *librairie* on the first floor of the tower, took me to my bedroom in the main wing of the building and gloomily wished me good-

night. No sooner was I undressed than I collapsed on the bed and fell asleep, still drunk, my mind haunted by I know not what unpleasant premonition, and completely worn out.

The sun was at its zenith when I opened my eyes again. The bedroom was filled with bright light. Haggard and exhausted, Jean was sitting on the edge of my bed, watching me wake up. I grumbled at him:

'That's two nights that you've left me to sleep alone.'

'Soon you'll be snoring in the arms of your Venetian.'

'There's a chamberpot under the bed. Get it out for me.'

As he was doing my bidding, Jean informed me:

'No need to look for a way of getting rid of me any more. I'm going off on a journey.'

'What's this you've dreamt up now?'

'I spoke to Monsieur de Montaigne just now. He's looking for a secretary who can take down his dictation and record his observations during his stay in Italy . . .'

'How long would you be away?'

'What do you care?'

A burst of anger swirled round in me and I restrained myself from hitting him. Ignobly I cried:

'Monsieur de Montaigne! Monsieur de Montaigne! And who shall I dictate to, if you go away?'

Gallant Hennequin! He merely shrugged his shoulders and left the bedroom without a word.

We stayed at the domain until the twenty-second of June, which was a Friday. Our host had a great deal to do in preparation for his journey and I saw very little of him, except at dinner which he kept brief as was his custom. He had ordered his people to set up a table in my room, and I stayed on my own there most of the time, reading and finishing my *Song of Circe*. Jean, who seemed to have been cured of his melancholy by Montaigne's proposition, had taken off his splint and was riding all over the surrounding countryside, not caring a fig about me any more. For my part, I refused to speak to the traitor henceforth, contenting myself with cursing him inwardly.

It was agreed that we would set off in the following manner: Montaigne on horseback, escorted by three gentlemen and Jean, I with my trunks full of books, in a carriage specially fitted out for my comfort. On the Thursday evening there was a dinner which promised to be agreeable despite the presence of a tearful wife. But only half an hour after the meal started, the master of the house got up abruptly and asked me to go with him. I had barely had time to make a start on a fricassée of eggs with herbs, and Lord knows I was still ravenous . . .

'Are we going for a walk?' I said, watching anxiously to see if he was going to take sticks out of the rack.

'Let's go to my *librairie.*'

We left the other diners to savour the aromatic dishes and went up to the tower.

'My dear Bruno, allow me to present you with a modest gift,' declared Montaigne, lighting an oil lamp.

Sitting on a book, the cat was observing me as if I were an intruder. Then he yawned. Opening my hand, his master placed a medal in it. I went over to the light and turned it around in my fingers. On one side it was struck with my host's coat of arms; on the other were the scales of justice with the inscription, in Greek, ἐπέχω.

'*I abstain,*' I murmured.

'The Pyrrhonian motto. I know you'll never take any notice of it, but at least the object will remind you of our friendship.'

Handing me a letter, he added:

'And there's this as well. A letter of recommendation addressed to King Henri. Perhaps you will find it useful some day. I am a knight, after all, and a gentleman ordinary of his chamber.'

I held out my arms and we embraced with more affection than brothers.

I did not even look up when Orazio brought me my dinner; he had to force me to agree to lay down my pen for a moment. I found it almost unendurable that he . . .

'Let go of my hand! I know you're going to burn it all! But let me write while there is still enough light to see . . .'

He got annoyed:

'Calm down, Brunus. Nothing will be burned. There is some news.'

I peered suspiciously at his one-eyed face. What trap had that treacherous rogue Clement concocted now? What was going on? But it had nothing to do with Clement. Orazio had informed Deza of my refusal to see anyone, priests, comforters or emissaries sent by whoever. So the young man had given some orders.

First, that these pages should be put safely away in some secret place. This is because there is a rumour going round among the Pope's entourage, according to which they are supposed to be sending someone shortly to destroy what I have written in the last three days; and to get rid of me too, so that there need be no burning on Thursday. What a fine, courageous politician Pope Aldobrandini is! Can there ever have been a more pitiful tyrant? Having sentenced me, he is now forcing me to fight to stay alive until the hour of my torment . . . Second, that my dungeon should be cleaned. A man will see to it presently, the guard has promised. Third, that a barber should be brought here, if I say I would like one. And that if the barber comes, he shouldn't be left alone with me – that's the fourth point – because he could be a thug paid by Clement to cut my throat. And what's more, no-one should be left alone with me. It seems that a certain Gaspard Schioppius, a German fanatic who was cheering when I was sentenced on Wednesday, kicked up an enormous hullabaloo just now at Tor di Nona, stirring up the crowd and demanding to be allowed to strangle the heretic with his own bare hands . . . I do not know this Schioppius. The soldiers of the watch took him away and freed him immediately, says Orazio, given that he is part of Dean Madruzzi's household. He goes round declaring to anyone who will listen that the stake on the Campo dei Fiori creates martyrs and is thus to the benefit of the enemies of the Roman Church . . .

'Is there a fifth?' I asked.

This is the best news of all: that I am allowed to write at night, by the light of an oil lamp, with a good pen and on better paper. Deza has gone to the Holy Office to fetch my glasses; he is a true friend, he really is. He has even brought me a bundle of letters and personal documents. His sixth order is that I should be properly fed, so that I can work. And indeed Orazio's little wicker basket did contain a real dinner: hot soup with beans, white bread, roast duck and wine. I had believed myself more dead than alive in this squalid cellar, and now here I was, feeling the pangs of hunger again. My sluggish fingers approached the piping hot bowl. Having drunk a few mouthfuls of broth, I questioned Orazio:

'You have a good memory. But why should I trust you? Do you really want to help me? Three days ago you were terrified that I might cause you problems.'

The Cerberus handed me the pitcher and said, in a conspiratorial whisper:

'A Christian is entitled to choose his own death, Brunus. That's what I think. As long as I'm alive, no-one will rob you of your right to burn at the stake.'

His hand had closed like a vice on my arm, preventing me from drinking.

'Aren't we both Neapolitans? And both more or less sons of whores?'

'Sons of women, yes.'

His face was split in two by something resembling a smile.

'And sworn enemies of the bishops and the Inquisition that put one of my eyes out! As for young Deza, although he's a Spaniard and the son of a lecherous scoundrel, I've got a feeling he's not like the others.'

At last he let me go. I took a long drink before putting the pitcher back on the table. I loved wine so much, in the old days. But I mustn't stop writing, whatever happened . . .

'Have another drink,' Orazio ordered me.

'No.'

I pushed the pitcher away.

'We will save your pages,' he concluded, 'even though I don't even know how to write my name, or what the magic

rules are for those signs that you draw on the paper. As for you, Brunus, you will die on Thursday in the flames! So now, what's your decision about this barber?'

'Tomorrow. We will see tomorrow. Go and get me the lamp instead; and also the new pen I've been promised.'

Sunday, 13th February, 1600

Thanks to the oil lamp I was able to write almost all night, and it was nearly time for the dawn light to shine in through the little top window when, with my fingers still gripping my pen, I fell asleep for a couple of hours with my head on the table, carried off by exhaustion into the depths of a sleep which was devoid of either dreams or nightmares. On the fourth day of his mortal agony, the heretic opens his eyes and the first thing he does is to take a sheet of paper and carefully fold it lengthways so that he can write, as he has always done, in eight-inch columns; the second is to note down the date ... Dear God, isn't this whole enterprise completely mad? What could be more ludicrous than the confidences of an old sodomite who is besotted with himself? From the way I am intermingling a life story and the chronicle of my last hours, I am getting the feeling sometimes that I am looking on as a witness at my own heroic death. Who knows whether I am not after all an unwitting actor in some absurd comedy, the dream of some divinity? Oh theatre, oh mystery in which the gods have dreamed their sufferings! Yes, madness, no doubt! But this burning at the stake is madness too! Man and nature are madness! And if I may have a dream? I should like to have the insane pride, on Thursday, to confront the circle of flames with an insolent burst of laughter!

As promised, Orazio has had my cell cleaned, and the condemned man's physical circumstances are improving. I may have lost my mind by now, but there is no doubt that the cesspit stench that prevailed in here has gone. The hole in the far corner is now blocked with lime and mortar to keep out the rats from the Tiber. As for nature's needs, I currently have the privilege of being provided with a bucket which the guard brought me last night: a significant event if ever there was one. A bedpan for the poet's excrement!

Having put the thing down, Orazio had just knelt at my feet in the humble posture of prayer.

'Am I a god now or something? Why are you kneeling like that?'

'Deza's orders,' he replied in complete earnest.

And he started to free me from my irons.

Although this guard is just an illiterate brute, he had enough skill to do the job carefully, showing consideration for my black, blood-covered ankles. Bless you, hideous Cerberus, and bless the demons who are watching over my derisory fate. In three days' time my flesh and bones will feed the flames, but for the moment it is I who am being fed on meat and wine! And the barber, who apparently is a trustworthy man, will be coming at midday to clean up my face.

As for the young and handsome Deza, he has not yet put in another appearance. Has he perhaps given up the idea of trying to convince me, having suddenly been struck by respect for my destiny, or by contempt for the futile schemings of his master? Or is it rather that he is hoping to win me round by improving and protecting my existence from behind the scenes? I don't know what this strange courtier's opinions are. Orazio has found a secret place to hide my notes for a little while until he can hand them over to him. I don't know what will become of this account either, or whether anything will ever come of it. Will it appear in print one day? If it does, I shall not have reread or revised it; but I confess that I have never taken much care over rereading or revising any of my works, having got into the habit, ever since *Noah's Ark*, of writing in a spurt, at the command of a tyrant known as inspiration. And in any case, that is the real meaning of the word *poetry*: the magic of the word, an epiphany, a spurting forth of the being. Driven by His own force and will, God invents language and behold, He is God, and behold His book: Creation. Has anyone ever seen God rereading and revising the world?

Thanks to Deza, these pages may be in the process of becoming a book for all eternity, a volume in a library, a food for your pleasure or your edification, invisible reader, but I shall continue to write them as I began on Thursday, namely

165

as a sort of long epistle addressed to the most absent, most obscure of all my companions: myself, the Nolan, that loud-mouth who not long from now, when he is no more, will be. I have resolved to write everything about his human and philo-sophical life, even its most private details and little ups and downs; and so I must go on – thus one learns to die – moving forward towards him step by step.

Every time I walked, holding my nose, across the place Mau-bert on my way back to my home in the rue de Bièvre, I would think of the dictum coined in his time by Erasmus: *Olet ut cloaca mauberti.* The drains there stank of the effluent from a number of dye-works in the area, and since these belonged to Protestant families, the local Catholics were at a notable advantage over other Parisians: they had a reason to curse their enemies every time they felt like breathing. I often joked about that to Monsieur Canaye, my landlord, himself a Huguenot who came from the Languedoc and whose family had grown rich from the pastel trade.

'Keep your voice down, Bruno!' he would reply, glancing fearfully into the street. 'Or we'll all end up hanging from that gallows over there!'

For this was the other drawback of the *Maubertus* cross-roads: the gibbet which stood in the square like a shadow of death, *umbra mortis*, a vague forewarning, in this century of sin, of inescapable punishment. Here as elsewhere, executions drew the common herd, and when this delightful form of justice was being carried out, it became quite simply impos-sible to get from one street to another. Thus there were times when I was forced to witness the spectacle of a man being disposed of by hanging or strangulation, amid one of those great frissons of popular delight known only to cities. Often the wretch's body was roasted, or cut to pieces with an axe by the executioner. I saw remains being dragged along by a horse and plastering blood all over the cobbles; the crowd would cry out in terror, for there's nothing they hate more than violence being carried out on a dead body.

But no execution was planned for this first day of Lent, and

the square, swept by a bitter late winter North wind, even seemed to have given up its usual hustle and bustle. The only people crossing it were the water-carriers, hurrying along at a smart pace, rival groups of noisy schoolboys, and beggars with numb, trembling hands. The first thing that drew my attention to the monk I saw coming out of the rue Saint-Victor, limping and dragging a stick, was the image of the Virgin that was bouncing about on his stomach to the rhythm of his limp, enclosed in a wooden frame and hanging from his neck by a string. Paris yielded on many counts to Italian fashions, and the cult of the Immaculate One was even more prevalent here than in Rome. Despite the attacks perpetrated on her by the Huguenots, there were still numerous idols bearing her effigy standing at every crossroads and on the façades of houses: madonnas embracing the Son, sorrowful mothers mourning and grieving over their sex and condition. As for this poor Dominican, no doubt he thought it was a novel idea to carry her around his neck like a relic. He was coming over. What did he want from me? To beg for charity? As if intending to put a curse on me, he suddenly displayed his right hand with the fingers cut off.

'Felix!'

'Out of my sight, renegade!'

With these words, he dealt me a blow with his stick that nearly cracked my skull open.

As I was regaining consciousness, I could feel the cold of the cobblestones under the back of my neck. Canaye was slapping my cheeks and a young priest from the nearby Saint-Michel College was mumbling a prayer. The two men, who had been standing a few yards away having a chat, had witnessed the attack and immediately flown to my assistance, as a result of which Felix had fled. I groped around in search of the painful bump.

'You're not by any chance thinking of administering the last rites, are you?' I grunted to the priest.

I managed to sit up.

'Very funny,' said Canaye. 'A moment ago you were dead to the world. That monk really gave you a going over!'

By now a crowd of gaping onlookers was gathering around us. They helped me back on to my feet. I was still a little unsteady.

'How do you feel?' asked the priest.

'I'm standing upright,' I answered, leaning on his shoulder. 'And very much alive, by heaven. I won't be dining in hell tonight, believe me.'

With shaky steps, but without anyone's help, I walked over to the front door of my house. I was nearly at the top of the steps when I heard Canaye shouting:

'Let's go and tell the officer of the watch! That blackguard's got it coming to him when they get hold of him!'

My bedroom had a fireplace and the fire was lit. In anticipation of my return the excellent Prospero, a black-skinned eunuch given to me by Cecil as a present, had furthermore had the good idea of preparing a bath. I had only to let myself be undressed and sink my body into the hot water. While I was resting, he applied scalding compresses to my head. I ruminated on my misadventure while watching the flames mounting an assault on the hearth.

'Do you know the man who hit you?'

'I've known him for a very long time. We were novices together, in Naples. I also met him in Chambéry, where he was hiding under the name of Saturnine. What's got into him? And what's he doing in Paris?'

After ten compresses or so, the bump was still the size of an egg, but the pain had subsided.

At that point I said to the eunuch, 'I want you to run over to rue des Vieux-Augustins. And tell the *signore* what has happened to me.'

Cecil lived on the other bank of the Seine, in a mansion which the royal administration had put at the disposal of the Venetian ambassadors. Prospero poured me a glass of wine. Then, wrapping himself up in a coat, he threw two large logs on the fire and dashed off.

'Felix,' I murmured to myself when he had gone out. 'Blasted Virgin-worshipper.'

And I covered my eyes with a damp towel.

Lord how I loved those baths I took, and what strange powers they had! They seemed to enable my mind to free itself from the finite nature of the body, and to set in motion the workings of reminiscence. Sensations, I believe, transmigrate from one soul to another with the aid of words and images, whether printed or not. Was it because of the mishap I had had? The liquid element carried me off to Naples, not to the company of Felix, but to that of Fra Teofilo da Vairano, my old master of times gone by. I had dreamed once of appearing naked in his presence, of being possessed by him in some steamroom in Rome or the Orient, and this dream, murmuring with the echo of Augustine's story, was still alive in me: eleven centuries earlier, in African Hippone, an adolescent had delighted in the image offered by his own body, and such, in its divine unity, was the ultimate secret of love. *Je quiers en toy ce, qu'en moy j'ay de plus cher*, sang Mauricius Scaevius. I seek in you what in myself I hold most dear. But how did he manage to find the beloved reflection of himself and his sex in that Delia? Was the poet being a little bit deceitful here? For my part, I loved my own body, by heaven, not that of women! And Lord knows they were in opposition to one another! On the one hand the perfection of intellect, disinterested beauty, the One equipped with every attribute; on the other the aberration of a necessary being conceived in haste, a botched job as it were, and for ever incomplete. Was it so very difficult to look beneath the worship of artifice on which the female of the species squandered all her energies and see that secondrate belly, that murky pouch devoted to the reproduction of the species? *Inter feces et urinam nascimur*, or so I am told! The beautiful and the feminine were quite obviously incompatible. And since the just, the true and the pleasing went hand in hand with the beautiful, so the just, the true and the pleasing could not but be alien to the feminine. That was why, at the pinnacle of the city state and the human hierarchy, the Greek philosophers practised Greek love, leaving the common herd to wallow in the belly of whores and the squalid slums of cities, as I had done during my tedious Neapolitan adolescence. I was pondering over this, half dozing in the

169

water which had gone cool by now, when Cecil came in, his sword banging against his thigh.

'Nice bump,' he said, smiling.

And, handing his velvet coat over to the eunuch:

'Your Felix has been caught. He'll be sleeping in a cell at the Conciergerie tonight.'

Cecil was only too delighted to fit in with the elegance of the court, and fashion required that a gentleman should spend a fortune to acquire a paltry twenty or thirty outfits in different fabrics, and the same number of satin waistcoats, not to mention the stockings, ruffs, ribbons and numerous pairs of boots and shoes he had to have. However, contrary to the current practice which favoured colourful garments, he was set on remaining faithful to the shades of night. And so black was the colour he had chosen for his slashed silk doublet, his hose and the Polish-style beret which he wore over his pomaded hair. A pearl necklace adorned his chest and an earring made of tiny criss-crossed swords fell to his shoulder. He drew up a chair next to the bath and enquired:

'So where's your man Hennequin?'

'He's been gone for a few days, travelling round Germany. I sent him there to buy me some books . . .'

'Just as well. Shall we call one of our embassy doctors?'

'For a knock on the head with a stick?'

He kissed me on the lips and said:

'Two pieces of news, Philip: one good and one bad . . .'

'Start with the bad one.'

'Parliament has raised a protest against *Candelaio* . . .'

'I knew it . . .'

'According to those gentlemen's taste the play is too debauched, and full of rascally Italian-style goings-on . . .'

Having been put on by Sanguino in Lyons, then in Nevers and Blois, my *Candelaio* had just, thanks to the efforts of our friend Baïf (although ill and exhausted, the poet was showing as much determination as Cecil to see me do well in Paris), had a great success with the audience at the Petit-Bourbon. It seemed that the time was right in France for Italian actors: all sorts of *Gelosi*, *Ganassi*, and other *Sanguini* were appearing

as Harlequin and Pantaloon, but also as harlots, pimps and pederasts, and attracting bigger audiences than all the preachers put together. Bonifacio and Carubina would soon be more famous than the twelve apostles, and a bookseller by name of Giuliano, at the sign of Friendship, was getting ready to publish the play, whose final version was composed of five acts. In memory of my erring ways in Geneva, I had decided to write in haste, for this edition, an epistle full of gibes in the form of a dedication to *la Signora Morgana Borzello* who was now living in Naples, married – for good, this time! – to her idiot of an arquebusier. The frontispiece of this book would feature my favourite apophthegm: *In tristitia hilaris: in hilaritate tristis* . . . The comedy was too debauched! More problems, more censorship! How much more would I have to put up with?

'I'm cold!' I said ill-humouredly.

'And I'm hungry. Can't the eunuch make us something to eat?'

'Let's go to bed first.'

And, Neptune-like, I swept aside the waters.

Prospero had warmed the bed. Between the sheets, I caressed my beloved and trapped the ermine head of his arrogant spur. In the throes of desire, my mind filled with lines of Latin verse. Was the *telum* that was growing in the hollow of my hand still virgin, as its owner had sworn in Rome fourteen years earlier? I knew perfectly well that it was not. Like many gentlemen, and the king himself, Cecil kept occasional bedtime favourites, young singers, actors, future poets and apprentice sculptors whom he did, however, endeavour to kick out of his apartments whenever I was due to arrive there.

'And the good news?' I asked, still devouring his neck as I spoke.

'Henri has forbidden anyone to bother the Italian actors. "I take delight in hearing them," was his answer to the killjoys in Parliament, "and in particular . . ." '

His voice died away in a sigh of pleasure, for my *mentula*, harder than iron, was knocking on his secret door . . .

'Do you know that line of Catullus, Cecil: *Pro telo* . . .'

'. . . *rigida mea cecidi*. I immolated him with my rigid member. Immolate me, Philip, if you feel like it.'

'I do feel like it . . .'

'He wants to hear you speak, apparently . . .'

'Who does? Who are you talking about?'

'No, nothing. I'll tell you afterwards . . .'

'Tell me!'

But Cecil never gave in unless he himself had decided to do so, for his heart was unyielding. Once I had gone through the brown ring, I remained for a long time inside that nocturnal, earthy place where forgetfulness is deeper and more delicious than death, listening to his moans and lending accompaniment to them, meditating on the approach of ecstasy, with my soul alert to the slightest quiver of life, and open to the most extraordinary visions. Suddenly, Thoth the Egyptian turned to face the sun, Romulus gave a mighty heave and sank his ploughshare into the glebe, Moses flooded the basins with blood – a moment blessed by the gods, I thought, holding my breath, now we are nothing but Love, Strength, Unity, pure Being. A blessed moment. The swift passage of time joins with eternity, God and Nature are as one, and so too are movement and rest, the straight line and the point, the ocean and the sky, water and fire, the arrow and its target, the beginning and the end, the microcosm and the macrocosm. Yes, a blessed moment.

'God Almighty!' I roared.

The physical world had just been obliterated: gone were the little trials of everyday life; and even thought itself was no more.

After waiting for silence to reign again in his master's bedroom, Prospero cautiously pushed open the door and came in, holding a tray on which he had laid out some sea bream pâté, four slices of marzipan, a bowl of plums, a plate of little waffles and some white wine. I pulled the covers up over our bodies.

'Why does an atheist call out to God when he comes?' murmured Cecil faintly.

'Remember the names of my heroes,' I answered, sucking a plum right next to his ear: 'Phylotheus, Theophylus . . . I am an atheist who loves God . . .'

172

'Not an atheist at all then . . .'

'So tell me, is it the king who wants to hear me speak?'

Yes. Having heard that Paris was applauding not only my play, but also the extraordinary lectures on Thomas Aquinas that I was giving at several colleges, Henri III had asked Baïf to arrange for this *famous Italian doctor* to be invited to give a demonstration of eloquence at his Academy in the Louvre. This was the successor to the old Académie Française, and had been created under Charles IX by Jean-Antoine himself; here the refined ear of the king (the left one, I should explain, since, as my beloved rather mischievously pointed out, le Valois was deaf in the right) regularly heard treatises on physics, poetry and moral philosophy. A request like this was the best possible sign of success, Baïf had claimed that same day, adding that Henri could be extremely generous if he wanted to. Furthermore, the poet hinted at the possibility of using this as an opportunity to land a chair at the Sorbonne . . .

'An excommunicate at the Sorbonne!' I cried, seized by a sudden fit of gaiety. 'You see some strange things in Paris, I must say!'

Having filled the glasses:

'What will I have to talk to him about, for heaven's sake? The Aquinate, Aristotle, Epicurus?'

'We'll talk to Jean-Antoine about that,' sighed Cecil, stretching languorously. 'Oh Lord . . .'

'What's the matter?'

'I think I want to be immolated again . . .'

Tied up, like Christ, between two thieves, Felix was expiating his crime in the stocks at Les Halles. Some callow urchins, urged on by the imprecations he kept showering on them, were caning his mutilated hand, which was held fast in its iron ring and by now was dripping with blood. I chased them away and they ran off like a flock of sparrows among the market stalls.

'Why did you attack me?' I shouted at the monk, watching out in case he answered by spitting in my face.

'You will burn in hell, accursed sorcerer! Heretic! Traitor

and renegade! Actor! Charlatan! Sodomite! Insulter of the Virgin! Seducer! We will trample on your bones!'

In his black eyes, once so soft but now, it seemed, completely insane, there was an expression of the most intense ferocity: a hatred which in all truth was far from Christian, and of which I wanted to know the cause.

'What do you accuse me of, Felix?'

'Do not speak my name, cur!' he cried. 'We shall kill you! And we shall kill that depraved, licentious king, that tyrant who gives shelter to infidels! God willing, my arm will deliver the world of this plague of heresy . . .'

'Henri III, a heretic? Are you out of your mind?'

'The Valois are pigs! And every day this Valois insults the host, the Holy Spirit and our Immaculate Mother! We shall slit his throat and pursue him with fire and the sword, and you too, Brunus – bah! I spit on your name! – we shall cut your body in pieces!'

With the nails of his left hand he was clawing the wood of the stocks, and had he been freed there and then he would no doubt have hurled himself at me with the sole intention of putting his plan into operation. But what was this *we* all about? Could it be that the Dominican belonged to the Holy Union? This faction, which had sworn to perdition the Huguenots and moderate Catholics, was continually calling, in God's name, for regicide. And why had the confounded fellow left his monastery? To every question I asked him he replied by vomiting forth a flood of invective and threats, directed most particularly at the upholders of Greek love, in whom he seemed to see the satanic incarnation of faithlessness. How distant that other Felix was, the one of days gone by, the Neapolitan novice who enjoyed nothing more than being, shall we say, immolated. At the time of the monastery, the student honoured, kissed and prayed on his knees to two idols: the Virgin and other boys' *telums*. What mysterious sufferings of the mind and body had forced him to renounce the second and turned him into this foul, wretched demon pinned to the wood of justice? I lent an attentive ear to his crazy vociferations and by the end had unravelled the thread

of his story: betrayed by his friend, the lawyer Lagrange, then beaten by his brothers, the monks (hence the extra disability of a lame leg) he had received a visit from a divine messenger, who had ordered him to come to Paris and carry out Universal Vengeance.

Sure enough the monk's imprecations had attracted first a crowd, which was becoming heated, then the watch. He went on louder than ever invoking the Virgin and cursing heresy and sodomy. Eventually the exasperated soldiers had to club him to reduce him to silence. Poor Felix passed out, and soon his blood-soaked head hung down against the greasy wood. I questioned the officer of the watch from Saint-Jacques de l'Hôpital who knew him. The man informed me that the wretch had been driven out of Chambéry and that he now roamed the streets preaching at the Parisians and carrying the sacraments in processions.

'He's a regular in the stocks,' he said pensively. 'He'll end up being hanged, that priest will.'

Taking off my hat, I showed him my forehead, and the bump.

'He could have killed you,' said the officer sympathetically. 'Watch out in future, because from tomorrow he'll be free.'

'He's sworn to do away with the king . . .'

'Oh come now, kings are well protected.'

A bad omen, I thought, this resurrection of Felix. As I left Les Halles market my mind was full of nightmare visions in which scenes of my past and future lives, all equally dire, were intermingled. I walked along beside the brand new Saint-Eustache church. In the rue Montorgueil, the engravers were exhibiting coloured pictures which they had printed on the premises. Christian divinities and Mothers of God, some of which were identical to the one I had seen round the neck of my attacker, were swinging in the wind, drawing the gaze of passers-by. What crimes would shortly be committed in the name of these idols? With a strange sense of disquiet gnawing at my heart, I ran towards the rue des Vieux-Augustins where Cecil was awaiting me for an English lesson – oh love, to clasp you in my arms and forget my troubles . . .

★

'*Den farrewel world*,' I croaked, reading the words on a little board decorated with putti that was hanging on the wall, '*dy utterrmosht I shee, Eterrnall Love maintaine dy life in me . . .*'

'Dear Lord, I can't stand any more of this!' cried Cecil. 'His accent is hurting my ears.'

Dropping his arms, he sighed:

'What do you say, Jean-Antoine, is it worth going to all this trouble? We're not going to get anywhere with this Neapolitan.'

Baïf was sitting huddled close to the fire, with both hands on his stick and his buttocks sunk, owing to an attack of haemorrhoids, into a pile of cushions. As for the bones in his legs, they were giving him so much pain that he couldn't stay standing for more than a few minutes, The poet, who was nearly fifty, was aging fast. He stirred slightly, pulled a face and answered conciliatingly:

'If he ever goes to England he can just speak Latin.'

'I want him to know English! England has its own poetry! And it's not written for uncouth peasants! And besides, just imagine this stupid ass in front of Queen Elizabeth: *I prrezhent my rreshpectsh to Herr Majeshty!*'

To imitate my delivery he had put on the airs of a drunken old madam. He shouted angrily at me:

'Even your Italian smacks of the countryside round Naples! It's like listening to a turkey gobbling! And those infuriating 'sh' sounds! Can't you get rid of them? It's *uttermost*, for heaven's sake, not *uttermosht! I see*, not *I shee!*'

'*Andiamo, andiamo*,' said Jean-Antoine, gently intervening. 'Don't fall out over such a trifle . . .'

'I'll try again,' I suggested.

'No, for pity's sake!' implored Cecil.

He collapsed on to a chair, more theatrically than was necessary. It was true that this language seemed to be so much at odds with my nature that I was afraid I might dislocate my jaw with every phrase I spoke; and that blackguard Cecil was turning out to be the most impatient of masters! Speaking to Baïf, he went on:

'If you knew how much effort it's taken me to persuade him to talk without deafening people . . .'

'A habit he picked up in the debates at San Domenico Maggiore, no doubt,' replied Jean-Antoine.

The poet gazed affectionately at us, one after the other, and endeavoured to turn the conversation towards less controversial matters. In a voice tinged with some nostalgia, he returned as he often did to the subject of Rome, which he would never see again: to Jacobi the bookseller and a certain evening long ago at Cardinal Vita's palace . . .

'The meeting of Elegance and Truth,' he said, recalling this memory and the couple we made.

Dreamily quoting himself from memory, almost singing to himself, he added by way of an illustration:

> *I salute you, my friend; lead me at dusk*
> *To the darkling place where my love awaits*
> *And the moonlight is dim.*

'I'm going to tell the servant to bring us in some drinks,' declared my beloved, getting up.

Cruel, merciless Cecil! He didn't like the Venetian's poetry any more than I did. The translations of Sophocles and Terence that Jean-Antoine had done were not bad at all, but his verses were rather heavy going, as were the languid feminine conceits they purported to describe.

When the master of the house was back and we had been served some wine, Corinthian grapes and fennel-flavoured dragées, the conversation turned to the desire expressed by His Majesty that I should speak at his Academy.

'Astronomy is all the rage,' asserted Baïf. 'All Henri wants to hear about these days is planets and celestial orbs; he's lapping up new theories faster than a cat drinks a bowl of milk . . .'

'Good for him!' I exclaimed, looking at Cecil for signs of approval. 'A king who's not well-read is an ass with a crown on . . .'

The poet went on:

'But take care: they also frighten him! You must be sure not to make him dizzy with planet earth and so on flying off at top speed into the sky, because he might take umbrage and get angry . . .'

'How's that? The earth does turn, it's a reality . . .'

'Yes, yes, to be sure . . .'

'I can't just bend my doctrine like a reed to suit the whims of one individual, even if he is sitting on a throne!'

To silence my objections, Jean-Antoine was waving his hands about.

'It's all a matter of diplomacy,' he continued, grimacing with irritation at the pain he was in. 'You're a teacher, aren't you? And a master of the art of debate! Haven't you learned how to be persuasive? It's up to you to find the words which will enable Henri to swallow your opinions without having his stomach turned by them. I'm just giving you a piece of advice, that's all. I imagine you've heard of Sieur du Perron . . .'

'Yes I have, he's a Protestant, and he doesn't like me one little bit! He goes around boasting that he has a better memory than mine . . .'

'For the Lord's sake, who cares whether he likes you or not? And stop shouting for a minute! Listen!'

Cecil got up, glass in hand, and began to wend his way elegantly from one end of his room to the other. Had his wrath of a moment ago subsided? When he got to the little board hanging on the wall, he stared at the little darlings carved into the wood, and the English words written in chalk, and smiled . . .

'So,' continued Baïf, 'there was du Perron, at one session of the Academy, coming along to present to Henri, with all sorts of details and developments going back to Anselm, the arguments in favour of the existence of God . . .'

Well really, so what? But Baïf went on:

'Wait! The king was so filled with wonder by the brilliance and beauty of the demonstration that in front of everyone he showered the orator with praise, congratulations and rewards. This fellow du Perron had never in all his wretched life

known such emotion. It made him go quite crimson, and his head was getting so big it nearly burst. And then do you know what the idiot answered?'

'No.'

'That next time he would try, with the same talent, to present His Majesty with the opposing arguments!'

Cecil gave a great roar of laughter. For my part, I couldn't resist asking him what the king had done.

'The king?' replied my beloved, still laughing. 'He threw him out of the court!'

Biting into a dragée, he added:

'As he will throw you out, Philip, when he has heard you. There'll be nothing for it but to pick up your pilgrim's stick again and put on your sandals, poorer and more miserable than the day you were born . . .'

'From what I've heard, du Perron isn't roaming about in sandals! He's well and truly back at court!'

'With Henri,' Baïf concluded, 'you've got to know how to tread carefully. Not least because he will no doubt insist that you do a bit of fortune-telling for him. God in heaven, why I have to put up with such martyrdom, and in such an unfortunate place? Do you know that I am obliged to fix bits of bandage down the back of my hose? Otherwise, when I take them off, they're covered in blood! You can't imagine how revolting it is . . .'

'Is the king superstitious?' Cecil interrupted him, handing him the dish of grapes.

I could read his thoughts; the last thing we want is to have the poet boring us with his ulcerated arsehole, and I wish he would stop making the atmosphere stink with his emissions . . .

Baïf plunged his fingers into the dish.

'All princes are,' he replied. 'Henri boasts that he never pays any attention to astrologers' chatter, but show him some learned key to his destiny and he will shower you with gold and gifts . . .'

'Jean-Antoine,' Cecil cut in again, 'thinks that the *famous Italian doctor* should dedicate his next book to the king . . .'

179

'My *Candelaio*? It's only a comedy!'

'The most amusing of comedies,' affirmed Baïf. 'All the human vices brought together in one single play, in a delightful setting. That Bonifacio is so funny, with his great big behind and pointed beard ... Ow! Oh dear Lord, as soon as I get the urge to laugh, these damned varicose veins take it out on me. What have I done to deserve such suffering ...'

Motionless, he grimaced again, waiting for the dreadful agony to go away. Then he sighed, pale, but free of pain for the moment.

In a weary voice he went on:

'No, it wasn't *Candelaio* I was thinking of, my dear fellow. But your *De umbris* something or other. Tell me, will it soon be printed?'

'*De umbris idearum*. Yes. By Gourbin, near Cambrai College ...'

'In that case, here's another piece of advice: as soon as you can, write a dedicatory epistle to Henri, and give him the book. Believe me, he'll be very grateful to you ...'

Suddenly a memory came to me:

'By the way,' I said, 'does either of you know how Henri received Michel de Montaigne's *Essais*?'

'I wasn't there myself when they met,' answered Baïf, 'but Giovanni told me about it.'

Giovanni Moro represented Venice at the court and kept a very precise chronicle for the Republic, based essentially on information supplied by Cecil's spies – *my flies on the wall*, as he called them: these were gentlemen, courtiers, tradesmen and servants, who were paid to keep the embassy informed of the sovereign's every movement, his plans, visits and even thoughts, moods, minor ailments, dreams and desires. Another group of *flies* was secretly employed to keep watch on Catherine, the king's mother, whom my impudent beloved heartily detested, and a third to spy on the heads of the league. To return to Giovanni Moro, he had for a long time been friendly with Jean-Antoine, whose father had himself once been ambassador to Venice.

'Giovanni wasn't at the meeting either,' said Cecil. 'He heard everything he knows from me.'

Leaning on his elbows on the back of a chair, he smiled at me. I could see a note of defiance in his black eyes.

'You were there?'

'No.'

Impatience got the better of me:

'Anyway, what does it matter? What did Henri think? Are you finally going to tell me?'

'You wouldn't happen to be jealous of the Gascon's success, would you, Philip? It's true that a second edition of his book seems to be in preparation . . .'

'The *Essais* are a delightful work,' Jean-Antoine declared, shutting his eyes, 'as delightful as this nectar which incidentally comes from down there as well . . .'

Rocking the glass to and fro, he breathed in the wine's bouquet and continued:

'And yet it doesn't conform to any rules. It's as if the author submits to nothing but the whim of his pleasure. Shall I tell you what occurred to me as I closed the book? That the Italians are absolutely right to call talent desire and desire talent. Because it really is true that the two things are one and the same. *Cuor contento, gran talento* . . . Ow! No, really, I can't take any more. I think I'll go back and die at home . . .'

Yes, let him go, I thought, suddenly in a hurry to be alone with Cecil; and I helped him to his feet. Poor Baïf lived in the old family home in rue Saint-Victor. The chaise-cart journey would only take half an hour, but it would be a torture because of the cobbles.

'A bath,' I said, 'would give you some relief. In my opinion it's the best medecine of all . . .'

'Bah!' cried the poet, leaning on his cane. 'Water does nothing for me. Dear Lord, if I have to die, let it be somewhere dry! Come now, my hat! My coat! May my body and soul perish. May my bones crumble away, for I have had enough! God is a torturer . . .'

'*Moi je n'espère rien qu'à jamais un martyre,*' recited that rogue

181

Cecil ironically. 'I hope for nothing better than eternal martyrdom.'

Jean-Antoine looked at him coldly – the alexandrine was of his own devising, chiselled at some time in the past by a poet in good health – and went off, bitter and groaning.

'Well then, what about Montaigne?'

'How impatient you are!'

'Tell me or you'll be sorry!'

Cecil loved to rebel. Was I going to have to hurt him? By now I had him in a tight grip, and was spoiling for a fight . . .

'Henri said he liked the work *very much indeed*, Philip. And the Gascon, having thanked his sovereign, replied: Sire, Your Majesty must like me then, since my work is agreeable to you . . .'

'He will like mine even better . . .'

'I should be very surprised if he did . . .'

These last words were said with the sole purpose of arousing my desire – and by the same token my talent.

At that time Montaigne had been back from Italy for three months. I learned that he was now mayor of Bordeaux, and wondered if his duties in that office would leave him any spare time to shut himself away in his round tower. As for Hennequin, he had remained in his service only until mid-February of the previous year.

My former disciple from Toulouse days had travelled with him to Germany, and then followed him to Venice, Florence and Rome, taking down day after day the observations his new master dictated to him, and keeping an exact account of his colics and the stones of all sizes that came out of the writer's body. In the evenings he read to him, and when he was ill he took care of him with the devotion of a good and faithful servant. Always carrying his writing-case, he accompanied him on his many visits and walks, and saw him kiss the feet of the Pope; together they attended the execution of the bandit Candena on the Campo dei Fiori, and a Jewish circumcision, a spectacle which Montaigne, Jean told me, found highly entertaining, given that he had some Hebrew blood in

his veins through his mother. The secretary had no time at all to himself except when some secret meetings were held in the presence of the French ambassadors in Venice and Rome; Hennequin guessed that the Gascon was the bearer of various messages sent by Catherine, King Henri's mother.

After Christmas, Jean suddenly started to feel very upset about the distance between him and me, and the fact that he had not received a single letter to ease the pain of separation. He missed the way I ill-treated him, he was to confide in me later (the blighter didn't lack spirit, I must admit), and no longer had the strength to hold back the tears that kept coming into his eyes at every hour of the day, whatever task he was engaged in at the time. Seeing him in such a pitiful state, Montaigne questioned him. He himself often let the deep grief and torment show that he still felt over the loss of a friend of his who had died at some time in the past. That made it all the easier for Jean to open his heart about his problem and beg to be given his notice so that he could get back, so he reasoned, to the man whom he would have all the time in the world to weep for when he was in the next world. At first Montaigne laughed heartily at this subtle joke, then he made a sour face, because he was very pleased with the work his copyist did for him. In the end he gave in.

'I love Bruno,' sighed Hennequin. 'That's my misfortune.'

'Well, goodbye then. And when you see him, give him my regards.'

It was Shrove Tuesday. Jean said his thanks, pocketed his wages and left Rome on a post horse.

By the time he arrived in Paris, my life was going ahead under the best possible auspices. Thanks to the combined efforts of Cecil, Giovanni Moro and Baïf, I had obtained permission to lecture on Aristotle and Thomas Aquinas in several colleges, and when I was not teaching the Parisian *pueri*, I was in my study in the rue de Bièvre or the library of the Saint-Victor Abbey, diligently writing thirty pages a day of the dialogues which would soon, I hoped, make me famous. I was enjoying an even freer, richer, more agreeable life than in Toulouse, surrounded by excellent friends and, to be fair, by a

handful of enemies who were always quick to complain to the authorities: talentless pedants for the most part, whom I, for no other reason than to keep up my reputation and good health, had at some time or another taunted in public. No doubt by now they were pondering their vengeance, but what on earth did I care about these sad individuals? Every night I met my living god, my sun, my Hermes Trismegistus: Cecil, my Cecil of the silver lips, sharp tongue and neck as cool as dawn. Needless to say he was the first thing I thought about when Hennequin, six months after leaving me, came knocking on my door.

'I want to start working with you again,' he said.

'Impossible. You know how jealous Cecil is.'

'But I love you too!'

'Be quiet! If you come anywhere near me he'll kill you.'

It won't be long, I thought, before my beloved hears about this visit. How? From the *flies* who I suspected were under orders from him to tail me every time I set foot outside my house, or from Prospero, perhaps . . .

'Am I not your disciple?' Jean went on.

'You were . . .'

Even as I spoke I was worrying about where the eunuch had got to.

'Didn't you leave me six months ago?'

'What's over is over, Philip. I know you need a secretary, a man you can trust, a permanent emissary. I know your work off by heart. Who can defend you and your interests better than I can? And anyway, I need the money . . .'

'Your father . . .'

'He's thrown me out. He can't stand my opinions . . .'

'Why the devil didn't you stay in Rome with Montaigne? I love Cecil! You won't force me to declare war on him!'

'Love whoever you want,' sighed Hennequin, looking sadly away. 'Just let me work for you, be useful to you . . .'

The fellow was right. Wasn't my work gaining in importance? I had to produce the definitive version of *Il Candelaio*, which Giuliano the bookseller was waiting for, and finish *De umbris*. My next book was to be the *Cantus circaeus* which I

had also begun in Toulouse, a hilarious bestiary in which all my opponents in Italy, Geneva, the Languedoc and Paris would recognise themselves as if in a mirror as the animals that I had transformed them into for the occasion: a stupider, more conceited collection than all the asses, monkeys, peacocks and vipers in paradise. But its two hundred pages still had to be put in order, not to mention the other dialogues, written in Italian this time, that were currently in hand . . . Was it my job, for heaven's sake, to sort out those wretched mountains of paper?

Contrary to all expectation, Cecil agreed:

'As a secretary, yes, if it's useful . . .'

'It is . . .'

'But if this Hennequin gets into your bed one single time I'll have him disposed of . . .'

It wasn't necessary because he never did get in there. Since Jean couldn't go back and live with his father in the rue du Cloître, I rented a room for him through Canaye in the Mathurins district, and, to quote his own words, started treating him just as badly every day again as I had done in the past. We would work in the rue de Bièvre or at Saint-Victor Abbey (where the librarian, Guillaume Cotin, was a friend of mine), I dictating and he copying. Tireless and loyal, more devoted to my work than to his own life, and unconcerned by my sarcastic remarks, he was second to none when it came to rereading and correcting proofs, engraving illustrations, overseeing the typesetting of texts and keeping an eye out for trouble on the financial front; and so he was given the responsibility of being my representative to booksellers.

A year went by. *Il Candelaio* was going to be printed, as was my *De umbris*, the book dedicated to Henri III. Before leaving for Germany Jean had delivered to a third bookseller, one called Gilles, at the sign of the Three Crowns, the pages of *Cantus circaeus*, carefully numbered and stitched. He was not due to return until the month of June, but events forced me to recall him as soon as possible:

'My dear Jean,

'Mercury willing, this letter will reach you in time, because

I want to see you back in Paris very soon. Baïf tells us that King Henri has decided to hear me speak in his academy on the second Tuesday after Easter. Although suffering from melancholia & other princely illnesses owing to the rumours and cares that beset him, he is very well disposed towards me, it seems, & those who have heard him in recent days say that he is highly entertained in advance by the thought of the fine lesson he is going to have. By now the *puttane* of the court can talk of nothing but *infinity* & they are going round the Louvre repeating it like the parrots they are. As for him, it is said – *dixit non solum* Baïf *sed etiam* Giovanni Moro & all the flies at the embassy – that he is already speaking about me in a sugary voice as *his Italian doctor*, & most important, that if he is pleased with me he will do whatever it takes to create an extraordinary chair for me at the Sorbonne! How could I disappoint him? I want you, my gallant Jean, to take down a detailed record of the proceedings. So pick up all the books you can find straight away (especially the *De occulta philosophia* I told you about) & get here as fast as you can. Don't stop on the way to polish up the rumps of shepherds & inn-servants (you needn't bother protesting and cursing like a whorehouse madam: I know you do it, because deep down your soul is vulgar). Think instead about what will happen to you when you get back to Paris if after all your talk about being my disciple you aren't there at the Academy & thus miss the most important session of the year!

'Your
'Filippo Nolano.'

Between the cultured man and the uncultured one, it used to be said in Florence, there is a wider gulf than that which separates man from the beasts. No doubt it was for that reason that Henri, having got back from Poland and suddenly discovered to his surprise that he knew nothing about literature and philosophy, had wanted to give a new lease of life to the institution created under his predecessor by Jean-Antoine. It was of course modelled on the famous Italian academies, such as the one run in Florence by the canon and courtier Marsilio

Ficino. To this palatine or Henrician circle, as Cecil ironically called it, poets were admitted such as the very Huguenot Théodore d'Aubigné, or Jean-Antoine's old friend Pierre Ronsard, or indeed, when he wasn't ill, Jean-Antoine himself. With the exception of Ronsard, who with old age and deafness was now turning openly crotchety and jealous, none of the rhapsodes summoned to the court bore me any ill will, and that went for Philippe Desportes, the king's close friend, as much as for the others. This cheerful, ridiculously conceited artist who was responsible for keeping the Academy's list of rules, elegantly penned on vellum, had laughed heartily, he said, at my *Candelaio*. Perhaps he only made these kind remarks to please his prince, but in any case he never stopped protesting his feelings of friendship for me. The same could not be said of those whom le Valois had appointed to instruct him in cosmology and philosophy: Bishop Pontus de Tyard and that idiot du Perron. Those two would have given any money to have me vanish from Henri's sight.

The sessions were held in the king's chambers in the Louvre. And so that was where I was bidden to go on that Tuesday in the spring of eighty-two, at four o'clock in the afternoon, and I remember that a divine sun was shining radiantly down on the world, as on the day when, as a young student, I had set off for Rome to meet Pius V. My goodness, how insignificant these ceremonies and exchanges of chatter with princes seem, viewed from the depths of a dungeon in a spirit of philosophical wisdom! And yet they remain for ever engraved on our memory, like those moments of happiness which, when all's said and done, justify the most insignificant of human existences. I went there accompanied by Cecil, grandly arrayed in a black outfit complete with plumed hat, Giovanni Moro, who to mark the occasion was sporting an astonishing pair of brilliant red stockings, and Jean Hennequin. He, as ever, was carrying his writing-case, and also a map of the sky which he himself had produced. Painted on a canvas that measured six feet across, it was carefully rolled up, like a huge, precious scroll of parchment. I was holding in my hand the copy of *De umbris idearum*, leather-bound in the

Milanese style by an artisan in the rue Saint-Honoré, that I intended to present to Henri. I was so afraid of being late that I forced the whole of our little troop (all the lackeys from the embassy had joined us) to leave the rue des Vieux-Augustins at three o'clock. We went on foot, walking as slowly as possible, and got to the Louvre fifteen minutes later, which enabled that rascal Cecil to poke fun at me in the most cruel and spiteful manner, vexed as he was by the presence of my disciple at my side. The only person who was not there for the great event was Jean-Antoine: he had gone to have a rest at Ronsard's priory in Saint-Cosme. As for Ronsard himself, he had flatly refused to come and hear me, and was putting it about everywhere that he had no time at all for my religion or my infinite heaven.

Henri III looked to me like a man who was very elegant but in extremely poor health. His eyes were weary and glazed, and his face was covered with pimples, some of which were suppurating. It was said that his head was shaved, and that was why he wore a skullcap, which in turn was covered by a bonnet; this lengthened his head and made him look so much like a horse that for a split second I could see him as a character in some future dialogue or comedy of mine, bald and neighing like a hysterical old nag. Oh Lord, what an inner struggle I had to keep that rush of imagination in check and drive such untimely images out of my mind! This sovereign, criticised by the Catholics and abhorred by the Protestants, was already, as Moro put it in a whisper the moment we left, *wearing his own mourning*, and I was not at all surprised either by his dark attire or by the tiny deaths-heads embroidered on the facings of his doublet and the ribbons on his shoes. Rumour had it that he loved jewellery and all sorts of other trimmings. Indeed his chest was adorned by no fewer than four rows of pearls, and his ears by drop earrings.

The gathering was made up of artists, scholars, Catholic priests, courtiers of both sexes, and dogs. Henri, it was said, owned more than three hundred dogs of various breeds, not to mention his other animals, and there was no longer a single woman in court circles who did not go around with a nasty,

vain, plump little lap-dog, usually with a preposterous name, to which she devoted endless love and attention. All the women had one on their knees, and so did several gentlemen. To the right of the king, I recognised Philippe Desportes, smiling more affably than ever; to his left, to use an expression that had all the aroma of Parisian patter at that time, the arch-*mignon* of the moment, one by name of Joyeuse, who in terms of dress was an exact replica of his master. A little way behind him sat the fabulously wealthy François d'O, once a favourite but now accompanied by his wife, for he had recently tied the knot. As for the inevitable du Perron and Tyard, needless to say they were staring at me in the most hostile way imaginable.

Bowing before his prince, Desportes declared:

'Does one not need the courage of a god or a demi-god, Your Majesty, to mount an assault on the firmament and on light? How many men have dreamt of breaking through the clouds and reaching the ethereal regions where the secrets of the universe are hidden? He who appears today before your Academy has not been afraid to yield to that ambition worthy of a celestial warrior . . .'

With a graceful movement of his index finger, Henri interrupted this gibberish. The poet took a step to one side and leaned over to catch the royal whisper. With a nod of approval he turned to me and continued, smiling broadly all the while:

'His Majesty would like to draw the attention of his learned guest to this: the Royal Academy has its own clerks (he pointed at a pair of mocking scribes leaning on their desks). It is therefore unnecessary for your secretary, my dear Bruno, to go to the trouble of copying the minutes of the session . . .'

Poor Hennequin stood there petrified. Respectful of my instructions, he had indeed begun, with his customary care, to record what Desportes was saying. His long pen now seemed to be suspended in the air, and it looked as if he was trying to act out some divine allegory from Scripture. Cecil, for his part, was jubilant . . . I opted for a firm approach:

'His Majesty will forgive my boldness: the Palace Academy has its clerks, and I have mine. Furthermore, this man is no

mere secretary; he is above all my disciple. Jean Hennequin is his name. He plays a part, if I may say so, in my work . . .'

A murmur ran through the audience. Was it because of what I had said or my *oh so provincial* accent? Joyeuse burst out laughing, as did the women present, thus waking up their dogs, several of whom gave high-pitched yelps. As for the king, he merely lowered his eyelids.

'Let us continue,' he ordered quietly.

Desportes went on:

'So, as I was saying, courage. And ambition. Not the sort of hunger, Majesty, that drives commonplace men to court honours or seek to gain the favour of princes by flattery; but an ambition, let us see, how shall I describe it? One that is natural! Natural to certain individuals, a favoured few among the best, and whose often cruel destiny consists in embracing the mysteries of the physical and metaphysical world. Giordano of Nola? A celestial archer, Majesty, a Hermes with winged sandals who fears not to break open the old spheres of the firmament to reach the stars he holds so dear. Today he is going to present his sky to your Academy, and describe for us what he has seen up above. May I be permitted, Sire, to hope that we shall not presently find ourselves having to sing:

> *In this place fell young Icarus the bold,*
> *In heav'nward flight his wings he did unfold;*
> *Here fell his body, plumage strippèd all . . .'*

Moved by his own rhymes, Desportes broke off for a moment; then he concluded:

'*Leaving all brave hearts envious of his fall.* The quatrain, if Your Majesty will forgive me, is mine. Your Majesty will have recognised it in any case . . .'

His Majesty gave an indulgent smile:

'It is delightful,' he said approvingly. 'And now, let us listen to the Italian doctor.'

Everyone sat down. I began:

'Indeed, Your Majesty, I am by no means lacking in either

boldness or courage, because my father is a knight who, for the honour of his prince more than for the wages he receives for it, defends the Catholic faith on the borders of the Kingdom of Naples. As for me, I am excommunicated. Must the son be exactly like the father? Some say he must. But in that case, how can he be the son? This is my belief, Your Majesty: the son will be to the father what the light is to the darkness, given that light is born from darkness, and day from night. From rest is born movement; from ignorance, knowledge; from tears, laughter; and often from love – the only riches we possess in this world – the misery of suffering and death. If Your Majesty will excuse my paradoxes, what is every minute of life other than a corruption, a destruction of life? I hold that in this eternal struggle between opposites resides the supreme Unity, invisible to commonplace minds, but accessible to philosophical ones, who alone have the power to gaze on the blinding light of wisdom. Perhaps, as was observed a moment ago by our poet of such great gifts, yes perhaps I shall soon fall, with my head, I beg your pardon, my body, stripped of plumage, like a bird whose wings have been burned by the sun. But was not the divine Socrates overcome by the light that spurted forth from his brain, a victim in a sense of his own qualities and thoughts?'

The king's powers of attention were excellent, I noted amid the silence that reigned for a moment, and his pleasure was obvious. His face bore no trace of boredom or suffering. Was my fine speech giving him release from his torments? I wondered whether he would be so ready to accept my views on cosmology. Hanging from a high easel, the map painted by Jean awaited only my pleasure to be unrolled and reveal its mysteries . . .

'The sage is he who seeks. Not so that he can shut the world up in the prison of his ideas, but in order to receive the sparkling universal light of life. This sky (I pointed to the easel) which today is disturbing people's minds, arousing the hatred of sycophants, worsening the bestiality of the common people, adding to women's disdain and making dogs bark, I discovered within myself, Your Majesty, amid the most

troubling emotions of childhood. One day, as I was leaning over a pond in the depths of a forest, I saw space reflected in it; and that mirror became the proof of its infinity. Later, my adolescent soul echoed to the terrible hubbub of libraries, that din of dispute that reaches us from the earliest times, before Moses or Adam; and time in its turn became increate, infinite. Finally I looked up at the firmament, and it seemed to me that the orbs on which bogus scholars had maintained that the stars were fixed were purely imaginary; if the infinite manifested itself in me, why should it be absent from the celestial ocean which was the dwelling-place of God? Every night, wrapped up in a blanket, I filled the margins of my books with notes and coined the syllogisms of the future: the world is the effect of God; the cause of that effect is infinite and perfect; therefore, whatever Aristotle's supporters say, the effect of that infinite, perfect cause will itself be infinite and perfect. Not long before I was born, Your Majesty, a German canon produced a little book in which he demonstrated that the world was not, as ignoramuses and commonplace minds chose to believe, the fixed centre of the universe, but one star among others, turning like them round and round the sun, the source of all life. I adopted his doctrine of the movement of the stars, then added the finishing touch to it by adding my own, thus finally inventing the new dwelling-place of God and men, that is to say a universe which is increate and infinite, moving like a river and filled with innumerable worlds . . .'

With these words, I unfurled my map.

Around a golden yellow star which contained the twelve gods of the horoscope, represented by the signs of the zodiac, Hennequin had drawn on a lapis-lazuli background the vast concentric circles of the Copernico-Brunian sky, each one indicating the immaterial orbit of a planet shown by a circle with its name beside it: *Saturnus, Jupiter, Mars, Terra*, with its crescent *Luna*, *Venus* and *Mercurius*. There was no sphere of fixed stars, no barrier, wall or covering to limit this world, nor was there any empyrean heaven. Thanks to the talent of Jean, who had dotted his canvas with unicorns, centaurs, salamanders, cherubs and most skilfully drawn clouds, it appeared

to be wandering through a firmament peopled, like an ocean, with a thousand generous souls.

The king, who had stood up, wanted to get a closer look at the world, and went over to the picture. Everyone, Desportes, Joyeuse, Moro, d'O and his wife, lords and courtesans carrying their dogs followed him as one man, joining together in a single, harmonious movement . . . Everyone? No, du Perron and Tyard chose to remain in the background . . .

'This,' enquired d'O, pointing an index finger at the third orbit, 'this is the earth, is it?'

'Indeed it is.'

'So,' continued Joyeuse, 'when it gets to this point, we're upside-down! Lord, how amusing it is! But one simple question, sir: how is it that we don't fall off?'

'Because we belong to the earth,' I replied, 'and to its movement. Each planet has its own top and bottom. These terms do not exist on the universal scale.'

The Academicians showed their incredulity by smiling and looking perplexed. Henri gave a little cough.

'Even if there is no top or bottom on the universal scale,' he began in an oddly feeble voice . . .

The whisperings died away immediately. Du Perron and Tyard came closer. Hennequin's pen stopped scratching on the paper.

'. . . there must surely be a centre of Creation . . .'

'Forgive me, your Majesty, but on the universal scale there is no centre either . . .'

'No centre,' breathed the king.

Every neck was twisted to hear what we were saying to each other more clearly. Luckily, Henri was turning his left ear – the good one! – towards me. Without raising my voice I explained:

'Yes, Sire. Man is the centre of a creation which has no centre.'

'And how do you explain the existence of this latest paradox, my dear Nolan?'

'The point is, Sire, that the *Centre* is not physical, but metaphysical.'

Hennequin was copying down this conclusion.

'I understand,' said the king, nodding his equine head.

And then he immediately corrected himself:

'I think I understand. In any case, I like it. What do you think, Tyard?'

The bishop wormed his way through to us. Skilfully, he too positioned himself windward of the good ear. Then, all smiles, he stood with his hands crossed and looked at the map of the sky as if he were gazing at a Madonna and child.

'We have heard a remarkably fine speech,' he began. 'But is a fine speech the same thing as science? And is eloquence the same thing as truth? In my humble opinion, Sire, the Neapolitan doctor's sky is a poem.'

Still studying my zodiacal sun and the azure sky with the planets floating in it, he spread his hands and added:

'A superb poem; but a poem nonetheless.'

Henri smiled in his turn and gazed questioningly at me. Catching the look in Cecil's eye, I decided that there was no point in shouting. I must shut this bishop up, but without creating a commotion. I remained perfectly calm.

'What this philosopher means, Sire, is that I would have done better to express myself in Latin, and preferably in an abstruse Latin peppered with off-putting expressions such as *impetus*, *epicyclus*, *sphaera immobilis fixarum*, *primum movens* and *decimum caelum*. But in my opinion that sort of language is the language of the ignorant. Worse still, it is an insult to natural language. Language is a divine faculty, and whoever insults language insults God. I have spoken to Your Majesty in simple, precise words, and Your Majesty has heard me. That these words are poetry is no cause for amazement, still less for indignation, for a truth that does not coincide with beauty is a bogus truth, a pedantic piece of nonsense, of no use at all except possibly to mislead the common herd, women and children.'

The king was delighted.

'Giordanus Brunus Nolanus,' he said, with a mischievous look . . .

'*Magis elaborata theologia doctor*,' I concluded with a bow.

'Tell us, why is a man with a mind as appealing as yours not teaching at the Sorbonne?'

'Sire, the position of an ordinary reader there involves attending the divine office. And I do not go to Church. Furthermore, I have been excommunicated . . .'

'Can the Church not go back on an excommunication?'

'It refuses to. And, if Your Majesty will permit me to say so, I am no worse off for it . . .'

Henri grew sombre, and frowned.

'How can one live without God?'

'Do you believe that God cares about our religions?'

'Ah yes, religions. You grew up in Naples in the Dominican order. Then you were a Protestant in Geneva, and a Catholic again in Toulouse. After all that, what is your religion now?'

'It does not yet exist, Sire. But if ever it does see the light of day, it will not be like any of those that are doing their utmost these days to wield the sword, cut off heads and burn books . . .'

'And what do you make of heresy, Brunus? Is it not the scourge of this century? A plague that infects people's minds? When this disease spreads in a city, are not the authorities right to declare war on it?'

'Heresy means freedom of choice, Your Majesty. The word comes from Greek. *Hairesin didónai*: to give the choice. Let everyone practise the religion he loves, without doing harm to others . . .'

Henri turned towards his friends: d'O, Joyeuse, Philippe Desportes. They all seemed to be worried by the turn that the conversation was taking. The poet had stopped smiling; had I wounded him in my speech? As for Tyard, he was still trying to stomach the punishment he had taken.

'What strange opinions,' declared the king. 'My mind is quite overwhelmed by them. And yet I like the man who utters them . . .'

'We like him too,' declared Joyeuse, relieved.

'I can see only one solution: to create a position at the Sorbonne as an extraordinary reader . . .'

'I humbly thank Your Majesty. And since my opinions

seem to interest Your Majesty, may I be allowed to offer this modest gift . . .'

Opening the copy of *De umbris idearum*, Henri could see that it began with a letter addressed to him. A caution in verse warned the reader of the difficulties he would have to contend with if he hoped to achieve some degree of wisdom.

'Does this book contain enigmas?' asked the king.

'I shall explain them, if Your Majesty will allow me to. I also have a letter here, concerning me. It is signed by one of your gentlemen . . .'

'Monsieur de Montaigne!' he exclaimed after he had read it through. 'Do you know him then?'

'He is a friend of mine, Sire.'

'One of the finest minds in the Kingdom . . .'

Having said that, Henri embraced me affectionately. In front of his court, he showered me with compliments of the most agreeable kind. When the time came for us to part, he slipped into my hand a purse of a thousand crowns.

To this day, I believe, people still remember the stir that my first lectures at the Sorbonne created. Right from the start they attracted a larger audience than the room could hold; every theologian, scholar, astronomer, Lullist magus and poet in Paris demanded the privilege of hearing me argue against Aristotle. I was given a rapturous reception, although a few voices were raised in opposition to my arguments; some of these people became so passionately aroused that they forgot all civility, and on several occasions the guards had to be brought in to calm them down, since they were in danger of starting battles worthy of my finest hours in Naples. During this time *Il Candelaio* and *De umbris idearum* were being snapped up in the rue Saint-Jacques, and Gilles the bookseller was speeding up the production of the *Cantus Circaeus*. One evening Cecil, Baïf, Jean Hennequin and I were celebrating my budding fame by emptying a goodly number of bottles of Gascon wine when Prospero came in in the middle of the meal and brought me a *billet doux* written in His Majesty's hand.

'My dearest Jordanus, I have lived less unhapilie after a certain day when you came to present your sky to my Academy & manny a time since the desire has come upon me to hear your fine words once more. Our Lord is my witness that I never doubt His infinite mercy, but why is it His will that I should be condemned to suffer continual cares and torments? Do you know that I would like to have you all to myself sometimes, for I feel that in calming my soul, your precious, well-tuned words would bring me closer to God. Having chosen to make a pilgrimage on foot to Notre-Dame de Chartres which is twenty leags from Paris, I have returned so exhausted that I have had to go to bed for several days & take medecine. I have been told that some beautiful phrases would be sure to help me chase away my sufferings. Would you be so good as to accept my affection & come, as you promised, to explain to me the enigmas in your book & your famous shadows of ideas which the hole of Paris is talking about?

'Henri'

Each of us examined the note in turn, and Jean observed that you could see how fatigued and melancholy the king was, even in his shaky handwriting.

'And his spelling,' added Cecil.

'Never mind the spelling!' retorted Baïf, who was beginning to get drunk. 'The rules need to be reformed. Just like the rules of poetry! Yes, a little more wine, if I may. For my part, I think that the royal familiarity with which our Philip is favoured augurs extremely well . . .'

How was I to respond to this note? By going to the Louvre the following day, suggested Cecil.

Henri received me at his awakening, wearing nothing grander than a dressing-gown, bareheaded and sitting on his commode. Tears had left gleaming traces on his cheeks. When he saw me, he did his best to regain some semblance of majesty, but his whole being was marked by the war he had been having to wage against the demons of solitude and insomnia. Footmen with deadpan expressions wandered

round and about; at the king's side was a doctor, who was clearly reluctant to go away and was staring discontentedly at the king.

'I have refused to be given another bleeding,' sighed Henri. 'I'm too tired.'

The smell of his breath turned my stomach.

'Do you want a little wine?'

'Has Your Majesty done?' interrupted the doctor before I had even answered. 'May I have a smell?'

With the help of a footman the king rose to his feet, and while the medic was leaning over his doings to breathe in their odour, he gave me a long, affectionate look. Then, opening the sides of his dressing-gown like wings, he placed his buttocks on the commode again. The doctor grunted that a smell like that was a very bad sign indeed, and noted down a few words in a record book; after which he began putting away his instruments and bowed his way out with an ill grace which I thought was most disrespectful.

'Their latest bright idea is to stick my head into a dead bullock's mouth!' Henri went on, almost weeping and taking my hand in his own. 'What do you think of doctors, my sweet Jordanus?'

'They're not all ignoramuses, Sire. I knew an excellent one in Geneva, a follower of Paracelsus . . .'

As if regretting that he'd asked the question, he immediately cut me off with a gesture:

'No matter. There are already too many of them buzzing around me like flies. Thank you for coming. I was assured that a friendly voice would bring me relief . . .'

'Does Your Majesty wish me to converse with him on any subject in particular?'

Was he cold? Was it because he was anxious? The prince was trembling like a leaf . . .

'We only have a few minutes,' he sighed. 'Soon the others will be here as well.'

'The others?'

'Joyeuse, Desportes, my mother. Oh well, I do love them so much . . .'

198

He was squeezing my hand harder and harder; I could see his eyes filling with tears.

'And you, Jordanus, I love you too. Do you think they'll let us become friends?'

'That's entirely up to you, Your Majesty.'

'Yes, yes, you're right. Talk to me. I'm listening. We are about the same age, aren't we?'

'There are three years between us.'

'Where were you born? I've been told but . . .'

'In Nola, Your Majesty, in the Kingdom of . . .'

'Those images you describe in your beautiful book, what do they mean, tell me . . .'

'Kingdom of Naples . . . Those images? Well, Sire, they are the astrological symbols that were used a very long time ago by an Egyptian sage called Hermes Trismegistus. And the importance of those signs is that I can use them to reconstruct the entire universe inside my own consciousness.'

'The entire universe . . .'

'Man is the *Centre*. Did I not tell you that the other day? A centre that is not physical. He lives within an infinite abyss that moves and is filled with innumerable beings and worlds, and he carries within him another abyss very much like the first.'

'But those images . . .'

'They must be arranged mentally in the middle of a wheel which has the letters of the alphabet inscribed on it.'

'The art of memory . . . Where did you learn it?'

'At the monastery, of course. By reading Ramon Lull and Peter Thomas of Ravenna.'

'Things like that fill me with terror.'

'You have nothing to fear, Majesty. Those signs are the shadows of ideas which give their form to beings. Picture the universe as a vast, immeasurable forest, seen through the eyes of a child, in which everything appears to have been thrown into complete and utter disorder. To encompass the way in which this All is ordered, you must start from those signs, for they are shadows or reflections by which the intention of God and nature is made manifest . . .'

The king was trembling more than ever. His hands were ice-cold. Closing his eyes, he murmured:

'Go on, my brother. Go on.'

'My images are meant to be imprinted on the memory. Thanks to them, you are in *sumpathia* with Knowledge. As the wheel turns, it allows for infinite combinations of words and letters, and calls up a mental picture of the concentric circles of the three worlds: mineral, vegetable and animal. The first is composed of the primeval rock that harbours fire, the second of all possible plants and the nutritional, aromatic and medicinal benefits that flow from them, and the third of the animals that Noah carried off in his Ark: the serpent with the venomous tongue, the stupid ass, the clever monkey immured in silence, the butterfly drawn to the light, the placid elephant, the bird that stood on its head, and the worm that the bird swallowed. On another circle, man and his many occupations will appear: pottery, weaving, wool-combing, cobbling, masonry, metallurgy, printing; the arts and sciences; architecture, painting, mathematics, astronomy, medecine, magic and its daughters, that is to say necromancy, chiromancy, pyromancy and hydromancy; finally, the virtues and vices: courage, eloquence, skill and cunning, of course, but also cowardice, deceit, scandalmongering, theft, blasphemy, prostitution and . . . sodomy. As for the last circle, Majesty, it will show a sort of procession, a whole series of figures who are famous for the good they have brought to the world with what they have created, Abraham with circumcision, Chemis with the worship of the dead in the pyramids, John with baptism and most of all, Majesty, most of all: Thoth the Egyptian sun-worshipper who invented writing, without which we would be like poor blind men wandering along a path strewn with pitfalls, whereas thanks to its existence we can not only see what nature and the destiny of every man are composed of, but also find our bearings and re-ascend the chain of being to the infinite heavens, so that we may gaze on the divine light . . .'

'Is this magic?' murmured the king without opening his eyes.

'A salutary magic, Sire.'

'Du Perron claims that your memory is unnatural, evil and contrary to the teachings of religion.'

That conniving holy water sprinkler was in for it now; I smiled at the king who was watching me.

'Apparently du Perron has an excellent natural memory, Your Majesty. I am sure the advice he gives you is useful. But he has not studied the *ars memoriae*. With the help of my images, you will be able to reconstruct within yourself the perceptible and intelligible world, the good and evil actions of men, even their dreams and secret desires . . .'

'Can you predict the future, Jordanus?'

'The future is written in the events of the past, Sire.'

'Where I am concerned? Tell me . . .'

The door opened and a footman announced the arrival of Joyeuse and Philippe Desportes. The two men entered before they had even been given permission to do so, and came over to us, smiling broadly. Henri had not budged from his commode, nor I from the stool I was sitting on to his left. The king was still clasping my hand between both of his.

'His voice and his remarkable opinions are doing me good,' he said to the favourite. 'They disturb me, and this disturbance gives me strength.'

It was true: he looked better than when I had arrived.

'That is often the way with those whom we love,' Joyeuse replied amiably. 'But there comes the day when we love them less; and then the disturbance makes us weary.'

'*The lover, once content, is full of fury,*' added Desportes, quoting himself as was his wont. '*Thus underneath the sky do all things vary . . .*'

'May I withdraw, Majesty?'

'Answer my question first . . .'

'What was the question?' enquired Joyeuse. 'Is it a secret?'

'Not at all,' said the king. 'Answer, Jordanus. Please . . .'

'Here comes the queen-mother on the way back from her mass,' announced Desportes.

The two men bowed. I took advantage of the opportunity to free my hand from the royal grasp, and rose to do likewise. Henri did the same, in one dextrous movement by which he

admirably contrived to avoid any immodesty. *The Widow*, as Cecil called her, was robust, severe, and dressed all in black. I noted that there was nothing melancholy about this woman. She seemed to have the strength of a warrior, and the soul of a man, perhaps. Having embraced her son, she exclaimed:

'The Neapolitan doctor! Do you know, I laughed at your comedy.'

'You do me honour, Madam.'

'However I am told that you are starting riots in the Sorbonne, and that doesn't please me at all. You are stirring up the common people, it seems to me, without realising how dangerous they can be.'

'The people do not attend the Sorbonne, Madam. There are only doctors and philosophers there.'

'Philosophers who are having fist-fights in the rue Saint-Jacques! You are making their heads spin by forcing them to despise religion, after which the idiots are taking it out on the soldiers of the watch.'

'Forgive me, but when it comes to picking a fight the halberdiers are just as . . .'

'A piece of advice, *Monsieur le Napolitain*: stick to making people laugh, or you too might get a taste of the cavesson one day, like the grammarian in your *Candelaio*. The cavesson or the flames . . .'

Monsieur le Napolitain! As we all know, it is a peculiar characteristic of the Florentines that they despise everyone else in the world. Well then, Cecil was quite right: this *widow* was nothing but a Catholic viper, like all the Medicis . . . I replied:

'There is nothing more philosophical than laughter, Madam. And if you were able to feel it come upon you thanks to my *Candelaio*, that was because a flash of wisdom went through your mind. I am delighted. Between that laughter and the enthusiasm that my lessons at the Sorbonne are arousing, there is no intrinsic difference . . .'

'*Intrinwhat?*' hissed Catherine, looking questioningly at Desportes.

He flushed crimson. Joyeuse, for his part, was laughing up

his sleeve. Fat ignorant woman, I thought, turning towards the king.

'May I withdraw, Sire?'

'Will you answer my question before you leave?'

'Yes. If Your Majesty will grant me permission to embrace him . . .'

Henri opened his arms to me and I pressed myself to his chest. While he was clasping me in his arms, I moved my lips close to his good ear and murmured:

'With regard to your future, Majesty, just one piece of advice: beware of priests.'

And that was how I became the only magus either in Paris or the world ever to utter an accurate prediction concerning this sovereign.

Despite the hostility of Catherine and a large part of her entourage towards me, Henri kept up his affection for me until the end of the year, and after that second meeting, I visited him almost every month. We conversed on various subjects to do with philosophy, magic and politics, and I even dealt from time to time with his health, so little confidence did the doctors who were in his service inspire in him. All I needed to do on those occasions was to recall the teachings I had once received in Geneva, owing to my friendship with Jean Pruss.

One of le Valois' obsessions at that time was his lack of an heir. At first the queen, his wife of seven years, had been accused of being sterile, and she had been afraid for a while that she would be repudiated if she did not succeed in giving Henri the son that the court was hoping for. Then suspicion fell on the person of king, given that he was not known to have any natural children, and that he was in the habit of surrounding himself with boys and showering them, as Cecil said, with *kisses and sweet words*. In the end his enemies whispered that he was infected with a *mal francese* that he had caught in Venice, and that that was the cause of his incapacity. I knew from Cecil that he had indeed frequented several courtesans there, but the king, for his part, denied suffering from this disease.

'I've already got more diseases than I need!' he would sometimes exclaim. 'Do they really want to inflict yet another one on me?'

Like Montaigne, he suffered from stones, and like Jean-Antoine, from haemorrhoid attacks which kept him bed-ridden for several days at a time; not to mention the countless abcesses, bleedings, headaches and earaches, attacks of indigestion and colic which poisoned his existence. In addition to the ills that resulted from his sickly constitution, he had others which were caused by the treatments he received from the quacks. To cure his sterility, they forced him at first to drink she-donkey's milk, which made no difference at all. Then they observed that the end of their patient's *mentula* was hooked, in such a way that the sperm, so they argued, was not carrying through into the woman's womb, but flowing back out instead. We're going to straighten it for you, Sire, they assured him; and, with that aim in mind, they had chopped into it with a lancet. One can imagine the pain that had resulted from this fine piece of surgery.

'What do you think?' the king asked me one day, after undoing his aglets to show me his poor member.

I was horrified: there was a far simpler method after all!

'Is there? Almighty God, what is it?'

I advised him to collect the royal sperm in a silver bowl and then straight away get a doctor to introduce it very deep inside the queen by means of a clyster-pipe. In that way the semen would not go to waste any more. As for His Majesty, he would no longer to have to give himself over, like an animal, to the act that was necessary for the reproduction of the species. I told him that nature sometimes made mistakes, and that it was entirely up to man to remedy them by simply using his ingenuity . . .

'But I like possessing my wife!' exclaimed the king.

'*Andiamo*, Sire. *Andiamo*.'

When he was not ill, Henri became the best of companions, a cheerful, cultivated man, as well as an excellent pupil, and I believe he had more goodness in him than my Venetian friends were willing to admit. Certainly it was hard

to forget the horrible massacre that he had unleashed under the pretext of punishing the Huguenots, and the thousands of innocents who were put to the sword or drowned in the Seine, but to what extent was he responsible for that crime? He protested, weeping, that he had not meant it to happen. Shouldn't it in all fairness be put down to the Widow? Wasn't she much more experienced at that time? And didn't the ferocity of her sex speak against her? On this point opinions were divided in our group. Moro defended the Medici woman. Cecil, for his part, despised her, but could not quite bring himself to excuse Henri. I, on the other hand, was inclined to argue in favour of the prince. To be sure, he did sometimes get lost in the vagaries of his erring Catholic ways, but was it not clear that in his heart he was anxious to be a good king, a king for whom philosophy would be politics, and politics philosophy?

'Are the virtues natural?' he was always asking me. 'Is it as easy for man to act well as for the earth to turn around the sun?'

'Natural? Yes, no doubt they are.'

Then I reflected on the century we were going through, and thought it prudent to correct myself straightaway:

'Less so, to be honest, than the gyration of the earth . . .'

In response to future chroniclers who might ask if I was in love with Henri, I answer in advance that I was not, and I hope that I will be believed, because, as everyone is aware, he who knows that he will soon breathe his last is loath to lie. For seven months, it is true, I was held in such esteem by le Valois that he did on occasion tell me some most important secrets, even though he knew of the close links I had with the Doge's ambassadors (was I not, when it comes down to it, the most active of all Cecil's *flies*?). I have told how he had created an extraordinary chair as a salaried reader at the Sorbonne for my benefit. Also true is the fact that he heaped money and gifts on me in return for the benefit he drew from our conversations, which in reality were lessons. He usually listened to them with his eyes shut, so much did he like the timbre of my voice, the universality of my memory, and the virtuoso skill

with which I invented words and phrases and intermingled not only the different Italian dialects, but also Latin, Greek and French (despite Cecil's repeated efforts, English and German remained a closed book to me). Yes, all that is true. But although Henri had opened the doors of intimacy to me, and circumstances would have lent themselves to it more than once, love did not spring to life between us. The truth, I repeat, is more simple; he loved my philosophy, and I was happy and proud to instruct a prince: all the more happy and proud because this prince turned out to be an extremely good pupil, himself endowed with an excellent memory and an unshakeable attachment to the arts, beauty and the philosophical virtues.

The only feeling I ever had for the king was that known as friendship, and those who peddled rumours to the contrary as far as London were merely obeying, either wittingly or unwittingly, the orders of the Medici woman. She, being a good Florentine, was a past master at producing false rumours, and that was precisely how she had worked out that she could keep her hold over her son, by fanning the ever-smouldering flames of discord between his favourites.

When, at the end of the year, Henri gave me the cold shoulder, because of the embarrassment, he said, that keeping company with a figure like myself was causing him, I did not doubt that such a fall from grace came straight from the Widow; but it did not cause me any pain. My resolution was to retain my affection for the king and never cease to defend him. I wanted to remain faithful to a certain letter written in praise of him, which, whatever happened, would appear for ever more in one of my works.

Of the events that had driven Henri to banish me from him, by no means the least was the riot that was started at the Sorbonne in November by the Catholics of the League. A sizeable crowd had sung a *Te Deum* in Notre-Dame that day. This office was followed by a procession, planned by Joyeuse and made up of virgins and young boys, Knights of Malta, Minims, Capuchins, and blue, grey and white penitents. The

cortège crossed the Seine so that it could parade its relics right over to the Grands-Augustins monastery. As usual, the citizens of Paris were forced to doff their hats to them, then kneel down and shell out good money to the priests to pay for their blasted indulgences. When the procession was over, a group of fifty or so hotheads from the League, to which the limping Felix had attached himself, decided to march on the Sorbonne where a large audience was crowding in to hear my lecture.

I did not witness the initial clash – an exceedingly violent one, I was told – because it took place outside. But the hubbub grew so quickly that I was forced to break off from what I was saying. The audience had turned towards the street where the shouts were coming from, along with the noise of fighting and the clatter of swords. The fear on many faces was plain to see: the attackers were numerous and better-armed. As for the room we were in, it was, as if by some deliberate plan, a veritable deathtrap. In no time at all the leaguers gained ground and came rushing in amid cries of terror and rage. I was to learn later that at that moment two students were already lying on the ground in front of the chapel, stabbed to death with a dagger. I yelled out:

'Will someone fetch the guards, for the love of Christ!'

'Do not take the name of Christ in vain, blasphemer!' they answered me. 'And long live the Pope!'

'Death to the heretic!'

I recognised Felix's voice.

'We're going to sew you into a sack and throw you in the Seine!'

'You'll have to come and get me first!'

For a split second I was back in the streets of Naples, reliving the fights I had had in the old days with the pimps . . . Why not admit it? A sort of intoxication took hold of me. By now the gallant Hennequin was trying to check the fanatics' progress, but to me it seemed inexorable. I came down from my rostrum only to find myself facing the man who had threatened me a moment earlier, a thickset, boastful, vulgar individual, (to my mind the quintessence of the sort of malevolent Catholic who is the enemy of letters and science),

207

surrounded by ruffians even uglier than himself, among whom I spotted Felix, with a knife dripping with blood in his hand and the Virgin round his neck. The leader of the band was brandishing a sword.

'So, Monsieur le Philosophe, you've insulted the host, the Holy Mother and the sacraments, and now you want to go around bragging about it?'

There were only a handful of us left now, prisoners, so to speak, of these rogues armed to the teeth.

'I have insulted no-one,' I answered. 'Be so kind as to let us out, or you'll live to regret it.'

'You're going out all right, but you're going with us . . .'

Were they intending to clap us in prison?

'Where are your leaders?' I asked. 'Do you know who you are speaking to?'

The papist burst out laughing. Keep this pig at bay, I thought, until the guards get here . . .

'Whoever you are, let me tell you that I am quite capable of giving you a thrashing that you won't forget for a while . . .'

He was still laughing uncontrollably:

'Where's your sword, you damned heretic?'

'Renegade!' yelped Felix the cripple.

I had no need of a sword; and besides, I no longer carried one. Grabbing hold of a chair, I took a long step forward. This took the other man by surprise, and he stepped back.

'So, with bare hands then!' he shouted at me. 'Like the beggar you are! Neapolitan scoundrel . . .'

'And you,' I retorted, still advancing, 'what are you but a sack full of shit with a feathered hat on?'

'Right, since we're talking about shit, I'm going to run my sword through his guts!' he roared, turning toward his men with his arms outstretched.

This stupid error just showed what a fine soldier he was: needless to say that was the moment I chose to leap forward and knock him senseless with a chair. At the same time Hennequin had the bright idea of hurling himself at Felix, thus dragging all my loyal supporters into the fray. Reinforcements arrived, then the local militia, followed by the king's bowmen.

Despite my protests, many leaguers managed to take flight, but some, including Felix, were arrested. As for the ring-leader, he regained consciousness and I ensured that he got his just reward and was taken off to the Bastille.

But the affair had fired people up in the area around the Sorbonne, and for several hours it was the scene of fights and disputes which in some cases led to fatalities. So it was that after dark, three fanatics thirsting for vengeance followed a friend of Jean's to the Porte Saint-Jacques. They disembowelled him at the foot of the ramparts, and his executioners plunged their arms into his blood, crying mercy to God and the Virgin.

In addition to the death of his friend, Hennequin paid a heavy price for this furious outbreak of religious violence. After the bowmen had gone, I found him stretched out on a bench, unconscious, with his head in his hands and his fingers covered in blood. I managed to get him taken by carriage to the rue des Vieux-Augustins, then entrusted him to the Venetian Embassy doctors who spared no effort in treating him. But his wound was so bad that Cecil and I had to take turns at his bedside for a whole week. As once before in Toulouse, I watched him lie there, consumed with fever and delirium. Several times he hovered between life and death. In the end he chose life – brave little Jean; but he had lost his right eye. Until his death four years later he had to wear a head bandage which was like a black line scored across his face.

How could I forget – I who forget nothing – that late December afternoon, with the sky greyer than lead, snowflakes swirling over the carriages blocking the Pont au Change, and a barely audible song being murmured by the beggar to whom I threw a coin?

> *I, Little Bridge, in my seat so fair*
> *Deep in the heart of Paris . . .*

I had expected, on arriving at the Louvre, to spend some time alone with His Majesty, but I was surprised to find

myself being shown into his chambers, where the meeting of the Academy had been held. There, in the half-light, I found the king conversing in a low voice with a man whom I knew by sight, but not by name.

'This is Michel de Castelnau, Seigneur de Mauvissière,' said Henri, avoiding meeting my eye, 'I expect you have heard of him, Monsieur Bruno. He is my ambassador to Elizabeth . . .'

Was that sudden 'Monsieur' due to the presence of the other gentleman? No, it wasn't just that, I noted as I listened to what followed:

'And this is Jordanus Brunus of Nola, who was one of my dearest friends. The fine philosophy he has invented has more than once assuaged my soul, and I must say that the patience he has shown in teaching it to me does him much credit. Perhaps he will explain it to you as well. I know that you have a great love of knowledge . . .'

Castelnau answered the compliment with a slight bow of the head. Henri went on:

'His religion, on the other hand, is far from commendable, and it is stirring up trouble in Paris and causing my entourage a great deal of anxiety. A simple peasant is free to choose his friends, my dear fellow; a king is not.'

His voice was barely audible, but there was no mistaking how embarrassed he felt at having to utter such words. I was quite well aware that he was constantly under attack from all sides, and that the lavish treatment enjoyed by his favourites had for a long time been putting his reputation severely to the test. An additional problem was that a recent poster campaign in Paris had accused him of selling the kingdom to the Huguenots and the English, with the result that there were rumblings of discontent all over the place from the common people, who in general were dyed-in-the-wool supporters of Catholicism. Henri said nothing for a while. Like silent shadows, footmen loomed up out of the darkness, coming and going around us to light the candles. Now Seigneur de Mauvissière spoke:

'I am sure I shall be a less gifted pupil than His Majesty, my

dear Bruno. But I am equally sure that we shall become friends. It is true that I am a lover of reason. As an ambassador, I believe that it is one of man's most precious possessions . . .'

Castelnau's voice was absolutely exquisite, and his gestures radiated an elegance that was just as delightful as the sound of his name.

'Such an opinion is much to your credit! And I don't think it is one that many of our contemporaries are willing to share.'

'You are most kind. And I may add that that comes as no surprise. Your reputation has gone before you to England, as you may know. Believe me, you are awaited over there with growing impatience.'

Suddenly a question burst from my lips:

'Do you mean to say, my dear Monsieur Castelnuovo, that the English are taking the trouble to read my books?'

'The ones who come to His Majesty's embassy are, anyway.'

This answer set my swelling heart ablaze with pride. Oh yes, I loved being published, read, listened to, commented on! I loved making people laugh, cry and feel afraid. I loved filling them with joy and anxiety. In short, I loved being loved. Wasn't that what my first debates at San Domenico Maggiore were all about? In challenging Aristotle, in breaking through the sphere of fixed stars, in opening up the heavens to infinity, what had I done but captivate and win over an ever more widespread audience? First in Naples, then in Geneva, Toulouse, Paris . . . And now, London? Why not? Would I have a . . . a particular role to play in England? At last the king looked at me. He was so full of emotion that his eyes filled with tears:

'Do you still love me, Jordanus?'

'I have written and published my admiration for Your Majesty, Sire,' I replied with a bow. 'And although this is a century in which everyone betrays everyone else, I am as yet very far from resigned to yielding to that vice.'

'Then that will make your role, as you call it, easier: I am giving you the job of convincing Elizabeth that I am not the brute she has been told I am . . .'

He too longed to be loved . . . He added:

'And you will take advantage of this visit to spread your fine doctrine in London . . . The English will like it, I am sure. Man is *The Centre*, you said, a centre . . .'

'Not a physical centre, Majesty. A metaphysical one, if you prefer . . .'

Filled with nostalgia at the memory of my lessons, the king was smiling, and at the same time fighting back his tears. Suddenly he opened his arms to me:

'Come, Jordanus, let us embrace.'

Cecil was overjoyed at the prospect of spending some time in England close to his family, in particular his younger brother, now a knight and a writer, whom he had not seen for six years. As for Jean, mercifully he had cheered up somewhat when the *Sanguini* had come and given a performance of *Il Candelaio* at the rue des Vieux-Augustins. And so we held one of those meetings *à trois* which we had taken to having since my beloved had given up hating my disciple. There it was decided that Hennequin and I would leave shortly after Christmas with Michel de Castelnau; Cecil would join us later. First he had to persuade the doge that the right place for him now was the court of Elizabeth, but this did not seem likely to pose a problem.

At the end of this conference, another subject claimed our attention: Felix. It turned out that he had stabbed one of the two students killed in front of the chapel during the attack on the Sorbonne in November. We learned from Giovanni Moro that he had just been proven guilty, judgement had been pronounced, and he had been sentenced to death by hanging. I thought of the prediction made by the officer of the watch at Saint-Jacques de l'Hôpital. But the magistrate had ordered that before being led to the gallows, the condemned man should be publicly tortured and have his hand cut off on the block.

'Appalling, futile suffering,' murmured Hennequin.

'What are you going to do?' Cecil asked me.

I sighed:

'Have we any money left?'

The farewell party we had held for Sanguino's actors, with music and a hundred guests, had cost us a fortune. Cecil opened a casket and got together a handful of crowns; he showed no surprise when I expressed the desire to sleep alone that night. Back home in the rue de Bièvre, I ended up staying awake all night. Prospero had lit a large fire in the hearth, and I kept it going myself as I sat there meditating in front of the flames, unable to stem the flood of my memory. It took me back to the San Domenico Maggiore monastery, to the years of study and the secret liaisons between the novices. I thought about Heraclitean time, which takes all and gives all; about the death of those whom we have loved.

I went out before daybreak. In a little while the sky would be light, and the dawn icy. My feet sinking into the snow with every step, I went off to the Conciergerie to find a guard whose name I had been given by Giovanni Moro. The man did not refuse the purse I held out to him, and promised that Felix would be strangled in his cell presently.

'The Spanish death,' grunted the guard, pocketing the money. 'This is a tidy sum for a nasty piece of work like that monk. Do you want to see him? Talk to him? At this price, I can arrange a meeting with him . . .'

'No. Just tell him . . . Don't tell him anything. But can I be absolutely sure that . . .'

'He will be dispatched before dawn, old chap. Word of honour.'

He will be dispatched before dawn. That sentence still rings in my ears as if it had just been uttered here, in the half-darkness, outside the circle of light around the lantern. Death is inevitable, not suffering. Will someone pay for me on Thursday morning? Deza, perhaps? He came at midday today, accompanied by the barber. While the latter was shaving me and cutting my hair, Deza himself served me some dried fish and wine.

'The times are changing, Bruno. I have studied a little philosophy and astronomy here in Rome.'

'A lot of good that'll do you.'

'Some Jesuits are saying that they are prepared to put their trust in the propositions of science rather than those of the Scriptures . . .'

'Then the Jesuits will end up at the stake too. Apart from Bellarmin. He'll always wriggle out of any difficulty, you can be sure of that . . .'

'I'm being serious!'

Dear God, how handsome I found him when he flared up like that.

'Yesterday I met some extremely learned people who know your books . . .'

'What did they tell you? That on Thursday an innocent man was going to be burnt? Did they shed a tear?'

'Your views are reaching a wider and wider audience! They talked to me about some astronomer in Padua, someone called Galileo . . .'

'Never heard of him.'

'He has heard of you. He agrees with you: the universe has no centre, and it is infinite. These learned people told me that he has perfected a telescope to help him observe the stars.'

'There's no need for a telescope! It's ridiculous! Divine wisdom can be seen with the naked eye. Another of these pretentious mathematicians, these inventors of clever devices . . .'

'Wasn't your Copernicus a mathematician?'

'Unfortunately for him, Deza. It was because of his obsession with arithmetic that he missed the essential point.'

'What do these details matter? Your doctrine is right! Why not agree to live and go on defending it?'

'Do you have a coin for this barber? I don't have any money on me, you see . . .'

Deza sighed. I gave him a bundle of pages to put in a safe place.

'Get them sewn together. Very carefully, so that none of them get lost . . .'

Deza promised that everything would be carried out according to my wishes. Was there anything else I might need?

'Time. I need time. And a pair of compasses.'

Night had fallen when Orazio brought me some bread, an artichoke and the instrument I had asked for. And now, my reader, my strength is abandoning me. Midnight must be long past. Images are fading away into sleep . . .

Monday, 14th February, 1600

It seems – not surprisingly, with the *somnus aeternus* drawing so near – that from now on the simple rest of the honest man is to be denied me; I awoke just now without having left the transparent surface of things, with my cheek on my hand and my pen at a standstill after the word *sleep*. Dawn had not yet broken. Cut a new sheet of paper, write a date on it . . . Today these actions which I have performed countless times during my fifty-two years of life require a superhuman effort. No sooner had I finished this humble task than Orazio the guard came in with a bowl of hot soup. He isn't sleeping any more either. He sits up all night behind the door, listening out for my slightest movements. Our enemies, he claims – I like that *our* very much! – will go on kicking up an enormous fuss today outside Tor di Nona. Led by the German Gaspard Schioppius, there are more and more of them every day, swearing that they will find a way of getting into the prison and cutting my throat here and now . . .

'Oh come now, they won't mind waiting until Thursday. And they won't have to get their hands dirty.'

'They're protesting that the stake on Campo dei Fiori creates martyrs, Brunus. Haven't I told you that already?'

More important, they are afraid that I may secretly be granted a pardon by Clement! Without a shadow of doubt these fanatics are under orders from Madruzzi and Santaseverina; they cannot be unaware that the Pope is working hard to convince me. What a snub it would be for them if the authorities were to make do with burning a mere effigy of their victim! But the punishment that my death will inflict on them will be even worse.

'Schioppius is the worst of them all.'

'Don't let anyone in apart from Deza, Orazio.'

'You needn't worry.'

I am not worried: in all my life I have never known fear.

And even if those howling dogs come into my dungeon armed with knives and clubs, I swear that I shall find the strength to stand up to them! This stool will serve as a shield, and a well-sharpened pen stuck into an eye can kill. But I would rather go on putting these objects to the use for which they were intended, in other words continue writing, since I have not finished summoning up the images of my existence. I do not know who you are, Gaspard Schioppius, nor what Teutonic pleasure you hope to derive from my torment, but you will have to wait until Thursday for that, for I am determined, stubbornly determined even, to die in accordance with the sentence pronounced against me. I want my natural destiny to be fulfilled. I also want to see my last book through to its conclusion. In case you ever read these lines, let me tell you that I have loved discord more than you love your non-existent god, your god of rogues and wretches. For half a century I have never been afraid to do battle. But I only came to blows when I was compelled to by force of circumstances, by the hatred and stupidity of my enemies. My real arguments are contained for all eternity in thousands of pages; study them. If nature has endowed you with a small amount of intelligence, reflect on this: while I was writing them, the cardinals, those corrupt masters to whom you are lending your services today, were setting out to bring peace to the world by means of the sword, the arquebus and the cannon.

All I knew about Cecil's younger brother when I arrived in London was his name: Sir Philip Sidney. According to Castelnau this knight combined all the best qualities, both human and divine; he ranked among the most elegant personages at Elizabeth's court. When he turned up at the French Embassy a few days after we landed at Dover, I was struck both by his extraordinary resemblance to my beloved and by his melancholy beauty, which beggared the imagination.

'Do you know our language?' he asked me in perfect Tuscan.

'Only a few words. It seems that my Neapolitan accent ruins every sentence I utter . . .'

He smiled:

'That's not what Cecil wrote to me.'

Needless to say it was a trick they had planned in advance. Castelnau was looking at me with affectionate benevolence. As for Hennequin, he remained impassive, his face half hidden behind his black head-bandage. He knew nothing about it.

'And could we hear this famous accent?' intervened the friend who had come with Philip, a Protestant lord called Fulke Greville.

At that moment I recalled with some emotion my English teacher in the rue des Vieux-Augustins, writing with chalk on the board carved with a motif of putti. Anxious not to make a fool of myself in the presence of such refined ears, I declined. They insisted. And so I began, puffing out my chest and doing my very best to correct my inborn failings:

'*Den farrewel world, dy uttermosht I shee* . . . Ah! No, really! I'll never manage it . . .'

'*Then farewell world,*' repeated Greville, closing his eyes, and in the most musical voice imaginable, '*thy uttermost I see, Eternall Love maintaine thy life in me.*'

As he spoke, his fingers, emerging from his embroidered cuffs, were twirling to the rhythm of the lines.

'Oh dear,' he sighed, feigning consternation, 'this is very worrying indeed. I'm afraid a shortcoming like this may well spoil your stay here . . . You still have a great deal to learn . . .'

Speaking to his friend he added:

'As for the poem, well, it's rather a good choice. What do you think of it, my dear fellow?'

I interrupted at that point:

'Don't ask me, I don't even know the name of the blighter who's responsible for it! But it's nearly dislocated my jaw on more than one occasion! As for what's been achieved by it, I'll let you be the judge of that! Signor Castelnuovo, don't you think we should all sit down and move on to another subject over a little wine?'

'The poem is by me,' said Philip Sidney.

In my surprise, I immediately replied:

'In that case, please accept the apologies of my teacher! The

rascal never told me where the English he was trying to teach me came from. And may I add my own apologies, for having mispronounced your . . . May I ask, gentlemen, what you seem to find so very funny?'

Sidney and Castelnau were splitting their sides with childish laughter, while Greville was guffawing in the most irritating manner. Only Jean remained stony-faced, having lost the ability to smile at the same time as his eye; and besides, he was completely baffled by the joke that had been cooked up at my expense, the explanation for which was as follows: during the weeks preceding my arrival in London, Cecil had made sure to fill his letters to his brother with any number of details concerning me, so much so that Philip was well enough informed about me to write a book. 'Ask him to say a few words in English,' he had suggested, 'and he will come straight out with some lines from a poem of yours, without even knowing that they were penned by you, and dear Lord, with such an accent! You and your Greville will be in fits of laughter all day.' He certainly was in fits, and so were Greville and Castelnau! Seeing that, and wanting to show that I could take a joke, I burst out laughing in my turn, which they seemed to like. And so our friendship was born.

A few weeks later, Elizabeth ordered Philip to take care of a Polish lord by the name of Laski for her; he had come to visit her island and wanted to go to Oxford.

'The Sarmatian is a nuisance and she doesn't know how to get rid of him,' Sidney told me in confidence. 'That's why she's entrusting him to me. I'd be delighted if you would come along. It'll give us the chance to get to know one another better. And also, how would you feel about expounding your religion to the doctors there?'

The Oxonians couldn't have cared less about my religion, a fact of which I of course was as yet unaware. We set off in great array, in a coach escorted by thirty horsemen and in the sort of incessant rain that is the norm in that region.

I knew from Cecil that the Polish have a great enthusiasm for drunkenness in which, as they put it, they see the mirror of

the soul. It appears that in their country they keep at their drinking for ten hours at a time, and put their hands to their swords if ever a foreigner shows any hesitation when it is time to raise glasses. Presumably our man was anxious to confirm his faraway homeland's reputation, because he wet his whistle with beer so thoroughly both before and during the journey that the conversation became bumpier than the rutted road we were going along. Being but little informed about the memory that Henri III had left behind him in Poland, I had the additional misfortune of letting slip a brief allusion to him; whereupon Laski, in a fit of rage, made a whole series of nasty snorting noises and spat on the floor. Then he went to sleep, to our intense relief.

'What a contrast with the way they run their country,' I murmured as discreetly as possible into Sidney's ear. 'I've heard their laws are so civilised that everyone is free to practise the religion of his choice.'

'No doubt. But tell me, my dear Nolan, is your Henri III as agreeable as they say he is?'

When he was eighteen, Philip had been in Paris at the time of the massacre and pillage of the Huguenots, and being a Huguenot himself had had to go into hiding for fear of his life in an attic near the Porte Saint-Germain.

'Even so, he is a good prince,' I replied. 'And what's more, as you well know I have been given the job of demonstrating that to your queen . . .'

'It won't be an easy task.'

'Why not?'

'Before you arrived here a rumour got around to the effect that you were le Valois' lover. Isn't your testimomy likely to be somewhat biased?'

'Not if I make it clear that the rumour isn't true.'

'What do you think, Fulke?'

The journey was so boring that Fulke had followed the Pole's example and taken refuge in sleep, and Hennequin had followed suit. All three of them were out cold, with their mouths open and their heads bobbing about in time to the jolts of the carriage.

'Come now,' Sidney continued softly.'We are alone, or we might as well be. Won't you talk to me about Cecil instead?'

'He and I are opposites; our souls are as different as snow and sunshine, the sea and the sky. But you are a poet, you know that line by Mauricius Scaevius: *The more the Stag flees, the more he is pursued.* That, I believe, is the magic truth of love . . .'

'I understand. But my point is, aren't your bodies the same? And then . . . desire, between two men?'

Although he was about to get married, there were two subjects that Sidney seemed only too happy to mull over: Greek love and lesbianism. Desire between two men? The most divine and natural thing in the world, I asserted. Provided one did not reject the proposition that there is a hierarchy of love, in the same way as there is a hierarchy of human beings:

'The lowest form of desire is crude, Philip, and immediate. It condemns vulgar people to take pleasure without artistry, because that's what is necessary for the reproduction of the species. The only desire worthy of interest is its opposite, which unites the eminent spheres of knowledge and cares nothing for physical differences. I call this love *heroic*; it takes the form of a sort of divine torment, a pure pleasure, as high and dazzling as the midday sun . . .'

To this day I do not know whether Philip found my arguments appealing, but I certainly did, and even as I was thinking my ideas through by speaking them aloud, I was inwardly coming to the decision that I would write a book on this matter in the near future. And that ass Jean had the nerve to waste his time sleeping! I woke him up so that he could record what I was saying; and while he wrote, with great difficulty owing to the shakes and bumps we were being subjected to, I went on talking to my friend about metaphysics all the way to Oxford.

The good doctors of that city, where any student who dared to stray from Aristotle was fined five shillings for every point of divergence, gave me the coolest of welcomes. From the first moments, I knew that there was only one person in

that room who would give me a favourable hearing: Philip. Apart from the glassy-eyed Laski, the inevitable Fulke and the gentlemen who had come with us from London, my audience was made up of a handful of hostile pedants. As for the vice-chancellor of the University, he seemed determined to conceal his stupidity behind a mask of insolent discourtesy. Two gold chains adorned his chest, and his hands were weighed down with so many rings that he looked more like a jeweller than a man responsible for the instruction of the English *pueri*. I had instructed Sidney to introduce me to him as a *Doctor of the most eminent theology*; that title made no impression on him whatsoever. I then laid my homage at his feet, assured him of my undying respect, and told him that the reputation of his college had travelled far across the seas and reached the shores of Naples. His response to this praise was a dreadful rumbling noise emanating from his stomach. Food lying heavily on the digestion, perhaps? Without dwelling on this detail any longer, I mounted the rostrum and began my lecture.

First, I contrasted Copernicus' sky with that of Ptolemeus. To back up my demonstration, Jean had drawn a quick sketch on a piece of paper, and I wanted it passed round the room while I was going through the necessary explanations:

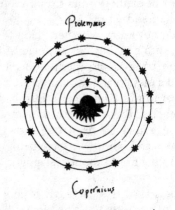

'In the sky as seen by Ptolemeus, Aristotle and the primitive philosophers,' I said, 'the earth is the fixed centre of the world.

You will observe on this drawing that in Nicolas Copernicus' sky, it is the sun which is at the centre . . .'

With all the courtesy of a common labourer, one of the doctors present cut straight in on what I was saying and asked in a nasal voice:

'What exactly do you think of this Polish fellow Copernicus?'

Laski jumped. Hadn't he just heard someone mentioning his motherland? Like a sleeper snatched from his dreams, he was peering around the audience in search of the culprit. What a promising start this lecture was getting off to! Without raising my voice, I answered:

'German or Polish, he had a great mind, and was a scrupulous man who dared to turn his back on common prejudices. Unfortunately he did not diverge from them far enough. In my opinion he devoted too much study to mathematics, and not enough to nature . . . What I would like to speak to you about concerns the sun . . .'

'And his opinions?' whined the doctor once again. 'Would you adopt them?'

Was I ever going to be allowed to speak? Was it customary in this country to interrupt the orator after every sentence?

'With one reservation,' I declared: 'I believe that the sphere of fixed stars – you can see it shown here on my drawing by the circle with the longest diameter – should disappear. Because in reality the world has no limit except celestial infinity. So now we've got that sorted out, at least I hope we have, I would like to talk for a moment without being interrupted (given that you will be able to ask me as many questions as you like afterwards) and move on to another point . . .'

My intention was to show these disagreeable fellows that the decision to place the sun at the heart of the universe was in keeping with the speculations of those discerning mages, Pico della Mirandola, Cornelius Agrippa of Nettesheim and Marsilio Ficino, and with the efforts they had made to get back to the greatest one of all, the Thrice Great, the Trismegistus Thoth-Hermes who was the inventor of language. I picked up the thread of my speech by drawing the attention of

the audience to this divine contemporary of Noah's who had once erected a temple to the Sun. But wasn't I just throwing pearls before swine? Were not such bold opinions likely to be trampled on by the arrogant Islanders?

'You see, gentlemen, I am not unaware that your verdant country has produced some great scholars, such as Alexander Neckham, if that is the correct pronunciation, Robert Grosseteste, who taught in this very place, or indeed his pupil, the intrepid Roger Bacon, not to mention the Scottish philosopher Duns Scotus, known as the Discerning, etcetera. However the Mediterranean, which, as its name indicates, is a vast sea surrounded by countries of myth and legend, and is therefore, if you will forgive me, the complete opposite of England, has itself continually brought forth fine minds. It is one of those, and by no means the least, a Florentine by name of Marsilio Ficino, who will be the inspiration for my speech today. Marsilio dreamt of uniting Plato the Greek and Hermes the Egyptian, ancient philosophy and ancient magic in one single way of thinking . . . Does the word *magic* offend your delicate ears? Patience! Like Ficino, I shall say that there are two sorts of magic: the first is black and diabolical; it is related to sorcery and must be kept apart from philosophy. Only the second, that of light and the sun, is of interest to the man of science, for it is natural and aims to master the celestial forces. *He who knows will conquer the stars*, as an ancient saying reminds us. Man has the power to know the sky and its fluxes, the movements of the moon, the influences and *sumpathia* of the heavenly bodies, the dry and wet zones of the firmament, the deepest desires of the stars, which are after all living beings, and the horoscopic gods. That, gentlemen, is why cosmology is divided into two inseparable disciplines, astronomy and astrology . . . Yes? What is the matter?'

The vice-chancellor, who had put on thick glasses, was turning the sheet of paper over and over in a furious rage. He looked for all the world like an illiterate who'd been driven to exasperation by the impenetrable mysteries of the written word.

'Where is the earth?' he was moaning. 'I can't see the earth! It is lost, by heaven!'

I signalled to Hennequin to go and help the wretched man. This he did with all speed, using his nimble pen to write the word *terra* next to the place where it was shown on the map.

'This is not how the Pole sees the sky!' cried the fellow, hammering on the table.

Laski jumped again. No doubt he believed himself the victim of an insult or a slander, or even a plot, for as we watched he leapt to his feet and uttered an exclamation in his own language which horrified the doctors. His servants came running, as did Sidney, who tried to calm him down. To no avail. Shouting and screaming with rage, the Sarmatian left the room.

Meanwhile the vice-chancellor was still roaring: 'This sky is all wrong! No scholar could have thought up such an insane system! We have Copernicus' book here! Someone go and fetch it! I want to compare his map with the Neapolitan's!'

So ended, before it had even really begun, this sorry encounter with the Aristotelians of Oxford. Although Jean's drawing was in every respect true to the *Polish fellow*'s maps of the sky, the pedant would not budge an inch, and needless to say refused to bow to the evidence. Finding nothing sensible to say in reply, he chose to leave the room in his turn without taking his leave of anyone, and yelling that no scientific mind could have put together such a lot of nonsense. I refused in these conditions to carry on with my talk, and we had no option but to leave.

Naturally I was disappointed so far with my trip to Oxford and the meeting with the pedants, since I suspected that England contained men of far keener intelligence than these pale imitations of knowledge and wisdom. On the other hand, the supper that Philip gave that same evening at Charlton Manor, where I had a most agreeable exchange of views and an encounter with a certain young actor, still lives on in my mind as one of those blessed occurrences that sustain your soul for a lifetime. The atmosphere was so open and friendly that the guests went on playing games and conversing until dawn.

The table had been set up in front of a fireplace in which a

wild boar was roasting. There were more than thirty guests, all in very high spirits, and gathered around Laski, who was wearing a brilliantly coloured doublet. The fellow was not so much talking as thundering. Anxious to amaze the assembled company, he talked about some of the marvels of his native land. We heard, for instance, how birds can be covered over by a thick layer of ice in the marshes in winter, and then fly off again as soon as the water thaws. Everyone applauded this anecdote, and he puffed himself up like a large, self-satisfied pigeon. The beer was flowing fast and free. Some travelling performers were juggling on a makeshift stage to music from a viol and some flutes. With the help of alcohol, music and good food, we were finally forgetting the conceited doctors at the University, and, as I called him to the delight of my fellow-guests, *their complete bloody ass of a vice-chancellor of Pedantry*. In short, the gods were granting us permission to savour one of those moments of Bacchic delight without which the brief parenthesis of human existence would be nothing but a cold, miserable wait for the moment of death. Perhaps it was the beer and absinthe that the people here were serving us, but for whatever reason, my head was filling up with memories. I thought back to my Genevese libations, and the nights spent working with Sanguino's actors; and suddenly I felt the urge to let my joy burst out into the open. Just for the fun of it I went over to mingle with the musicians, then had a go at dancing and singing, adapting the lines that were coming back to me to the rhythm of their melodies:

> *Brother Porro, nonsense-rhymer*
> *Up in Milan you string up your garland*
> *Of saveloy, black puddings and tripe*

'Who wrote that culinary tercet?' enquired Greville, who was in fact a great lover of offal.

'Pietro Aretino,' answered Sidney. 'A fine poet who uses very risqué imagery . . .'

Then, raising his glass to clink glasses with the Pole, and singing in his turn in an extremely well-pitched voice:

'*O fra Porro, poeta da scazzate . . .*'

'Are you saying that images can be both beautiful and licentious?' asked Fulke in amazement.

'I should say so!' said Philip with a smile. 'Isn't that right, my dear Nolan?'

'Judgements of what is and is not licentious in art are just fabricated by bigots – it's enough to make you sick! Of all our passions, poetic frenzy is the one we need most, as the great Ficino said . . .'

'Thanks for calling me a *bigot*,' grumbled Greville.

'And Heaven knows he was right,' I went on. 'That's still Ficino I'm talking about. Only poetry arouses the things that lie dormant within us! It is the pure harmony, the celestial prosody that balances the emotions of the soul . . . And so it must be free. I raise my glass to your health, S*ignor Grivello*! And don't get annoyed about a mere word. It is already forgotten, flown away like a little bird . . .'

'I drink to you too. May your life be long,' said Greville, pursing his lips, 'whatever the word you have just used to describe me is meant to signify.'

Leaving the musicians to continue without me, I had returned to my seat at Philip's side, and had had another tankard of beer poured out for me.

'And now, I should like to know what on earth it is that you write, Sidney. Cecil has never breathed a word about it, as you have already seen. Is it a secret?'

'It's my brother's profession that's a secret, not mine.'

This knight of a thousand talents had an excellent memory, a prodigiously quick wit, and a gift for story-telling which had in the past earned him the opportunity to do a turn in front of Elizabeth. Quite suddenly he started translating whole passages for me from a book he had just finished; it was influenced, I thought, by tales of chivalry in the French style, and by the writing of someone like Sannazaro, where the prose was interspersed with eclogues. It told the story of Basilius, the King of Arcadia, who had been unable to resist (here I thought about Henri for a moment) the sin of consulting an oracle. It kept reeling off to him a list of the misfortunes that

fate was hatching to strike at his person, his kingdom, and his two daughters, one of whom would be abducted by a scoundrelly prince, the other forced to experience an unnatural love . . . To escape these gloomy prophecies, the unfortunate Basilius took it into his head to flee from Arcadia. A foolish decision, as he was to discover: his behaviour was unworthy of a sovereign, and did nothing but bring down the most terrible calamities on his family, thus confirming the soothsayer's visions.

The night was mysterious and sweet, next to this hearth where the flames were crackling; the meat and beer were rich and the guests amiable; and I was stirred by this tale in which the supernatural forces of love and destiny were at work. Did Sidney also dream of a language in which the secret depths of the universe might reveal themselves? His ambitions were very similar to mine, and a coincidence like that disconcerted me more than I could say. For him, language and style were the coats of arms of the civilised man, the symbols of human dignity. The poet, he said, created images which had the power to awaken the love of virtue and wisdom, for in them were inscribed, like the macrocosm in the microcosm, the universal truths. I listened with ever-growing enthusiasm as he talked: in my *De umbris idearum*, I had pursued a similar aim. As for the new book that was coming to maturity inside me, not long from now it would depict a philosophical conversation interspersed with sonnets, a walk in a magic place, a palace or garden decorated with emblems . . .

'Do you have another book in hand?' I asked Philip.

'Ah! Here come the actors at last!' he exclaimed as if he had not heard my question.

It was Greville who answered:

'It's not his ambition to be a writer, you know, even though he writes.'

That remark left me utterly perplexed, and I wondered for a moment whether poor Fulke had not over-indulged in absinthe to the point where he was coming out with spurious paradoxes, but no: what he had said did indeed reflect Sidney's deeply-held conviction. I had understood – and I was not far

by now, I may add, from adopting this point of view myself –
that Philip considered poetry to be superior to philosophy,
because poetry was action, and philosophy merely knowledge.
But there was a form of action that ranked even higher than
poetry, and that was life itself: for Sidney, writing was only a
means of bringing the style of his elegant existence to perfec-
tion, and that was why his heroic deed at Zutphen, three years
later, was nothing other than a final, wondrous poem.

On the stage a venerable and sumptuously dressed king had
just appeared. He was waiting for the laughter and conversa-
tions to die down, so that he could address the public.

'Quiet!' ordered Philip.

The actor expressed his thanks, then announced:

'Gentlemen of the audience, we ask you to forgive us, dull
wits that we are, for venturing to perform such a noble theme
as ours on such a modest stage. To be sure, what you see before
you – a dusty floor, a rickety bed – is no king's chamber, but
you will have the kindness to make up for the poverty of our
devices in your own minds. If you will but be so good as to
lend us the aid of your imagination, we shall transport you to
another time and another place.'

With these words he humbly bowed his head, and then
really did become the king. We witnessed a tender exchange
between him and his wife, a strikingly beautiful young man
who imitated the posturings of the opposite sex to perfection.
Then, unfastening his baldric, the king expressed the desire to
take some rest, and lay down. Sleep came and took over his
spirit. The young man (the queen, that is) knelt and swore
eternal fidelity to him. There followed a lengthy song and a
mime show to let us know that night was closing its mysteri-
ous wings over the kingdom. Oh hours of night under the
changing moon! The very time when, elsewhere in the world,
bats hurl themselves into the hair of walkers who have lost
their way, moles venture out of their holes, finless fish show
their faces on the surface of lakes, creeping cats claw the walls
of cemeteries . . . As for humanity, it too nurses demons in
its breast: no sooner has the queen left her husband's bed-
side than a false-hearted rogue dressed in black enters the

bedroom. He pulls a phial out from under his cloak, goes over to the sleeping king and pours poison into his ear. Then he leaves as he came in. The hapless sovereign has just returned to *nox aeterna*, without even seeing the stars again. The song that follows proclaims a new day, and that day sees the coronation of the traitor who is none other than the brother of the dead man . . .

'Outrageous!' cried Prince Laski, leaping up and raising his hand to his sword.

There were more outrages to come! After the ceremony there is a ball. There the treacherous king tries to seduce the queen. She resists; in taking a second husband, would she not see the first one die for a second time? And now we witness the woman's torment, the breaching of her first defences, her tears and remorse; for the traitor, the early signs of victory. Soon he is fondling her at the scene of his crime, and in the end he marries her. Laski is growling like thunder. Several other gentlemen follow suit. Their indignation is echoed by phantoms, black spirits which, sprung from hell, hurl themselves on to the stage and run all over it in every direction, demanding retribution. Yes, providence is always working away in the dark, where it spins its invisible threads. A courtier, the queen's nephew, is the instrument of justice. We reward his efforts with shouts of support and encouragement. And indeed justice is done, when the traitor is punished with a stroke of the sword. But when infamy strikes at a family, it is doomed for all time. And the tragedy ends in a blood-bath in which they all perish.

The actors (and the manor where we were) belonged to Robert Dudley, Earl of Leicester, the fabulously wealthy uncle of Philip and Cecil and a long-time intimate of Elizabeth. Dudley had opened a theatre in Shoreditch, a none too reputable district to the east of London. People can be very shaken by watching a theatrical performance, and there was great emotion among the audience as they left this performance. Prince Laski was brooding over his terror in silence. Several gentlemen decided to go and make love, whether with a woman or with some lovely young man, in the hope that

230

afterwards they would manage to sleep. Soon there were just a handful of us gathered by the fireplace, chatting and drinking as we awaited daybreak. The players had joined us – actors being the sort of people who as a rule are incapable of sleeping – and they too were gradually getting drunk. The most troubling of them all was the one we had seen playing the role of the queen, a boy of less than twenty who called himself Snitterfield. *Signor Grivello* did not fail to notice how much the sight of him aroused my senses, and just to make me jealous he claimed in a voice dripping with nostalgia that he had had him as a page-boy when he was living at Beauchamp Court; which the actor didn't deny, moreover, even though he looked more like a ruffian reared in the street than the nephew or son of a good family.

'Your tragedy is delightful,' continued Fulke, stroking his chin. 'Terrible and delightful. But is it based on real events, or did you make the whole thing up?'

With more than a hint of arrogance in his voice, Snitterfield replied:

'What does it matter to you, my dear Lord Greville? Men copy fables, or fables copy men, depending on the circumstances. Wherever it comes from, my story is only a fiction, the shadow of a sorrow. But is it the sort of thing that will entertain both the people and the gentlemen of the court? That's all I care about . . .'

The shadow of a sorrow! What a beautiful expression that was! Could it really have sprung to life in the brain of this gallows-bird? I saw Greville move so close to him that their breaths were able to mingle. He stole a look in my direction, then said:

'That is a highly philosophical remark, which I imagine will be far from displeasing to a certain dealer in concepts who is here among us.'

Then, suddenly putting on a comical expression, he said imploringly:

'But it hasn't convinced me at all. So I must insist . . .'

The actor burst out laughing:

'Could it possibly be that you're a better actor than I am,

231

Lord Fulke? Come on then. I invite you and your friends to play a game: whoever gets the right answer to your question will win my favours for tonight.'

Not surprisingly, this idea gave rise to a storm of exclamations, some of which were indignant. As he spoke, Snitterfield had been looking deeply into my eyes. I reflected that it was that time of night when the line between good and evil, clear enough in the sober light of day, becomes very blurred . . .

'A contest?' cried Fulke. 'Count me in. As God is my witness, I find the idea of going off to bed on my own most unappealing!'

'If I understand you correctly,' interrupted Philip, 'your fable is copied, and the riddle is: "Where does it come from?"'

'That is indeed the first part of the answer. The more difficult part remains. I'm listening, my lords . . .'

He raised his goblet and drank.

'It wouldn't be a Polish story, would it?' someone suggested. 'Prince Laski, who must be sleeping the sleep of the just by now, was more moved than any of us.'

The young actor shook his head.

'The poison in the ear,' muttered Greville. 'I detect a very strong whiff of Catholicism there. I shouldn't be at all surprised if it was some Spanish city.'

'You're on the wrong track, Lord Greville. And what's more, I don't see what's particularly Catholic about the poisoning. Keep your spiteful remarks about religion for a more suitable occasion.'

'Naples!' exclaimed a gentleman. 'I've been told a very similar story. Listen: a prince, whose name escapes me for the moment, I'm afraid, is poisoned one day by his own brother who inherits all his property, including his wife. Unfortunately for him, the witch who prepared the fatal potion thinks she has been cheated, and so off she goes and tells the whole story to a judge. She gets burned for her crime forthwith. As for the fratricidal prince, guess what . . .'

'It's not Naples either,' Snitterfield cut in.

Then, suddenly turning to Sidney:

'And you, Sir Philip, with your quicksilver mind, don't you have any idea?'

'As it happens I do know the answer,' replied Sidney.

Fulke gave a start:

'May one ask why you don't say it?'

Sidney, who could read my mind like an open book, looked at me and smiled:

'The prize in this contest doesn't interest me. I'm not physically attracted to men, even when they are moulded by the hand of the gods.'

To which Snitterfield replied, in an exceedingly brusque tone:

'If, as you say, the prize doesn't interest you, you have only to give it away to one of your friends.'

I stood up and bade them goodnight. The Duke of Urbino was murdered by Luigi Gonzaga, who poured a Venetian poison into his ear, a voice kept repeating deep inside me. Furious, I stared round defiantly at the astonished faces of everyone present. Then I turned my back on them, left the gathering and went out into the night.

I was gripped, and my senses were calmed, by the cool which always precedes dawn. The rain had stopped. In a moment, the darkness would relent and start to give way to the first pale light of day. I looked up at the stars which were about to fade, and mused upon their invisible course, upon the inexorable movement of the world and time, upon the slow and secret work of death. How many years would go by before this sky would disappear, swallowed up by another sky, perhaps born of itself? Ten paces behind me, someone spoke my name. In the darkness I could make out Philip's silhouette, with his beret and puffed hose. He took my arm and we walked through an orchard, cutting a path through the wet grass.

'Why didn't you say anything just now? You knew the answer, didn't you? And you were devouring the actor with your eyes.'

'I love Cecil. I've never been unfaithful to him. And that

Snitterfield looks to me like an utter rascal – such a very desirable rascal, admittedly, that . . .'

'You are a pure-hearted man, Jordan. I am happy to have you as a friend. Look, the sun is coming up.'

Indeed, the colours around us were becoming visible. A blind old dog was trotting towards us, sniffing every inch of the ground, and it occurred to me that that dog was not a bad metaphor for human existence. Where on earth was Philip taking me? He raised a finger to his lips to tell me to keep quiet. We climbed over a hedge of brambles, then came upon a house with a ladder at the back leading to the loft. From up there, by the light coming in between two loose planks, we were able to look straight down into a room and on to a bed with two naked women in it . . .

'My muses,' whispered Sidney. 'I call them Philoclea and Pamela.'

The daughters of King Basilius. Philip's muses made love woman to woman, in their small-minded, lascivious way. As for the poet, he hid in this loft and took secret delight in their games every time he came to the manor. So the richest inspiration could spring to life in a dusty boxroom, at the spectacle of two meagre bodies in search of pleasure.

'No, really, it leaves me cold,' I said. 'And my spirits are very low. Please excuse me. I'll see you down below.'

I sat for a long time at the foot of the ladder, gloomily stroking the blind dog and hoping in the depths of my being that Cecil would get to London soon. The animal had laid his head on my knee.

'Poor old creature,' I murmured. 'When will the spirit give you what is your due?'

London was no less infested than other cities by those unemployed beggars, wretches and pickpockets that one encounters on the steps of San Paolo in Naples, on the Campo dei Fiori in Rome and next to the Porte du Palais in Paris. These delightful individuals who sat grim-eyed under the columns of the Royal Exchange would have flayed you alive for a few pence. Luckily, most of them were so bone idle

that they didn't even
just sat there, holdin
and if he dared refu
they could go and
with the insults an
tongues, or even
above these wre
keepers, boatme
uncivilised and
given to mock
of contrasts it
populace tha
on the othe
divine class whose o
as a beacon for the whole of Eu
for the whole world.

I couldn't fail, in particular, to like the views of
on justice: they abhor torture, and I observed that on
point their doctrine is very much like that of Montaigne, and
my own, for it is wisdom itself. The rope and the flame are
such violent practices that they go against truth, quite often
compelling the accused to confess whatever he has been told
to confess, and forcing the judge to send innocents to the
gallows. The English method of execution is hanging for the
majority of those who are condemned. Nonetheless there is
one vestige of barbarian times which the English have not
removed from their law – perhaps they need to keep this
shadow on the picture – and that is the punishment for any-
one convicted of treason: after publicly chopping off his pri-
vate parts, they tear out his entrails and throw them on the fire,
and his body is cut up into several pieces.

While I was in England I was as happy as could be doing
my twelve hours a day of writing and dictating, publishing
some new books, and at the same time discovering a culti-
vated humanity which seemed to be a model for future soci-
eties. My observation post was none other than the French
Embassy. Indeed, thanks to the hospitality of the excellent
Michel de Castelnau and his wife, I lived there with my

pero, and a little later Cecil –
my stay. My debating companions
Sidney, Fulke Greville, the doctor,
thew Gwyn, John Smith, John Florio –
r of French and Tuscan, had been per-
undertake a translation of the *Essais* – and
om I could name in the certainty that, if they
they will remember me to this day, so frequent
oned were our debates. As for the mission that
seen fit to entrust to me, I carried it out as best I
hat is to say rather badly, having never, unlike Cecil,
e slightest talent as an ambasador.

On the day of my meeting with the queen, I was wearing a
ifling ruff in three thicknesses of embroidered silk, a cloak
with fur trimmings, and *a genuine philosopher's hat*, as Castel-
nau, who had personally taken charge of my outfit, described
it. As for Hennequin, he was growing mean as he got older,
and refused to wear anything other than his modest habit of
dark woollen cloth with the high collar. At least his dismal eye
patch had been replaced by a new one – a shrewd gift from
Philip – which was no more than a slender grey ribbon deco-
rated with a festoon. An impudent rainshower had forced all
four of us to pile headlong into the embassy coach, and I
remember how I cursed the congestion of the city that day, as
we were forced by a cart that was blocking the entrance to the
bridge to sit for more than an hour observing the vast number
of boats floating on the *Thamesis fluvius*.

Elizabeth, who like all those in positions of power was pas-
sionately interested in natural philosophies, kept an astrologer
called John Dee who, whether well or badly, consulted the
stars for her and advised her on her decisions. She herself, in
her moments of great inspiration, was occasionally visited by
prophetic dreams in the course of which she took on a dual
personality; these were often painful experiences which she
bore with fortitude. I should add that everyone who had deal-
ings with Her Majesty, including myself, was greatly struck by
her. To tell the truth, she seemed to me more like a goddess
than a woman. People said she was cunning and highly skilled

in the art of dissimulation, but I could see that the flaws and weaknesses of her sex paled beneath her unreal beauty and the intelligence she had inherited from the late King Henry VIII. In the course of our conversation, she was anxious to show her learning in the field of stoic metaphysics, because she asked me whether in my opinion it was possible to govern peoples or to seek happiness on earth without the support of a conception of the universe based on reason. I answered by quoting Zeno:

'Reason is the science of things divine and human, Your Majesty, and it is the most precious of man's possessions. If he neglects it, he becomes lower than a beast. As for my conception of the universe . . .'

She liked my conception of the universe, and was even amused by it. After listening to me without once batting an eyelid or yawning for nearly an hour by the sandglass, she turned to Philip and asked him this:

'Can your Neapolitan friend explain to us where God is in his system?'

If, as Aristotle claimed, the face expresses the qualities of the soul, this particular soul was certainly not short of determination.

'Every part of my universe is completely alive, Your Majesty. In a way, if I may say so, God and it are one and the same.'

She turned towards one of her advisors, a certain Francis Walsingham (whose daughter, incidentally, Philip was soon to marry):

'Priests have changed, don't you think, Sir Francis, now that they've got away from the monasteries.'

Sir Francis agreed. I thought of the Black Friars Dominican monastery, which had actually been turned into a theatre.

'Please,' I went on, 'forgive my boldness: I am no longer a priest, but an excommunicate, like Your Majesty herself.'

This queen's indifference to religion was one of the most curious and appealing phenomena I have ever had the good fortune to observe in this world. She gave the impression that she was determined to govern her kingdom without there

being any question of subjection to one church or another. And wouldn't Henri de Navarre do the same a few years later? This was how politics was evolving at the time. At that moment Elizabeth and I were thinking the same thoughts, because she continued:

'You yourself, Jordan Nolan, if I have correctly understood what you have said and what I have been told about you, demand the right to exercise your talents in complete freedom, without the interference of priests, popes and cardinals.'

'If you don't need to be a priest to govern an island, you don't need to be one to interpret the heavens and nature either, or indeed to write dialogues and plays.'

'Then write what you like while you are here, signore. Philosophers and astronomers are very much at home on this island, as you say. While you are constructing your marvellous heaven, we English will conquer the sea and the world. Thank you for your agreeable and learned visit.'

Michel de Castelnau wanted to intervene before it was too late:

'Your Majesty, I believe this doctor has not just brought a fine doctrine with him, but also a message of friendship from the King of France . . .'

Elizabeth's face darkened. Her voice turned brusque:

'Under the pretext of curbing the activity of the reformed church, your Henri is currently authorising a campaign of hatred in France against the English. My ambassador's protests have had no effect at all, as you, my dear Castelnau, are no doubt aware.'

Michel de Castelnau took on an air of contrition. Sir Francis cut in before he could speak:

'We have been sent some of those odious posters that have been stuck up all over Paris. They caricature the English queen in a most shameful manner.'

'Like many sovereigns,' answered Michel, 'Henri is unfortunately forced to put up with fanatics of all persuasions. His real feelings cannot be judged by the lies and treachery of those who are in fact his enemies. The heart and the good sense of France are with you, Your Majesty. Even if it is true

that the League does not leave the prince much room for manoeuvre.'

'Is Henri the king,' asked Elizabeth with a smile tinged with irony, 'or a plaything in the hands of Catherine?'

'Your Majesty!' implored Castelnau.

But all of a sudden she seemed resolved not to let go of the prey that we had placed in her claws. All traces of affability had vanished from her beautiful features:

'Henri doesn't know what he wants, my dear Michel, and you know it. Doesn't everyone say that he changes overnight from courageous to cowardly, candid to deceitful, cruel to magnanimous, intransigent to liberal? One year he loves war, the next he thinks of nothing but dancing. For a while he's passionately interested in the government of his kingdom and the highest affairs of state, and then not long afterwards he's out in the streets playing cup-and-ball. He claims to be religious, but his processions are followed by parties and carnivals where all his most unsavoury friends come and wallow in the mire! The massacre of several thousand innocents can't even wring a sigh out of him (well of course, they were Protestant innocents) whereas he sheds every tear in his body over the death of one of his pretty-boys! Tell me, Monsieur de Castelnau, when it comes down to it, is this king a man or a woman?'

'Your Majesty . . .'

'Your Majesty,' I repeated, 'may I be permitted to fly to the assistance of that sovereign, who is your friend?'

'Your business,' she replied, 'is the reform of the heavens. Keep watching the stars . . . And take care not to do as Thales did and fall into a well because you're walking with your nose in the air. The subject is closed. Sir Philip, I should like to speak to you about your marriage in the company of Sir Francis alone. If your friends would be so kind as to wait for you for a moment . . .'

'Henri is a good king!' I flared up all of a sudden. 'God has granted him a generous heart! He loves the arts and sciences!'

It must be said that my tone was anything but that of an arch-diplomat, and these remarks of mine were followed by

an embarrassed silence. Where does this Neapolitan think he is? was the question that was written all over Walsingham's outraged face. Even Sidney, as he confided in me a little later, was afraid there might be an incident, and that I would shortly afterwards be sent off to Dover en route for France. But, surprisingly, the queen started to smile again:

'An indolent love of the arts, sciences and *mignons de couchette*, as they say in France, is no substitute for government, signore. I know that you have a great affection for this prince, so much so perhaps that you do not notice his faults. Such loyalty is to your credit. But a sovereign must be black or white, friend or enemy. He can be sun or moon, not both, as you as an astronomer must know. Please accept my compliments on your interesting doctrines, and my best wishes for your stay in England.'

Cecil's lack of eagerness to join me in London was not due to the doge's reluctance to let him go, as I had thought at first, but to an affair he was having with a *mignon* in Paris. He loved this boy, who was one of the king's actors, and could not bring himself to leave him, or take him with him. In the end Cecil wrote to Philip about his problem; he, after considerable hesitation and a very great deal of embarrassment, came to see me at Castelnau's house and told me all. He would have been deeply reluctant, he said, to let a lie by omission sully our friendship. Here is the letter I wrote that same evening:

'My love, your plan has succeeded; your brother came to see me just now & confessed the reasons why you are staying away from me, even though a year ago there was nothing you wanted more than to come to England. Naturally I was anxious that he in return should know that you had used him as an intermediary to let me know the *nudam veritatem*, while at the same time you were assuring me in your letters of your undying love. He is normally so melancholy, but on this occasion was clearly amused by your stratagem, so at least it has made one person happy for the few moments that he was roaring with laughter, & that's always something to be grateful for.

'As for me, despite the fact that the news was whispered delicately in my ear by an innocent Mercury, it has not exactly filled me with joy. Although I must admit that after the number of times you have gone on about what you so charmingly call "the doge's prevarications", I was beginning to smell a rat. But come now, are we not liberal people? I do not know the name & face of the pure star that you have stolen from the king, but with or without him, come to London. Life here is as rich & varied as could be, Michel de Castelnau is an agreeable host, the female sovereign has a fine intellect, and that's not to mention the theatre that goes on here & all the people who are being won over by my opinions & proclaiming themselves my friends and disciples. There are of course a few pedants who've gone toothless from gnawing on Aristotle's bones, but they're not much of a nuisance, & no more unpleasant than anywhere else. Philip is a god in your likeness, your uncle Dudley a perfect gentleman; as for Maria, I have only seen her once, & she has not reconciled me to liking her sex. Philip has decided to dedicate his superb *Arcadia* to her, given that he was close to her as can be during the time when he was writing the book. What an idiot I am! You hate your sister, & I have to go bothering you with talking about her!

'My sweet Cecil, do you know that the chastity I have been keeping to for nearly a year now is giving me a thousand headaches & stomach aches, because my humours are not being discharged? I cannot believe you have stopped loving me. I repeat, with or without him, come. Come quickly. A thousand kisses & sweet words from the one who awaits you.

'Your
'Philip
'this 14th December MDLXXXIII'

A few weeks after that, the handsome actor left Cecil, with a display of the most arrogant contempt; on top of that he took it into his head, for good or ill, to go and get himself killed in a duel. And so my beloved finally arrived in England, his spirit devastated by an ordeal which he believed was an omen sent to him by Time. Was he mistaken? We were nearly thirty-five

years old, and were probably halfway through our journey already . . .

'Success won't come so easily any more,' I heard him murmur close to my ear, the first time I awoke in London in his arms.

When does the twilight of life begin? Was the ribbon across Jean Hennequin's face the first indication of it? Or was it to be found in the signs of aging – oh, so very slight – that could sometimes be seen now on my living god's features when, in the grip of his recent sorrow, he fell into a sort of amorous languor? Certainly I did have happiness of a sort over there, thanks to the mania for writing that was always with me, and also to the success of my Italian dialogues; but it was a happiness tainted with fear, for in truth Cecil was growing away from me, and what showed in his despair was the ugly grimace of death.

My books were published by John Charlewood, a yellow-haired, no-nonsense, beer-drinking giant whose presses were not far from Butcher's Row, just a stone's throw away from the embassy. John was a fanatically cautious fellow, who insisted that the words *printed in Paris* should appear on the frontispiece of all my books.

'Because you are from Paris, aren't you?'

'Like Socrates, I am a citizen of the Universe.'

'Well then, we'll put *printed in the Universe* in the next one. What do you think?'

'What I think, John, is that the police and the censors are a tonic to the imagination. They force people to invent ingenious devices, and that's how the world makes progress.'

As well as a new edition of my *Cantus Circaeus*, I produced no fewer than seven books while I was on the island of Britain, six of which were dialogues written in Italian, a language for which the English had a great liking. Those who open my *Triumphant Beast* will find in it the message from Henri which had failed to reach Elizabeth owing my lack of expertise as an ambassador: the King of France did not like the Guises, I reminded the reader, nor the fanatics who were urging him to

start the religious wars again. Thus I did eventually carry out my mission to the queen in my own writerly fashion, which was a great relief. *The Heroic Enthusiasts*, a book which I hold in great affection, was dedicated to Philip. It is a blend of poetry and philosophy in a series of five dialogues in praise of pure, divine love. The last of these – no harm in doing something different once in a while – describes a conversation between two Neapolitan women. This was because I wanted the book, which owed a great deal to my friend, to contain in addition to the dedicatory epistle an allusion to the muses whose love-making he enjoyed watching at Charlton Manor.

I do not have time to mention all the works I published in *Britannia*. Several of them, including the *Ash Wednesday Supper*, in which my cosmology is revealed, were to be used against me at the trial, as the ultimate proof of my heresy, a treasure-trove of material which my judges drew on to condemn me to the stake.

Although Jean Hennequin was still taking charge of my publications with unfailing efficiency, I often went to the printer's myself. As a matter of fact, one of Charlewood's proof-readers was none other than young Snitterfield. Although married and already a father, this lad was leading a life of complete freedom and debauchery, drinking and spending the little money he earned in disreputable taverns. Apparently he was to be seen in the company of the most notorious thieves and bandits, now that his father had withdrawn him from college.

Like Sidney, he seemed to be fascinated by unnatural love, by costumes and masks that made sex difficult to determine, and ultimately by words, by poetry and the stage. When he was not correcting proofs for John, he was acting in Shoreditch, mainly in plays by Seneca, or by Fulke Greville, that pale imitator of the Ancients, and on several occasions I had been unable to resist the desire to go and admire him in secret. He had a look about him, like a pimp bewitched by death, which reminded me of the bandits of Santa Maria del Carmino. Whether he was acting on stage, spinning out images or suddenly breaking into song in the street, his beauty

243

was so disturbing that it drove me to tears; and the more like a hoodlum he seemed, the more I liked him!

What a struggle I had to resist his many, unambiguous advances! Cecil was out most of the time, riding on horseback all over the countryside around London, alone or with Philip. Often he would mope in our room, dreaming of his young departed friend and showing little concern for me. And yet, I still found the idea of betraying him as unbearable as ever . . .

'Aren't you carrying the role of virtue in the achievement of happiness a bit too far, my dear philosopher?' the actor challenged me one day, imitating a jester speaking to his prince.

'That's certainly not something you're ever in danger of being accused of!'

Had he not abandoned his wife and child to devote himself to drinking, artifice and every possible variety of love? Was he not incurring the wrath of his father by frequenting taverns every night? Yes, to be sure, but he was capable of dashing off poetry that neither Petrarch nor Mauricius Scaevius would have been ashamed of:

> *As love is full of unbefitting strains*
> *All wanton as a child, skipping and vain,*
> *Formed by the eye and therefore, like the eye,*
> *Full of strange shapes, of habits and of forms*

His sense of poetry and metaphysics was just as great as his talent as an actor, and although I allowed myself to possess him only in my mind, I made no attempt to conceal my delight at listening to the stories he made up, and the virtuoso skill with which he handled every sort of language from that of the streets to that of palaces, from learned aphorisms to popular rhymes.

He loved to ask me about my life at San Domenico Maggiore, about the Toulouse Catholics, the doctors at the Sorbonne and the intrigues at the French court.

He was completely taken by my philosophical views, and

never wearied of hearing my opinions about poetry and the Italian theatre. He had read my *Candelaio*, he said, and had loved it so much that he was toying with the idea of translating it into English and putting it on at Blackfriars . . .

'At Blackfriars? Don't you belong to Sir Dudley and his theatre in Shoreditch?'

'Under another name, and a different appearance, I shall play whatever role I like, Signor Brown, wherever I want to play it.'

Suddenly quoting my play from memory, he murmured:

'*Da candelaio volete doventar orefice* . . . What exactly does that line mean? Teach me . . .'

My heart was thumping fit to burst. How hard I had to fight to keep my hand from stroking his neck! As for my *mentula*, I'll be damned if it wasn't quivering continually under my cloak . . .

'In Naples,' I replied, 'the *candelaio* is the man who practises Greek love passively, in the most basic, uncouth way and just to earn money. *Orefice*, on the other hand, means a goldsmith, an engraver.'

'Venal and divine love united in one single phrase. Yes indeed, I would very much like to act in that play . . .'

I do not know what became of this idea, or whether the actor ever did anything about it, because I saw him for the last time on the evening of that Ash Wednesday which I am now finally going to talk about. One sensed that he, more than any other English artist of that time, was full of inner oppositions and conflicts which sometimes drove him to the edge of insanity, yet it was partly this madness that gave him his strange powers of attraction. I was already behind bars in Venice when I learned nine years later that gentlemen and yokels alike were packing out the London theatres where he was having a success tinged with scandal under the name, I think, of Shakspere. I was told that he had even written and put on a play featuring a philosopher called Brown, or Berowne. The allusion to our long-gone friendship was transparent. Did Snitterfield know that by then I was shut up in San Domenico di Castello? At a time when I could see the darkest, most

245

solitary days of my existence approaching, this gesture from him filled me with emotion and nostalgia.

My ten-page reply to the grammarians of Oxford, entitled *Hell's Purgatory*, seemed like an echo of the pamphlet printed by Giovanni Bergeon in Geneva which had got me thrown in prison by the Calvinists. It went the rounds in London for several months, and sure enough aroused a storm of protest from the orthodox Aristotelians. Anxious to fan the flames of their anger, I went around everywhere saying that the prospect of doing battle with asses, even if they were doctors at the University, did not frighten me in the least; and that was what gave Greville the idea of devoting one of the meetings of his circle to the issues which without a doubt they were burning to discuss. And so it was arranged that the meeting should take place at his house on the fourteenth of February eighty-four, which was Ash Wednesday.

'A supper,' Fulke had explained on his way out of the embassy. 'A philosophical supper. After dark.'

On the agreed day, exactly sixteen years ago tomorrow, I set off for this banquet, and for the memorable debate which was to inspire me to write yet another book. I had with me a grave and melancholy Cecil, the sombre Hennequin and Michel de Castelnau, and once again we had occasion to come up against the ill humour of the common herd in England. It had been decided that we should take one of those small flat-bottomed boats that look like graves and glide over the waters of the Thames at night. First of all the boatman, seeing us standing in the rain and stamping our feet to keep warm, came over to the landing-stage very slowly, as if there was a gibbet waiting for him there. Then he conveyed us with such ill grace and discourtesy that Cecil drew his sword, swearing that he was going to run him through and throw him into the river. This was a grave mistake. The boatman retaliated by steering towards the bank and threatening to hit us with his oar. He then abandoned us without further discussion in a place that was pitch dark and muddier than a bog. From there, we had to set off on foot across a maze of

foul-smelling gullies and paths full of potholes. As we walked to *Master Grivello*'s house, fate heaped one ordeal on us after the other. First we had to squelch around in the mire, shouting and yelling to chase off packs of famished dogs. Then we came up against the inevitable thieves, which of course resulted in an ugly fight. By the time we finally stepped across the threshold, we were in such a state that we looked like four gallows birds. Fortunately every last one of my friends had turned out to support me: Sidney, Florio, Smith, Gwyn. They were all very kind and sympathetic, and showered us with words of affection. However they were few in number compared to my opponents, who meanwhile were muttering indignantly about the fact that the Italian had had the audacity to keep them waiting. I noticed that they were led by the vice-chancellor of such dismal memory.

As was only proper at a supper such as this, complicated rules of precedence had to be obeyed, and while everyone was being allotted a seat there was ample time for the food sitting quietly on the table to go cold, which infuriated the guests even more. Eventually it was decided that Sir Philip Sidney should preside over the gathering, with Cecil to his right and Fulke Greville to his left. After that we devoured the first course in silence: kid's meat garnished with berries and mushrooms. I had been seated opposite the vice-chancellor, and the discourteous pedant did not condescend to favour me with a smile. He sat there drinking, eating and licking his fingers as if there was no-one else there. I glanced questioningly at Philip: had the eminent doctors only come to stuff themselves and act like spoiled children? Once the delicate morsels of roast meat had been gobbled down into our twenty stomachs, Sidney whispered something to Greville, who, in an attempt to improve the atmosphere around the table, began the long ceremonial of the pitcher and glasses, a custom by which each of the guests passes his glass across the table to the people he knows, inviting them to drink from it, with the result that everyone, as a sign of friendship, applies his greasy lips to it and in the process drops something into the wine, whether it be a breadcrumb, a hair from his beard or a piece of snot from his nose.

Once we had all complied with this custom, Greville ordered the second course to be served – piglets dripping with zabaglione in the Italian style – then he declared:

'God willing, this banquet, like Plato's, will be a source of wisdom and philosophy. Horace used to say that full goblets make us eloquent, and I am sure he was quite right. So now, gentlemen, let us drink again. After which, Jordan Nolan will expound his religion to us, since he has agreed to join us . . .'

'Does he understand our language?' asked the man sitting next to the vice-chancellor.

This monkey-faced sycophant, whose refined behaviour I had already had a taste of in Oxford, had got up without even waiting for Fulke to finish his speech!

'No!' I answered. 'I'm delighted to say I don't, because it means that the vulgar remarks of your boatmen, beggars and postilions don't get through to my intellect. As for those with whom I normally spend my time on this island, they are all extremely polite, distinguished people who express them-selves in Latin, French and Italian . . .'

These opening remarks of mine were certainly far from affable. At least they succeeded in forcing a smile out of Philip and Cecil, who until then had been having to struggle to keep from yawning. Like Socrates, I was awakening slumbering brains. The man, who was clearly a talentless sophist, was still on his feet, more indignant than if I had slapped him in the face.

'May I suggest that we turn our attention to Copernicus,' he said, turning obsequiously to his august neighbour. 'What do you think of him, sir?'

Copernicus again? Did these idiots take me for the repre-sentative on earth of the canon's immortal soul? Wasn't there any other subject they wanted to tackle?

'I have not come here to speak to you about Copernican astronomy, but about my own philosophy, which is in fact more far-reaching in its ambition . . .'

'No doubt, signore, but the so-called movement of the earth . . .'

'*Andiamo*! It has been proven by modern mathematicians . . .'

'As I was saying, the so-called movement of the earth is as much part of your doctrine as . . . well, as eggs and sugar are part of this sauce . . .'

'It certainly is, and that's quite a nice metaphor, but I repeat that I am not in the business of serving up dishes prepared by other cooks, however eminent they may be. I would be afraid, you see, if I were to explain to you tonight what is in their saucepans, that I was dealing with an audience of ignorant kitchen boys . . .'

'How very kind of you,' said my opponent, sitting down again.

He grabbed a morsel of piglet and sank his teeth into it.

It was then that the vice-chancellor stood up in his turn. With what was meant to be an air of majesty, but merely succeeded in being one of self-importance, he cast his eyes *circum circa* . . .

'We are all ears,' said Philip Sidney.

The other man pretended not to have heard him.

'Perhaps you would like to speak?' Fulke Greville enquired amiably. 'The Italian doctor is listening . . .'

The vice-chancellor gave a contemptuous belch and shrugged his shoulders. Then quite suddenly he called out to me in an arrogant voice:

'Have you ever taken the trouble to read through a certain introductory epistle that appears at the beginning of Copernicus' book?'

'Of course . . .'

'Does it not say that the movement of the earth does not exist?'

'Yes indeed . . .'

'Yes indeed! Because that sort of motion is not only unseemly, but impossible, isn't it? The astronomer, as is revealed in the epistle, only invented it to fit in with his calculations, like those scientists who put forward hypotheses without any concern for their plausibility, just so that they can go on with their research! So there you are, the truth about you is out!'

He sat down again, confident of winning the approval of his allies. I let him quench his thirst – he had made a very good effort, after all – and said, as calm as could be:

'So, do you think what you've said about your epistle will shut me up?'

He gazed at me with that stupid air that pedants affect when they find that they are not going to have the last word. I continued, this time addressing the whole gathering:

'Gentlemen, it is true that Copernicus' treatise includes such an epistle, and to be quite honest it is the most perfidious epistle that has ever been written. But there's nothing surprising about that, because Osiander, the Lutheran who perpetrated and signed it is a deceitful ass who only steps back to open the door for the learned man so that he can trip him up! And I do greatly fear that anyone who trots his argument out again must be very much like him, for as they say in my country: *chi si assomiglia si piglia*. The idiot was afraid that a doctrine like that would throw the censors into a panic, that's all! Oh, there are plenty more like him: timorous, over-cautious, feeble-minded people who take fright at the prospect of the slightest change in the organisation of the world . . .'

'Are these some more kind words served up in the Neapolitan style?' enquired the monkey-headed grammarian.

I went on imperturbably:

'I am sorry gentlemen, but Copernicus believed that the earth was in motion, and if the vice-chancellor had read on beyond the epistle, he would be convinced of that! What is more, the astronomer confirmed what his doctrine was in a letter he sent to the Pope. But I said that I would not be pleading the cause of other scholars tonight, since I have plenty to say about my own . . .'

'Perhaps,' interrupted Greville, 'the vice-chancellor has another objection to put forward . . .'

'The earth cannot be in motion because it is in a fixed position!' barked the vice-chancellor, banging on the table.

That was how he answered, with an argument so subtle that my friends burst out laughing. However, not all the guests

thought that it was a laughing matter, and the first vengeful growls started to rise from the ranks of the orthodox lords.

'Come now,' proposed Sidney, 'let us move on to what our dear Nolan wanted to speak to us about . . .'

But the man sitting to the right of the vice-chancellor returned to the attack, and I realised that I would not be allowed that evening to talk about the One, the universal principle which presided over every movement in the world, both physical and moral . . .

'There is another objection however,' he continued. 'Still concerning Copernicus . . .'

'No, no! We've had enough of Copernicus!' begged Matthew Gwyn, the musician.

'Sir Philip,' said Florio emphatically, drawing himself up in anger, 'it seems to me that we have heard too much twaddle already! Be so kind as to hand over to the Neapolitan and let him finally have permission to speak . . .'

'Thank you, John. But I do not like leaving my opponents with the impression that they have carried off even a meagre victory just because there is a point which I have refused to debate. Well then, sir, what was the objection?'

The doctor gave the following reply, which might as well have come from the mouth of a child:

'If we admit that, as you claim, the earth makes one revolution in an easterly direction in twenty-four hours, why do we not see the clouds flying through the air at high speed towards the west?'

'Asses!' guffawed Smith and Florio together. 'They are asses!'

'Take care that those asses don't break your back with a well-placed kick!' shouted a gentleman.

Smith leapt up:

'Are you running short of arguments already? Is that why you've got your hand on your sword?'

'You're welcome to a taste of it if you like!' retorted the gentleman.

Philip tried to appeal to reason, but by now everyone was fired up by wine, beer, meat and celestial motion, and several

of the gentlemen were spoiling for a fight of the most unphilosophical kind. While we were being served the third course, some heavily salted mutton, I attempted to explain that the air, the clouds and the winds were part of the earth, that vast body, that divine animal of which they in a sense were the internal and external movements ... Despite my celebrated vocal power, I had to make a huge effort to be heard above the shouts of the guests:

'What must be understood by the planet earth is the whole of the system: stones, flames, streams, rivers, oceans, clouds and turbulent air, for all these elements originate in the body to which they belong. I repeat, the stars are just as much living beings as men and animals. It is only their dimensions that are different. As far as proportions are concerned, we live on them in the same way as flies or other tiny creatures sometimes live on our own bodies. They feel the air coming into our lungs, and sometimes rushing in violently, just as we feel the air that, by a similar process of breathing, enters the cavities and bowels of the mountains; and that air is what we call the wind ...'

'This is ridiculous!' yelled someone. 'The Neapolitan will soon be trying to make us believe that the earth farts when it's had too much to eat!'

'*Anticyram navigat*,' sighed the vice-chancellor, getting up to leave the table.

'What did he say?' asked Gwyn, 'I couldn't hear.'

'An Erasmian adage,' answered John Smith. 'He's saying that the Nolan is mad ...'

The contents of a sauceboat hit him right in the face. Cecil was the first to draw his sword against the insolent gentleman, who shortly afterwards had to be carried out with a nasty wound on his shoulder. Of the guests who, like me, had never learned to use a weapon, several took to their heels, others fought with their bare hands, or instead of throwing ideas about, pelted each other with eggs and pieces of meat and bread. Florio lay unconscious for a moment, having been knocked out by a pitcher. Gwyn lost a tooth in the course of an exchange with the monkey-headed doctor. As for me, I was surprised to find that for the first time in my life I took no

pleasure at all in the spectacle of such an eruption of violence. On the contrary, I joined Fulke, Philip and Castelnau who were making heroic efforts to curb the fury of the grammarians, thanks to which the final number of people injured was small.

And that was the end of the Ash Wednesday supper, on which I was to base the dialogue of the same name. If he has the wish or the patience, the reader can consult this book; it contains the cosmological doctrine born of my reading and intuitions. I have done no more here than relate the circumstances of a debate, such as my memory has retained them. Soon afterwards, all anyone wanted was to get back home. Smith and Gwyn went with John Florio, who was still unsteady on his feet, to his coach. Hennequin took a seat beside Castelnau in his. Finally Philip invited Cecil and me to come to his house and spout poetry until dawn, an invitation which I declined, preferring to be on my own. I waited until the coachmen had whipped the horses, then after embracing Greville I disappeared into the night.

That dinner was not as disastrous for humanity as that of our first parents, Adam and Eve, but it resulted in Sidney's learned circle, and I myself, being severely rebuked by Elizabeth. A few days later, an emissary presented himself at the embassy with a message from Her Majesty to the effect that if I went on in the same way, it would not be long before I was considered *persona non grata* in her beautiful English island. Once again Philip had to intercede on my behalf, but the queen had taken umbrage at the incident, and I was never to find favour at the court again.

The tavern to which my steps had taken me sported the sign of the Boar's Head. In the ill-lit street where sharp gusts of wind rippled the surface of the puddles, I stood for a long time banging on the door. I could hear Snitterfield's voice singing in Italian over chords played on the lute:

> *Not a flower, not a flower sweet,*
> *On my black coffin let there be strown;*

253

Not a friend, not a friend greet
My poor corpse, where my bones shall be thrown.

I continued to hammer on the door and eventually a hussy showed her face, which was more heavily painted than Carubina's had been once in *Il Candelaio*. The actor himself was playing the instrument, sitting on the edge of a table strewn with goblets with his crossed legs perched on a stool:

A thousand thousand sighs to save,
Lay me, O, where
Sad true lover never find my grave,
To weep there!

'Mr Philosopher! How odd! What a surprise to see Wisdom appear like this in a place with a worse reputation than hell itself!'

He put down his lute and addressed the people who a moment earlier had been listening to him singing:

'Gentlemen, shame on your common faces and ignorant souls. Yes, *lasciate ogni speranza*, for here is the man who has turned the sky head over heels and made the universe an uncertain place. Look at his eyes: for him, light is dark, and bright the starry sky . . .'

Wisdom took off his drenched cloak in front of a hundred pairs of menacing eyes, and ordered some beer. Snitterfield seemed overjoyed to see me, and was soon taking me off to his table at the back of the tavern, where he called over a poor devil who was nothing but a heap of skin and bones.

'This is Signor Brown,' he shouted to the man as if he were deaf. 'Look closely at him, empty-head, because people will still be talking about him when the worms have finished eating away at the last atom of your useless body. Fill your memory with his face . . .'

The man was looking at me with a sort of horror.

'He is mad,' Snitterfield told me, 'or he pretends to be. Who knows if it's not the same thing?'

He turned to the fellow again:

'That's enough, now. I want to talk alone with the Italian doctor.'

The man obeyed. His silhouette wandered for a while among the tables and then suddenly seemed to disappear.

'Has there ever been a more wretched creature,' continued Snitterfield. 'That fellow writes sonnets of a purity which many a poet would envy, starting with your friend Greville.'

'Greville is more your friend than mine. As far as I am aware I have never served him as a page.'

'But you have done as a philosopher. What's the difference, when it's a question of serving . . . But let's not talk about that. I wanted that madman to see you.'

'Why?'

Snitterfield gave a hint of one of those crafty smiles which only he could give:

'Just an experiment. I thought that gazing upon wisdom would give him back his reason straightaway. It doesn't seem to have worked. But at least we've tried . . .'

Now it was my turn to smile.

'Well, Signor Brown, how goes it with the handsome, talented Cecil, my lucky rival?'

'Very badly.'

'No offence meant, but I'm delighted. So tell me, what's he suffering from? Colic? Dyspepsia? Haemorrhoids perhaps? Or some catarrhal infection owing to the prevailing damp here in London's fair city? God created man in His own image, and every part of man has its own diseases, including the head, as we have just seen in the case of that wretched genius with the devastated brain . . .'

'Cecil is suffering from grief.'

'Wasting away for love. A wounded, inconsolable heart. So soothe him by dropping a poison . . . sorry, a poem into his ear. There are some very beautiful ones. I read one from your own pen only yesterday while I was working for that brigand Charlewood who pays me so badly:

> *Blind error, miserly time, spiteful fortune,*
> *Unreined desire, vile rage, iniquitous zeal,*

255

Cruel heart, impious soul, strange effrontery
Will not suffice to darken the air around me . . .

'. . . *Will not throw a veil o'er my eyes,*' I went on.
Softly, Snitterfield concluded:
'*Will never prevent my bright sun from shining . . .*'
Seizing me suddenly by the chin, he kissed me on the
mouth. Then he smiled:
'I am drunk, Signor Brown. Please forgive me.'
'There is nothing to forgive. Soon I shall be drunk too.'
'And you in your turn will lose your reason . . .'
The kiss had set my whole being on fire. Now I was
devouring this ruffian with my eyes as if he were Hermes in
person, the god of thieves, suddenly appearing in the first light
of dawn and already planning to steal Apollo's herds . . .
'The first time I saw you, at Charlton, you were wearing a
woman's garment . . .'
'Just a device, so common these days in the theatre, at court
and even in taverns. That didn't stop you being seduced.
And you yourself, my dear philosopher, are you male or
female? Without undoing your aglets I can't tell. Perhaps what
you're hiding under your hose is, ugh! a horrible woman's
organ . . .'
He was in fits of laughter.
'You rogue!' I exclaimed, grabbing his wrist. 'I'll give you a
taste of my woman's organ . . .'
'Gently does it, old chap . . . Tell me something instead: that
scribe with the black eye patch who follows you like a
shadow, do you love him? Have you ever loved him? Does he
love you?'
'His name is Hennequin. Jean Hennequin, my disciple.
Since his accident, he has given up loving anyone, he hates
life.'
'Hennequin, Cecil . . . not to mention his brother, the great
Philip Sidney, perhaps the most melancholy poet the world
has ever known . . . Poor Master Nolan, surrounded by
gloomy souls . . .'
'You don't know how right you are. Nevertheless, when

256

he's in company Philip can be a most cheerful companion, even if what he writes is serious, and his life even more so. Come now, isn't there any more beer in this tavern? Why don't they bring us something to drink?'

We drank, and when Snitterfield picked up his lute again and started plucking it, all the merrymakers, tipsy men and lustful women who were in the place gathered around us. We saw the madman we had spoken to earlier coming over, long, thin and silent: a veritable allegory of death. Creatures of a pitiless god, flesh of cities . . . What do they care whether or not the earth turns in the infinite heavens? All they want is to sink back every evening into the womb of a tavern where they can forget their sorrows. People of Dionysus, in love with drunkenness and shunning reason . . .

'What I drink here,' the actor whispered in my ear, 'I pay for with songs. And you, doctor, will you sing something for these villains and ignoramuses?'

'I shall recite a poem, if you insist . . .'

Snitterfield plucked the strings again. His repertoire included a dozen or so Italian, English and French ballads which he also played about with by translating them from one language to the other while still singing each of them to the same tune. Most of them were his own compositions, others were borrowed from obscure rhymesters, some insane, some of sound mind, all well-acquainted with brothels and venal embraces, he admitted to me, and all tremendous lovers of beer. The customers in the tavern were crowding round to listen and humming along as they raised their glasses, damp-eyed, and wound their arms around women dressed in rags. When it was my turn to entertain this high-class crowd, I improvised a short poem of Petrachist inspiration on a theme which is close to my heart – death by the kiss:

> You have left my heart
> Light of my eyes, you are with me no more.
> Let him kiss my lips with the kiss of his mouth,
> For he holds me fast
> And I languish for this too cruel love.

257

A strange silence fell while I uttered these Italian words punctuated by brief chords. Who on earth could understand my language here? To my great surprise, I encountered no hostility. On the contrary, the gathering was gripped by emotion, and at the end they all applauded me.

Snitterfield lived, or hid away, to the east of London, not far from Shoreditch. Before going there, we walked along the Thames. The rain had stopped.

I do not doubt that a demon who knew all the mysteries of destiny was observing us, as we stood in silence and watched the dawn light up the truncated tower of St Paul's. No doubt the future was unfolding before his invisible eyes: how I would spend the best hours of the day savouring the delights of love with the actor (a pleasure which I had begun to think was lost for ever, now that Cecil was being so cold to me) and how, shortly afterwards, Snitterfield would disappear without trace.

What danger had he had to run away from? Neither Greville nor Dudley had any idea. Charlewood, who knew the company he kept, simply assumed that he was dead. When summer came, the rumour went round that he had been reconciled with his father and had gone back to living with his wife in his native village, forty leagues from London. For my part, I never saw him again, and never heard anything from him at all, except through the medium of *Love's Labours Lost*, a play in which, according to letters that people have written me, I appear in the company of John Florio, the King of Navarre, and a few unknown lords.

The news of my father's death reached me in the spring of eighty-five, at the time when my *Heroic Enthusiasts* was coming out of John Charlewood's presses. Two letters arrived at the same time at Butcher's Row, the first signed by one of my Savolino cousins, who said that he was writing on behalf of Fraulissa, or that she had dictated the letter, the second from Morgana Borzello. I would not have been surprised to learn – and perhaps this, of all my desires, was the one I had cherished the longest – that Gioan had been blown away by

a cannonball or skewered by an enemy sword in the course of some remote and legendary battle, but of course it wasn't the case. On the contrary, the letters said that he had passed away peacefully at home, on il Colle di Cicala to which he had retired five years before. I felt no sadness. To me it was just as if the iron-clad knight were disappearing one last time at the end of the stony path . . .

'What news?' enquired Cecil.

'News from the gods,' I sighed, folding up Morgana's letter.

Philip was most surprised:

'The gods? May I ask what they have to say?'

'What my destiny will be, of course . . .'

Turning to Jean, I called out:

'Come on! Let's get back to work.'

Before starting to dictate again, I smiled at my beloved. He was engrossed in reading *Arcadia*. His beauty had not diminished, but every day he grew a little further away from me. If the death of those we love brings with it a little wisdom, we were both going to become wiser and wiser: soon after this Philip would be mortally wounded at Zutphen, and Jean Hennequin in Paris.

Wisdom? It was during the last months I spent in London that I began to consider another way of practising my philosophy. Wearied by nearly twenty years of disputes with ignoramuses, weary of seeing them clinging ever more tightly to their motionless earth, their dessicated language, and their stupid, violent religions, I suddenly decided that in future I would speak only to an esoteric audience that was willing to receive my teaching without instantly crying heresy, in this case only the initiates who had gathered around Sidney. I even began to toy with the plan of recruiting from the colleges some young followers who would become ambassadors for my ideas in all four corners of Europe.

> With the sound of the trumpet the captain calls
> His warriors all to a single flag . . .

Those who are familiar with my work will already have encountered these lines in my *Enthusiasts*. They were intended to magnify the universal One, the *spiritus mundi*, and the way in which, in a single movement, he embraces the apparent multiplicity of things; but at the time, the discerning reader could not fail to notice that they also contained a murmured message, a call for the creation of the Brunian learned circle. This idea was gradually to gain ground, and there was even an attempt to put it into practice some years later in Germany.

To my audience, whose members from now on were few in number, and chosen with care for the quality of their learning, I strove to demonstrate that the ancient wisdom of Egyptian hermetism had degenerated at one time into Judaism, then Judaism into Christianity. Torn apart by wars between enemy sects, the latter was in danger of collapsing in its turn, and quite right too, for its long-standing dominion was tainted by too much misery, too many lies and too much killing. The troubles that tormented the century left nothing behind them but ashes, but from these ashes the natural religion of Thoth-Hermes would rise again like the phoenix. Having completed its universal revolution, Time was returning at last to the point where it had started and, according to Cusan metaphysics, that point of departure would coincide with the point of arrival, deepest darkness with dazzling light. Yes, it seemed that in our time we had sunk to our lowest point, to the very dregs of opinion and morals; but opposites always came back together, for that was the law, and before long this intellectual morass, this moral turpitude, this theological quagmire would engender the most eminent wisdom. The Trinity of the Catholics? The Predestination of the Protestants? The devil take all that nonsense! It was time to return to the solar religion of the past, in which God lives absolutely in all things.

Needless to say, the least convinced of those who were keeping up with my efforts to follow in the footsteps of the great mages of the past was Cecil. He accused me of adopting a preaching tone. He professed himself a complete atheist, and never had any sense of a cosmic order, or providence.

'God does not exist except in grammar,' he claimed, 'and there is no justification for the world.'

'Don't be stupid,' I answered, still covering his skin with kisses which no longer made him quiver. 'Stop mixing up language and grammar, will you . . .'

'And you stop slobbering all over my neck.'

Have patience, I sighed in my inner depths, and take pity on this wounded heart . . .

'The language that I invent is of the sort that captures the thoughts of God, and those thoughts are acts which transform life.'

'Your thoughts have no power, Philip. In any case they can't do anything to stop death . . .'

'Death! That's all you can talk about these days!'

It seemed that his affection for me had disappeared with the soul of the *mignon* in Paris. Was this how I was to be rewarded for my love? Lord, how I hated these moments of suffering which injected me with the poison of doubt! One day, the iron would no longer attract the magnet, nor the amber the straw. The rivers would suddenly stop wanting to join the ocean. And all the *sumpathia* in the world would vanish for ever . . . Oh Cecil! I had been trying for months to win you back with gifts, caresses, games, poems and sweet words, and all I had got for my efforts was tears and disappointment.

'Do you still love me, Cecil?'

'I'm going back to Venice. Down there, no-one needs God to live.'

I can remember the last time our four destinies were united, when Cecil set off from Dover on a ship of the Levant Company. There was something about the climate on that island that did not suit his temperament, and once he had decided to leave he started smiling again. He was the only one of us who seemed happy, or at least calm. Philip, who had wearied of his marriage and could not seem to find happiness here below with women, was fretting continually. Not long afterwards he would go off to fight against Spain. Hennequin, for his part, quite definitely had a sense of impending doom, for he never

opened his mouth except to curse his life. As for my soul, once again fate was delivering it to absence.

The excellent Michel de Castelnau, whose friendship was at the root of all my success in *Britannia*, fell somewhat out of favour after Cecil's departure. The slanderers and jealous men had done their job well, and as a result my reputation at court had suffered badly; and I am quite sure that it was because of me that the queen's attitude towards Michel changed, even though he was the most distinguished and tolerant man in the world. Because of the Ash Wednesday supper and my prolonged presence at Butcher's Row, Elizabeth started to show a certain irritation towards him, while in the meantime Henri stopped paying him his emolument as an ambassador. Misfortunes never come singly, and his wife Maria (a woman with whom I had no quarrel, an excellent mother and a most unobtrusive hostess) fell seriously ill. Thus we watched him in eighty-five spend most of the year having to beg for credit from the Italian bankers in London so that he could meet his financial obligations. By November he was so disheartened and anxious to sort things out with Henri that he decided to go back to France. Cecil was far away. On the queen's orders Philip was preparing to leave for Flanders; I suspect that she wanted to separate us at any price. There was nothing to keep me in England. We boarded ship with Castelnau and his family. No crossing can ever have been crueller than that one was. First our boat, a sailing-ship of modest tonnage which was carrying a cargo of salted meat, was attacked by Spanish pirates. We offered no resistance, having nothing to defend ourselves with but our bare hands and the sailors' cutlasses. Our own crew had to run under the threat of the whip from one boat to the other with all Castelnau's possessions, and we thought for a while that the scoundrels would even steal their children to sell them as slaves to the Turks. But fortunately they abandoned this odious plan. When it came to the other passengers' turn, Hennequin, who had concealed the crowns earned by the success of my books in some secret drawer in his trunk, commanded my admiration by refusing

to show where they were hidden. Stand fast, little Jean! The harder they beat him, the more he dug his heels in. He did not give in until they had started to cut one of his ears off. This scene was such an ordeal for everyone that those who had a purse seemed happy to be relieved of it without further suffering. Finally, their task accomplished, the pirates noticed the captain, an intelligent Irishman whom I had amazed a moment earlier by explaining the earth's motion to him. For no other reason than to observe some sort of custom that they had in their country, they broke his limbs with the back of a felling axe and threw him into the black waters. Then they gloated over his death agony, which lasted an exceedingly long time, because the poor man kept struggling not to drown until every last ounce of his strength was exhausted.

No sooner had we escaped the clutches of the pirates than the elements erupted so violently, it seemed they were trying to hurl us straight to the bottom. Had we done something to deserve divine punishment? With a furious blast of wind, Neptune tore off almost all the sails, and the ship was lifted up like a wisp of straw on the crest of waves as high as mountains. Then masses of icy water fell on our heads. You would have sworn that the sea and the sky had resolved to confront one another that day in one last battle. We were all clinging on to whatever we could find, be it a halyard, a streaming wet spar or a ship's rail, screaming in unison as the boat groaned and creaked and the rain lashed our faces, and believing at every moment that our last hour had come. Crushed up against each other, trembling in their wet rags, men and women were weeping and calling on the Lord. Many were muttering prayers or brandishing a rosary at the invisible skies. Some, seized by a deadly hope, abandoned all caution and stupidly went off in search of a better place to take shelter. Then the boat listed even further, and in return for their efforts they were thrown over to the bulwark and then swallowed up by a wave. Michel had found a rope and managed to tie his wife and children together to a hatch-ladder, but they were all struggling to free themselves from this intolerable bond, suffocating and crying out that they were going to drown,

Tuesday, 15th February, 1600

In my earlier days I would never have abandoned the reader like that, right in the middle of a description. I hope he will forgive me; when the moment came to tell him about the terrible storm that nearly saw us all perish off Dieppe, I had written eighteen pages in a row, struggling at every second against exhaustion. In the end sleep came crashing down on me, and the pen fell from my hands. By going to sleep on the table, next to the hot lantern, all I did was let images of the apocalypse invade my mind and breed a succession of night-mares in which the most painful reminiscences became en-tangled: Felix garrotted for the thousandth time in his cell in the Conciergerie, Hennequin run through with a sword at the college in Cambrai; Philip dying yet again beneath his armour . . . After my dead had filed through the theatre of my dreams, just as much here and perfectly themselves as perhaps they ever were before in what we call real life, I found myself being snatched brutally from the comfort of my cell and dragged by the guards to the *Banchi*, then to the Campo dei Fiori where the market was in progress, with its abundance of flowers, fruit, onions and olives, its cartloads of seeds, its squawking beggars, hurdy-gurdy men and fortune-tellers, its halberdiers standing guard in front of the French embassy . . . So was it just an ordinary day? No indeed. But a demon had decreed that this profusion of movement and colour should arouse my senses for one last time. They say that the condemned man savours the pangs of death more fully for as long as he still has within him the sights and sounds of life, knowing that they will still be there when he is no more. But at the heart of all life is death, and as a reminder of that, the stake towered up at the far end of the square along with its allegorical gibbet. The imagination can play mischievous tricks; the gallows appeared to be an exact replica of the one at the Maubert crossroads. As my gaze rested on the oil-soaked faggots they immediately

burst into flame, giving off a smoke so black that it was an offence to the sun, like a dark cloud heralding disaster. To stop me shouting out, the guards had put the bit in my mouth, as on Wednesday after the reading of the sentence. Barefoot, wearing nothing but a piece of rag, with spittle dripping from my lips and my hands tied, I was stumbling along at the front of a procession of monks and black friars singing psalms. Their veiled tablets swayed above wild, enraged beggars who were throwing stones at me. I was prodded with pikes towards the blinding flames and was still completely conscious as I reflected – so these are what my last thoughts will be! – on the butterfly that is drawn to the deadly light, the adventurous child on his frail barque, Acteon pursuing his own death, Dante's heretics shut up in their burning sepulchres, Socrates drinking his poison, and the martyred saints of the Christians: Sebastian riddled with arrows, resuscitated then beaten to death, Julian of Anazarbus sewn into a sack with scorpions and vipers, Vitalis stabbed by a pimp, Benjamin impaled, Sigismund thrown into a well, Lawrence roasted alive on his gridiron, Desiderius stoned to death; then Ramon Lull flogged by the Saracens, Victor crushed under a millstone, Eleazar forced to eat the pork they stuffed into his mouth, Ahmed nailed to a tree, Serapion whose executioner only cut halfway through his neck so that his head hung down over his chest; Saturnine of Toulouse tied to a bull, Bonfiglio thrown into a cesspool at the age of eighty, Leger having his tongue cut off, Placid having his lips cut off, Polycarp having to have his throat cut because the flames refused to devour him; Vincent of Saragossa torn apart by iron claws, Crispin and Crispinian hurled into a vat of molten lead, Benignus shut up with rabid dogs after having his feet embedded in stones, Ignatius thrown to the lions, the forty martyrs of Sebaste, trembling all night in their frozen pond and then being clubbed to death; and Sarkis, Eulogius, Blaise, Theodotus, Julius, Prudentius and Antimus, decapitated – all great lovers of peace, and nevertheless drowned, strangled, clapped in irons and burned; racked, bled, disembowelled, castrated, crucified alive, caged in, chained up; grossly insulted, slandered, made to ride naked on donkeys

with bells round their necks, mocked, tortured to death and then having their bodies trampled on, covered in spit, filth and vomit, sniffed at by dogs, mutilated, pissed on, shat on, and finally thrown into a common grave to the relief of all, noblemen, churchmen and the common herd alike, united as they are in the same passion for destroying the life they find so intolerable; and now I in my turn was being beaten in front of that curtain of flame. The guards were striking me, the women were booing me, the beggars were throwing rotten fruit at me, the friars of San Giovanni Decollato were rejoicing at the prospect of seeing me buckle and twist in the fire. A stranger with a sabre in his hand suddenly came rushing out of the crowd, grabbed me by the hair and tried to slit my throat before I could get to the inferno. Was this assassin, this robber of death, the man called Gaspard Schioppius? Someone (Deza? Cecil?) held on to his arm and stopped him. Weapons clashed. The bolt grated against the cell door, and it opened. Orazio was staring at my face which was distorted with terror . . .

'How long have I been asleep?'

'It has been light for two hours . . .'

'I'm thirsty!'

'Here is some wine, Brunus.'

I was trembling so hard that the drink spilled out all around my mouth. A flash of pity shot across Cerberus' one eye.

'Why do you hide yourself away day and night in this prison, Orazio? Don't you have a wife or child?'

'What do you care?'

What did I care, indeed. This man was fertilised by pure chance in the womb of a whore. Does he even know the date of his birth? I can see his mother, disfigured by pain, cursing her lot and the god she hates. I can see my future guard being heaved out into a dark corner of the Piazza Perduta, along with a stream of shit, urine and blood, and the newborn child being picked up by a nun, carried off to San Genaro, and brought up as a gallows bird among the down-and-outs at the hospice. Today, Orazio's only kingdom is Tor di Nona, on the lowest rung of the civil ladder. But pity and respect are human

feelings which even a torturer with a squint can have; and he likes the idea of acting as servant to an infidel . . .

'Young Deza will be coming presently to fetch what you have written and record your last wishes.'

My will and testament, by heaven! Deza and Orazio are the last sentinels on guard over my life. Like a eucharistic gaoler, the latter brought me two slices of bread and some dark red wine; I watched as he lifted up by the handle the bucket in which my excrement was rotting. Thanks to him, it will return once more to the waters of the Tiber. In two days' time, the philosopher's body will cease to contribute to the cosmic movement of being, and to transform the fruits of the earth into ideas and faecal matter . . . Having read the last words that I wrote yesterday, I folded a sheet of paper and wrote the date of this new day.

A wine with an infinitely more delicate flavour, one from Gascony, this time, was slipping delightfully down my throat. I put down my glass and said to the friends who were with me:

'You ask me what I think of religion, and I answer you this: Plato stated on one hand the need for God, and on the other the importance of moral freedom, which we today call free will. The illustrious academician had followed the teachings of Socrates; his wise mind reigned over an era of good sense. This need and this freedom were considered by the Greeks at that time to be compatible, and united by a mysterious *sumpathia*. I observe that in our dark century the priests and pastors of the nations almost always forget the second term of the ancient duality. Why? The explanation is simple: they are afraid that the common herd, which is by nature prone to evil and unable to exert self-control, will put it to harmful use. But without freedom, science cannot exist, and nor can the search for the natural truths! We would all agree that the populace should be protected from an excess of licence. But that we who have contemplative minds should be forced to subject our art to the canons of this or that belief, that is what I think is dangerous, and what is more, harmful to the way in which reason works to enlighten our minds. Truly, my dear friends,

these princes are committing a grave error. Can't they see that our ideas are not accessible to the herd? The common man feeds himself on gruel and black bread, for heaven's sake! Serve him up dainty dishes and he will trample on them as swine trample on pearls! No, fine theories appeal to eminent minds. Only they have learned to savour, love and enjoy them, and to handle them with the delicacy that precious objects call for. There is therefore nothing to fear from letting them have complete freedom to spread their wings . . .'

I saw Giovanni Moro, who certainly didn't think of himself as a common rogue, show his approval of what I had said by smiling around the company as he always used to. One image called up another, and I was visited by memories of other agreeable evenings in the past. I thought briefly of Jean-Antoine, who was so ill now that he hardly ever left his house in the rue Saint-Victor, and of course of Cecil, my distant star. Of all the scholars who had come to hear me that evening, the most talented were Jacopo Corbinelli, an opponent of the League and close advisor to Henri, and his friend Father Piero del Bene. The latter dreamt of seeing the King of Navarre rule France one day, and to that end was trying hard to persuade him to embrace Catholicism. No-one doubted that he would succeed in his aims. Although Paris was given over once again to the tyranny of the Guises and other fanatics, there were many who, secretly or not, would rather have had peace than a victory for their own faith at the cost of a bloodbath. Religion? There were many who saw it by now as nothing but a necessary constraint, an ill-fitting garment that had to be worn just to give the common people a set of rules and to keep up appearances; the real decisions were being taken without reference to the faith. I could not help regarding these two Italians as the messengers of the future; it was as if they were applying my own views to the art of governing nations, and were thus teaching them to their respective masters . . .

'Would you yourself,' del Bene asked me, 'be willing to return to the bosom of the church, if the opportunity arose?'

'Yes,' I said without hesitation.

No-one was surprised by my answer. On my return from London, I had gone to see Don Bernardin de Mendoza, who at that time was the ambassador to Paris, and presented him with a request to that effect. How could the fact that I had taken that step have escaped the notice of Piero, the world's best informed man? Now he had confirmation of it from my own mouth.

'And what was Don Mendoza's reaction?'

'He sent me to confess to some Spanish Jesuit, I forget his name. Needless to say the fellow refused to hear me, claiming that he could not absolve an apostate who was forbidden to receive the holy sacraments.'

'Round and round in circles,' sighed Corbinelli.

I spoke again to del Bene:

'Perhaps your King of Navarre will be granted the privilege of returning to the papal bosom, my dear Piero, but as far as I am concerned, it seems that the matter is closed.'

'Are you sad about that, by any chance?' asked Giovanni Moro, intrigued.

'Not in the slightest. I am by nature sensible, polite and conciliatory. I like to espouse the belief of the prince in whose country I am living, given that that is never what dictates my thoughts, or my behaviour.'

'Yes, you were a Protestant in Geneva, weren't you.'

'What does it mean these days to *be* Protestant? A name enrolled on a register? In that case why should I not be a Catholic here? As far as I know, that is Henri's religion . . .'

But Henri was no more willing than Mendoza to accept my gestures of affection and goodwill. All the letters I had sent him remained unanswered, and in the end I even wondered if they had ever reached him. Indeed, under the leadership of du Perron (who for his part had had no problem at all in converting to Catholicism!) a cohort of pedants was devoting itself to protecting the king from my deplorable influence. Despite the strategies employed by Corbinelli on my behalf, I was never again to be invited to the Louvre. No chair for me at the Sorbonne any more, and so, no more money or protection. On the contrary, the wind of rumour frequently whistled

round my ears, carrying threats from fanatics and grudge-holders of every description. Isolated, I could only survive thanks to the sale of my books, a few lessons that I was allowed to give at the college in Cambrai, and the circle of *Venetians* that had gathered round Giovanni Moro. Cecil was far away, his letters rare. Absence added to my solitude. Those who knew me at that time will remember me as an anxious man, renting a modest lodging in the rue Saint-Jean de Latran, going every day to the library at the Saint-Victor Abbey where I read, dictated and wrote for hours on end, with my sad-faced disciple at my side.

I do not know whether Guillaume Cotin, the abbey's librarian, ever mentioned my name in his journal, but I do know that he wrote endlessly in it about the character and opinions of all those who paid regular visits to his domain. The man was famous for his exasperating curiosity. Every day without fail he would yield to his vice and ask me questions about my travels and my books, the ones I had written, the ones I was planning to write . . . By the way, what was this he'd heard about my dialogues in Latin about Mordente's compasses? Hadn't they caused quite a stir?

I had got to know Fabrizio Mordente the mathematician through Giovanni Moro. He was something of a pedant, but since some of his views were very sound it seemed at first that we would get on well together, especially since we found that we were linked by a curious coincidence: his brother Gaspare had served for some years in the same company as my father!

When he showed us the compasses, which were fitted with all sorts of special features, everyone was full of admiration, and I immediately offered, simply to be agreeable to this near-compatriot, to describe it in a forthcoming treatise. That way the invention would be appreciated beyond our circle. Mordente was quite a good geometrician, but a terrible philosopher. On top of that, he knew no Latin. How could he have explained the significance of his discovery in the proper scholarly way? At first he was bashful about my offer. Then, after a great deal of dithering tinged with the sort of mistrust

that only a Salernitan could show, he accepted, intoxicated by the prospect – always an irresistible one for an ignoramus – of seeing his name printed on the frontispiece of a book.

'*De Mordentii circino!*' I exclaimed. 'That will be the title of the work. Is that acceptable to you? Perhaps you would have liked it to be longer?'

'*De Mordentii,*' he repeated, pink with pleasure. 'It's perfectly acceptable to me, but . . .'

'But?'

'Are you a mathematician?'

'What are you trying to insinuate, Fabrizio? That I haven't grasped the significance of your . . . instrument?'

The treatise took the form of two dialogues dedicated to the excellent Piero del Bene; Jean Hennequin took them to be printed by Pierre Chevillot, my neighbour in the Rue Saint-Jean de Latran. In them Mordente was baptised the *father of mechanical inventions and god of geometricians*. The Salernitan, I wrote, had restored life to the dead sciences and coherence to those which the pedants were trying to smash to pieces. Yes, where all others had failed, he had succeeded, etc. Wasn't my praise sufficiently glowing? The cautious Fabrizio didn't like my book, in fact he hated it. But for goodness' sake, would Copernicus have liked the way I described his sky? However scholarly these mathematicians may be in their calculations, they are not aware of the essential truths which their inventions help to shed light on – I still believe that to this day. Is that to say that they are ignorant? No indeed! But they are like interpreters whose role it is to translate words from one language to another, or like boatmen who help pilgrims across the river. Will the interpreter ever know all the mysteries involved in the creation of the languages he deals with? Has the boatman ever visited the countries where the people who spend a moment or two in his boat are going? Geometricians are needed as intermediaries with nature, but it is the metaphysician's business to reveal causes and principles, for as Seneca said, *visu carentem magna pars veri latet* . . .

'*From him who cannot see, a large part of the truth is hidden,*' translated Guillaume Cotin, acting as interpreter in his turn.

'So the philosopher, if I understand correctly, is the one to whom it is given to *see* . . . Would you define him as a kind of magus?'

'An inspired magus, yes. Certainly not a mere calculator.'

'You're absolutely right. One last question though: was it really necessary to compare poor Mordente to the ass on which Our Lord rode into Jerusalem?'

'It was a metaphor, Guillaume! Just a metaphor! Like the geometrician, the ass is a useful intermediary, but who triumphs in the end? The ass that has carried Christ, or Christ himself?'

The librarian accepted my objection, but did not think that the *metaphor* I had chosen augured well.

'It doesn't make any difference,' he sighed. 'It's never pleasant to see oneself depicted as a donkey, even if it is divine. Take care that the wounded animal doesn't start scheming to find some way of kicking you back.'

Guillaume didn't know how right he was: no sooner had the book about his compasses been translated than the bashful Salernitan turned into a wild animal. First he spent a hundred crowns to buy back all the printed copies from Chevillot and have them burned. Then, having kicked up a furore and stormed out of the circle of *Venetians*, he rejoined the ranks of the papists in the hope of recruiting some allies there – not a very difficult thing to do – who would help him take his petty revenge; and after moving heaven and earth, stirring up my natural enemies, and taking his complaint right to du Perron, he was rewarded for his magnificent efforts when that revenge was carried out on Whit Thursday, eighty-six, at the college in Cambrai. There Jean Hennequin met the violent death that was intended for me.

Jean had just finally written the last word of a book of his own – the only one he ever published – pompously entitled *A hundred and twenty errors made by peripatetics concerning nature and the world*. We had carried it with great ceremony to Giuliano the bookseller. The work, which was supposed to be an incisive analysis that would shut the Aristotle-worshippers up

for good, was in fact just a pleasing synopsis – by no means badly put together, to be fair – of my principal themes. For my taste it was rather dry and lacking in real meat, however I was very careful not to tell my disciple that, but to be very complimentary instead. Jean felt some pride at holding his first printed pamphlet in his hands, and heaven knows his existence was quite miserable enough already without my denying him this modest pleasure into the bargain. It even occurred to me to reward him. I had decided to give a special lecture to draw the attention of the masters to my latest works (the charming *Arbor philosophorum* and a new treatise on memory, *Figuratio aristotelici*) and when the day came, I offered him the chance to speak in my place at Cambrai College.

Never had we had such a hostile audience. True, our posters had attracted a large number of students who supported my doctrine, but gangs of thugs armed to the teeth and paid by the League prevented them from attending the lecture by mingling with the *lecteurs royaux* and taking up all the available seats in advance. A certain Raoul Callier, who wrote sonnets and was Bishop du Perron's *mignon*, was lording it in the front row along with some henchmen, having been sent by his master, and of course Mordente, just to let me know that if anything went wrong I could not count on the king's support. As soon as I saw this arrogant individual, I debated with myself whether it would not be better to abandon the debate. But it was too late to back out; Hennequin had already taken his place in the great chair. Tormented by a sense of foreboding, I sat down in a smaller one, near the door leading to the garden.

'Where has this dreadful one-eyed fellow come from?' people shouted. 'Isn't it Brunus that we have come to hear?'

'This is a trick!' agreed a student.

Callier stood up in his turn and said, glancing in my direction:

'Perhaps the Neapolitan is afraid of getting gibes and rotten eggs thrown at his august head, and that's why he prefers to send his lieutenant into the firing-line like this.'

'Hennequin is my disciple,' I replied. 'He knows my work and will speak today in my name. Anyone who doesn't like

that can go away. There are people outside who are only too keen to come in . . . Go ahead, Jean. Let us begin . . .'

'The disciple is not the master,' persisted Callier.

'And you know something about that, if I am to believe your reputation.'

'My reputation, sir?'

The confounded fellow already had his hand on his sword. I calmly folded my arms and went on to the attack:

'They say in Paris that your verses are nothing but slobbery licks on the arse of a certain recently converted prelate. Take care that he doesn't fart in your face one day, because that could make things very uncomfortable for you. Hennequin doesn't lick anyone's arse. He has written a work of science, which you certainly couldn't do.'

At this point I thought that Jean's speech was over before it had even begun, because the sonnet-writer was coming towards me, pointing his rapier at my chest. I did not move a muscle. The *lecteurs royaux*, on the other hand, were itching to get out of there . . .

'I could stuff those *slobbery licks* back down your throat,' the fellow hissed furiously.

I continued to look straight into his eyes.

'You are at the University here,' I went on, without raising my voice. 'Not in a tavern. Go back to your seat and open your ears.'

The idiot was taken aback for a few moments. Then he swore that I would live to regret what I had said. I watched as he took four steps back, still waving his sword about like some ridiculous soldier in a slapstick comedy. Jean started diligently reading his text:

'Knowledge was once shut away in a prison, a cramped cave, where it was unable to wonder at the vastness of the sky. Its clipped wings prevented it from rising up to the clouds, *a fortiori* from tearing away the veil they formed and discovering the innumerable worlds beyond. Thus man lived in the dark cavern of ignorance, a prisoner of his pipe-dreams and prejudices, deceived by the sophists with many faces who came to teach him fallacious ideas about the world. To be sure, divine

intelligence sometimes whispered some truth into his ear, but only the poetic part of his soul was touched by it; and then, amid cries and groans, he would respond to this call in verse:

> *My reason, oh my reason is lost.*
> *What warrior soaring to the skies*
> *Will bring it back to me?'*

Thank you, little Jean, thank you for singing the praises of my poetry – a lesson, let it be said in passing, to the odious Raoul! As I listened to you I was thinking of Theophylus, or Filoteus, the now-famous hero of my books, the divine spokesman, the messenger of a Nolan for ever more absent . . . Growing ever more assured as you spoke, you went on:

'Let no man among us be the ablest, said the Ephesians, or let him be so elsewhere! And yet, at the risk of burning his eyes in the light, one man has not been afraid to turn his back on the deceiving images of the cavern, or scale its sheer walls, or leave behind its tainted air; and that man is my master. Thinking only of the good of all, he has dared to cross the bounds of the world alone, to do away with the imaginary walls of the false astronomers, to strip the veils away from the beautiful body of nature and restore sight to the blind, so that they may gaze upon their true image in the mirror of the universe. Thanks to him, the stars that were known and listed by the ancient traditions are as close and familiar to us as the one that carries us on its back. Thanks to him we know that these celestial animals, however different their dimensions and natures may appear to us, are composed of one single substance, a visible shadow of the invisible god, an effect of the primary cause; the same applies to the air in which these stars move and glisten, to the earth, the water and the fire in which, as Heraclitus said, all will be judged and devoured. God is majesty, unity, infinity. A single majestic, infinite universe befits Him better than a miserable cave, haunted by erratic shadows, closed in behind high walls . . .'

Brave, talented Hennequin! You had done as good a job of shutting those thugs up as I could have done myself. But how

strange and faraway your voice suddenly sounded to me! The day before, when you got back from the library, you had spoken in two or three laconic sentences of an imminent and mysterious departure, thus warning me that I would soon have to do without you. And yet the date and the destination of the journey had remained unclear. When I saw you suddenly stop reading and continue your lecture, never taking your black-patched gaze off my face, those sentences came back to me, and it occurred to me that you were saying goodbye . . .

'This boundless universe is the true home of the mind, its clothing and finery, its discourse, poem, book, garden, reflection and soul. The divinity does not have one form, but every form; likewise its increate work, which we call creation. One of these forms is death, for out of death comes the future, and thus time. From time springs reason, from reason language. By liberating the heavens, the Nolan has set them both free. But will reason and language never enable us to know the form that they originally come from, that is their mother? Epicurus considered that question to be futile and of no interest. If I may be forgiven, I wish to ask it now: who knows what happens to a poor soul when it is separated from its body? Will it fertilise another life? Will it quiver for a little while in immeasurable space, as if in a new dream? Will it rejoin the *anima mundi*, the first breath of the first atom, that place which may not really exist where movement and immobility merge into one? That is all I have to say, Philip . . .'

The whole audience, *lecteurs royaux*, gentlemen and students alike, seemed to be struck dumb. Troubled myself by this strange oration, I remained silent for a moment; then I invited those who had made boastful remarks earlier to reply now to Jean's beautiful speech:

'Doesn't Monsieur Callier have anything more to say?'

No answer. For the benefit of the masters, I declared:

'It seems that my disciple's lecture was to his liking.'

At that he called out, more furious than if I had insulted him again:

'Your theories are so contrary to common sense that they deserve nothing but contempt! Hence the silence . . .'

'Silence is the argument of the vanquished,' I retorted, standing up. 'It only remains for the victors to withdraw.'

Jean left his chair and joined me by the door where I was standing, ready to go out. But Callier, as I was to find out later in a letter from Corbinelli and del Bene, had been paid by Mordente to have me disposed of by his men.

'Stop him!' he shouted.

The thugs drew their swords and surrounded us, and I thought that my last hour had come.

'They're going to kill me! It's a trap! An ambush! I appeal to you, gentlemen!'

My shouts were aimed at the *lecteurs royaux*, but many of them were hiding their eyes behind their hands to avoid witnessing the massacre. At that moment Jean, with astonishing presence of mind, opened the door and pushed me into the garden. Then he turned to our attackers, spread his arms and clutched on to the door frame to bar their way.

'You are murdering reason!' he shouted.

No fewer than ten blades ran through his body.

As I was fleeing from Paris to Darmstadt, then on to Frankfurt, Marburg and finally Wittenberg, I more than once had occasion to think of the premonitory speeches that Philip Sidney had made on those evenings when we conversed at Butcher's Row or at Fulke Greville's house. Often the debate turned on the nature of my ideas and the disposition of my soul. Philip said – and everyone else agreed – that Germany would soon be the only refuge on offer to the eternal exile that life had turned me into. Had he himself been forced to leave his native country, he would have had no other choice than to go to those northern regions, since the Mediterranean no longer loved freedom.

But as fate would have it, that prophecy only came true where I was concerned. Whenever the poet travelled it was always for his own pleasure or in the service of the queen, and he would never go through the ordeal of banishment. I had been living for five months in Germany when the news of his death reached me:

'I curse the fate, my dear Jordan, that forces me to write to you with grievous reports. Our great friend, the gifted Sidney, has perished for Elizabeth. He was thrown from his horse during a Spanish attack at the siege of Zutphen, & was transported to London where he breathed his last twenty-six days later, on the 17th October last. The queen decreed that he should be buried with full honours & great ceremony in St Paul's cathedral. Thus it is the youngest, most courteous & most refined of our circle who is the first to leave it, wounded in action, enduring the horrific agony of the pangs of death inside his beautiful armour, whilst surrounded, it is true, by the affection of his soldiers. It is said that he refused to drink from a goblet which one of his captains held out to him & that he offered it himself with trembling hand to another wounded man, murmuring in Italian, his need is greater than mine. Oh dear Lord! That supremely elegant gesture sums up his life as a sign of farewell addressed to us all & heightens the despair of those who loved him. We still have his books, but how can the written word, however divine, ever replace living beauty? It is said that Fulke has withdrawn to some manor to weep there, crying out that it would not be long before he joined the person he had loved most here on earth, wherever he might be.

'As if one bereavement were not enough to cast a shadow over my days, death also came to deliver Maria from her illness and carry her off on the 9th December. I cannot forget that she was one of the few women whose praises have ever been sung by your pen. I will leave you to imagine the sorrow that overwhelms me, & my poor children. What good can come of these trials? Why does God call back the best, the innocent? The loss of Maria has turned me into an old man, Jordan, & like Fulke I long only to go in my turn.

'Corbinelli tells me that you have been granted the right to teach your philosophy freely in Wittenberg. He himself heard this news from Alberigo Gentile who accompanied Elizabeth's ambassador to Germany & whom you have met there, I believe. I know Gentile. He does not like your doctrine, but he is good, discerning and very wise. Every prince would

like to have him as an advisor. So try to spare him, if you can.

'I do not know how long it will take for this letter to reach you, but if I do not tell you about these deaths, who will? Cecil, they say, is on a mission to Turkey for the Serenissime, and is probably unaware of the misfortune that has struck him. Not many people know where you are living now. Your enemies are gloating over your departure & putting it around that you left Paris like a cowering dog, but those who love you are defending you. They tell everyone that you are not a coward & that your life was in danger after gallant Jean's death.

May your life be long & happy.
'Michel de Castelnau
'Seigneur de Mauvissière,
Knight of the King's Order
'Saint-Dizier, this 18th December MDLXXXVI

The one thing to be said for Philip's death was that at least it restored his brother Cecil to me. He heard the news on his return to Venice from Constantinople, by which time Philip had been buried for two months. Hurrying back to London where he was to meet his much-despised sister, the Countess of Pembroke, he tried to wrangle with her for control of Sidney's work. It was to no avail. This woman had appropriated everything the poet had left for posterity, and was refusing to share the inheritance with anyone. In return for his initiative, the bastard, as she called him, was subjected to countless nasty digs and scathing insults. and emerged from this defeat more gloomy and desperate than ever. Who better than I to take on the task of consoling him? I had received Castelnau's letter in the middle of February. Cecil was back in my arms again in the first days of spring.

I had not had to *spare* the powerful Alberigo Gentile. He himself had been driven out of Italy by a trial involving the religious authorities, and seemed willing to lend me his support as soon as we met in Wittenberg through Johannes Zanger, the rector of the University. This man's great passions

were the law and the rules for the conduct of relations between governments. He declared that he liked my friends del Bene and Corbinelli very much, and that he had heard tell of me in London and Oxford. He told the rector of the high esteem in which I was held there by people of quality, and added with a smile that I had itchy feet: no sooner had I come to rest somewhere than I already wanted to move on. Then he urged him not to let me get away, as the English had done.

'Give him a teaching post instead. Soon your university will be boasting about having a master of his calibre.'

'Shouldn't we be wary of his opinions?' Zanger asked him mischievously.

'His opinions,' replied Gentile, 'are that the moon is an orb on which there are cities, seas and mountains; that the earth moves, etc. Illusions of that sort are no danger at all to your students, my dear rector. They convey the activity of a wonderful mind that has not learned to keep itself in check, which in many cases is a sign of talent. But there is something more important that he has to offer, believe me. You won't find a finer Aristotle scholar anywhere.'

So it was that in exchange for a good salary and pleasant lodgings, I found myself entrusted with the task of teaching four books of the *Organon*. Zanger and his Lutheran friends were of such noble and liberal character that my work was able to proceed without any hindrance during my time there. I lived in peace in their beautiful city for two whole years. After that the Calvinists hauled themselves into power. Harking back in their loathsome, sly way to the bad impression I had once created in Geneva, they chose to dismiss me.

I shall not go into any detail about the six works that I published in faultless Latin while I was in those climes. If the reader ever opens them, he may judge them to be less entertaining than my previous dialogues. He should not be surprised by that. Age was creeping up on me, and the dead whom I had begun to leave by the wayside seemed to cast their shadow over my white pages every time I put on my glasses and dipped my pen in the inkwell. Not that I felt fatigued, but a kind of sadness weighed heavily on my soul

and my work. The *infinite infinities* of the universe, which had once intoxicated me and lifted me up to the highest spheres, now laced my sleep with nocturnal terrors in the form of chasms whose disquieting atmosphere stayed with me all day long, like a vague melancholy.

Most of my books from that period took their argument from my public lectures, in which I gave a detailed analysis of the many errors of Aristotle. There were also some new treatises on memory. There is one, however, which I cannot pass over in silence: my *Lampas triginta statuarum*. For although the work is also the product of some lectures, they were not ones given at the University.

> *With the sound of the trumpet the captain calls*
> *His warriors all to a single flag*

Wittenberg was where my learned circle came into being. At first it consisted of a handful of students who supported my views, and to whom I gave what you might call private tuition, of a clandestine and acroamatic kind. These soldiers of Hermes, as I called them, were almost all recruited by a turbulent professor who had sprung up from my past, that same Jerome Besler who had once been my pupil in Geneva.

Were these, as Cecil angrily proclaimed, the delusions of a disappointed, aging man? I sometimes imagined that one day these *pueri* would go and spread my doctrine throughout the cities of Europe, each one creating his own circle, instructing new disciples there, sending them out into the world in their turn, and so on and so on until all the moribund old beliefs were completely extinct, their gory death having thus been hastened by me. We met a stone's throw from the church where Luther had once defied the pontiff. There I taught them what gradually seemed to be becoming my own reformed religion, a belief which was natural, rational, peace-loving, free of all dogmatism, inclined to a love of knowledge, the body and pleasure. I invited my new friends to admit of no liturgy but that of deeds dictated by love and the philosophical

282

quest, no other divinity than nature itself, that living force sustained by the sun and reason together.

'My emblem,' I would say, 'is a young boy stretched out naked in the green grass and gazing up at the luminous sky, that is to say at the world and the spirit of the world.'

'What does this child mean?' the disciples would ask me.

My answer was a few lines from the *Heroic Enthusiasts*:

> *Boy that I am, I know not of thy fires*
> *Nor of thy bonds that fetter men and gods*
> *They do not burn me, nor do they enslave*
> *Oh Love, if thou dost wish to enter me*
> *Let pity guide thee and unveil my sorrow*

The naked boy was talking about the Enthusiast, in the sense in which I was using the word: someone who cared nothing for sweet death, being preoccupied by the desire to love and to discover; and he meant that whoever wanted to know must first learn to die. In the secret places of my memory, this was an image heavy with nostalgia, in which a hundred others lay hidden: Augustine quivering under his father's eye at the baths in Hippo, myself in Naples, in love with the sage Vairano, then the venal lover of Marcellus the librarian, Cecil in his Roman alcove, Philip Sidney perhaps, who would never suffer the indignities of age . . . Besler awoke me from my rêverie:

'What does it mean to gaze at the world and the spirit of the world?'

'The world which presents itself to our senses and the soul of every individual can be represented in the form of one single geometrical figure. This figure is a circle, a wheel driven by the Mind, the Intelligence and Love. Just as the earth in the course of its rotation presents to the sun first one side, then the other, the soul and the universe are made up of a diurnal and a nocturnal region, each one arising out of its opposite in a process of perpetual motion. If we examine the diurnal region, we shall see the Father begetting the Son, or the Word, then the Son engendering the Light. In the nocturnal region,

Chaos engenders Death, which I call infinite appetite or the desire for being, and Death in its turn engenders Night. This is the most ancient divinity. The artist seeking to portray it would draw a woman dressed in black carrying off the child we were talking about just now to devour him in the darkness. You will note that in the diurnal, luminous regions, which are those of reason, the Son is the Word of the Father, His speech, knowledge, Spirit and destiny, in short the being in which He accomplishes himself. Conversely, in the dark regions, the Son is the death of the Father . . . But here, look:

That, in an extremely simplified form, is my metaphysics, such as with a pen, pencil and compasses I was able to expound it to my *Giordanisti* that day. The letters surrounding the solar star stand for the principal *statues* that inhabit the human memory: steady, constant Apollo, gloomy Saturn, far-sighted Prometheus, industrious Vulcan, intrepid Sagittarius,

ecstatic Minerva . . . Forgive me, I do not have time today to list them all.

Views such as these formed the subject matter of my *Lampas triginta statuarum*. In my opinion it represented the rebirth of the natural religion of the Egyptians, whose colossal statues erected in times past to the glory of the sun spoke, at the first light of dawn, with the voice of the gods themselves.

As I have said, with the learned circle of initiates which Jerome Besler created and I reigned over like a new mystagogue, I incurred the wrath of Cecil. As far as he was concerned I should have been trying to get the excommunication lifted at last and return with all speed to the papal bosom.

'No religion is any good,' he claimed. 'And yours is no better than any of the others.'

'If none of them is any good, why should I go back to the Catholic one?'

'The Catholic one is *useful*, Philip, because it is powerful. You will be dead and buried before your sect of callow youths has even got off the ground. And by the time it has, it will already have spawned its own heretics.'

'My religion will have no dogma, so there can't be any heresy. It's just a way of spreading my opinions.'

'How can you trust this Besler fellow whose only ambition is to take your place, and a bunch of apostles who are so simple-minded, you'd hardly think they'd left their mother's skirts.'

'They are young, not simple-minded! And unlike you, they defend my doctrine.'

But Cecil raged on. Suddenly he shouted at me:

'Do you think you're that old madman Luther or something?'

The monk from Eisleben, or his ghost which still haunted the streets, did indeed have some appeal for me. I liked the fury with which he opposed Leo X, and the virulence of his attacks on theologians. I was all in favour of his desire to simplify the liturgy, his dream of a living language, his passion for paradoxes, his strength of mind, courage and intransigence,

his love of the city and pleasure . . . I admit that I had no time at all for the nasty quarrel he picked with Erasmus about man's ability to recognise goodness; likewise his rejection of charitable works, his love of women and large families, and his hatred of the Jews, even though their religion was more natural than that of the Christians! But when all is said and done, the mark that this man had left in people's minds and at the heart of the University was more honourable than that of the indulgence-merchants.

'What Luther and I had in common,' I went on, 'was that he was forced to create his own religion too! All he wanted was to stay in the Church.'

Oh Cecil! My black angel. The years had drawn shadows on your features, but isn't that how time works on a landscape, in order to sublimate its beauty? Goodness, how bored you were by Germany, and even more by the reforms of the faith, not to mention the never-ending speculations about the future of the world and the salvation of its inhabitants, about which you couldn't have cared less, for that had always been your philosophy. Here scholasticism would soon be no more than a memory, as would the mass, and the monasteries which were gradually emptying. All that seemed to count was mundane urban life, the day's work done, the weekly wage, and the salty foods that people stuffed into their faces without worrying whether it was good or bad. Unconcerned about hell, priests and nuns rolled in the hay together, and cast off the veil and the habit as soon as they had enough money to buy themselves a woollen dress and a doublet; after which, off they went to tie the knot and breed whole strings of blond children; but what did these metaphors of Christianity matter to you? The Serenissime with its golden tints and delicate splendours was your only homeland, your haven and your universe. Life down there, you used to say, was ruled by art, light, beauty, grace and real freedom . . .

'Do you really want me to go and stick my head in the lion's jaw again when I've only just escaped from the Leaguers?' I cried. 'I've been excommunicated, I have lived by

infidel customs, and published irreligious texts! Do you think the Inquisition will just leave me in peace?'

'Write a milder book,' replied Cecil, 'and dedicate it to the pontiff, confessing some errors by the by. The Church needs scholars, they'll be grateful to you for making the first move.'

'Or they'll throw me in prison as a heretic. The Catholics hate me and despise my gestures of good will. They drove me out of Naples, Rome, Toulouse and Paris. They tortured Jean, and then they killed him before my very eyes. They murdered your brother.'

With a wave of his hand, Cecil brushed aside painful memories and arguments he had already heard a hundred times.

'Their religion is an old house,' he sighed,' but it is a house. Who wants to spend their whole life sleeping outside?'

'I tried to convince Mendoza in Paris. It didn't work. I don't have your talent as a diplomatist.'

'For the last time, Philip: let's get away from here. I really don't like this cold, melancholy country, or these fanatics that you call friends.'

In the end Cecil wearied of making his point over and over again, and went back to live among the senators, painters and poets of his bewitching Republic. Thanks to his diplomatic missions he became extremely rich, bought a palace on the island of Malamocco, set up an academy and had several infatuations with lords and artists. But he never stopped loving me, he wrote, and I received more than a hundred letters in which he begged me to join him. Resisting his appeals, I stubbornly persisted in wandering around Germany for four more years; then I gave in and in my turn went to Venice, where I lost my freedom once and for all.

After I had left Geneva, Jerome Besler had gone on studying philosophy and then, as a pupil of Jean Pruss, the magic art of Paracelsus. Once he graduated he set off towards the east and the north, drawn there by the Lutheran religions. He went to Poland and Saxony. An uncle of his practised medicine in Magdeburg; he became his assistant. Eventually he was given a full-time post as an ordinary reader in philosophy at

Wittenberg where I met him again, mature and bearded, but as cheerful and boisterous as before. It was said that he loved to boast about having been my friend under the Calvinists, and his lectures at the University were essentially commentaries on my books. He had bought them over the years at a bookshop in Frankfurt, and he knew them better than if he had written them himself. He assured me that he had been anticipating my arrival in Wittenberg for a long time, and became what in a nutshell he had always dreamed of being: my disciple. I found his character less pliable than that of Jean Hennequin, but he helped me in my work with the same steadfastness and efficiency, copying and writing for me until his last breath, which he drew in Frankfurt, one night in the winter of ninety-one.

The learned circle of the *Giordanisti* was much talked about, and was assumed for a while to be a new Lutheran belief springing up in a country that already had seventy of them, spread over the territories of Saxony, Hungary and Bohemia. The circle grew continuously throughout my time in Wittenberg, and sure enough, as Cecil had predicted, serious dissensions arose between these new Epicureans, some of whom quickly forgot that we were supposed to be united by a common love of wisdom. To be sure, most of them remained true to the idea that had brought us together in the beginning: that of establishing my doctrine of the soul and the heavens in the great universities with a view to hastening the ruin of scholasticism. But some of them took to dreaming of a Brunian republic, a sort of City of the Sun given over to the arts and to beauty, similar to that which the Duke of Florence had wanted to create under the name of *Paradisus*. There they would all have come together to live the bucolic life in the company of beautiful, affectionate young men, surrounded by books, magic figures and statues, cultivating the earth, all sleeping together, speaking a language of their own invention – yes, dear reader, such were, in these overheated heads, the effects of my teaching. Hermes Trismegistus, I would hear them say, had once built on the borders of Egypt a radiant city called *Aldocentyn*, which had in its centre a famous omphalic

tower that was protected from evil by images carved in the stone . . .

'Who did you get this knowledge from if not from me?' I would exclaim in the middle of the incessant quarrels. 'Let me tell you that a city like that is not what I'm aiming for! The sun shines its light on the whole of the earth, and so does the mind that possesses its properties! The world will become the new *Aldocentyn* once we've got rid of the monks.'

But I was wasting my breath; they'd already stopped listening to me.

This band of irritable, schismatic brothers included several Hungarian gentlemen who had large fortunes that they couldn't get rid of quickly enough. Buzzing like wasps with excitement about their project, they bought a former Dominican monastery on the banks of the Elbe. When I was so foolhardy as to protest again against such a piece of madness, these fanatics that I had created stirred up a conspiracy and replied that I was behaving no better than a pope. Then, in the course of the most vulgar ceremony imaginable, they burned my *Ash Wednesday Supper* which had suddenly become, to use these fine people's expression, *Aristotelian toilet-paper*!

You can imagine what bitterness I felt. I refrained from mentioning a single word about all this to Cecil, but he heard about my misadventure anyway, and gloated over it in a letter, beseeching me yet again to leave those heretic climes, dismiss Besler – who in his opinion was the instigator of the revolt – and come to Venice where the affection of his peace-loving friends awaited me. They were all atheists and Catholics, he said, but they would never have burned a book, not even one they regarded as truly detestable.

And so I slowly – far too slowly! – allowed my learned circle to die a natural death, and the *Giordanisti* to take refuge in other sects and kick up a huge fuss as they went. The only one I kept with me was Jerome. We scarcely had time to ponder over the error we had made because the Calvinists in the meantime had taken control of the University; and one of the first measures the scoundrels took was to force me out of Wittenberg.

★

We had only been in Prague for a few hours when I spotted, next to St Guy's Cathedral, the figure of Fabrizio Mordente; an unexpected and highly disagreeable encounter which knocked me sideways right at the start of my time in that city. You think that by moving to another part of the world you are getting away from your enemies, and then suddenly they loom up in front of you in a new setting, like the direst of omens. I immediately resolved to turn round and go back the way I had come, and was so determined to stick to this decision that Besler had to use all his powers of persuasion to make me get out of the carriage.

'Rudolph's academy,' he cried, losing his temper, 'is the most prestigious in the world! The prince is expecting you; you have no right to disappoint him!'

But Mordente – how could I forget it? – had Jean Hennequin's death on his conscience! Why did he have to be in Prague at the same time as I was? I spent the night dreaming that I was up against thugs paid by him to dispose of me in my sleep. On the following day we went to Hradschin Castle, only to learn that this confounded murderer had just been appointed imperial astronomer there.

Many at the court took offence at the award of such a prestigious office to a mathematician whose treachery was hated by all. Tycho Brahé, the famous stargazer, whom we met not long after we arrived, did not attempt to conceal his ill humour:

'I'd rather leave here than work with that slow-witted Neapolitan . . .'

'Salernitan,' I corrected him. 'Mordente is a Salernitan. I'm the Neapolitan.'

We were both walking at the head of a group of German scholars who could not restrain themselves from crying out in wonder at every moment. This was because the rooms we were walking through contained the collections of paintings that Rudolph had built up over the years. One of these, showing an enigmatic horseman in armour with a lance and sallet, reminded me of my father.

'Giordano Bruno,' Brahé went on pensively. 'The roar of

Vesuvius . . . They say that you are a fearsome opponent, a veteran of dispute.'

'And that you are an astronomer of genius. Your calculations . . .'

'For my part, I don't much like debating. It's the stars that I'm interested in. I couldn't care less about ideas.'

A fiery temperament, I thought, and a likeable one. At some time in the past the fellow had lost his nose in a duel, and in its place he had an excellently crafted gold one which he stuck on his face and only took off to sleep. This strange device added to the disquieting nature of his facial appearance, and he frequently touched it to check that it was still properly in place. I was reminded of the lord on to whom Jean Pruss had once grafted the nose of one his servants. I said a few words about this anecdote . . .

'I do not think that the part separated from a whole can retain its virtue,' retorted Tycho.

He abruptly let go of my arm. You've hurt him! Besler was thinking, as I could see from the furious stare that he was giving me. And so nothing more was said as we continued to walk between the rows of paintings guarded by attendants. The astronomer was flanked by his disciple too, a certain Kepler who, after a while, tried to ease the uncomfortable atmosphere by declaring:

'I can't wait to find out about your sky, Master Bruno.'

'You'll be finding out about it any moment now,' growled Tycho. 'We're here.'

Two doors opened as if by magic in front of our troop, which by now had fallen completely silent. Seven columns of light shone down from high up above into a chamber furnished with stalls whose carved armrests formed a fabulous bestiary of strange animals. In the centre of the room stood huge tables, on which astronomical maps had been rolled out and there was a skilful display of a set of graduated rulers, set squares, compasses (including the famous *circinus mordentii*), and copper spheres representing the earth and the seven planets.

The first person I saw was Mordente, standing to the right

of the emperor; he gazed back at me without flinching. Then I saw the emperor, a weak-featured man with his head resting on his hand as if he were suffering from melancholy. But on reflection I could imagine how we looked to his weary eyes: a procession of scholars rushing hither to taste the honey of his divine recognition and led by two demons, one corpulent, of Nordic appearance, ginger-haired, dressed in furs and sporting his gold nose, the other small, nervous, soberly attired and as brown as his name suggested; two opposing forms of one and the same wisdom. To the left of the sovereign, a fellow was smiling broadly at me. I assumed that this was Gian Maria della Lama, Rudolph's doctor, another Neapolitan, whom Rome, it was said, would gladly have sent to the stake. Next to him was a gloomy, bearded personage, who was peering at the new arrivals and drawing sketches with a pencil in a note-book. Last came a handful of courtiers.

In a faint voice, the emperor tried to exchange some polite remarks with Brahé, who answered in a tone of indifference, by which he intended to show his disapproval of the favour bestowed on Mordente. The monarch was still sitting with his head bowed and his forehead in his hand. He heaved a long sigh, then turned to look at me, enquired whether I had had a good journey and, without even waiting for the answer to that question, asked another one: did I know the man whom he had just made his astronomer?

'Your Majesty,' I answered, 'I met this mechanic in Paris. I wrote a treatise on his compasses in which I praised him to the skies. But he did not like the book, I believe. It must be said that, as is customary, I had written it in Latin, a language which he does not know.'

Mordente was giving me a murderous look, sensing that I was preparing to polish him off in a single mouthful. But his master saved him by turning the conversation on to another topic.

'Paris,' he muttered, pulling a disdainful face. 'I know you advised a king there . . .'

'A great king, Your Majesty.'

'Did he make use of your talent for divination? They say that you read the future from wheels.'

292

'I practise the art of memory. And it is true that the future is written in the past as day is in night. As a matter of fact I did once advise the King of France to watch out for the priests who were getting close to him.'

'And why on earth was that?'

'Because, Your Majesty, he is a little too fond of them.'

Rudolph looked anxious:

'Must we now mistrust the people we love?'

'Good heavens, Your Majesty, the people whom sovereigns love are rather well placed to do them harm . . .'

The emperor invited me to continue. I explained:

'Supposing a prince loves priests, Majesty. How will some-one who wants to assassinate him set about it? He will play at being a priest. Should the prince happen to love, let us say . . . scholars and philosophers . . .'

'It's not as easy, however, to don the habit of the scholar as that of the priest. But from what you are saying, should I not begin by mistrusting you?'

'You asked me a question, Your Majesty. I answered it. For my part, I always state my opinion according to the dictates of reason, whether or not anyone likes it or I have anything to gain by it.'

A murmur ran through the gathering. Mordente's loathing of me was plain for all to see. Doctor della Lama, for his part, was laughing heartily. His black-bearded neighbour had started sketching my portrait.

'Well indeed,' the emperor went on, 'my academy would like to know what your opinion is concerning the heavens. Is it true that you have claimed that it is infinite and filled with innumerable worlds? Do you really think the world is in motion?'

I glanced at Tycho who was adjusting his nose.

'That is the truth,' I said. 'If God exists, he exists everywhere in actuality; likewise the soul, movement and infinity.'

'But are these views in keeping with the teachings of Scripture?'

'They are in keeping with those of nature, Majesty. I have

not spoken on this point theologically, but philosophically. Scripture teaches us moral truths, nature physical ones.'

'What do you think, Tycho?'

Tycho gazed up at the high windows, and for a moment it looked as if it pained him not to see the stars there. This man's passion was for observing, I thought, for recording on his charts, hour after hour, the variations of outward appearances. Yes, day by day he was trying to produce a twofold arithmetic of the sky, so that he could keep it in his memory, or in a book which would enable him to forget death and time.

'The Neapolitan magus,' he declared, 'is a noble-hearted man. I could see that straightaway. He speaks his mind, and that is all to the good. I hope that what he has suggested to Your Majesty concerning treacherous rogues who learn to disguise their hearts in order to take advantage of princes will be regarded as a wise piece of advice. But Bruno is a good philosopher as well as a good politician; question him about the planets, and he will speak to you of God. Ask him about divinity, and he will draw you a beautiful map of the sky that has come straight from his volcanic imagination. Moreover he greatly enjoys discord, which I do not . . . While I am speaking these clumsy words and trying to catch the words that are swirling around in the mists of my brain, I have no doubt that he has already guessed where my remarks are leading, and weighed up his answer carefully.'

I smiled: no, as yet no answer had come to me. This man was the most civil opponent I had ever faced.

'The movement of the earth?' persisted Rudolph.

'I do not like this idea of movement, Your Majesty. I like to observe the stars from my island in Denmark, and for my calculations to be accurate I need it to be stable.'

'Indeed, but his arguments . . .'

'What good are they compared to my observations? I have seen with my own eyes how all the planets move in the sky; the earth, never.'

'You are *on* the earth, Tycho!' retorted the sovereign, like the prince and the gifted debater he was. 'How could you observe its movement?'

'Its movements, if I may be permitted to correct Your Majesty! In their infinite generosity, Bruno and Copernicus attribute two to it! And I may add that I really do wonder why. What body has ever moved in two different ways that are natural and concomitant? No. The issue was raised in its time, and solved by the Greeks. And no phenomenon, as far as I know, has ever come along to confirm these strange hypotheses . . .'

'If your island,' interrupted Besler, 'were on Mars or the moon, and you were to observe the sky from up there, you would be able to record the trajectory of our planet . . .'

Weary of this idle chatter, Tycho was shaking his head.

'Your master borrowed Copernicus' idea that the earth is moving because he found it beautiful, and because an idea as new as that could not but appeal to his subtle, whimsical mind. It now remains to provide proof, and unfortunately that is impossible.'

'The proof,' replied Besler, 'is contained in Copernicus' calculations . . .'

'If I may interrupt, my dear fellow: I was talking about a proof that is visible, measurable, and which I could take down in my records just by writing a number.'

'The eye is not the organ of truth.'

'Ah! A plague on these schoolboy arguments!' said Tycho, suddenly losing his temper. 'Your Majesty, I would like this academy to lend me the support of its imagination.'

'You have it,' said the emperor approvingly.

Tycho came over to me and placed his hand on my forearm.

'Will you allow me to question you, my dear Bruno? This will not be a duel, but an amicable debate between two scholars with opposing opinions.'

'It is often from opposing opinions that the truth emerges,' I answered. 'But why not carry on the debate with my disciple? I shall enjoy listening to you all the more for not having to reply.'

'You are right.'

Turning to Besler, he asked him to picture two completely

identical cannons, one of which had its muzzle turned to the east, the other to the west.

'In your opinion, Jerome, will the two cannonballs fired at the same second travel equal or unequal distances over the earth?'

'Equal,' said Besler.

'Excellent. We agree. And yet you maintain that the earth is turning from east to west.'

'Yes.'

'Which means that our two cannonballs, before being shoved into the muzzle of the cannon, have read your master's books and learnt his doctrine off by heart.'

Besler looked up at him with a completely idiotic expression.

'I'm afraid I don't understand what you mean, Master Tycho.'

'It is not my intention to seem obscure, my friend, but find me another explanation for this mystery! Either your terrestrial movement does not exist, or the cannonballs do their best to neutralise it during their flight, one by accelerating, the other by slowing down. I repeat, perhaps they have learnt to conform to the Brunian theory, and by doing their sums are both able to fall at an equal distance from the point of departure.'

Wretched Dane. Poor Besler was suffering like a bad pupil caught in a trap. Hennequin would have replied to the argument without the slightest hesitation. The disciple tried to catch my eye and implore my help. All he got from me in response was silence.

Johann Ulrich Zasius, who had held the office of Vice-Chancellor of the Empire under Maximilian, had a face which was appallingly disfigured by age and, I was informed, by the effects of the *French disease*. The fellow had lived well and had been punished for it. Age had forced him to inflict upon the world the spectacle of his monstrous ugliness, which was accentuated here for all eternity by a sorry-looking brown wool cloth bonnet which hugged the shape of his skull.

'Is that a human face?' I asked.

The young painter who was guiding me on my tour of the studio invited me to examine the portrait more closely.

'Take a good look, Signor Bruno.'

Was I seeing things? Zasius' swollen nose, eye and eyebrow were represented by a little plucked bird, his scrofulous cheek by a chicken leg and the orifice of his mouth by the ridiculously small lips of a dead fish. What an extraordinary thing! The artist's skill was so great that two illusions seemed to merge together into one. If the imagination took in the whole picture, the old man's ruined face appeared. If on the contrary it decided to hang on to the individual elements of the painting, the work immediately became an assemblage of animals with rotting flesh . . .

The guide took me over to stand in front of another portrait.

'This is Wolfgang Lazius,' he said. 'He was once librarian and curator of the imperial collections.'

Here the torso, limbs and head of this Wolfgang had taken the form of a stack of books. One of these had its pages open to represent a head of hair, from which bookmarks dangled down ironically; others served as his forehead, nose, cheeks . . .

'Immortalised in the attributes of his function,' smiled the painter with just the slightest hint of cruelty. 'Note the fingers made of strips of paper. Do you wish to continue, signor?'

'Good Lord! Who is this?'

'A Viennese gentleman. Who died, if I may say so, in the prime of life. May his soul rest in peace . . .'

His soul? It was about as easy to make that out as to see to the heart of the ancient god Glaucos! The young man's face alone, which stood out in profile against a dark background, was like a fisherman's net packed to smothering point with every fish, crustacean and aquatic beast in creation: there was a sunfish, a sheat-fish, a skate, an eel, an octopus, a sea horse, a frog, a crayfish, an otter, a turtle . . . he had a shell for an ear, a mantis shrimp for an eyebrow, and a crab in place of his chest.

'So this,' I murmured, 'is your master's style . . .'

'Yes, signor. We, his pupils, produce only poor imitations . . . There is also, although you will not be able to see it here, a superb portrait of Rudolph, made up entirely of the finest and noblest fruits that Nature has ever borne . . . But look at this one with the birds, isn't it delightful?'

What crime had the unfortunate model committed, I wondered, to deserve to go down to posterity with a head bristling with beaks and feathers? I grabbed the disciple by the arm:

'One question, my friend: does Giuseppe ever paint . . . like other people?'

'Like other people, signor?'

The blasted fellow favoured me with a smile tinged with contempt.

'I believe I can guess the reason for your concern,' he said. 'But I am afraid that . . . Ah! Speaking of Master Guiseppe, here he is . . . Allow me to leave you in his excellent company and return to my imitations . . . Your servant, signor.'

Walking briskly and tapping nervously with a stick on the mosaic floor, Giuseppe di Milano, the bearded, darkly-clad man who had been continually sketching us during the session at the imperial Academy, was advancing towards me amid his masterpieces. He walked past me without giving me a look.

'You will be my last subject!' he called out testily. 'After which I'm getting away from here. I am leaving Prague.'

'Look here,' I ventured, 'I'm not terribly sure if . . . if I really want to go ahead with this portrait . . .'

'Rudolph wants to go ahead with it. Come.'

Since his tone admitted of no reply, I followed him to his office. There was a table in there, on which the sketches were laid out that he had made while we were discussing the movement of the earth in the emperor's presence: Tycho with his artificial nose, Jerome, Kepler, and myself drawn in about ten different poses. I examined them all, and was deeply moved, I must admit, to see the shadowy outlines of my own face on paper for the first time. This is how others see me, I thought. But the contemplation which seemed destined to

298

arise from this experience was nipped in the bud: Giuseppe was already pointing at a sketch with the tip of his stick.

'This one,' he said peremptorily. 'I shall paint you in profile.'

'Oh, good. The drawing is an excellent likeness, I must say. But there is one thing: I would like to know in what form you intend to . . .'

'Haven't you been shown my work?'

'Yes, that's what I wanted to talk to you about . . .'

'What are you afraid of?'

'Good heavens, Master Giuseppe, images have a certain power over the world. And after all, it's *my* image we're talking about . . . Would you like to be see a picture of yourself with a chicken wing for a chin, radishes sunk into your eye-sockets and a slow-worm in your mouth instead of a tongue?'

Furious, the painter looked me scornfully up and down. Was that the only judgment I was capable of passing on his extraordinary art? He went on:

'You may be a philosopher, Bruno of Nola, but the elements that go to make up your immortal soul still belong to nature. Do you think it is difficult to see right through them?'

'That is my point: I would be glad to know what your conclusions are before you start painting my head.'

He motioned towards the studio.

'May I ask what your feelings were just now when you saw nature mimicking, and even mocking man through the medium of my genius?'

'I was flabbergasted, Giuseppe di Milano. And I'm bound to say that I still am.'

'Then you're not much different from the rest of mankind, because that is how everyone has felt. However, the prince who reigns here must hold you in high esteem to have bestowed upon you the inestimable privilege . . .'

With an air of disdain, he was playing around with his stick to jumble up the drawings and notebooks that were strewn over the table.

'Well?'

'. . . of appearing in one of my portraits, of being able a

short time from now to gaze at your own soul as if in a mirror. The most faithful of mirrors, let me tell you: my own . . .'

'He who gazes at his own soul is getting ready to die, my dear master. And I am in no hurry to leave this vale of tears.'

'That's not a very philosophical attitude. Even Rudolph played the game with a good grace.'

'Your sovereign has his reasons. For my part, I repeat that images are not ornaments designed for the amusement of courtiers. Like the stars, they exert an influence on the world and alter the course of things, the *sumpathia* that exist between people . . .'

'You are afraid, that's all.'

'Afraid? Me?'

'Whatever sympathy or *sumpathia* you inspire in Rudolph, in my eyes you are nothing but a little Neapolitan magus, a braggart born at the foot of a flashy volcano.'

'And you are an arrogant Milanese.'

Giuseppe brought his stick crashing down on the table.

'Silence! I have been in the service of the imperial house for twenty-five years. I have served three emperors in Vienna and Prague; each one has loved me more than the last. As a *fabricator* I have devised all the festivities and all the costumes at this court. Whether you like it or not, you will appear in my completed work when I leave this fortress, in whatever form it pleases my hand to give to your soul . . . Do you know my four elements?'

'What do I care about your elements? Empedocles' elements are enough for me.'

'Nature is divided into four elements, time into four seasons, the body of man into four humours and his will into four temperaments. You, for example, suffer from an excess of yellow bile, that is clear to me, hence your choleric disposition . . . Where are you going?'

'Good day to you sir. I shall leave you to construct my soul at your convenience, since that is your hare-brained scheme.'

'Wait!'

Turning my back on him without further ceremony, I left his office and strode across the studio, under the gaze of the

wretched creatures who haunted it, prisoners for all eternity of their mask of suffering, and soon to be my companions . . .

'Bruno of Nola!'

The painter's authoritatian voice rang out for a moment in the deserted studio. With my hand on the door I stopped and listened to the regular tapping of his stick on the floor. The noise drew nearer and Giuseppe appeared ten paces from me, a ghostly figure in the light . . .

'Yes, what do you want?'

'Fire,' he said. 'You will be fire.'

Looking down on the city of Prague from the Hradschin fortress, I thought about the aimless, rootless life I was leading. True, the emperor allowed me to deliver regular lectures to his academicians and to publish my works, but his mind, like that of Henri III, was too much like a chessboard to inspire a feeling of trust and security: its white squares alternated with an equal number of black ones, its bright flashes of wisdom with the most unfathomable darkness. This prince was quite capable of treating you as his most loyal friend and showering you with a hundred proofs of his affection in the morning, and then on the same evening giving you a veiled rebuke for being at his table for dinner. It seemed that he could hate the intolerance of the religious orders one day, only to take offence the next at an innocent joke at the expense of the Jesuits. He welcomed discerning scholars with open arms, while at the same time he was rewarding complete asses. There was nothing his advisors could do about this, it was said, except anxiously assess the political consequences of such whims and sudden changes of mood.

Was my world-weariness due to the cold climate in these plains, the absence of Cecil, or the quirky character of the sovereign who was protecting me? Did exile weigh more heavily on me now than in my youth? The veils of melancholy darkened all my hours and I was working with neither enthusiasm nor talent, dictating exceedingly dull works to Besler in which I was doing no more than chewing over the old principles of my doctrine and crossing swords with

mathematicians. How far I was from the inspiration I had had when I wrote those dialogues in London! As far in fact as I was from my friends themselves. I had no-one here to assist me any more except the efficient but not very affectionate Jerome, and life at Hradschin was as constricted, mean and lacking in poetry as in a Capuchin monastery. Mordente was still being heaped with riches and honours, and was becoming more arrogant by the day. Tycho could talk about nothing but going back to Denmark to observe his beloved stars and comets in peace. In his studio, Giuseppe Arcimboldo di Milano was working in secret on his last painting, no doubt toiling away to give me a volcanic head full of fire and ashes . . .

I was to languish at Rudolph's court for no more than six months. Not long after the debate between the Dane and Jerome, young Kepler, who had a discerning mind and was intrigued by my views, paid me a long visit. He wanted to know how I would have answered his master's point about the cannonballs. I invoked Copernicus and taught him that every object belonging to the earth had to follow it in its movement.

'It's the same as if I throw a stone in the air from the deck of a boat. It will fall back down into my hands, because it belongs to the movement of the boat.'

'My master thinks that that is a lie, not an argument.'

Tycho was so determined to oppose the rotation of the earth that he had used calculations to invent a most peculiar sort of heaven, in which the moon and the sun turned around a completely motionless earth, and the planets went round the sun . . . Thus there was no danger of Aristotle and Ptolemeus coming back across the river from the Underworld and going to his island to cry treason and take revenge on him by disturbing his sleep. But I had had wind through Jerome that there were some differences of opinion by now between the Dane and his pupil. I wanted to know what Johannes thought.

'Like Copernicus, I admit that the earth is moving, Master Bruno. It's your infinite universe that I don't like. I am afraid that the mind will wear itself out for nothing, wandering

around this endless space in which it will find no rest in its calculations, no stopping-place, no milestone to show the way back . . . They say that you yourself never stop travelling round the world.'

'Take care not to become an over-cautious, stick-in-the-mud thinker, Johannes. We meet the idea of infinity in the spirit of God, and the universe in which we wander is that spirit in actuality; and thus it is infinite, however frightening that may seem.'

'Forgive me, but those are theological arguments. My master and friend Tycho is right to say that your philosophy is better than your astronomy. Our science is based on what the heavens look like, according to our scrupulous observations. What does the man of science care about what he cannot see with his eyes? Who has ever experienced the infinite?'

'I have. At every moment of my life.'

Kepler looked away towards the window where the first stars were twinkling.

'Is that some kind of intoxication?' he asked in a low voice, as if he were talking to himself. 'I must admit that I don't find it very tempting. Surely it would bring some hidden horror along with it . . .'

Once again he gazed deep into my eyes.

'Any more than I am attracted by your muddle-headed divinity who gets all mixed up with nature. In my opinion, God is a geometrician, and creation is his mathematical reflection; an image that is ordered, perfect, finite, visible . . . Why are you smiling, Master Bruno?'

'Is your argument any less theological than mine?'

The young man seemed to want to reconstruct the sky as a precise mechanism which would confirm the Christian Trinity. According to him, the Father was embodied in the sun, the Son in the starry vault, and the Holy Spirit in the air all around . . .

'Stuff and nonsense! The free exercise of reason must take no heed of religious dogma, because it offers too limited a framework for thought. Get the stale old smell of the mass out

of your brain, Kepler! The imagination must be freed from such chains. Where the Bible sees only one sun, I invent hundreds and thousands of them.'

Panic-stricken, he was waving his hands about on either side of his head, as if what I had said was making it spin.

'Why, why should there be more than one sun, Master Bruno? Isn't one enough for you?'

'Why just one, for heaven's sake?'

'If the universe is infinite, filled with suns and innumerable worlds, where is its centre?'

'Nowhere! There is no centre! To hell with the centre, top and bottom! I want a space around me that is free of all limits! A pure breath of being . . . An increate river, a whirlpool of life that engenders all and carries all away with it . . .'

Kepler sighed:

'I am afraid that you, Besler and your sect of *Giordanisti* are refusing to step outside your minds and look at the world as it is actually constructed. You fell in love with an idea one day and you won't give it up, that's the truth of it. You are obeying your imagination, you say? Come now, astronomy and poetry will never go hand in hand for long. There is an order, a harmony . . .'

'A harmony, yes. But certainly not the harmony of Aristotle. And there are others apart from mathematics, believe me.'

He was a talented opponent, that little geometrician, far sharper and more generous than the sinister Mordente, and a tireless worker to boot. Crossing swords with him was a pleasure on every occasion, and one of the few enjoyable activities that fate granted me at Hradschin. I wonder whether, as he has got older, he has stopped trembling like a wet chicken at the thought of infinite space. Did I help him to free himself from the strait-jacket of piety that was holding his brain in check? I don't know, just as I don't know if he ever had any success with his research. Perhaps he managed to get the best out of the most contradictory teaching imaginable: when he was not arguing with me, he went on going to the observatory built by Rudolph in one of the towers of the castle, and pondering

with his master over the slightest movements of the stars. He left Prague not long after Tycho, and I never saw either of them again.

It was said of Giuseppe di Milano that when he was a young man, he discovered sketchpads in his father's house that had belonged to the great Leonardo. The sketches were of freakish forms he had observed in human beings and nature. To educate his hand and his mind, Giuseppe had copied them with passion, until his eyes could no longer see anything in an individual's face but the sum total of all the strangest details that could possibly define it. He had done his apprenticeship at Milan Cathedral where his father himself worked as an artist, and no doubt the way he eventually painted owed something to the memory of the illuminated manuscripts he had seen there: we have all been fascinated by their initial capital letters, which are often drawn inside a complex assemblage of plants and animals. His talent, I have to admit, was very highly thought of at Rudolph's court. The prince looked on him as a member of his own family, and promised him even more glory and riches if he gave up his plan of going off to die in his native city. But such was Giuseppe's determination that he simply had to give him permission to leave, which he did in the middle of the summer. Once the sumptuous ceremonies held in his honour were over, the *fabricator* set off without showing the slightest sign of regret. The whole court was summoned to come and weep on the ramparts and lament the spectacle of a procession of carriages loaded with gifts moving slowly through the city of Prague, surrounded by fifty horsemen whom Rudolph had placed at the artist's disposal to escort him back to Italy.

For my part, since I had never been back to the Milanese's studio – after our exchange of pleasantries, he had fiercely forbidden me to go anywhere near it – I still did not know what my soul looked like. I was not to see the painting until the day before I in my turn left Prague, when I went to pay one last visit to Rudolph to thank him for his hospitality.

The monarch had been struck down a few days earlier by a

serious attack of melancholy, and was refusing to leave his bedroom. I found him buried in a heap of cushions, looking disdainful and tired, and pulling faces as he drained the last of a drug which della Lama had just prepared for him. He pointed with a weary hand to a purse that was intended for me.

'That money, Bruno of Nola ... Your payment for the lectures at the academy. Where are you going?'

'Helmstedt, Your Majesty.'

The emperor could not restrain himself from pouting irritably.

'So life is better at Duke Julius' court than at mine.'

'There is a large university there which is willing to take me in and offer me work.'

I didn't get the chance to say any more about it, because Rudolph had already closed his eyes, exhausted in advance by the prospect of putting up with my chatter. What was I in his eyes but another traitor? According to rumour and gossip, it was because all the scholars and artists he loved were leaving that he was in such torment ... For a long while he stayed so perfectly still that we thought he had gone to sleep. Was he pretending? I looked questioningly at the doctor. He spread his arms to indicate that there was nothing he could do; and so I just stood there, said nothing, and waited on the prince's pleasure.

'Do you want to admire your portrait?' he asked me all of a sudden.

He said it without even opening his eyes, like a man talking in his sleep.

'Yes, Your Majesty.'

'A masterpiece. Della Lama will show it to you.'

The masterpiece was in a chamber that was separated from the bedroom by a long corridor.

'The devil take those who rule over us,' the doctor whispered in my ear. 'This emperor is more capricious than a dried-up old woman ... But what can you expect? Everyone's abandoning him.'

'He's still got Mordente ...'

'Come in, it's over here.'

He closed the door behind him. The painting was standing on an easel in front of a window. As an ironic allusion to the debate between Besler and Tycho Brahé, two cannons with threatening muzzles seemed to be coming up out of my shoulder. Instead of a chin I had an oil lamp, the flame of which was about to set light to a bundle of straw representing my moustache. My ear was a poker, my forehead a hemp wick, and in place of my eye I had the end of a burned-out candle. My nose – a second allusion to Tycho – was nothing less than a heavy iron fire-steel. As for my hair, by heaven, Giuseppe had made it into a glowing red, blazing pyre! *You will be fire!* his voice proclaimed again in some distant corner of my brain . . .

'Lucky you,' della Lama went on. 'Don't we all dream of getting away from this blasted fortress for ever?'

Leaning on his elbows at the window, he seemed to be scanning the horizon for some sign addressed to him, a promise that his dream would soon be fulfilled . . .

'Tell me, Gian Maria, what do you think of this portrait?'

The doctor came over from the window, walked right round the easel and thought for a moment.

'Goodness me, I think it's a very good likeness . . . After all, you are a heretical rascal, like me, a seducer who's destined for the flames; a suitable prey for the Pope's and the Inquisition's dogs . . . Forgive me, it was just a joke. But does it really matter to a wise, philosophical mind like yours? Come now Giordano, what you see before you is a surface that is quite skilfully covered with coloured materials, no more than that.'

'Do you think we'll ever see Naples and Italy again?'

'I doubt it very much!' he exclaimed, laughing heartily.

Then, intrigued:

'What a strange question . . .'

His face clouded over and, as if trying to read my thoughts, he gazed with his dark eyes, from which all mischief had now disappeared, deep into mine. In a quiet voice he added:

'One piece of advice. Whatever you do, don't make the mistake of going back there . . .'

The letter that I had written to Julius, in which he saw himself

307

baptised *the bravest of heroes, the wisest of princes and the most celebrated of dukes* was enough to ensure that I was received with honours in Helmstedt. I was invited to deliver several lectures on Aristotle, and immediately paid fifty florins, which were added to what remained of Rudolph's three hundred thalers. And so at first sight the Julian university seemed to me to be worthy of its reputation as the most liberal one in the whole of Germany. It was said that the best jurists in Europe had presided over its birth. And indeed I met teachers there who were very little inclined to petty controversy, and numerous students eager to find out about my views. After stifling for six months at Hradschin, I thought at first that I was coming back to life.

Still assisted by Jerome, I had begun to reread Pico, Ficino and Cornelius, and to complete my own work on magic, the art of equilibrium between man and nature. I had the idea of describing with precision the circular scale of being by means of which the soul is joined to the divinity through the experience of the senses, elements, demons and stars. I thought again about the bonds that unite men with the world, and those very special bonds, men themselves. As ever I was dealing with several subjects at once, amassing a multitude of notes and comments, and forcing Besler, who was ill and tired, to stay up until dawn to record my thoughts; and by now what was soon to become my last printed book was beginning to take shape.

Yes indeed, however agreeable and full of hope the beginning of my stay in the duchy was, I cannot think of that period of my existence without seeing the wings of death gradually closing in on me. The circle of *Giordanisti* once created by Besler had left behind bad memories here and there in people's minds, and I sometimes heard myself described as intolerant or as a follower of Manichaeanism. The Aristotelian fanatics at Helmstedt were few in number, but the amount of energy they expended was on the same scale as their ignorance. And so it was not long before I heard the news: that I would never be given the permanent teaching post that I was entitled to hope for, considering the importance of my work. On top of that, Duke Julius was to die before the summer.

Despite his avowed support for me, his son and successor was not able to contain the conspiracy that was being mounted against my person by a handful of sycophants. To be sure, I was left to work in peace, without any threat of physical danger to recall the ferocity of my Parisian enemies, but I was tormented by the fear that I had not yet found the place in the world where my wanderings could cease, and that perhaps I would never find it.

On the morning of the first of August of the same year, Henri III of France was stabbed by a priest called Jacques Clément; he gave up the ghost in the course of the following night, devoured by fever and groping around his perforated gut with his fingertips. The priest had managed to get into his bedroom without much difficulty. Piero del Bene sent me a long letter to inform me of the sad news. He wrote that I would not be surprised by the circumstances of the king's death, since I had once predicted them with such philosophical acuteness. Although I could see that he had taken a lot of trouble to write in a style that appeared to be sincerely sorrowful, he was unable to conceal his rapturous sense of triumph; his friend Henri de Navarre was King of France now, and he was willing to change his faith in order to keep the crown. Was Piero telling the truth when he claimed that the Parisians had lit bonfires to celebrate the news of le Valois' assassination? Or was he just carried away by the success of his political ambitions? I have never found out the truth about that.

In his enthusiasm, he was now pressing me to return to France at the earliest possible opportunity. According to him, the kingdom would soon be *governed anew*, as he put it, and religious freedom would be assured. He was confident that he could get me a chair at the Sorbonne and absolute guarantees of safety. In a note enclosed with his friend's letter, Jacopo Corbellini trumpeted the same joyful message. But for heaven's sake! Was I to go back and haunt a place where the Catholics had tried to kill me? To watch Jean's murderers insolently swanking about? To put up with the fact that they had never been condemned for their crime? And

did this Henri de Navarre think he was so sure of his control over the leaguers? For the fanatics on both sides, would he ever be anything but a traitor? A hundred questions whirled round in my head, and I admit that I spent a long time thinking it over, weighing up one argument after another, questioning Besler, writing to Cecil . . . He had not changed his opinion in the slightest, and as usual swore only by Venice. That was where my salvation lay, he answered, only there, in that most agreeable of republics, could liberty be found. As for Jerome, he could think of nothing more frightening than the thought that one day he might have to live in France, which according to him was not a civilised country. The truth was that the only country he cared for was his beloved Germany . . .

'But I can't stay in Helmstedt for ever!'

'Is life here so unpleasant?'

'I'll be lucky if they print my books! Soon I'll have no money left. Am I going to have to start begging again?'

'Let's go to Frankfurt, Philip. There isn't a city in the world that has more publishers, or as many booksellers.'

'Who knows me in Frankfurt? No. We'll go to Paris. At least there I'll get my chair at the Sorbonne back, thanks to the few friends I still have left.'

'The leaguers will murder you . . .'

Paris? Frankfurt? It was Baïf who, by dying in his turn, made the decision for me. I had just heard the news in a letter from Cecil. I was well and truly running out of money, and only surviving thanks to private lessons which my enemies watched over suspiciously, convinced that we had started up the sect of the *Giordanisti* again. It is true that my fame was attracting many visitors, very often young ones from Saxony and Poland. The richest of them sometimes offered me their hospitality; I always refused it, arguing that I was a philosopher, not a jester, and that the only thing I was interested in from now on was a chair in a great academy. By now Besler was suffering from the pulmonary infection which was to carry him off. And we were still continually quarrelling about where to go next. I could not interpret the demise of Jean-

Antoine as anything other than an ill omen hanging over a possible return to Paris.

'We'll go to Frankfurt,' I called out to Jerome.

The works in Johann Wechel's bookshop were among the most beautiful and delicately bound that I had ever held in my hands. This man knew all my books that had been printed in Paris and London. In his personal library there was even a copy of my *Noah's Ark*, bought ten years earlier in Venice by one of his agents. I presented him with three completed manuscripts: the *De minimo* in which my metaphysics was expounded, the *De monade*, a study of the significance of the numbers deriving from the One, and finally the *De immenso*, in which I corrected certain errors or imperfections which had cropped up here and there in my earlier Italian dialogues. Feigning caution, Wechel questioned me at length about my vagabond existence. I answered him sharply:

'Am I to be depised, like Paracelsus, just because I haven't spent my whole life sitting on my arse beside a stove?'

The bookseller took no offence at this rebuff, and gave up his inquisition. I even observed that he was having some difficulty concealing the enthusiasm that fired him at the idea of publishing my books. Moreover, a conversation he had a little later with another printer, Fischer, was to get back to me: they both regarded me as nothing less than the greatest philosopher of the century.

I needed time and money, I said to Wechel, to finish a fourth work entitled *De imaginum, signorum et idearum compositione*, a treatise on memory in which it would be possible to discover how ideas are formed.

'All four of your books will be on sale at the great autumn fair,' he promised me. 'In the meantime, consider yourself my guest. You will be put up – most comfortably, believe me – at the Carmelite convent.'

I said I must have a house; my disciple was seriously ill, he needed to be looked after.

'Well exactly, the sisters . . .'

'I'll have no women at Besler's bedside, Mr Wechel. He must be saved.'

The bookseller grinned from ear to ear.

'You and your friend will live at my house, Giordano of Nola. And my personal doctor will take charge of curing the patient.'

But it was already the middle of summer. No sooner had we started working in the comfortable study which had been placed at our disposal than Jerome's health deteriorated. Anxious, and preoccupied by the care he needed, I was neither willing nor able to immerse myself in my book again without his help. Only the first three books, which I managed to proof-read myself, appear in the catalogues that Wechel published and which went the rounds in the autumn at the huge Frankfurt book-fair.

Being a man of his word, the bookseller spent many a thaler on drugs and electuaries, changed doctors three times, and brought Jerome's uncle from Magdeburg at his own expense; but no amount of human effort seemed capable of stopping the illness from getting worse. My disciple, once so fiery and eager to do battle, now looked like a poor soul who had run out of breath and energy, and whose meagre will was being consumed by exhausting fits of coughing. I can still see him, bent double with pain and struggling to spit a trickle of black blood into the bowl that I was holding out to him. His agony went on until the middle of winter. He kept refusing to give in to the onslaughts of death, and strove courageously to muster up his strength, accepting the need to live a miserable, restricted life, continuing to demand his share of the labour, and begging me to let him write to my dictation whenever his illness gave him a moment's respite. At those times I would fix up a desk with ink and paper over his bed. No sooner had he copied half a page than the pen would slip from his fingers. He would smile apologetically, and I would watch as he sank into sleep.

One night when I was working by candlelight, he stumbled over to me and asked to sit in my seat. Wrapped up in my blanket, he bent over the writing-case and ran his eyes over the lines on the page.

'How far have you got, Philip?'

His voice was barely audible.

'Second image of Apollo.'

'Come on then.'

'*A man holding a bow,*' I dictated right next to his ear, '*killing a wolf. Above this man, a raven.*'

Suddenly Jerome was copying so slowly that I was gripped by fear. My hands clutched his shoulders, which were as thin as a puny child's. The lightness of the body, the weight of life. Epicurus taught that only those who are ill can feel themselves existing, because they can feel themselves dying . . .

'Is there a third image of Apollo?'

'*A young, handsome man,*' I went on, '*carrying a lute.*'

The scratching of pen on paper started again straight away, then seemed to falter. Jerome would never reach the end of the image.

That *De imaginum* was my last published book. I finished it at one go after Besler's funeral, spurred on by a sort of rage. But reading it through again did not give me much satisfaction. All it did was take up the themes of several of my earlier books – the *De umbris*, the *Triumphant Beast* – but with less vigour and clarity. I did not even see any point in overseeing its production. Wechel printed it and launched it at the spring fair. On that occasion he wanted me to appear and speak against Aristotle to a group of literati from all four corners of Germany, but I declined his offer. Already certain senators were muttering insidious threats every time they heard my name mentioned; according to one rumour there were even plans afoot to issue an expulsion order against me. Why take part in debates which were likely to annoy these people even more? And anyway, there were too many deaths weighing on my heart now. In my despair I decided to let my beard grow, and shut myself away day and night in Wechel's library, receiving very few visitors, writing letters to Cecil, reading and rereading Augustine, Ramon Lull, Erasmus . . .

The fair was nearly at an end when two Venetians introduced themselves to my host and asked to meet me. The first,

Battista Ciotti, was the owner of the famous bookshop at the sign of Minerva, the second a highly effeminate, outlandishly dressed gentleman of about thirty. His name was Zuan Mocenigo. He was a great admirer of the philosophers of magic, and had discovered my books through his good friend Ciotti. He declared without further ado that he wanted to study the mnemonic art under my supervision.

'Do you think I am an easy master? Don't you know that I have already worn out two disciples?'

'They say that you read the future with your Lullian wheels, and that you have advised the greatest princes . . . I am willing to pay a good price for my lessons, and to offer you hospitality as well. The Serenissime has fine academies.'

'And charming inquisitors.'

'The Catholic church will soon be a great market where all sorts of opinions can sell their wares . . . Venice is not Rome, Master Bruno. Life is safe there.'

Cecil . . .

'Now tell me who has sent you, Signor Zuan.'

Mocenigo's gaze did not falter for a second.

'I think I can guess who you are thinking of,' he answered. 'But no, no-one has sent me here on any kind of mission. Once you are there, it will be the easiest thing in the world for you to confirm that.'

He pulled a purse out of his doublet. Then, speaking pleasantly and lowering his voice:

'You are poor, Bruno of Nola. Unfairly poor. And just as unfairly, I am rich. You have no house to work in, and I am offering you one. Perhaps you don't like me? That doesn't matter. All I want is to serve your work. This excellent book-seller has known me for several years. He can attest if need be not only to my fortune, but to the love that I as a Venetian have for sages and artists.'

I turned to Ciotti. The fellow had an honest face.

'Everyone knows,' he said, 'that the government here will not let you last long inside its walls. So where do you think you're going to go?'

'The Holy Seat excommunicated me once.'

'Nothing lasts for ever in this world, except the world itself. That is your own philosophy, I believe. Nothing stays the same, everything changes. Can't a judgment be reconsidered? I know Cardinal Mendoza. I once published his book on the military art.'

'I saw Mendoza in Paris myself, Signor Ciotti. As God is my witness, he refused to listen.'

'What's to say he won't change his mind?'

'Allow me to insist,' went on Zuan Mocenigo. 'For my part, I am setting off the day after tomorrow. If you want to you are welcome to come along in my coach. It would be a pleasure, and a great honour.'

The library we were in contained many maps, some of which were extremely rare. Unrolled in front of us was one showing the countries of the North and the Mediterranean, the island of Britain and the great cities of Europe. The two Venetians had found me pondering over this map, magnifying glass and pencil in hand. I had just drawn up an itinerary of my travels, bumping along the roads of my memory and underlining the names of each of the thirty cities and more where I had lived, if only for a few weeks or a few days. A column of figures that I had scribbled on a piece of paper spoke for itself: from Nola to Frankfurt, five thousand leagues covered in my forty-three years. Did that, in terms of the science of arithmetic, add up to a human life? My father had roamed too, before coming to the end of his dream on his hill. If Cusan logic was applied to destiny, it would dictate that the point of departure should be the same as the point of arrival, the beginning the same as the end . . .

'Half these cities are no longer obedient to the Pope by now,' I observed. 'And yet how many are willing to take me in?'

'Venice is,' Mocenigo proudly insisted.

Why was I visited at that precise moment by the memory of Brother Sisto da Lucca advising me in Rome to flee to the heretic countries, where in his opinion my salvation lay? A feeling of intense excitement bubbled up inside me. I drove the prior's face and his unpleasant smile out of my mind. It

was immediately replaced by that of Cecil. My desire, my beloved, raging desire . . . The two gentlemen had taken their leave, and were on their way out through the library door.

'Signor Zuan . . .'

'Master Bruno?'

'When did you say you were leaving?'

Wednesday, 16th February, 1600

This is the end of my book, the end of my mistakes, the end of my end. Have I already abandoned my body? I observe that the handwriting it is now producing has no strength or character. A plague on these hours. Sleep has deserted me, I shall never dream again, and I have no desire to do anything but keep my eyes closed and wait for the kiss of death. Montaigne, I remember, wanted it to come to him while he was planting his cabbages! Fate granted his wish, and the fellow expired while a mass was being said in his bedroom. Why am I not a stoical philosopher like him! And how easy that last gasp would be if some mollifying spirit would come in through the walls of my prison, close its wings in on me and blot out the world. I would fall with my pen in my hand, and together we would go to the unmeasurable beginnings of the universe . . . Come now, cries a voice within me, did you not demand to suffer the fire's embrace? Yes, the devil sees to it that our truest and most remote desires are fulfilled. That ineffable pain should merge with ineffable pleasure . . .

Last night I spoke to Deza. He had come from the Castel Sant' Angelo. To punish him for his failure, Pope Clement is throwing him out of his job as an advisor. He's furious that a public execution carried out in the due and proper manner is going to jeopardise the much-trumpeted jubilee before it has even begun. Wasn't this year supposed to fly the flag of forgiveness, reconciliation, penitence, piety and mercy? As from tomorrow, the ambassador of France will be holding his nose as he breathes the odour of apostolic Roman justice coming in through his window. Once again there will be lampoons stuck up on all the walls round here mocking the cardinals and calling them vile, ignorant beasts. Weary of crimes fomented in the name of religion, many of the most cultivated gentlemen will make their voices heard. Some merchants will leave the city and go to less brutal countries, thus depriving

the pontiff of their credit, and forcing him to raise new taxes. After swearing that they would slit my throat with their own hands, only the fanatics led by the German Schioppius will take delight in my sufferings and lend Clement their strident, hateful support, which at the moment he would be only too happy to do without. As for the brothers from San Giovanni Decollato, no-one will be able to stop them marching in procession tonight to Tor di Nona, coming into my cell, praying there until dawn, and accompanying me to the Campo dei Fiori.

Deza is now free from papal subjection, and he says it is a relief. He unearthed the *Ash Wednesday Supper* in a bookshop on la Scrofa, and is longing to discover my other works and take on my views. So after dreaming of saving my life, he has now grown attached to my work and will do whatever he can to make it more widely known. He promises that the ashes of the blaze will barely have had time to cool before what I am writing now comes out of the shadows in its printed form . . .

'Take it to Frankfurt. There are two good booksellers there: Wechel and Fischer. Don't forget those names. They know all my books.'

'I shall travel for you, Bruno.'

In another time, another place, I would have loved this new disciple, and covered him with caresses. This morning, I don't even have the strength to imagine the gestures of love . . .

'In a few hours,' he went on, 'I shall no longer be in Clement's service. However I am under orders to try one last time to persuade you.'

'You're wasting your time.'

'I know. But I want you to know that until the black friars arrive, a coach will be standing ready to leave Rome under safe escort.'

'If Schioppius lets it leave.'

'Schioppius is under orders from Madruzzi, Santaseverina and my father. He hasn't the slightest idea what Clement's real intentions are.'

'Orazio says he's besieging the prison.'

'The guards can be trusted. There are secret ways out.'

'Do you really suppose that that loudmouth will be happy just to watch an effigy burn tomorrow?'

'When the effigy is burning, you will be far away.'

'And you were maintaining just now that you were no longer in the Pope's service! Are you his emissary or mine, for heaven's sake?'

'Forgive me. It wasn't the Pope I was thinking about, it was you. When we love someone, we would rather see them live than die . . .'

What friendship, what sorrow there was in that handsome face, on which black shadows of anxiety stood out in the lantern light. *If thou dost care that I should live, open, O beauty, the portals of thy doors; and look on me if thou wouldst give me death.* Only my verses will survive, I thought. I had to look away, and think of nothing any more but the death of the poet.

'I have only one day in which to write about eight years of life. If you stay, we'll talk. If we talk, I shall stop writing. And if I don't write any more, I shall come back to life, to Clement's coach . . .'

While Deza was getting up and wrapping himself in his cloak, the thought crossed my mind of a kiss from him on my icy lips . . .

'I won't break my word, Bruno. I'll go to Germany.'

'Will I see you again?'

'This evening. I'll come and fetch what you have written.'

By placing a coach at my disposal after demanding the greatest possible severity from my judges, Clement is merely showing the same inconsistency that I have had to put up with all my life from princes. This Ippolito Aldobrandini was elected pope on the day of my forty-fourth birthday. How could I forget such a portent? I had been in Venice for six months at the time. Thanks to Cecil's *flies*, I had been kept informed week by week about the deliberations of the conclave, and had been afraid for a while that victory would go to his adversary Santaseverina, the ally of the Spaniards, whom we had christened the *heretics' butcher*, and who was later to have me brought before the Roman Inquisition. When the new

pontiff's name became known, a wind of hope, and even of slight madness, blew over the cultivated society of our circle of friends. Certain that with this blessed news my exile was finally going to come to an end, Cecil had organised a sumptuous feast in my honour in his house on Malamocco, with dancers, maskers and actors. I can see myself now, goblet in hand, receiving rapturous applause for swearing that I would dedicate the book I was working on to Aldobrandini: *Of the Seven Liberal Arts*. Carried away by my enthusiasm, I toyed afterwards with the plan of coming to Rome and laying the work at His Holiness' feet, in the confident expectation that I would now be granted a fresh examination of my case, absolution from the church, and permission to live freely on Catholic soil. Not for one minute did I think of my *Noah's Ark*, and the way in which that first manuscript had once been received by Pius V, then by the cardinals: wasn't the time ripe in every clime now for hope, forgiveness and justice? I knew from Piero del Bene that Henri III's successor was preparing to recant his faith for the sake of reason and religious peace. Thus the predictions I had made in my *Triumphant Beast* were about to come true: out of the darkness of intolerance were springing the first sparks of a new, wise and universal concord.

No, I was not at all surprised to hear that Clement had been elected: it was in keeping with the natural order of things. And to tell the truth, it didn't seem as if anything could cast a gloom over those rather agreeable hours that I was enjoying with Cecil. While my living god was attending to the affairs of the Republic – and at the same time taking the opportunity to see to his own – I was visiting booksellers, keeping up a regular correspondence with my friends in Paris, and going every day to Zuan Mocenigo's home, not far from San Samuele. My fabulously wealthy pupil's palace contained one of the most beautiful libraries in the region, where I loved to read, write, play with the compasses, draw the complex figures of the mind, the intellect and love, and finally explain about the innumerable worlds to a handful of followers. It must be said that my disciple appeared to be disappointed by my

320

teaching and had been threatening for some time to stop paying me. The rascal had hoped to learn all the secrets of memory in just a few lessons, and he kept bemoaning the fact that he still could not foretell the future, or penetrate the ultimate mysteries of the universe. But neither his threats nor his complaints had any hold over me. I was the adulated guest of the best academies, I was being showered with gifts and urged to expound my views to prestigious audiences. I had even, much to my surprise, come across Duke Rizzo again; a troupe of·actors paid by him was planning to put on my *Candelaio* for the doge and the senators and gentlemen of Venice. I had plenty of money, and if I ran short there were quite a few well-heeled *pueri* in the city who were attracted by my reputation and were longing to study under my iron rule. Moreover, Cecil thought that the time had come for me to open my own school at last, and was doing his best to raise the necessary funds so that I could realise what he knew was one of my oldest dreams.

'Forgive me, Signor Zuan,' I said to my pupil one day, when his ill humour had really irritated me, 'but I am not afraid of losing your protection. I have many friends in Venice. Andrea Morosini has offered me sixty crowns to address his academicians.'

Mocenigo shot me a jealous look.

'I know perfectly well how effective your charm is, given how skilful you are at winning over the powerful. But when it comes to me, you refuse to teach me anything, despite the fact that I allow you to come to my house.'

He pointed with a look of pique at the copy of my *De magia* that lay open on the lectern.

'The magic that you have been teaching here for ten months is of no use to me.'

'What can I do if you keep confusing magic and sorcery? My philosophical art is an arduous science, a form of asceticism. Do you think a disciple is an ass to be stuffed full of Latin and theurgic formulae? You have to use your intellect, Zuan, and dig deep inside yourself until you discover the reflection of the universe there; that is the way. Like Socrates, I am only a

guide, a bridge, an intermediary between your thoughts and the *anima mundi* . . .'

All of a sudden he stuck his fingers in his ears. Was he tired of listening to me?

'You have deceived me,' he hissed between his teeth.

'If you cannot trust a master,' I declared as I took my leave, 'how can you ever trust yourself?'

'I'm leaving Zuan, as from tomorrow.'

'About time too,' sighed Cecil.

The May night was enveloping Malamocco in its mysterious murmurings. On the marble chimney piece I could see the candle flames flickering slightly in the gentle sea breeze. In my beloved's bedroom were a stone lion, some books, the lute I had caught a glimpse of twenty-four years earlier in Rome, and, hanging on the wall, three old sketches of a Saracen without a stitch of clothing on, drawn in three different poses by Jacopo Robusti. Nestling in the shadow between his thighs, the model's *mentula* looked like a child's. Great is the power of images. The briefest glance at this one was enough to make either of us shudder with desire.

Oh Cecil! Is there still that delicious bond between us, that magic spell which united our souls? Our games had not changed at all, I recall: the same mixture of kindness and fury, affection and combat, peace and turmoil; and pleasure that made us cry out like dying men. In the seclusion of your bedroom, we devoured one another so that we could blot out death and time, we were the universal One, infinite love, God and nature, sky and ocean, sun and snow, concord and discord, starry sphere and pure consciousness, light and darkness, divine reason and human blindness. All at the same time we could hear the monotonous song of the sea, the messages of the gods, the voices of the past, the groans of those we had loved, the clamour of a terrible century. We thought of ourselves as each other's lover, friend, brother, confidant and pitiless adversary. Our bodies longed to become but one body, our desires but one desire, our lives one single death, an eternal rest, an unbroken dream. Oh the pleasure of that

intermingling of minds! Our two imaginations produced the same language, the same universe peopled with loving shadows, and would suddenly come together as one in the remembrance of a sublime warrior, a poet and knight of great elegance and style. Sidney was our legend, the strength of his heroic deed was our bread and wine, his sacrifice our victory. He lived with us in the form of a portrait which Cecil had brought back from London, a magnificent image in which the opaline face of the poet stood out against the dark background of his thoughts; and in us as well, thanks to the memory of his melancholy voice, which we could never forget.

I remember the gondola that took us out to Malamocco almost every evening, gliding like a silent shadow over the gleaming surface of those waters that were always changing, always the same. Wasn't it rather like an allegory of death? But the house was beautiful and peaceful, if there is such a thing as peace, and the hours that drifted by there were happy, if happiness is not just an illusion. We had many nights in that magic place frequented by the gods, which I have no doubt still murmurs today with the sound of our sighs. The one I am going to talk about now was to be the last.

'You've put too much trust in that Mocenigo fellow.'

'I don't think he's dangerous. Stupid, yes. What made that strange thought come into your head?'

We were only just emerging from our warlike struggles. Was this the moment to torment myself over a bird-brained disciple? Still gasping for breath, I bit Cecil's cool neck; he stifled a groan. I bit harder. His hand groped between our wet bodies, in search of a *mentula* which was far from child-like . . .

'He has had several visits from your old friend Sisto da Lucca. That's why I'm thinking about him.'

An unwelcome sense of foreboding came over me, as I remembered the prior's smile. *Your old friend*! I'd rather make friends with a snake! A scorpion! Everyone knew that Rome had entrusted him with the task of censoring heretical books.

'Your stomach is freezing,' murmured Cecil, pulling the silk sheet up over us.

'Sisto da Lucca, did you say?'

'Have you talked a lot to Mocenigo? What does he know?'
'Everything. He knows everything.'

When I presented myself the next day at Mocenigo's home, it was my intention to thank him for his protection and hospitality, which was a polite way of putting an end to the dealings we had been having since Frankfurt; since you are so very dissatisfied with your teacher, sir, feel free to look for another one, and let us part good friends – those were the words I was pondering over as I arrived there. But the master of the house, I was told, must have gone out. Squinting to avoid meeting my eye, the two Styrian brutes he had as servants invited me to wait in the library. Which I did, hoping that I could find some way to kill the time, and that Signor Zuan would not be too long.

As I went in I was surprised first of all to notice that my *De magia* was no longer on the lectern, and then that my other books had also disappeared from the desk that was set aside for them; likewise a bundle of papers containing notes and sketches made by me. Had Zuan taken them off into his study? Whether by chance or by negligence on his part, the study, into which I rarely went, was not locked. And indeed when I went in there I found, dumped in an untidy heap on the desk, the books and documents which we normally used for our work, along with various objects belonging to me: a pair of compasses, some spectacles, a ruler . . . There was also the rough draft of a letter, on which I recognised his handwriting:

TO THE VERY REVEREND FATHER GABRIELE
OF SALUZZO
INQUISITOR OF VENICE
22nd MAY 1592

'I, Zuan Mocenigo, son of Lord Marco Antonio Mocenigo, residing near San Samuele, declare, under the dictates of my conscience & on the order of my confessor, that I have heard it said by Giordano Bruno Nolano, during conversations we

have had in my home concerning philosophy and theology: that it is a great blasphemy on the part of the Catholics to claim that there is transsubstantiation of the bread into flesh; that he, for his part, is opposed to the Mass; that he finds no religion to his liking; that he is expecting the present King of France to reform the religions at last; that our Catholic Faith is full of blasphemies against the majesty of God; that we have no proof at all that our Faith is the one that God wills; that the brothers must be forbidden to debate, because debates make people stupid; that the brothers are all asses; that our opinions are the doctrines of asses; that he is amazed that God continues to put up with the heresies of the Catholics; that St Thomas & other doctors know nothing; that he knows everything & will shut them up in the end.

'He has also said that Christ Our Lord was a sorry individual; that instead of seducing the people with his deceits, He would have done better to foresee that he would be hanged; that there is in God no distinction between persons, because that would be an imperfection in God; that the miracles of Christ were illusions & that He was a magus; that Christ was not at all happy to die; that He would have avoided that fate if he could have done; that the Virgin cannot possibly have given birth, because virgins do not have children.

'He has said that to live well it is enough not to do unto others what you would not wish them to do unto you; that he couldn't care less about any of the other sins; what is more, that the sins will not be punished; that the souls created by nature pass from one animal to another; that the world is eternal & that there is an infinite number of worlds; that God creates new ones every day because it pleases Him so to do; that he knows & practises the art of divination; that he has been the leader of a sect in Germany; that he loves young boys; that he will not always be poor because he also loves wealth, which he has had a taste of in heretic countries.

'Finally he has told me that he has been examined by the Inquisition in Naples for heresy, in Rome because of a priest whom he murdered by the Tiber, & in Toulouse because of his doctrine; that he is not afraid of the Inquisition, because

they are asses; that he will shut them up as well; that the Serenissime is a free & wise Republic; that he has its protection as a great philosopher.

'What was this man doing in your home? you will ask me. I invited him there so that he could teach me the so-called wonders of his philosophy. I was unaware at that time that he was such a wicked individual. Today I consider him to be mad & possessed by the devil. With the Very Reverend Father Inquisitor's permission, I am also sending him three books printed by the said Bruno. The subject of one of them is magic & certain other things which escape me for the moment, but which will no doubt . . .'

I pocketed the letter and, trembling with rage, began to pack up my books, notes and belongings. But when I tried to leave the palace, I came upon something that seemed too extraordinary, too incredible, too shameful to be happening in a civilised country: posted as sentries on the doorstep, the two grim-eyed Styrians were preventing me from crossing the threshold. I went back in and ran from room to room in search of a way out; it was no use, all the exits had been sealed off. Then the servants who had been sent after me tried to pin me down. I reminded them of my rights, my titles, my patronages, even my powers! I threatened them with the whip and the rope; still they refused to back off. Violence is the only language people like that understand. And so I decided to give them a dose of their own medicine, and struck out. I would easily have made short work of the wretches if Zuan Mocenigo had not suddenly appeared in person, out of breath but crying out in a high-pitched voice that I was not to be allowed to escape. He was accompanied by a captain and five halberdiers of the watch. They threw themselves on me like a pack of dogs.

I was brought before Inquisitor Gabriele of Saluzzo only after I had been left to rot for four days, alone in a dungeon, without permission to write or speak to anyone. When questioned as to my surname, Christian name, place of birth and family, I

answered that I was Giordano Bruno, born in Nola, a town twelve leagues from Naples. My late father was Gioan Bruno, a soldier of the very Catholic king of Spain, and my mother Fraulissa Savolino.

'What is your connection with Signor Mocenigo?' Saluzzo asked me.

'I met this man in Frankfurt, Reverend Father, where I went last year to have my books published. He declared that he wanted to become my disciple, and invited me to come to Venice to teach him my philosophy. By the end it had been clear for some time that he was disappointed with the lessons; he was convinced that I was concealing certain truths from him and that the benefit he was deriving from my company was not worth the expense.'

'Did he ever mention that he intended to denounce you to the Holy Office?'

'Several times, Reverend Father, but I could not regard such threats as anything other than jokes, since I have nothing to hide from your Tribunal, and nothing to feel guilty about.'

'If you are innocent, what was the witness frightened of? Does anyone come and seek the assistance of a captain of the Holy Office unless there is a good reason for it? Perhaps you threatened him with a spell of some kind . . .'

'Forgive me, Father, but I have read the letter he sent you. I happened to find it a few minutes before they came to arrest me. A tissue of lies of the sort one would expect from a half-witted child.'

'A tissue of lies,' repeated Saluzzo, glancing through Zuan's epistle. 'Do you deny that you have lived in heretic countries? Just a moment ago you yourself were speaking about a German city where your books are printed.'

'Frankfurt, Father.'

'Aren't there any printing houses here then? Is that why you have to go to the Protestants to find some?'

'Father, I did live for fourteen years in France, England and Germany, that is true. But without ever adopting the beliefs of the heretics or taking sides in religious quarrels. I didn't leave Italy to listen to the sermons of the Huguenots, still less to live

327

a life of debauchery, but because I needed freedom to do my research.'

'But you did renounce the Catholic faith . . .'

'I have never stood outside the Church of my own free will. On the contrary, I have tried to have my excommunication lifted, first of all by applying to Brother Sista da Lucca, who was then Prior in Rome and Procurator of the Dominican order, then to Cardinal Mendoza, during a visit he made to Paris. The book I am just finishing will contain a dedicatory epistle to His Holiness Clement VIII. Many Venetian gentlemen and scholars can attest before your tribunal to my intention of laying the work at the Holy Father's feet myself, and imploring yet again the Church's forgiveness for my past errors.'

Saluzzo was pensively turning the pages of my *Heroic Enthusiasts*.

'Which errors are you speaking of, those contained in your books?'

'No, Reverend Father. Only lapses and omissions concerning the mass and the sacraments. As I have told you, I lived for many years in countries which are hostile to religion. I did not want to draw attention to myself there as a Catholic, and run the risk of offending my hosts and being taken for a bigot or a madman. I repeat, religious quarrels are alien to me. My passion is not for preaching the faith, but for making known the truths of nature.'

'What about this work, for example? Doesn't it contain some mockery of the Church?'

'You can easily check that for yourself, Father. I am willing to provide the tribunal with a complete list of my writings, whether printed or not. There is a very large number of them . . .'

'And what are they about?'

'Their subject matter, let me stress this point again, is not religious but philosophical, and what is more quite diverse. I proceed in my books according to the principles of natural light, never those of faith, and so you will find nothing in them that could call in any way for condemnation.'

328

'Nothing that contradicts the Catholic truths, really?'

'Of course the heretic doctrines are sometimes mentioned, Reverend Father, but always as an example, as is customary when one wishes to examine a subject in terms of all its implications . . .'

If Cecil had very little difficulty in persuading the Holy Office to make my régime less harsh, it was largely because the initial interrogation had in no way confirmed the accusations levelled at me by my betrayer. On the contrary, I had answered Saluzzo courteously, without showing any fear or laying myself open to the slightest suspicion that this could be anything other than a case of petty vengeance. I was transferred to a cell occupied by two prisoners – one of whom was a wretched, epileptic Capuchin monk – and was given the use of another one so that I could receive visits from the many friends who presented themselves at the gates of San Domenico di Castello to console me with gifts of books, writing materials and other things that would make life more pleasant for me.

The inquiries that Cecil was making on his own behalf confirmed our suspicions regarding Sisto da Lucca, the *deus ex machina & fabricator* of the trap. Could it be that the primary cause which had eventually produced such a splendid effect was the secret pleasure he had long been hoping to derive from seeing me sentenced, and if possible tortured? The whole affair certainly bore the stamp of this false-hearted rogue, who was no doubt convinced that he had sniffed me out all those years ago as an infidel, an impenitent, the perfect prey for the gaols of the Holy Office. The only reason why he had opened the door of his monastery in Rome to me, and given me money and clothing, was so that he could have a better chance to judge me according to his fallacious criteria. Later he had defended my cause with studied nonchalance to the Holy Seat, and had not hesitated when the moment came to denounce me as a heretic to the leaguers in Toulouse. And so the last part of his strategy must have been to dispatch to Frankfurt a Judas whose job it was to lull me into a false sense

of security, lure me to Venice, keep his ears wide open and carefully record anything that could be held against me later. It did seem then that, stupid though he might be, that effeminate ass Zuan Mocenigo must possess some small grain of talent, an aptitude for play-acting and exploiting people, since he had in fact carried out his mission, and so successfully that I appeared in my own eyes, not to mention those of Cecil, to be the most complete idiot the world had ever nurtured in its generous bosom.

Thank heaven, we thought; it was most unlikely that things would turn out badly for me: Saluzzo was by no means on bad terms with the government of the Serenissime, where we had more than enough allies. As for the witnesses whom Mocenigo had specifically named and who were likely to add weight to the charges against me, there were only two of them and they were hardly well chosen: first the bookseller Ciotti, and then Andrea Morosini, a friend and former lover of Cecil's, whose house was open to the most discerning minds in the region.

According to the reports supplied to Cecil by the *flies* who kept watch over the hearings – I have no idea how – Ciotti stated that he had heard of me in Germany where he went every year to trade in books. As a bookseller, he knew my *De minimo*, my *Heroic Enthusiasts* and my dialogue on *Infinity and the Worlds.* He also knew that I was at that time the guest of his colleague Wechel. One day he was talking to Zuan Mocenigo who told him that he had been captivated by the principles contained in my works and was longing to meet me, because he wanted to learn the secrets of memory and the future. They decided to share the expenses of the journey and went together to Frankfurt, where Ciotti agreed to act as an intermediary.

'What was Giordano's reputation there?' asked Saluzzo.

'Reverend Father, it was excellent. People spoke of him as having a great talent, as being a man of letters and a polymath.'

'Was that just what the German he was living with thought of him, or was it the general opinion?'

'It is true that Wechel considered Giordano to be as

eminent a philosopher as Aristotle was in his time, which is why he printed his books. But everyone I talked to about him, students or booksellers, said the same thing. Some say that he has been the friend of the greatest princes. He is even supposed to have accurately predicted the assassination of the King of France by a priest.'

'But what about his religious ideas?'

'Giordano was thought of there as a man without belief, Reverend Father.'

'Is he an atheist?'

'An atheist? Great heavens above!'

'Is he one or not?'

'Well, I really don't know anything about that . . . I'm not sure I know exactly what being an atheist means, or even if such an abomination is possible . . .'

'It is. And here in Venice, have you seen Giordano?'

'He often comes to my bookshop.'

'Do you talk to him?'

'About any number of things, Reverend.'

'In your opinion, is he a good Catholic or not?'

'Good gracious, I have never heard him say anything that could make me doubt that he was.'

Asked in his turn if he knew me, the grave, tormented, and very elegant Andrea Morosini replied that he had bought my book about the heroic enthusiasts from Ciotti. We had met for the first time, he added, on Malamocco, at a party given by a friend of his, in whose house it seemed moreover that I was living; then on several more occasions in the best circles . . .

'Do you know what the relationship was between Giordano and Signor Mocenigo?' the Inquisitor asked him.

'I know that he went to his library, father, which is a very rich one; and that he gave him lessons.'

'What kind of lessons?'

'He taught him his mnemonic art, I believe, such as he himself had learned it from the works of a Catalan, Ramon Lull. Signor Zuan had been attracted by Giordano's great reputation. They say he went all the way to Germany to see him.'

331

'And you, Signor Morosini, what is your connection with this . . . philosopher?'

'He came to my home. We had conversations about poetry and literature, and I was so impressed by his learning that I invited him to join my academy.'

'What faith does he belong to, in your opinion?'

'I confess that I never touched on religious matters with him. We talked only about art, literature, the passion of love, physics and metaphysics . . .'

'Did he ever in your presence utter words that were contrary to the Catholic truths?'

'If that had been the case, father, I would not have allowed him to enter my house.'

'Mocenigo is their only witness,' I murmured.

'*Unis testis, nullus testis*,' observed Cecil. 'So it'll all be over soon. It'll just be a matter of doing whatever they want, confessing some breaches of the rules, imploring forgiveness, etc. Give them something to chew on and all will be well.'

I looked up. How high in the wall the architect of this prison had placed that window through which you could see a patch of sky, so perfectly clear and distant!

'What about your cellmates?'

'Fra Celestino is convinced that he is possessed by a diabolical heresy. He throws himself against the door, yelling that he wants to be punished. He has an attack nearly every day.'

'And Graziano?'

'Unbearable. When he's not reading his missal aloud, he's praying. When he's not praying, he's bombarding me with questions.'

'Whatever you do, don't answer a single one of them.'

'I've already answered a large number . . . Are you leaving?'

'Take care that he isn't being paid by Saluzzo to make you talk. Yes, they're expecting me at the Council . . .'

Who would be sleeping in the arms of my living god tonight? The faces of several possible lovers passed through my mind, including that of the grave, tormented Andrea Morosini. One of Rizzo's young actors, perhaps . . . No. These

days Cecil was only unfaithful to me with mature men, ones who were proud, rich and powerful . . . Once again my heart tightened at the thought of his bedroom, of the Adriatic Sea and the picture of the handsome Saracen hanging on the wall. For a split second, I could even hear the never-ending sound of the waves . . . Cecil brushed my cheek with a light caress.

'You've let your beard grow again, the way you did at the end of your time in Germany.'

'Some premonition or other . . .'

My lips were sealed by a kiss.

'In no time at all we'll be celebrating your return to Malamocco, Philip.'

Sincere, affectionate words . . . To tell the truth, I did not doubt Cecil's love, or on this occasion his loyalty. Why should he have worried, or lost hope? Mocenigo's accusation, which no longer carried any weight, was further discredited by the letters which our friends, some of them in very high office, were sending every day to the Inquisitor to protest my merit and virtue.

Then came the second hearing, in the course of which I was surprised to observe that Father Gabriele of Saluzzo appeared to regard my views concerning the innumerable worlds as insignificant. Indeed, he hardly deigned to turn his attention to them at all. On the other hand, he made it his duty to question me at length on the Holy Trinity and the Incarnation. Give them something to chew on, whispered Cecil once more inside my head:

'I confess that I have been unable to overcome my doubts about the transformation of the word into flesh, because the whole idea seemed so extraordinary to me when I examined it in the light of reason. I admit that this can be held against me. However, I have always avoided expressing those doubts in public.'

And without leaving Saluzzo time to start speaking again, I added:

'What are we to understand by the Holy Spirit, Reverend Father? All my life I have thought about it philosophically; and philosophically I cannot see it as a *person*. The word *person*,

you see, does not seem to me an appropriate one to describe the divinity. You will observe moreover that there is no mention of it in the Scriptures. No, I prefer to talk, in the Pythagorean manner, about the *anima mundi*, the soul of the world which engenders all life. I do not know if that is likely to redeem me in the eyes of your tribunal, but I will add that my metaphysics contains a trinity: in it the Son is the Spirit of the Father . . .'

The poor man, who was clearly anxious to keep his feet on the ground, was afraid that the heights to which my answers were taking him might make him dizzy.

'Yes, yes, of course,' he said irritably, 'but let us get back to the eucharist. Do you deny that the bread and wine are the body and blood of Christ?'

'Please forgive me, but when the question is put in those terms it means nothing to me. Once again, the subject of my books and teachings is not theological, but philosophical. I am a scholar, Father. Meditating on the mass is outside my field, and beyond my abilities as well no doubt . . .'

'Am I to conclude from that that you are not a Christian philosopher?'

'I repeat that I have had doubts about a precise point of Christian doctrine. I humbly ask that I may be forgiven for them. On the other hand, I have no doubts at all about the First Person, which in my language I call the first principle.'

Again my ideas were preventing him from thinking straight.

'Let's see now,' he said, 'would you be willing to come before this tribunal and make a declaration in support of the Holy Trinity, in the sense in which the Church views this . . . mystery?'

'I believe there is only one God, Reverend Father, and I am ready to state that when and where you like. If you want, I shall say that He consists of three parts: Father, Word and Love. Thus my doctrine will be respected, and our religion.'

'Our religion which in private you delight in mocking; you scoff at the Lord, you deny the purity of the Virgin.'

'I have never blasphemed against Christ, Father, for I hold

him in great respect. These are just lies, the fabrications of a perfidious mind.'

'We have other evidence apart from that of Signor Mocenigo.'

Goodness me, what a crude trap it was! Wasn't this Saluzzo overstepping his legal rights by putting forward as proof documents which didn't exist?

'I repeat that these are lies,' I declared firmly. 'I am a man of great renown and good reputation. Who would dare boast that he had never been tarnished by base slander?'

'Who would dare set himself up as a paragon of virtue?' he retorted. 'Would you be prepared to swear before God that your morality is in every respect in accordance with the rules of Christianity?'

So this was it at long last. The fellow felt much more at home talking about moral standards than about science.

'I think I can guess what you are hinting at, Very Reverend Father. I confided in Mocenigo that I liked teaching *pueri*; that is what the novices are called in Naples.'

'Here in Venice we don't have much time for sodomites.'

Come off it, you old crook! There was more buggery going on in the *palazzi* and brothels of Venice than there was in Athens; which I may say in passing was a sure sign of high culture . . .

'I don't like them either, Father. I like teaching, nothing more than that. Instead of paying attention to my lessons, the delator has once again allowed his chaste ear to be stroked by the sirens of malicious gossip.'

'If he is to be believed, the sin of the flesh was not limited to the . . . *pueri*.'

'I did occasionally yield to women of ill repute in my youth, and also had dealings with a Neapolitan woman in the course of one of my journeys. So it didn't amount to much, and as God is my witness I never reached the total that King Solomon notched up in this regard. With the tribunal's permission, I shall ask God's forgiveness for this sin.'

There were only a few points left to examine, one of which seemed to disturb my judge's sensitivities. With a grimace of

disgust, Saluzzo asked me if I absolutely believed that the immortal soul passed from one body to another, perhaps even into that of an animal. My answer was no, *speaking in Catholic terms*. I did however insist on introducing a slight nuance into my remarks. Pythagoras, I began, acknowledged that it was a possibility . . . But the hour was late, and the Inquisitor was tired of my lessons. Preferring to cut things short, he questioned me briefly on my knowledge of prohibited reading matter. I cited Erasmus, Luther, Ramon Lull . . . Had I ever adopted their doctrines? No. They had taught me nothing that I did not already know. Turning to his colleagues, Saluzzo gave a gesture of utter weariness to indicate that he saw nothing in all of this that could justify a condemnation. After which he closed the hearing.

It was almost with a happy heart that I went off between two guards back to Fra Celestino and the pious Graziano, convinced that I would not be sharing their miserable fate much longer.

'Brother Giordano,' declared Saluzzo on the morning of the thirtieth of June, 'we are going to hear you today for the last time. I ask you in a spirit of affection to unburden your soul and, if possible, to tell your judges the truth even better than you have done before. Think what could happen if you should refuse to confess some infamy of which they, unbeknown to you, are aware. I beg you not to force them to carry these legal proceedings through to their conclusion, to those extreme lengths in which as you know only the Holy Office has the right to adjudicate. You have travelled a great deal in the infidel countries, living as the heretics do, betraying the faith of your fathers, vilifying the Church and those who govern it. Is there a sin which you now wish to confess?'

'Very Reverend Father, I fled Italy because of the threats that hung over my freedom. In the course of my exile, I turned many a time to priests of high rank to make known to them my intention of returning to the bosom of religion. I wanted to be forgiven for my impetuousity, and to have the excommunication that had been imposed on me lifted. These

attempts proved to be in vain. I certainly do not wish to incriminate anyone, but who regrets it today more than I do? And so I have had to make my way in cities where, it is true, different beliefs prevail. Did I listen to any preachings other than Catholic ones? Yes, out of curiosity, out of courtesy, without ever commending them. While I was there, did I neglect the rules of Christian doctrine, confession, communion, going to mass, fasting? Yes, in order not to become a laughing-stock by behaving ostentatiously. Did I occasionally praise the heretics? Once again yes, but never for their heresy; always for their virtue, as I did moreover in Naples a very long time ago, an act which was enough to bring a heavy condemnation down upon me. Did I sing the praises of infidel princes in my books? I confess that I did that too, but those princes were protecting me as a poet and philosopher against the hatred of sycophants and the violence of the intolerant. It is customary in all religions to thank those who have welcomed you at their table. For these sins, Reverend Father, I ask the Church's forgiveness. I have no other fault to confess, even if your tribunal should choose to go to the ultimate extremes of its justice. My slanderer claims that I have acted for love of earthly wealth. That is a lie which is easy to refute. Those who have known me, here and elsewhere, know that I have only one love: the truth, whose other name is wisdom. Far from enriching myself, I have paid the price of exile, of hardship, and very often of dire poverty. The errors that I have committed, the doubts to which I have given way, the few impious words that I may have uttered, I now detest and abhor. I repent them all, and finally I beg your Holy Tribunal to show me the remedies and penitences which will lead me to salvation. Amen.'

Having said this, I fell on my knees, bowing my head in an attitude of such deep reverence that Saluzzo did not dare intervene. In the end he murmured:

'The tribunal has taken note of your profession of faith, Brother Giordano. You may arise.'

When I failed do so, he went on in an even gentler tone:

'Do you think that Signor Mocenigo may have been driven by malicious intentions?'

'That's perfectly obvious, Father. But I forgive him, as I hope that your tribunal will forgive my faults.'

'We have no further questions to ask you, Brother Giordano.'

The Capuchin Fra Celestino had already managed to save his skin once when he was tried for heresy the first time, but he had suffered a relapse, and as a result now found himself incarcerated in San Domenico di Castello. During the hearings he created an uproar, insulted the judges and demanded to be subjected to the cruellest punishments, then abruptly changed his tactics, gripped by terror no doubt when faced by the reality of death; Venice thronged to hear him recant yet again the vehement pronouncements he was in the habit of making against the corruption of the priests and cardinals. He drew a frisson of pleasure from the crowd by concluding the ceremony with a tremendous epileptic fit. Certain aspects of Celestino's moral make-up inevitably reminded me of Felix, but there was nothing at all about him that inspired sympathy. In August, he was sent off to a monastery not far from Verona, and I found his departure a great relief. Graziano, also a relapsed heretic, underwent torture. By September he was seriously ill, and was transferred to another cell where he almost died; the following year, he was condemned to life imprisonment.

And so I spent that second summer in Venice languishing in the midst of vociferations, groans and tears, receiving no visits apart from the regular, affectionate ones that Cecil paid me, and hoping every day to hear the Inquisitor pronounce the admonition at the end of which they would finally resign themselves to setting me free. Despite the anxiety and the strain of prison life, I had finished my book on the liberal arts and written the dedicatory epistle to Clement VIII. I was thinking that once I was out of prison I might take the manuscript to Frankfurt myself.

But the law insisted that Saluzzo had to wait to pronounce a verdict until he received the opinion of Rome. On the advice of the sinister Sisto da Lucca, who according to Cecil

338

was often seen prowling about in Venice, he had sent the central tribunal not just a summary of the affair, but a complete copy of the whole investigation. This fell into the hands of Cardinal Santaseverina, a man who was disappointed by his failure in the conclave and known for his universal hatred of humanity, and who had cultivated the sort of memory that only tyrants possess. Searching through his recollections, the monsignore relived the years in which he was a prior in Nola, and remembered me as a student, the circumstances of my trial in Naples, and my hurried flight from the monastery; he dictated to his secretary a letter addressed to Saluzzo, in which he demanded that I be transported to Rome and given another hearing there.

He had to keep trying for five months before the doge agreed to give him what he wanted. The first command was issued to the Inquisitor himself, who appeared most anxious to obey his superior's orders with all possible speed. As it happened, he said, a ship was preparing to set sail for Ancona, which would enable the prisoner to be transported in complete safety. Why not seize the opportunity? The governor of Ancona had already been warned, and would take full responsibility for the last part of the journey.

'I promise you that the matter will be carefully investigated by the College and the Senate,' said the doge with a smile.

'Time is short, Your Most Serene Highness. The ship . . .'

'Just for now you can let this ship go, my dear Saluzzo.'

Neither the College advisers, nor the senators, nor the doge himself had any intention of agreeing as easily as that to hand over to Roman jurisdiction a prisoner who had been arrested and examined in Venice. After some deliberation they replied courteously to Saluzzo, and thus to Santaseverina, that it was not customary in the Republic to act in such a way. Was there not a good judicial system here, which came under the authority of his Holiness himself? Was it not easier to send recommendations to the judges than to transfer an accused man?

The cardinal's reply was to dispatch another emissary in December, in the person of the apostolic nuncio.

'The judicial system in Venice is the best there is,' he said, bowing before the doge. 'But this is a special case. Did the investigation really start here? No, your Serene Highness. It began in Naples a very long time ago, and was continued in Rome in the absence of the accused. Bruno is a convinced heresiarch.'

'That is precisely what no witness has been able to bear out. As for the mistakes that Giordano made in his youth, as far as I know they were dealt with at the time. I am sorry. A trial begun in Venice must be completed in Venice. And besides, it is already over . . .'

The nuncio's voice grew harsher:

'I have here a list of twenty-four cases of prisoners sent to Rome without the slightest difficulty.'

'I am sorry, Monsignor,' repeated the doge.

Faced with what he of course regarded as scandalous prevarications, Santaseverina ended up appealing to the Pope himself, the inaptly named Clement of whose victory I had noised abroad my approval a few months earlier. The pontiff lent an ever more attentive ear to the repeated appeals of the head of the Congregation. It was not long before he was sending to Venice a special ambassador, who based his arguments on the fact that I was a Neapolitan and not a Venetian, and thus succeeded in weakening the advisers' resolve. I had just completed my eighth month of imprisonment. Like a listing boat, the College suddenly felt inclined towards giving in. The matter was sent back one last time before the senators. In a vote that turned the tables on their previous opinions, they agreed to send me to Rome. When he heard of the ugly turn that things were taking, Cecil rushed to the Palace; but it was too late:

'I cannot risk offending a Pope who has just been elected,' sighed the doge. 'He is in good health. He will rule for a long time. They say he is all for peace . . .'

'Your Serene Highness, I beg you on my knees, in the name of our city's independence . . . Giordano is innocent of the

charges that are being heaped upon him. Think about the fact that Saluzzo could not produce a single witness apart from that fellow Zuan.'

'My dear Cecil, if Giordano is innocent he has nothing to fear from his judges, not even the ones in Rome.'

Among the papers that Deza brought back to me from the Holy Office, I came upon these words which was I never able to send:

'My sweet friend, my star, my brown planet, my living god, your last letter dates back to the month of July; since then, I have heard nothing more. Is this censorship? The prisoners here have dreamt up any number of strategies to elude the vigilance of the father inquisitors & I hope that these pages will get to you without passing through their hands. Can you not find a way on your side? Through the French Embassy, perhaps. Apparently they have people who are willing to help.

'It is nine months today since I entered the gates of this prison, towards which a prophetic genius, if you remember this detail, once guided my steps when I was on my way out from seeing the Pope. At that time the building was still under construction. Today it contains about fifty monks, all of whom chatter away incessantly. Some of them are good philosophers, all are accused of heresy, & a number, it is said, will suffer the unspeakable torment.

'For my part, I have not yet been heard by my judges, of whom there are nine. The list includes Santaseverina (the butcher, you know . . .) a Spaniard called Deza, & finally Madruzzi, their most senior member, a doddery old man who's near the end of his days & is consumed by hatred & the fear of death. They have, I know, forced Saluzzo to reopen the investigation from the very beginning. He has been most obedient (as usual), but he hasn't been in much of a hurry: a copy of the new hearings has only just arrived at the central tribunal. And so Zuan Mocenigo will have been invited once again to spew forth his venomous accusations. I am not aware that Morosini & Ciotti have gone back on their favourable

opinion, but I beg you to make sure of that, if you haven't already done so, because I no longer trust anyone.

'Do you remember Fra Celestino, that Capuchin I had the misfortune to share a cell with in San Domenico di Castello? I do believe that he has been bribed by Santaseverina's agents, because he has just sent the Holy Office a letter from Verona concerning me. There is a clerk of the court here who is from Naples. Getting him to give me a summary of this fine epistle cost me a fortune (as a matter of fact it was my entire fortune, don't forget to think about that if you write to me), but this is it: Celestino claims he heard me say that Christ led a debauched life & screwed harder and more often than a billy-goat! Can you imagine? Apparently I also said that the Pope was a traitor, & even cocked a snook at him several times. No doubt the blasted Capuchin's letter was dictated to him, because not content with pouring out this kind of filth, he talks in it about things he knows nothing about, such as the countless worlds, the infinite heavens, the transmigration of souls & Moses, who I am supposed to have said was not the institutor of the Hebrews, nor even a magus, but a mere sorcerer, & a billy-goat as well. Celestino also heard me shouting that Cain was right to kill his brother & other fabrications of the same ilk – can't list them all, because I haven't got space or time.

'I don't know what Santaseverina expects to gain from the allegations of an epileptic who's an old hand at heresy trials, but I am afraid he will go and interrogate Graziano in his prison. He is not at all mad & has been given a heavy sentence. Who knows what they will promise him in exchange for his evidence?

'The interrogations should start soon. I shall adopt the same strategy as in Venice, giving them some bone or other to gnaw on. Then I shall ask their god for forgiveness as many times as they like; in a few months I shall be free, & on Malomocco in your arms. Love whoever you want, my sweet Cecil, but forget not in his absence your faithful

'Philip
'Rome, Prison of the Holy Office,
'this 27th November MDXCIII'

I spent the year of ninety-four trying my best to deny before my judges that I had ever blasphemed against God, the Catholic Church and the Pope. As expected, they had dictated to Graziano (the gallant fellow immediately had his sentence reduced to five years' imprisonment) a delation capable of worsening the charges that hung over me. Thus, in its impartial quest for divine Truth, the Holy Tribunal now had three testimonies deemed by it to be indubitably sincere, the fruits of mature reflection and a profound examination of conscience. I must say that in order to give satisfaction my slanderers had given free rein to an imagination of which I would not have dreamed them capable. By their account, I had professed an unshakeable atheism, proclaimed that Jesus was nothing but a coward and a sinner, spoken in unflattering terms about Moses, Cain, the prophets, the angels, the Saints, the relics, the apostles, the mass, the missal and the authors of the missal. I had insulted the Mother of God and doubted her virginity, taught that Christ had not been crucified but hanged, once served an infidel prince in the person of Henri de Navarre, tried to create culpable sects of *Giordanisti* all over the place, practised hostile religions, slept in heretic countries with men and women, sometimes with both together; I had also stated that hell did not exist, any more than the punishment of sins did, and that everything was therefore permitted here on earth. When my cellmates had refused to adhere to my views I had insulted them, calling them ignorant goats and punching them with my fist. I had continually shouted at them that I was the greatest philosopher of the century, that I possessed supernatural powers and would soon have the whole world running along behind me . . .

To these shameful lies I could not but respond with utter contempt, but God knows I did so without ever showing a less than civil attitude towards the tribunal. I merely observed, in order not to appear like a complete fool, that two of my accusers, convicted of heresy and regular inmates of the Inquisition's dungeons, could not be regarded as models of probity. As for Mocenigo, he was unquestionably motivated by hatred, spite, the spirit of vengeance and the incomprehensible

certainty that he had been deceived, even though it was he who had come to see me in Frankfurt and begged me to teach him. No evidence had been produced against me by people who were beyond reproach. Was not that proof *a contrario* of my innocence?

Dissatisfied with the slow progress their cause was making along bumpy roads such as these, the cardinals were forced to turn off on to what looked like a more well-trodden path, that of what Madruzzi subtly called my *artificial & memorative art*. He referred to a certain little book which Zuan had felt it his duty to enclose with my denunciation, and which was none other than my *De magia*.

'I willingly admit to having written this treatise,' I declared, or words to that effect. 'But the Holy Tribunal should not misjudge what it contains. I condemn as sins sorcery, idolatry and every sort of superstition. In my opinion, magic means a knowledge of the secrets of nature, and the bonds that it weaves between beings. Is the peasant who marries the elm and the vine to produce a better wine a sorcerer? And the doctor who knows the plants that are likely to alleviate diseases? The sage who sees into friendships and enmities? The vulgar man moves away from nature, the scholar imitates it and moves closer to it. Does that mean that he is performing wonders? Yes, Reverend Fathers, if one regards as wondrous the causes and effects that are visible in the universe. Those are the ideas that are written down in my book. Nothing, it seems to me, that contradicts the principles of the faith . . .'

'And this loathsome opinion about human souls transmigrating from one animal to another,' exclaimed Madruzzi, 'isn't that an affront to Catholic doctrine?'

'It is, Your Eminence, without the slightest doubt.'

'Nevertheless you professed it.'

'Not as far as I know.'

'Can the accused give some explanation on this point?' asked the suave Deza, licking his lips.

'Your Eminences, like you I regard the soul as immortal, and the body as perishable. The question is, what does the soul become when the flesh dies?'

This sort of apostrophe generally had the effect of plunging them into an abyss of anxiety and perplexity.

'I do not think,' I said, 'that it *transmigrates*, as the Reverend Father put it, from one animal to another, because that is indeed contrary to our religion. Nor do I claim ever to have dwelt in the body of a snake, a frog or an ass, because to tell the truth none of these beasts would be stupid enough to offer hospitality to a being as disagreeable and troublesome as I . . .'

Deza burst out laughing, and it was as if at that very moment his immortal soul had just become incarnate in a neighing horse. The hilarity was contagious and spread to several of his colleagues. Only Madruzzi and Santaseverina remained deadpan.

'No,' I continued, 'the idea is purely a hypothesis in the Pythagorean style, an intellectual game. It is possible that I have supported such a postulate at some time or another, but as a joke, never as a truth.'

'From this postulate flow consequences which are incompatible with Catholic dogma, Brother Giordano, as I consider myself obliged to remind you . . .'

'I repeat, a scholarly hypothesis with no practical implications at all. A mere flight of fancy. Something said in fun . . .'

But things said in fun had no appeal for the Inquisitor; his court was supposed to be as cold and keen as death itself. There was not much room in his tribunal for the flashes of gaiety that can sometimes burst forth in debates and stop the argument from getting too heated. The aim of these long, exhausting interrogations was rather to wear down the accused until in a moment of weakness he let slip a contradiction which would enable them to confound him. The hearings that drained my strength more than any of the others were those concerning my increate universe, the infinite heavens and the innumerable worlds.

'The Scripture postulates the creation of time,' Madruzzi kept saying.

'Thomas Aquinas admits that it cannot be proved,' I would reply.

'He also accepts that this is an article of faith, Brother

Giordano, not a fact that can be proved by some demonstration or other. I note moreover that you have stated in the presence of witnesses that nothing of what the Church teaches can be proven. Do you dare after that to claim to be a good Catholic?'

'I have never uttered such words in my life, my dearest Fathers. As for my doctrine of cosmology, I hold that it is not irreconcilable with the dogma to which you are alluding. I understand the worlds – and among them our own – as being subject to generation and corruption. They can therefore have a beginning and an end. But the universe itself never comes into existence, never decays or dies, because it is matter in a state of perpetual transformation. Our earth, which is a living body in the sky, was created and will one day die. But not the universe . . .'

'If I understand you correctly, you do not deny that on this particular point the witnesses have told the truth.'

'The witnesses have accused me of all sorts of blasphemies against the Church and I repeat that they have lied. We are talking now about my natural philosophy, such as I have always taught it, wherever I have been.'

'Where does this hare-brained idea about an infinite number of worlds come from, if not from reading heretical books?'

'I acknowledge that I have read a large number of books; my profession demands it. From my earliest days I have held knowledge dear, and had no other wish than to fathom it and know it in all its forms and attributes. Aristotle himself studied conflicting opinions, as did Thomas, and Augustine. Ought I to feel ashamed of being a conscientious philosopher with a passion for his art? In my opinion every science and every belief, considered in its own right, contains its portion of universal truth, because every man, Your Eminences, is entitled to think for himself. I have therefore studied all the various doctrines, without ever adopting any single one, because I would never trust anything other than my own judgment. It is true that the exercise of reason has sometimes led me to have doubts about certain religious truths. I confessed those doubts in Venice, and I confess them again, and entreat this tribunal

that I may be forgiven for them, for in the depths of my heart I have remained a Catholic and faithful to the teaching of my parents and my Neapolitan masters, who are the best that can be found anywhere under the sun. The idea of the innumerable worlds was placed in me by God, not by the demons. God is the Author of the universe, He is Perfection and Infinitude. Why should an effect of Perfection have to be imperfect? God is unity. Why should His house be divided just because it is ours as well? Why, when there is only one God, should there be several sorts of matter?'

'In what sense do you think God is the Author of the universe?'

'The universe is the effect of His infinite will. God is at every moment the thought in nature, and at every moment nature is as a mirror willed by Him, a shadow or image in which He is reflected, in the infinity of space and the centuries.'

'Do you believe that is a Catholic way of thinking?'

'It is a way of thinking in accordance with nature, father.'

'And the Scripture.'

'The Scripture is another book. When I am praying, I pray; when I am thinking, I think . . .'

'Keep on holding forth like this, Brother Giordano, and quite soon you won't have the chance to pray or think any more.'

Warnings like that, of which I received plenty from Santaseverina, were only issued to intimidate me. I am not easily frightened, however, and I knew that the direction my case was going in was not particularly dangerous. Indeed, the impression that fifteen interrogations had left on the minds of the judges did not in any way confirm the picture that had been painted of me first by Zuan Mocenigo, then by Celestino and Graziano. It was obvious that I was not the foul-mouthed braggart whom the slanderers had described, and all Santaseverina's efforts were in danger of being thwarted by the simple good sense of those who were repelled by the idea of condemning an innocent man. To be sure, my

adventurous life, which was fundamentally suspect anyway, seemed to be peppered with breaches of the rules and customs of Christianity, but was I not showing myself willing to confess these faults humbly, and ask the Lord's forgiveness for them? There remained the delicate problem posed by the innumerable worlds. I had defended my doctrine on this point with such openness, such assurance, and such concern to conceal no part of it from the tribunal, that they had every reason to ask themselves whether it really did contain a heretical message. As I presented it, I could see some of the judges were thinking, its heterodoxy was not clearly apparent. The issue merited at the very least a thorough investigation and the assistance of the experts in canon law.

After the hearings twenty months went by during which I met the inquisitors on only two occasions, when they visited the prisoners to enquire after their needs and ensure that the rules of detention were being adhered to. When I complained about the delay in concluding my trial, Madruzzi informed me that he had decided to have the witnesses questioned again in Venice. Neither Ciotti nor Morosini altered one word of what they had said in their previous statement, but the others, not content with tirelessly repeating their calumnies, embellished them with a few more horrible details that they knew would satisfy my holy judges, things that they said they had remembered since the last time; hence their claims about the antics I had supposedly indulged in every day in prison, making up grotesque mock prayers just to make fun of believers and denigrate the liturgy: all of which I would deny, as I had denied the blasphemies and beatings.

But already it was becoming clearer what lay in store for me in this place where every new day brought the promise of a deadly despair. Madruzzi had ordered that my lot should be harsh; of all the prisoners I was the one who was most closely watched over, and had it not been for lack of room and the large number of brothers incarcerated I would have been shut in a cell on my own. My cellmates were still very often informers under orders from the tribunal, which forced me to

be sparing of my natural tendency to show fellow feeling. Because of this net that had been woven around me, I soon stopped hearing anything at all from Cecil, and it became impossible for me to communicate with the outside world. All I had was a little ink, a certain amount of paper which was rigorously controlled, and also a few books, but I was only allowed to work and take up my pen on subjects that were directly related to my case.

My only real friend there was one Francesco Pucci, who was to be imprisoned for three years and share my cell for a while. We had in common the fact that we had both travelled in England and Bohemia, and had been prompted to return to Italy by the sure expectation that religious reforms were about to take place which would enable philosophers to live freely at last. Like me, he had pinned his hopes on the politics of this same Pope who was now delivering us to the shackles of his judicial system. Together we taught the art of metaphysics to the youngest of our companions. We also exchanged numerous opinions on Ficinian magic, and a great many memories. Yet again I had to endure the death of a person whom I held in high esteem and great affection. Torture had failed to extract any confession or repentance from him. At the end of his trial, Francesco refused to recant his errors. He died with his throat slit in Tor di Nona. His remains were taken to the Campo dei Fiori and burned there. That was three years ago. As a sign of mourning and revolt, I ordered the brothers to keep a day's silence.

The other figure that comes back to mind is that of the giant Calabrian Tommaso Campanella. He was a devil of a fellow, who was only at the Holy Office for a few months, but was so keen and so determined to get to know me that the instructions issued by the cardinals that we should be prevented from seeing each other had very little effect. Traitors to the Pythagorean dogma, we would debate at night in low voices. Our exchanges attracted a handful of young infidels who marvelled at our knowledge, and Tommaso liked nothing more than to make them feel under his beret and touch the seven bumps that adorned his voluminous skull, or the

seven planets as he called them, while in the meantime his hand was diving into the boys' hose.

Although the Calabrian was not yet thirty and his life seemed to consist of going in and out of prison, he had already read most of my books. His great ambition was to see the Southern regions rise up, rebel, and kick out the Spanish and the Inquisition amid riot and uproar. One of the reasons why he was so eager to be my friend was this idea he had heard about – my idea, he believed – of founding a city of wisdom which would have made me its prince, a republic of the sun, a German *Aldocentyn* on the banks of the Elbe. Try as I might to deny that and more, to tell him that these were crazy ideas concocted by former disciples who were misrepresenting my doctrine; try as I might to curse those who peddled such rumours, he refused to listen. He himself was haunted by a similar project, he said. Hadn't the astronomers seen signs of great changes in the sky? Didn't we know that *Sol* was drawing closer to *Terra*? Yes, the cycle that was ending would engender another one, for out of turmoil comes concord, out of chaos comes order. To these celestial revolutions, those of men would respond. The decline of charity, goodness and faith, the conflicts which set the people against its men of religion, the pervading corruption, the proliferation of heresies, the violence of wars and counter-wars, the terrible extremes of the judicial system, all these were signs that the new law would triumph, and there was an urgent need to make the best possible preparations for this era of peace and happiness. Calabria, and the South in general, seemed to him the most appropriate place in the world to lay the foundations for the golden age in the form of a circular city standing on top of a hill, surrounded by seven walls, dedicated to the immortal virtues and the worship of the cosmos . . . Of course I could hear that what he said had the ring of my own oracles, but by heaven, was there any need to draw such absurd conclusions from them? He seemed like an intelligent young fellow; why was he being swayed in his turn by these old pipe-dreams?

'Do you think it's enough to build an ideal city on a lump

of Calabrian rock, Tommaso? We need to achieve philosophical reform everywhere . . .'

'We will achieve it. But let's start by setting an example and taking back possession of our land and our wealth. In Naples, in your own monastery, the brothers hate the clergy and the Inquisition.'

'That was already true twenty years ago.'

'Today they want peace, straight away, and happiness here on earth . . .'

Happiness? Peace? These two notions always sent a tremor through my soul. But the image that went with it was not one of a solar fortress built around a temple; far sooner one of a bedroom cradled, at night, by the eternal murmur of the waves.

In April ninety-six, I consoled and cared for Francesco Pucci whose interrogations were being carried out under torture. How could I ever forget the wretched man's face, his look of horror when the guards brought him, or rather dragged him back to our cell? I would block out the window with a sheet so that he would not suffer from the light, then, with infinite care, I would wrap my poor friend up in blankets. As he lay there on his bed with his teeth still chattering, I would murmur words of comfort to him. Francesco had been so afraid of confessing to his judges that when he came out of these sessions where he was hung from a rope, his icy lips refused to open, even to take a drink of water; it took endless patience and affection on my part to convince him that this was not the torturer any more, but a friend. Was Madruzzi reckoning that the company of the tortured monk would force me to reflect, and thus prompt me to confess to the tribunal the faults that I had succeeded in keeping secret? There again he was on the wrong track. To tell the truth, I was not afraid of torture, and had no intention of changing my attitude.

During a visit to the prisoners on the last day of the month, I was amazed to receive some indication that the cardinals regarded the end of my trial as imminent: their most senior member informed me that he was preparing to draw up the

sentence. It would turn, he said, on the breaches of the Church's rules of which I was guilty, and also on my conceits with regard to the transmigration of souls and the innumerable worlds. For the last time, was I sure that I had concealed nothing from the Holy Tribunal? Was there anything I wished to add to my previous declarations?

'I am willing to repent of my errors,' I replied, 'and I have no others to confess.'

Once again Madruzzi could not resist hinting at the threat of a more rigorous interrogation. Torture, he insinuated, made it possible in many cases to make up for the lack of witnesses and to obtain from the accused a full and complete confession. For a split second I went back in my mind's eye to Francesco trembling with fear and pain on his bed; but I stood firm. Then came a long silence, during which I kept my head bowed, in a position of humble meditation. At last the Inquisitor appeared to soften. He asked me about my health, my material needs. I was not ill, I admitted, but I had no possessions apart from a pair of glasses, a few pieces of underwear and the wretched woollen garment I had been wearing for three years.

'When you are released we shall see to it that the Dominican order provides you with a little money,' he assured me.

With these words he sent me back to my cell.

Could it be that the case was finally over? Already dangerous waves of hope were sweeping over me. Unless Madruzzi had deceived me, it only remained for the tribunal to send its conclusions off to Clement so that he could approve them. The punishment would be light – an act of contrition, followed by a few months' penitence – and the pardon granted without difficulty. Soon, yes, soon I would be free, and I would be allowed to return to Venice. Forgetting all wisdom, I abandoned myself to pleasant dreams, tinged with reminiscences and set in the Serenissime, in its chattering academies and the palace on Malamocco. I would find peace again, my journey would come to an end, and so would the voyage of my thoughts. There, little by little, I would end my destiny, my years, seasons and days, my writings, my life of quarrel and

passion. To start on new books, to work until dawn, to listen in the darkness to the breathing of my living god! Cecil, my sweet friend, to kiss your lips again. Your body was beginning to come back to life in me, that body which in order not to add to my sufferings I had been doing my utmost to forget . . .

But the Pope, advised by some genius whose name I can easily guess, refused to be satisfied with the cardinals' work. He let the summer go by, then the autumn, slowly but surely killing off my renewed hope. In November he demanded that the investigation be resumed, not on the strength of the witnesses' evidence, which he regarded as questionable, but on that of my books, pure and simple. Those which the tribunal had made available to him, he wrote to Madruzzi, were not enough to shed light on the truth about my heresy; it would therefore be advisable to get together some more. The whole business, I reflected with terror, would take several months! On top of which there would have to be fresh interrogations, new and exhausting battles of wits . . .

The task of gathering together my works and the writing of the censures did indeed take up the whole of the year of ninety-seven and part of the next. Agents dispatched to France and England found my Italian dialogues, which are easy to come to grips with, and which the canonists perused with indefatigable zeal, copying out the passages that were opposed to their dogma, and amassing the evidence against me which the cardinals had lacked. Madruzzi did not even wait until all these splendid efforts had borne fruit before starting the hearings again. Having reconvened the tribunal, he put the matter of torture to the vote. It was agreed on unanimously, and authorised by Clement himself.

'My sweet Cecil, an animal is loath to torment one of his own kind; not so man. You may be assured that I did not tremble when the guards undressed me for a sacrifice which was not that of love. While the torturer was operating his winch & I was rising like an angel above the ground, ready to reach the very pinnacle of suffering, I even thought of what Montaigne said against the torture chamber: he condemned this form of

justice in the name of reason, & because it sullies the man who carries it out. What would he have thought if he had experienced it? For my part, after undergoing four hangings by the rope, I wanted to die, so unbearable were the shame & the pain. Do you remember *death by the kiss*? It was the art, once practised by the Egyptian sages, of going into an ecstasy at the end of which the soul detaches itself naturally from the body. But I no longer had the strength to get that far; & so it is, my Love, that I am still alive. I have even taken up my pen again, although I cannot be sure whether this letter will ever reach you.

'While I was under torture, the inquisitors asked me if I had intended to destroy the Catholic faith with my *anima mundi*, which according to them was a perverse idea, & opposed to their Trinity. As I have never stopped doing since I was in Venice, I said I was sorry for my doubts on this point, but refused to confess anything else. They are even more outraged by my innumerable worlds. These, they say, prove that I despise the Holy Scriptures. Madruzzi begged me to renounce them. I answered that I could not. I was in such pain that I thought I would faint. My eyes stared at the upturned sandglass on the table. Since there was still a little time left & I had not given them satisfaction, the judges ordered one last strappado. You have never heard a man shriek more loudly than your Philip did that day.

'Clement wants my books to testify against me & his jurists will soon have finished dissecting them. Then the trial will start again, & the torture too perhaps. Am unable to say when my miseries will come to an end. I only know that I have been held here for five years, that I have heard nothing from you or anyone, have no money & no support of any kind. I have had just one friend in this prison, & they took him last year to Tor di Nona & slit his throat. Forgive my trembling, feeble handwriting. Forgive my despair. Will I ever see you again?

'Philip
'this 2nd February MDXCVIII.'

But the hearings resumed without there being any question

354

of administering the rope to me again. At the end of that winter of ninety-eight, I had to do battle one last time before the tribunal, in a final defence of my philosophy in which those who care to read the minutes of the trial will be able to take delight. Madruzzi had in front of him, duly copied, the extracts from my books which were proposed by the canonists for censure. Questioned once again *circa rerum generationem*, I calmly stated that there are two eternal, incorruptible, inseparable principles in the universe: Spirit and Matter. Like the Heraclitean river, Matter is always changing and transforming itself, without ever altering in its essence. My doctrine, I repeated, was not in contradiction with Genesis, because if it is written: *In the beginning God created the heaven and the earth*, it is also written: *That which is done is that which shall be done, and there is no new thing under the sun.* Asked if I still insisted that the universe was infinite, I answered as ever that this truth could be deduced from the perfection of the divinity:

'He who denies the infinite effect denies the infinite cause . . .'

'But the innumerable worlds?'

'There is no limit to God's freedom, or to that of His will.'

Questioned on my definition of the soul, I declared that every spirit is the reflection, the mirror, the fragment of the one Spirit known by the Ancients as *anima mundi*:

'The soul that lives in me, and in you, Father, comes from God and returns to God; it is different in that it is a particular accident of being, but identical to the principle from which it emanates. The spirit of each individual possesses all the properties of the universal Spirit.'

'As you conceive of it, does this soul inhabit the bodies of animals, or only those of men?'

More than any of my other heresies, transmigration had offended the vanity of the old prelate. Did such an idea increase his feeling of anxiety about approaching death? I found the strength to smile:

'May I here again quote the very Bible that you are invoking against me? I read in it a very long time ago that men and animals suffer the same ills and the same misfortunes: *As the*

one dieth, so dieth the other; yea, they have all one breath; so that a man hath no pre-eminence above a beast. However I am very willing to admit that there is a difference, and that a man's soul lives on after his death. Let us say that those of the beasts return to the great All.'

After that the cardinals, who had read my *Ash Wednesday Supper*, condemned my views *circa motus terrae*. I declared that I had indeed demonstrated that our planet was a star going round and round in the sky. This theory was not due to any wish of mine to denigrate the dogma, but to my concern to judge at their true worth the astronomical calculations and irrefutable conclusions of the most authoritative scholars.

'Every sage, one day, will recognise their validity. And the Church will not have to suffer for it . . .'

'It is a truth which bears little resemblance to the Scriptures, Brother Giordano.'

'The Bible is a great book in which all shades of being and thought are reflected. Ecclesiastes – forgive me for quoting it again – emphasises the earth's eternity, not its immobility.'

'Ecclesiastes also says that it is the sun, not the earth, which rises and sets.'

'Because that is how it appears, Very Reverend Father. But beyond the simple, wonderfully poetic language of the Bible, there exists a natural reality. Our eyes see the sun rising, Homer's rosy-fingered dawn of old; then comes the day when our reason discovers the mysterious machinery that engenders these phenomena.'

Having read aloud the passage from the *Ash Wednesday Supper* where I say that the earth has a soul which is capable of feeling and understanding, Madruzzi asked me if I still stood by such a fanciful idea.

'I stand by it, Reverend Father, and I do not see anything in it that gives cause for censure. Our generous earth belongs to the universe, and thus to the *anima mundi* whose properties it possesses. It is a body endowed with life and breath – *all one breath*, ever and always. Yes indeed, I think of it as a vast animal, and one moreover which is endowed with reason. Are not its actions perfect and reasonable? Do not both its movements,

one around the axis of its poles, and the other around the sun, obey an intelligible rule?'

A definition like that could not fail to draw sighs of horror and indignation from my judges. The Inquisitor demanded silence, then referred to one last heresy in my writings:

'You have published the proposition that the soul is to the body as the pilot to his ship, Brother Giordano. Are you not aware that the Church condemns those who attribute a form to a human soul?'

'This is a misunderstanding, Reverend Father. I was speaking metaphorically, and do not think in any way that the soul has a form. But how can one convey the bond which is said throughout the Bible to unite the soul and the body? In my philosophy, the soul imprints its will and its desire on the body; as people do on the homes they live in, and travellers on the journeys they make.'

I emerged from this last series of interrogations very weary, but by no means discouraged. Indeed, I was sustained once more by the feeling that the matter was nearly at an end. On almost all the charges concerning insults and blasphemies against Christ, the Saints, the Virgin and the sacraments, the Inquisitor's convictions had been shaken. I had confessed at length my doubts and my lack of respect for the rules of religion, admitted having frequented infidels and read their books, and having praised princes hostile to the Church. But I had denied, including under torture, having ever practised supernatural magic, or sought to embrace or create any kind of heresy. What was there left to condemn? My intuition of an infinite universe? The support I had given as a philosopher to recognised doctrines which were respected by the best minds everywhere in Europe? To be sure, my defence of *anima mundi* was a hard dish for the delicate stomachs of the nine cardinals to digest, but I had backed up my thesis by quoting numerous passages from the Bible; and what is more I was prepared to ask God's forgiveness for holding this opinion which He Himself had sent me, if that was the price I had to pay for my freedom. Let Madruzzi's consultants finally produce a summary of the

investigation, I thought, and let sentence be pronounced! But it was not pronounced, so deeply were the judges embroiled in their awkward dilemma. They were bailed out in a sense by the recapture of Ferrara, which kept my trial on hold for another year. Clement decided to make a full state visit to his new legation, and every prelate and advisor the Curia had was kept fully occupied by the preparations for the journey and then the journey itself. The business of the Holy Office was suspended; it was not to start up again until December.

Once the whole court had returned to Rome, Madruzzi looked around for a theologian capable of sorting the matter out and writing the document which would make it possible to decide whether or not I was guilty of heresy. His choice fell on a priest who had been head of the Society of Jesus in the Neapolitan region. He was said to be highly esteemed and admired by Clement, who was preparing to make him a cardinal and was full of praise at all times for his extraordinary intelligence, his perfect knowledge of the dogma and his inexhaustible will to fight the infidel. The elegant Robert Bellarmin, as this prodigy was called, visited me in my cell on the eighteenth of January last year. He saw my spectacles sitting on the table, and a pair of compasses, a ruler and my pen lying on top of the sheet of paper.

'You are the oldest prisoner in the Holy Office,' he said, sitting down.

The man was serious, but not at all formal.

'A privilege which I would gladly go without,' I replied coldly. 'When are they finally going to end the trial?'

'Soon. Very soon. It's only a matter of days now. I grant you that the tribunal ought to have pronounced its judgement long ago, but the case is a difficult one. I have examined your books in detail, and the minutes of the trial. I have got them to agree to leave aside the accusations of blasphemy which have never been able to be proved.'

'A tissue of slanderous lies . . .'

'Perhaps. But you will note that by agreeing not to go back

over them, the tribunal is showing its good will. As for the rest, Clement is counting on a sincere retraction.'

'Clement will get what he wants. But they must let me go. I am a scholar, not a criminal. I have been waiting for six years to be told what I must recant.'

Bellarmin held out a sealed document:

'I repeat, a *sincere* retraction. That is the Pope's wish. This is a list of eight propositions taken from your doctrine, compiled with the greatest rigour on the basis of your own writings and your declarations before your judges, in both Venice and Rome. They alone will enable us to reach the agreement that everyone is hoping for. May I emphasise, Brother Giordano, that what this list contains comes entirely from you; it has nothing to do with your denouncers.'

I turned the envelope over and over in my hands. He went on:

'All the propositions you will read there are heretical according to the canons of the Church.'

'If they are,' I murmured, 'or if the Holy Seat judges that they are, then I shall revoke them. When and where you like.'

The Jesuit's voice turned harder:

'They are, Brother Giordano. No-one could be in any doubt of it.'

He stood up and banged on the door to call the goaler.

'The tribunal entreats you to study them closely. For that purpose it grants you a period of six days.'

'And if I refuse?'

'Six days, Brother Giordano. Not one more.'

On the basis of quotations from my writings and statements, this fine, scrupulous *pensum* did indeed set out to sum up in eight points what it was about my philosophy that threatened to destroy the Catholic religion. Eight heretical propositions! So that was all that a theologian as experienced as Bellarmin had deemed it necessary to retain of a set of complete works which spread over more than forty volumes!

When the allotted time ran out, I was taken to Madruzzi's palace on the Piazza Navona, for a highly solemn hearing

which could have been the last, had I not suddenly been driven by a mysterious urge to see the wind of dispute blow over the gathering. The cardinals had surrounded themselves with their advisors, among them the efficient Robert Bellarmin. He did not even look at me. Having declared that I had acquainted myself with the eight propositions taken from my books, and was willing to retract them as false, I handed over to the clerk, who in turn handed it to the dean, an eighty-page document intended, as I explained, to provide my defence.

'What is in this new document?' enquired the dean, looking anxious.

'In it I go back over in detail, and for the last time, I think, the principles of my philosophy, Very Reverend Father, in order to demonstrate to the tribunal that they are not in contradiction with the Holy Scriptures.'

Bellarmin had turned pale.

'I am astonished,' the dean went on, 'that you can declare yourself willing to recant your errors and at the same time persist in defending them.'

'I am indeed willing to retract the Reverend Bellarmin's eight propositions, Father, since that is the will of the Church. But I am afraid that as far as my doctrine is concerned, it is not at all happy about the idea of being trapped within the narrow confines of a few phrases taken out of their context. Forgive my vanity, but the philosophical act is a moving force, like the world itself, never completed, always living and ready to spring back to life.'

'He is treating us with contempt,' sighed Santaseverina. 'That's perfectly clear now.'

What a derisory sham it all was – a trial that had dragged on for eighty months! I confess that, faced with this learned assembly of impotent judges, I was visited by a continuous stream of the most frivolous thoughts, and the imperious desire for one last time to play the buffoon – yes, one last time: by the very nature of my philosophy, such bouts of gaiety could only be interpreted as the reverse reflection of a crack which had appeared in my soul, and would soon lead me to

my death: *in tristitia hilaris, in hilaritate tristis.* Had I not once had that pithy little saying printed on the frontispiece of my *Candelaio*?

The treatise which I had just submitted plunged the cardinals into considerable confusion. Running through it was a rediscovered talent, a pleasure in writing, playing with words and arguing which I had thought had been stifled by seven years of boredom. Oh the magic of language! In it I returned point by point to the controversy over the censures, and through the medium of new metaphors, I strayed miles from the narrow path of the much-discussed, dry-as-dust eight propositions, without in any way betraying the deeper meaning of my thoughts. To write! To write again! To re-invent the language of the gods! That was certainly the aim of my life, and thus of my death. The document was entrusted to Bellarmin, whose brief it was to work out whether it contained new errors and heresies, or whether it tended towards retraction; in which case it would finally become possible to make the Pope happy and be done with the matter. It was pitiful to imagine the judges caught like this between two opposing lines of fire: on the one hand Clement, who was pressing them to expedite the matter as soon as possible; on the other, a defendant who was doing his best to complicate things as much as he could! But the theologian, who had had the honour in March of donning the Monsignor's robe, suddenly found that he was completely taken up by the demands of his new office. He was not able to pronounce his conclusions until the end of the summer.

When the hearing finally came along on the tenth of September there was, by a curious trick of the devil, a shadow hanging over it: that of Fra Celestino, the epileptic Capuchin who had testified against me in Venice. The wretch's madness had got the better of him, and he had ended up denouncing himself to the Roman Inquisitor as an infidel, a relapsed heretic, a blasphemer and a villain, and throwing himself headlong into a final trial, still bawling out strings of insults about Christ and the leaders of the Church. In the end they had shut him up once and for all by burning him alive on the Campo

dei Fiori. The fire's ashes had barely had time to cool, and it had provoked angry outbursts at the French Embassy and in cultivated circles, yet again bringing the Pope's system of justice into disrepute.

'I acknowledge the eight propositions as heretical,' I declared. 'I am willing to recant them when and where it pleases the Holy Office.'

'Excellent,' said Madruzzi, turning to Bellarmin. 'My dear Father, you have, I believe, examined the document which the accused has handed over to us. Does it show that he persists in his errors?'

The theologian, who had what I had written in front of him, was studying them with manifest perplexity.

'Brother Giordano's document is very strange indeed. What is its purpose? I cannot tell exactly. Perhaps it is about religion, perhaps not. Poetry and philosophy, on the other hand, are mixed at will in a skilful attempt to seduce the reader, and the phrases are turned in such a way that it is hard to decide whether the infinite spaces and the innumerable worlds belong to a marvellous legend, or whether they are the expression of a sure belief.'

'Yes, yes . . . but what about the attitude of the accused with regard to your eight propositions?'

'The attitude of the accused appears to me to be correct, my dear Father; so far, I repeat, as it is possible to tell. On one point, however, Brother Giordano does clearly seem to persist in his error, by continuing to state that the soul lives in the body as the pilot does in his ship.'

My repeated explanations of this aspect of my doctrine were so far from finding favour with the judges that the dean, urged on by Santaseverina who was anxious not to see victory slip away from him, felt obliged to suggest to the tribunal that there should be another *rigorous* interrogation. The vote took place in my absence, and the result was a small majority in favour of a few hangings by the rope. It was still necessary to obtain Clement's approval. The emissary dispatched to the Castel Sant'Angelo came back a couple of hours later with the answer: the Pope, having asked the Lord

for guidance and pondered the matter over, refused to authorise the torture.

So now Madruzzi, deeming that my opinion on the nature of the soul was in fact the eighth of Bellarmin's list of errors, decided to stick to that document alone in order to expedite the matter, thus setting aside my latest piece of writing as he had set aside the accusations of the slanderers. What a ridiculous farce! Sounding just like a schoolmaster, he then declared that he was granting me another period of forty days, at the end of which the tribunal would demand a complete and sincere abjuration of all my heresies, *without exception*. Forty days, this time! This stalling tactic made me smile. Since these aging men considered in their hearts that I was unrepentant, why could they not bring themselves to condemn me? Were they afraid that if I died my work would suddenly rise to spectacular fame?

I did not use the new waiting period to meditate on the wretched tribulations of this system of justice, but to exchange views with Brother Cyprian, my last cellmate. And also to prepare myself to die, by reading and rereading Augustine's *Confessions*, the only book, along with Thomas' *Summa*, that I was allowed to possess. When, for the twenty-fourth time, I was led before the cardinals, I was unable to conceal the contempt that these people inspired in me, and refused to kneel. In an insolent voice, I repeated that I was willing to recant whatever they wanted. Madruzzi eyed me scornfully as if I had spat in his face. He opened his mouth, but nothing came out.

'Do you now doubt again that the eight propositions are heretical?' intervened Bellarmin, who was still hoping to save the situation.

'Heretical they are, since you have described them as such. I only doubt whether they are false.'

'By doubting whether they are false, you are admitting your heresy.'

'If I am a heretic, burn me.'

Was not that what the holy canons commanded? Cries of indignation burst forth from all four corners of the assembly.

Only Santaseverina was able to remain calm, and was visibly satisfied at the turn events were taking.

'You said you were willing to recant,' Bellarmin went on. 'Was that a lie?'

'I never lie. I said that; it was true. It still is. You compiled a list of errors and I acknowledged them as such. Prepare a document of abjuration and I shall read it publicly.'

'But you do not repent your errors?'

I smiled.

'Why should I repent propositions that were written or dictated by you, Your Eminence?'

'I wrote them, but they are *your* opinions. You declared yourself willing to execrate them as irreligious . . .'

'What I execrate *hic & nunc* is this tribunal and its miserable proceedings. I believe you know Naples, Your Eminence. A man like you will not have failed to observe that the people of the Kingdom abhor the Inquisition. Have you ever asked yourself why? Well, I shall tell you: it is because they hate fear, and because fear is the soul of this system of justice. It lives in it, forgive me for going back to this, as a bad pilot lives in his ship, committing error after error, arrogantly making mis-calculations, groping its way along in defiance of reason, always mistaking good for evil and in the end leading the cargo and crew into disaster. The soul has no form, no, but it governs each and every thing in this world.'

They all sat there, aghast.

'For these judges whom you say you hate,' Bellarmin then retorted, 'there is nothing more terrible than to see a brother die impenitent.'

Then, shaking his head angrily and rising to leave the tribunal:

'What good will ever come of such obstinacy!'

I suddenly felt a sort of relief. This clever man had tried to kill my spirit; all he could do now was meditate on his failure.

There were, I believe, more deliberations on my case, about which I refused to be kept uninformed. I imagined that once again the Inquisitor was in an impasse. Clement would be viewing the approach of his jubilee year with some anxiety, I

thought; no doubt he was still demanding a sentence . . . For me, the issue was now clear.

During the visit to the prisoners on the twenty-first of December, Madruzzi asked me in the usual way about my material needs. I could see no point in answering him. Then, cautiously moving on to the subject of the accusations, he asked me if I was still willing to retract my false opinions.

'I do not see,' I said, 'that there is anything in my writings that needs to be retracted. I affirm that I have never uttered or published any heresy.'

'It seems that the Holy Office has judged otherwise.'

'The Holy Office is mistaken. Its advisers have misinterpreted my books . . .'

To the two members of the tribunal who were dispatched to my cell the very next day to soften me up, I declared that my decision was irrevocable.

'So you want to be burned to death.'

'I want to live. And I shall live.'

'What glorious light are you hoping to arrive at?'

'It is you who are condemning me, don't forget.'

On the twentieth of January last, Madruzzi presented to Clement the sentence which was to be read to me in his palace when I made one final appearance, only the date of which was yet to be decided. It is said that the pontiff flew into a mad rage, yelling out orders that I should be handed over to the secular arm, since that was the will of the Holy Office. To the priest who was sent to tell me the news I did not address a single word; I merely opened my book and pointed with the nib of my pen to the passage in the *Confessions* which says: *And so I in my turn shall go beyond this energy that is my substance, and rise step by step up to Him who made me. With those words, I now pass into memory . . .*

Within the limits of a single human existence there opens up eternity, which is also known as Love. A few hours away from my last breath, and as the procession of the black friars has set off from San Giovanni Decollato, I am the happiest of mortals: thanks to the extraordinary diligence of Deza and the

complicity of Orazio, I have been able to kiss my pure star, my living god, my Alicibiades; Cecil, life of my life, soul of my heart, treasure of my memory, my blood and my eyes. To whom but you could these last lines, written this evening in my hand, be dedicated? I thought I would faint with happiness when I saw you. And yet age and sorrow have hardened your features and turned your hair white; and you were so pale, so trembling, so exhausted by the journey, the waiting, the uncertainty. We exchanged only a few words, very simple ones; but in the final hour I, like Socrates in his prison, have been granted the presence of one who is beloved, more than beloved. Is it a miracle? A prodigy? A sign? Yes, our lips touched, my fingers brushed against your neck; and my body, soon to be nothing but ashes, trembled.

As if our two spirits were suddenly one and the same mirror, there was a fraction of a second in which we forgot the miserable condemned cell, and dreamed of the past which holds all the world's joys. For one last time we were gods, transported by the magic of reminiscence and some phrases that were murmured very close to here, on the Piazza Capodiferro – who knows what love affairs are going on inside the mad cardinal's palace today! – then in Geneva, Paris, London, Wittenberg and Malamocco, in the house cradled by the waves to which you will return to end your days. We spoke, so very briefly, of the memory of departed friends, as we used to when we talked under the perfumed sheets, with the sea wind coming in through the windows and threatening to blow out the candles and plunge us into delicious darkness. For a long time I cherished the hope of continuing my work there with you, of receiving visitors there, of teaching my wisdom there to serious, handsome *pueri*. Did you wait for my return? I believe you did, I know you did, because I have never doubted you. And I also know that however different our bodies and souls were, you have never loved anything as much as their embraces. But it seems that with the end of my existence, my ideas must end as well. And so long may my books live on, and my innumerable worlds, my paradoxes and my errors! Sidney once said he would like his death to be one final poem; I make

of mine the last act of my philosophy. I am sorry for the tears that this accursed pride of which I am prisoner is costing you. I have loved you as much as I have loved knowledge. You wanted to see me live, knowledge is killing me; and human existence is a sad farce invented by the gods.

You visited me in this antechamber of hell whose walls are colder than those of a sepulchre; I asked you not to come tomorrow to the Campo dei Fiori. I do not know where you are now. If my thoughts are reaching you as I write these words, I beg you, do as I say. Why should I suffer you seeing me tied naked to a stake, booed and despised by the common herd?

Deza is with me at the moment, waiting until he can take these pages away. I have a feeling that you have given him a purse for the executioner. Thank you, my love. No-one has been able to save me from death, but certain sufferings should be avoided. I was afraid of having to cry out in the flames as I did under torture . . . The black friars will be here in a few minutes. One last kiss on your lips, one last caress on your neck. For you, for you alone, one last line of poetry:

Aflame with love, I die in great misfortune

THE AUTHOR

Serge Filippini was born in 1950. A philosopher and critic he is the author of six novels. It took him fifteen years to complete his grand project and follow in the footsteps of James Joyce by writing a novel about his hero, the 16th century Italian philosopher, Giordano Bruno. *The Man in Flames* has been a major critical and commercial success throughout Europe.

THE TRANSLATOR

Liz Nash is a freelance translator living in Oxford. Her translations for Dedalus are Sylvie Germain's novels *The Medusa Child* and *Infinite Possibilities*.

Contemporary Literature from Dedalus

The Experience of the Night – Marcel Béalu £8.99
Music, in a Foreign Language – Andrew Crumey £7.99
D'Alembert's Principle – Andrew Crumey £7.99
Pfitz – Andrew Crumey £7.99
The Acts of the Apostates – Geoffrey Farrington £6.99
The Revenants – Geoffrey Farrington £3.95
The Man in Flames – Serge Filippini £10.99
The Book of Nights – Sylvie Germain £8.99
Days of Anger – Sylvie Germain £8.99
Infinite Possibilities – Sylvie Germain £8.99
The Medusa Child – Sylvie Germain £8.99
Night of Amber – Sylvie Germain £8.99
The Weeping Woman – Sylvie Germain £6.99
The Cat – Pat Gray £6.99
The Black Cauldron – William Heinesen £8.99
The Arabian Nightmare – Robert Irwin £6.99
Exquisite Corpse – Robert Irwin £14.99
The Limits of Vision – Robert Irwin £5.99
The Mysteries of Algiers – Robert Irwin £6.99
Prayer-Cushions of the Flesh – Robert Irwin £6.99
Satan Wants Me – Robert Irwin £14.99
The Great Bagarozy – Helmut Krausser £7.99
Primordial Soup – Christine Leunens £7.99
Confessions of a Flesh-Eater – David Madsen £7.99
Memoirs of a Gnostic Dwarf – David Madsen £8.99
Portrait of an Englishman in his Chateau – Mandiargues £7.99
Enigma – Rezvani £8.99
The Architect of Ruins – Herbert Rosendorfer £8.99
Letters Back to Ancient China – Herbert Rosendorfer £9.99
Stefanie – Herbert Rosendorfer £7.99
Zaire – Harry Smart £8.99

Bad to the Bone – James Waddington £7.99
Eroticon – Yoryis Yatromanolakis £8.99
The History of a Vendetta – Yoryis Yatromanolakis £6.99
A Report of a Murder – Yoryis Yatromanolakis £8.99

Memoirs of a Gnostic Dwarf – David Madsen

'A pungent historical fiction on a par with Patrick Suskind's Perfume.'
The Independent on Sunday Summer Reading Selection

'David Madsen's first novel *Memoirs of a Gnostic Dwarf* opens with stomach-turning description of the state of Pope Leo's backside. The narrator is a hunchbacked dwarf and it is his job to read aloud from St Augustine while salves and unguents are applied to the Papal posterior. Born of humble stock, and at one time the inmate of a freak show, the dwarf now moves in the highest circles of holy skulduggery and buggery. Madsen's book is essentially a romp, although an unusually erudite one, and his scatological and bloody look at the Renaissance is grotesque, fruity and filthy. The publisher has a special interest in decadence; they must be pleased with this glittering toad of a novel.'
Phil Baker in The Sunday Times

'. . . witty, decadent and immensely enjoyable.'
Gay Times Book of the Month

'There are books which, arriving at precisely the right moment, are like life-belts thrown to one when one is drowning – such a book for me was *Memoirs of a Gnostic Dwarf*.'
Francis King

'. . . its main attraction is the vivid tour it offers of Renaissance Italy. From the gutters of Trastevere, via a circus freakshow, all the way to the majestic halls of the Vatican, it always looks like the real thing. Every character, real or fictional, is pungently drawn, the crowds are as anarchic as a Bruegel painting and the author effortlessly cannons from heartbreaking tragedy to sharp wit, most of it of a bawdy or scatological nature. The whole thing mixes up its sex, violence, religion and art in a very pleasing, wholly credible manner.'
Eugene Byrne in Venue

'. . . a hugely enjoyable romp.'
Jeremy Beadle in Gay Times Books of the Year

'The most outrageous novel of the year was David Madsen's erudite and witty *Memoirs of a Gnostic Dwarf*. Unalloyed pleasure.'
Peter Burton in Gay Times Books of the Year

'this is a rigorous and at times horrifying read, with something darker and deeper in store than the camp excess of the opening chapters.'
Suzi Feay in The Independent on Sunday

'Madsen's tale of how Peppe becomes the Pope's companion and is forced to choose between his master and his beliefs displays both erudition and a real storyteller's gift.'
Erica Wagner in The Times

'Madsen's narrative moves from hilarity to pathos with meticulous skill leaving the reader stunned and breathless. The evocation of Italy is wonderful with detailed descriptions ranging from political problems to Leo's sexual proclivities. The novel is so hard to place in any definite genre because it straddles so many; historical novel, mystery and erotica – it is simply unique.'
Steve Blackburn in The Crack

'not your conventional art-historical view of the Renaissance Pope Leo X, usually perceived as supercultivated, if worldly, patron of Raphael and Michelangelo. Here, he's kin to Robert Nye's earthy, lusty personae of Falstaff and Faust, with Rabelasian verve, both scatological and venereal. Strangely shards of gnostic thought emerge from the dwarf's swampish mind. In any case, the narrative of this novel blisters along with a Blackadderish cunning.'
The Observer

'If you're into villainy, perversion, religious pomp, the inquisition, torture, freaks and a smattering of sex, guess what . . . this *Gnostic Dwarf* has got the lot. Not only that, but the writer weaves a bloody good tale into the proceedings as well.'

All Points North

'This is what historical novels should be like, rendering the transitory world views of the historical and fictional characters, as believable as their more intrinsic characteristics of hate, greed, love and loyalty. Forget Martin Bloody Amis, *Memoirs* will make you laugh, cry – it may even impart a little wisdom.'

David Kendall in Impact Magazine

'Some books make their way by stealth; a buzz develops, a cult is formed. Take *Memoirs of a Gnostic Dwarf*, published by Dedalus in 1995. The opening paragraphs paint an unforgettable picture of poor portly Leo having unguents applied to his suppurating anus after one too many buggerings from his catamite. Then comes the killer pay off line: "Leo is Pope, after all." You can't not read on after that. I took it on holiday and was transported to the Vatican of the Renaissance; Pepe, the heretical dwarf of the title, became more real than the amiable pair of windsurfers I'd taken with me.'

Suzi Feay in New Stateman & Society

'*Memoirs of a Gnostic Dwarf* was overwhelmingly the most popular choice of Gay Times reviewers in last year's Books of the Year. Reprinted now this outrageous tale of the Renaissance papacy, heretics, circus freaks and sex should be at the top of everyone's "must read" list.'

Jonathan Hales in Gay Times

'the best opening to a novel ever written was published in 1995 by a man who uses a pseudonymn. It's Rome in the year 1518 and it goes like this:

"This morning His Holiness summoned me to read from St. Augustine while the physician applied unguents and salves to his suppurating arse; one in particular, which was apparently concocted from virgin's piss and a rare herb from the private *hortus siccus* of Bonet de Lattes, the pope's Jewish physician-in-chief, stank abominably. Still, it was no worse than the nauseating stench of the festering pustules and weeping ulcers adorning His Holiness's cilicious posterior. With his alb pulled up over his hips, and his underdraws down around his ankles, the most powerful man in the world lay sprawled on his bed like a catamite waiting to be well and truly buggered.

"He has been buggered, plenty of times – hence the state of his arse. His Holiness, in case you are unaware of the fact, likes to play the womanly role, thrashing and squealing beneath some musclebound youth, like a bride being penetrated for the the first time. Not that I've any personal objection to such behaviour – Leo is pope after all."'

Eugene Byrne in The Venue Interview of David Madsen

£8.99 ISBN 1 873982 71 2 336pp. B Format